ALSO BY JUDITH DUPRÉ

Skyscrapers
Bridges
Churches
Monuments

FULL *of* GRACE

FULL of GRACE

Encountering Mary in Faith, Art, and Life

JUDITH DUPRÉ

RANDOM HOUSE • NEW YORK

Published in the United States by Random House,
an imprint of The Random House Publishing Group,
a division of Random House, Inc., New York.

RANDOM HOUSE and colophon are registered
trademarks of Random House, Inc.

Permission credits can be found on page 323.

LIBRARY OF CONGRESS CATALOGING–IN–PUBLICATION DATA

Dupré, Judith
Full of grace: encountering Mary in faith, art, and life / Judith Dupré
p. cm.
ISBN 978-1-4000-6585-1
1. Mary, Blessed Virgin, Saint—Devotion to. 2. Mary, Blessed Virgin,
Saint—Art. I. Title.
BT645.D87 2010
242'.74—dc22 2009051676

Printed in China

www.atrandom.com

9 8 7 6 5 4 3 2 1

FIRST EDITION

Book design by Simon M. Sullivan

COVER IMAGE: *Annunciation* (detail), 1393. Porziuncola Chapel, Basilica of Santa
Maria degli Angeli, Italy. Photo: Bednorz-Images
TITLE-PAGE IMAGE: Titian, *Assumption* (detail), 1516–1518. Basilica of Santa
Maria Gloriosa dei Frari, Venice. Photo: Bednorz-Images
ENDPAPERS: © shutterstock/Yellowj

To my mother, with love and gratitude

Preface

I N THE END, I came to understand that this was a love story—and one with not just one narrative, but many. As a scared child, proud parent, grieving mother, and beloved icon, the Virgin Mary has inspired countless stories of love, in all its nuance and variety, both commonplace and rare.

This is a book about love between friends, neighbors, sisters, and soul sisters, and the support that women give one another daily as we navigate life's shoals. It is about mother love, that womb-deep love we have for our children, an eternal bond as tender as a rose petal and stronger than death. It is about a father's love, the steadfast courage to stick around against all odds, protective and unmoved by what others might say. It is about the love that has always existed between men and women and remains evergreen, despite everything that says it is dead, twisted, or bad for us. It is about the terrible, tumultuous love at the end of life, when the dying must say goodbye to everyone and everything they have ever loved, and those left must love enough to let go.

Mary knew a lot about letting go.

If this is a book about the love that Mary ignites, it is also about our engagement with transformation—the battles that we fight within ourselves, and those that have changed the world. A poet once compared Mary to the very air we breathe, and to that apt description of her effortless, all-enveloping presence, I would add that she is also like the horizon line—that distant but ever-present reassuring marker of the place where earth and heaven connect, where people come together in all their vulnerability and mystery.

Mary is here, right now.

To lose, or find yourself in these fifty-nine stories you do not need extensive knowledge of the Virgin Mary or even Christianity. Instead, in this examination of the divine in the ordinary world, I

This text is a three-part invention: narrative, visual narrative, and marginalia. In the main text, I offer short essays, sometimes personal, sometimes theological or historical, on Mary's place in our everyday lives. The imagery and captions form a "book within a book" that traces Mary's influence on Western art. The selections from history, poetry, and prose in the margins offer additional insights into Mary and are formatted after the *midrash* commentary on the text of the Hebrew Bible, which is used also but to a lesser extent in the New Testament and the Qur'an.

have looked for essential truths about the human condition that are not tied to any one faith. By making an empathetic, interpretative leap into Mary's historical past, I found parallels in contemporary life with those distant events and through them fuse new and old approaches to the study of Mary. In my previous books, I stepped back from the narrative, but here I offer more personal reflections, in hopes that you, too, will find yourself in these pages.

Millions of people already know Mary intimately, and every day many more are discovering her importance in their lives. Increasingly, she is a vital part of the larger culture, with some of her most inspired reimaginings occurring outside theological circles. I've included a contemporary photograph of a Sudanese refugee child, for example, which on the face of it has no obvious connection to Mary but perfectly expresses her limitless capacity for both grief and compassion.

The narratives are offered as fifty-nine meditations, or beads, equal to the number of beads in a traditional rosary. The book is a journey undertaken, like the rosary, in the spirit of pilgrimage. The idea of the beads came to me nearly eight years ago when I began researching this book, but as my work progressed, I started to doubt the wisdom of the structure. I put the question to Mary: *What to do?* Moments later, fifteen dots of light—fifteen being the number of the mysteries of the rosary—appeared on the wall. Not trusting my eyes, I snapped a photo. The image you see in the margin has been a constant affirmation, for me, of the many ways in which Mary is with us.

Contents

FULL *of* GRACE

Full of Grace

EVERAL YEARS AGO, just as summer was ending, I went to an art opening at Yale University. I met a student, a young girl about eighteen years old, who possessed the kind of guileless beauty that needs no embellishment. As we talked in the heat of the crowded galleries, she took off her jacket, revealing to my surprise that she was completely covered, neck to wrist, with tattoos. Inscribed into her body were beautiful, artful images of flowers and storybook characters, the ones she loved best from childhood, she told me, inflecting her words as though her youth were decades past. We continued to make small talk and eventually drifted off into other conversations, but I couldn't shake the memory of her painted skin and quiet beauty. I was overwhelmed by the feeling I had been looking at an image of the Virgin Mary, who bore the wounds of the world as her own. I never saw the girl again, but the encounter was an awakening. Like a door thrown open, it made me realize how the sacred can be experienced in unlikely places, often when least expected.

Through the centuries, Mary's historical identity became a living canvas on which humanity's deep need and essential woundedness were transformed into beauty and so into truth. Her persona has been culturally "tattooed" on and by many groups for multiple reasons. It is difficult to say exactly where her physical, cultural, and theological reality stops and embellishment begins. The canvas and the object have become one, like the tattooed girl.

Thanks to artists immemorial who honored Mary with their best gifts, she is associated with a rainbow of colors that capture her spiritual vibrancy. She is the crimson pomegranate of fertility, the deep claret of wine, and the blood red of Christ's passion, death, and remembrance. She is the color of the sky, spreading like a protective blue mantle or the tidal ocean, and also a symbol of those situations in life that arrive out of the blue. Honored as a

Hail Mary, full of grace, the Lord is with you! Blessed are you among women, and blessed is the fruit of your womb, Jesus. Holy Mary, Mother of God, pray for us sinners, now and at the hour of our death. Amen.

—Hail Mary (Ave Maria)

Whether we regard the Virgin Mary as the most sublime and beautiful image in man's struggle towards the good and the pure, or the most pitiable production of ignorance and superstition, she represents a central theme in the history of Western attitudes to women. She is one of the few female figures to have attained the status of myth—a myth that for nearly two thousand years has coursed through our culture, as spirited and often as imperceptible as an underground stream.

—MARINA WARNER, *Alone of All Her Sex,* 1976

queen, she is haloed in gold, a crown of stars upon her head, catching and reflecting light like a glittering Byzantine mosaic. She is white, like the lily and the woolly fleece of the sheep that surrounded her son's crib. She is darkness, at the foot of the cross and on the blackened soles of pilgrim feet.

Capable of great suffering, Mary's is a wounded beauty: scarred by life yet beautiful because she allowed that same pain to transform rather than disfigure her soul. In giving birth to God, she let her old self die so that she, and we, could be reborn into eternal life. Although she is usually portrayed as a young woman, Mary's

• • •

Gates of Paradise (detail, Adam and Eve), 1425–1452 (postrestoration)
Lorenzo Ghiberti (ca.1378–1455)
Gilt bronze
Panel: 31.3" (79.4 cm); doors: 18'6" (5.64 m) high
San Giovanni Baptistery, Florence, now in Museo dell'Opera del Duomo, Florence

Of the many extraordinary scenes on the doors of the Florence Baptistery, the Adam and Eve panel is considered the most artful. God, standing amid tiny lizards and succulent plants, brings Adam to life. In the central foreground, Eve is born from the slumbering Adam's side, her beautiful nude body stretching before us. Distracted by the beauty of Eden, the viewer almost misses the story's subtext: Tucked into the background is a depiction of the couple eating the forbidden fruit. This discovery provides a revelation: Just as desire blinded Adam and Eve to God's command, earthly beauty has temporarily distracted the viewer from humanity's fallen state. In the vignette to the right God ousts Adam and Eve for their sin, leaving them in a rocky wilderness. In biblical narrative, Eve—and therefore womankind—often bore the blame for humanity's fall from grace. Yet Christians would find their salvation in another woman—the Virgin, the "Ave" who would reverse the sin of "Eva."

Dubbed the *Gates of Paradise,* supposedly by Michelangelo himself, the baptistery's glorious eastern doors were Ghiberti's first major commission, won against notable artists such as Filippo Brunelleschi. Ghiberti worked as a goldsmith, a trade that required a facility with detail and one that ultimately benefited his larger-scale works, particularly the baptistery doors. The *Gates* were not always as magnificent as they appear today. Over the centuries, grime accumulated in the sculptures, settling into their subtle details and obscuring their theatrical impact. In the early twentieth century, the doors were restored to their original splendor, but five panels were knocked off the doors during the 1966 flooding of Florence's Arno River. These panels, along with the others, were taken to the Museo dell'Opera del Duomo in 1980, where they underwent restoration for more than twenty-five years and were finally completed in 2007. The panels remain in the Museo today, and replicas have been attached to the baptistery doors.

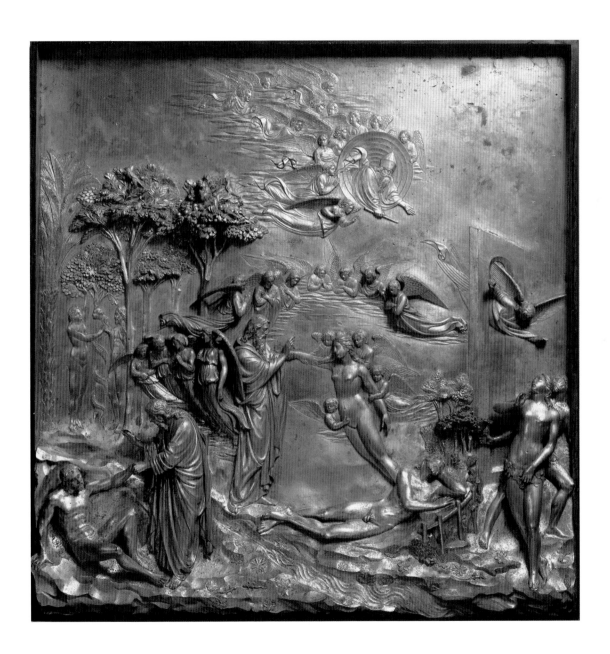

youth is not an indication of her chronological age but a sign of her willingness to do that most difficult thing: to maintain innocence and remain vulnerable in spite of life's most painful demands. In the spiritual imagination, she is ageless. What abides is the fact of her faith and love.

We know so little about her, yet she tells us who we are and something about who God is. She was human, made of flesh, and had a real earthy existence of considerable hardship before she was received into heaven. She models the tenderness and responsibilities of motherhood, whether physical, spiritual, or creative motherhood, and is a mighty fortress of solace for those who, like her, have lost their children and suffered spirit-extinguishing sorrow. It was not that she did not experience every human emotion—she was spared nothing—but that she turned, repeatedly, toward kindness, empathy, patience, forgiveness, and compassion.

• • •

The Manger, ca. 1901
Gertrude Käsebier (1852–1934)
Glass plate print
8×10″ (20.3×25.4 cm)
Library of Congress, Washington, D.C.

Many of Gertrude Käsebier's photographs celebrate motherhood. The woman in this image is swathed entirely in white, as is her infant, placed in the earthy atmosphere of the stable but clearly not of it. Mary's diaphanous, glowing veil, far too impractical for someone to wear in real life, heightens the photograph's drama, as does the powerful light coming in through the window. Such luminosity expresses the holiness of the figures depicted. They are pure beings in an impure world, found in a stable but unsullied by its dirt and grime. The theatrical lighting is used to evoke awe in art, but it also frequently appears in the films of Steven Spielberg, who has coined it "God light."

Käsebier was one of the first to treat photography as a serious art form. Born in Iowa to a Quaker family, she began taking pictures of her family while she was a housewife. Later, when she was thirty-seven, she enrolled in the Pratt Institute in Brooklyn and trained in portrait painting before opening her own photography studio in New York in 1897. After meeting Alfred Stieglitz, she became a founding member of the Photo-Secession, a group of photographers that championed the medium as a valid means of artistic expression.

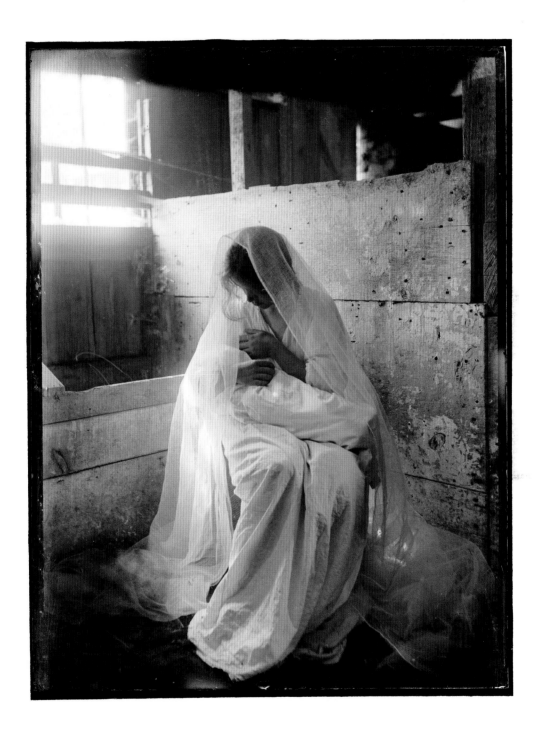

Quite simply, and irrevocably, she said "yes" when the angel asked: one woman's personal act of unconditional faith that changed the way we communicate with God and the way God communicates with us. Full of grace, beloved by God, as we are also beloved, she possessed an indelible goodness and wore it lightly.

By most measures, Mary is a paradox. Perpetual virgin, exultant mother, grieving mother, Nazarene peasant girl, Byzantine queen, liberator of the poor, steward of the environment—no one persona can express her full identity, which is found in its very breadth and fluidity. From the moment Mary consented to bear God's son, she became the bridge between heaven and earth. Her life unfolded on a long spectrum, from willing servant of God to the glorious Queen of Heaven, and yet she was only human, suggesting the depth and breadth of faith that is available to us too. Like the tattooed girl, her person became a canvas stretched across time and space. Her identity is beautiful and multicolored, tattered in places to show vulnerability and gaps in human understanding, yet capacious enough to shelter the hopes and ease the fears of multitudes.

A Girl from Galilee

"IT IS CERTAIN because it is impossible," wrote the third-century Christian theologian Tertullian. Indeed, many agree that Mary has held us enthralled for two millennia because of the paradoxical impossibility of virgin motherhood. She captivates us because she occupies the realm of mystery, both in the detective and doctrinal sense of that word. Because her womb carried the Creator of everything from all eternity, including herself, she had to be more than a peasant shepherd girl. She had to be exceptional, many believe, in ways that no other human being before or since has been. Others think the greater mystery lies in the choice itself: Mary was chosen precisely because she was, in a worldly sense, nothing, thus demonstrating God's power and choice of similar "nobodies" when some great task had to be accomplished. To support both sides of the paradox, Mary's slender biographical bits, strung together like the beads on a rosary, have been magnified exponentially over the centuries in popular culture and pious tradition.

Given Mary's hold on our imaginations, there is startlingly little historical evidence—no eyewitness accounts, letters, histories, birth or death records—about her actual life. From her thirteen appearances in the New Testament, we glean that she was called Maryam, grew up in the hills of Galilee, and married the carpenter Joseph. We are told that she was a virgin yet gave birth to a son who was from God and was God. She was a reflective person, pondering and treasuring in her heart what she learned about her son. She traveled—to the Judean hill country, to Bethlehem, to Egypt, to Jerusalem, to a wedding in Capernaum, to the place called Golgotha, where she watched as her child was scourged, humiliated, and nailed to a cross. In the moments before he died in agony, Christ entrusted his mother to the care of John, the "disciple whom he loved," and he to her.

When we do encounter Mary in Scripture, she rarely speaks.

We hear her voice on four occasions: her question to the angel Gabriel and subsequent assent, her admonishing the teenage Jesus after he had gone missing for several days, and her directive to the servants at Cana—all of them short, almost telegraphed communications, with the exception of the Magnificat, her great exhalation of gratitude and praise for having received God's favor in the form of the physically incarnate Christ.

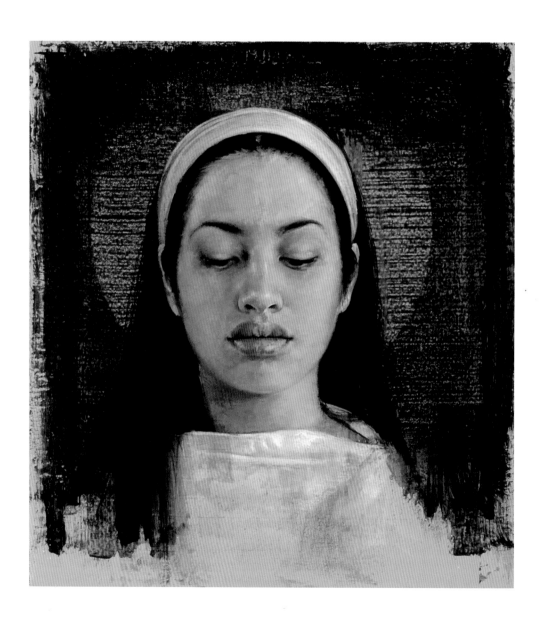

Long after Mary's death, the apocrypha (literally "hidden stories" that were eventually excluded from the canonical texts known as the New Testament) have filled out the sparse details in Scripture with biographical color that, while satisfying, cannot be confirmed. In particular, the enormously popular *Protoevangelium of James*, a book usually thought to have been written by Jesus's half brother James and that began to circulate in circa 150 C.E., focuses its attention on Mary, draping her in legendary stories embroidered with intriguing details that artists have mined for centuries. In this book, we learn of her miraculous birth to Anna and Joachim, a wealthy, pious, and previously barren couple; her pure upbringing in the Jerusalem temple; and the selection of Joseph, an older widower, as her husband.

Paradoxically, cocooned in a bubble of doctrinal privilege and exemption that is denied to others, Mary's person is "bleached of blood and guts" and her image idealized beyond human recognition. Writers such as Lesley Hazleton, one of Mary's many biographers, who have delved into the theology, history, geography, and

Joachim placed her on the third step of the altar, and the Lord God put grace upon the child, and she danced for joy with her feet, and the whole house of Israel loved her. And her parents went down wondering, praising and glorifying the almighty God because the child did not turn back. And Mary was in the Temple nurtured like a dove and received food from the hand of an angel.

—*Protoevangelium of James,* ca. 150 C.E.

• • •

Study for a Virgin, 2001
John Nava
18×16" (45.7×40.6 cm)
Oil on canvas
Private collection

We first encounter Mary as a young girl who is visited by an angel. Artists through the centuries have tried to imagine how Mary received the news of her astonishing pregnancy, whether with fear or, as artist John Nava has depicted her, with a sublime serenity that belies her youth. Rather than portraying apprehension at the angel's arrival, Nava paints her as a shy teenager with downcast eyes yet aware of the implications of her consent. This painting was made as a portrait study of the Virgin that was proposed but not realized for an apse mural for the Cathedral of Memphis. It was inspired by a well-known painting of the Italian Renaissance by Antonello da Messina, the *Vergine Annunciata* (ca. 1476).

Nava wanted to paint a non-European Madonna in the New World tradition of the soulful, dark-skinned Virgin of Guadalupe. His model was a sixteen-year-old girl of mixed Irish and Chinese heritage, but the artist did not disclose her specific ethnicity to the Memphis parish. By portraying Mary with features that could be seen in any number of places across the globe, the portrait was intended to engage the spiritual imagination of a wide swath of viewers.

the customs of first-century Palestine, help us reimagine the life of Anna's olive-skinned, dark-eyed daughter, who struggled with the other Jews of Nazareth to survive in an unforgiving land controlled by the equally unforgiving Roman state.

Just as interpretations of Scripture have continually evolved to accommodate the dynamics of history and new understandings, contemporary theologians see that to ignore Mary's earthly reality is to miss the powerful lessons inherent in her actual life and largely commonplace concerns. By dismantling the idealized, patriarchal trappings that have effectively removed Mary from the real world, and by acknowledging her existence in an impoverished, agrarian, and politically oppressed society, women as well as men are finding in her a guidepost in their own quest for wholeness and full human dignity. Mary learned through her earthly journey how to open herself to the word of God. Step by step, in light as well as darkness, she learned how to become a disciple of Christ. More significant than any of her actions or words was her willingness to bear witness and reflect. Mary was an ordinary person called to live an extraordinary life, both paradox and proof that nothing is impossible for God.

Nazareth

NAZARETH, IN MANY ways the same dusty outpost it was two thousand years ago, is eighty-eight miles north of Jerusalem; Bethlehem lies six miles to the south. The population of the modern city, an Arab territory since the 1967 partitioning, consists largely of Christian Arabs. Although the long antagonism between Jews and Palestinians continues to run both ways, the city supports numerous shrines and monasteries that are sacred to the three Abrahamic faiths, sites tucked up high in the hills that cup Nazareth like a bowl.

The largest is the Basilica of the Annunciation. The latest iteration of it was constructed in 1969, built over earlier Byzantine and Crusader structures and the ruins of what tradition holds to be Mary's girlhood home, the spot where the angel Gabriel appeared to her. A lavish confection of arcaded and turreted Jerusalem limestone, the basilica is hung with dozens of portraits of Mary, whose differing facial features and ethnic costumes reflect her veneration around the world. Its emotional heart, however, is the Grotto of the Annunciation, an unembellished, cavelike space on the lower level.

These remnants of Mary's actual home, or one that was quite similar, tell us how she must have lived. Galilean homes were simple one- or two-room structures made of fieldstone and covered with thatched roofs, and many, like Mary's house, incorporated caves into their dwellings. Homes were clustered around a central outdoor area where the community's shared oven, millstone, and cistern were located; the interior rooms were used for sleeping and sex, birthing and dying, but most of the time, life was lived outdoors.

Most of the archaeological remains found in Nazareth—olive and wine presses, millstones for grinding grain, water cisterns, holes for storage jars—point to farming as the village's main occupation, while the lack of evidence of public paved roads or civic

Maryam would certainly have been puzzled at the idea that anyone would think of calling stone walls a house. In her world, a house was not stones, but people. . . . the extended family and everything it owned, including land, livestock, and produce.

—LESLEY HAZLETON,
Mary, A Flesh-and-Blood Biography of the Virgin Mother, 2004

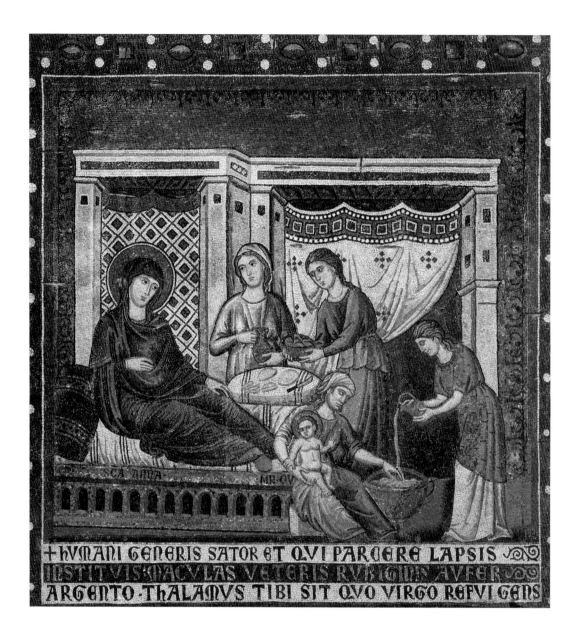

+hVMANI GENERIS SATOR ET QVI PARCERE LAPSIS
INSTITVIS MACVLAS VETERIS RVBIGINS AVFER
ARGENTO ·THALAMVS TIBI SIT QVO VIRGO REFVIGENS

. . .

Nativity of the Virgin, ca. 1291
Pietro Cavallini (ca. 1250–1330)
Mosaic
Basilica of Santa Maria, Trastevere, Rome

The Basilica of Santa Maria in Trastevere, a neighborhood of Rome, occupies a site used for churches since at least the fourth century. The current building dates largely from the twelfth century, when the entire structure was rebuilt by Pope Innocent II. Inside, above the apse, are six mosaic panels portraying scenes from the life of Mary.

This panel, the first of the six, depicts Mary's birth. The other panels portray the full course of Mary's life, including the Annunciation, the birth of Jesus, the presentation in the temple, the adoration of the Magi, and her death. Together, the panels form a visual biography of Mary that would have been understandable to even the most illiterate churchgoer.

The woman seated to the left is St. Anne, who is not named in the canonical gospels but whom tradition and some apocryphal gospels hold to be the mother of Mary. Four servants, all women, attend to Anne at the birth of her daughter. Two bring food and drink, while the third holds the infant Mary to wash her in a bowl being filled by the fourth. St. Anne is identified by the words *SCA—ANNA,* while Greek letters identify the child as Mary. Both Mary and her mother are distinguished by halos. Cavallini's mosaic reflects an awareness of Byzantine iconography but goes beyond it. His figures have a greater gravity and depth than was common in the art of that time. Note the shadows on the women's faces and the intricate folds of their clothing, which increase the dimensionality of the work.

Cavallini created the mosaic at a time when the papacy was reinvigorating Rome by investing in art projects and new buildings. As such, he was well positioned to take advantage of Church patronage. Much of his work has been lost to time, but the cycle of six panels from which this is taken is the best extant example of the artist's oeuvre.

buildings, decorative frescoes or mosaics, or items such as perfume bottles indicate that its residents occupied the lower rungs of the economic ladder. The good life meant getting one's daily bread—*Every one of you will eat from your own vine and your own fig tree* (Isa. 36:16)—as well as the olives, grapes, pomegranates, honey, and figs that are native to the region.

We can reasonably assume that Mary lived and died as a faithful Jew and kept an observant household. However, there are no remains of a synagogue in Nazareth, which at first glance is surprising, given that evidence of other Jewish ritual structures and items has been found. This absence can be explained by considering that while the word *synagogue* conjures an actual building in our imagination, the original Greek term *synagoge* referred to a gathering of people who met in a public square or a private home to pray or study—much like the word *ecclesía,* or church, originally referred to a gathering of the faithful. People themselves form the synagogue or church.

Heavy taxes burdened the Jews' already hardscrabble existence and marked inequality under Roman rule. Families such as Mary's would have had to pay taxes in triplicate—the tithe for the temple in Jerusalem, a tribute to the Roman emperor, and a third tax to the local authority through whom Rome ruled by proxy. Mary's joyful Magnificat song, declaring that God has "filled the hungry with good things and sent the rich away empty," has particular resonance in this impoverished context. It is through a Galilean lens, too, that we can understand the Assumption as the "glorious culmination of the mystery of God's preference for what is poor, small, and unprotected in this world."

Except for some notable exceptions—the Holy Family's trip to Bethlehem, the journey to Jerusalem for Passover observations, and the flight into Egypt—Mary's was a small world, typically cir-

cumscribed by the distance that one could walk and return in one day. However, with our imaginations fueled by Hollywood's epic presentations of the Holy Land in films such as *Ben Hur*, *The Ten Commandments*, and, more recently, *The Passion of the Christ*, we anticipate Cecil B. DeMille's supersized vision of this land. In truth, Israel is quite small, about the size of New Jersey, but has the geographic diversity of California, squeezed in between its desert mountains. The past and present history of the Holy Land, shifting like desert sands, cannot be divided into neat bits or a single set of assumptions, beliefs, or perceptions. The complex reality of the political

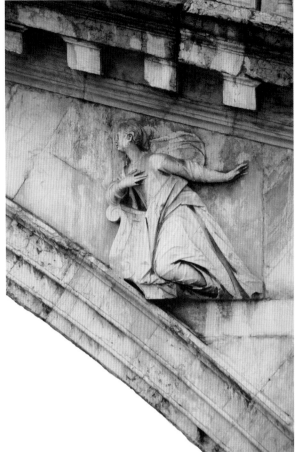

• • •

Rialto Bridge, 1591
Antonio da Ponte, engineer (ca. 1512–1597);
Girolamo Campagna, sculptor (ca. 1549–1625)
Grand Canal, Venice

Venice, that most improbable and fantastic of cities, is cobbled together with bridges of every size and description, bearing names like the Bridge of the Honest Woman, Bridge of Paradise, Bridge of Sighs, and, over the Grand Canal, the landmark Rialto Bridge. That bridge, called the Ponte de Rialto by the Venetians, to distinguish it from the Rialto Bridge district, is one of the many that have crossed the site over the centuries.

The design for the current bridge was the result of possibly the most distinguished architectural competition ever held, with proposals submitted from the pantheon of Renaissance artists, including Michelangelo, Sansovino, and Palladio. Ultimately, the commission went to the appropriately named, lesser-known Antonio da Ponte, who, with his nephew, Antonio Contino, would build the single-arch marble bridge.

The bridge's south side depicts the Annunciation: On the arch's left-hand side is the angel Gabriel, on the other the Virgin, and between them, in the keystone, is a dove symbolizing the Holy Spirit. Carved in bas relief, the scene recalls that Venice, according to legend, was founded in 421 on March 25, the Feast of the Annunciation. In *The Stones of Venice,* John Ruskin singles out the portrayal of Gabriel as the bridge's loveliest detail because of the way his foot lies on a flat plane, anchored firmly in the terrestrial. The north side features portraits of Sts. Mark and Theodore. All four figures were carved by Girolamo Campagna, a leading Venetian sculptor.

situation, where the past dominates the present and the future, and where no single group's narrative is accepted as *the* narrative, gives a claustrophobic sense that there is too much history crammed into too small a place. The way the gospel writers evoked this landscape, including the profound connection that exists between land ownership and familial identity, reflects today's reality as well.

What theologians call the "scandal of the particular" is very much in force in the Holy Land, which St. Jerome described as the "Fifth Gospel." It's jarring to actually see Nazareth, to look up at Mount Tabor, to swim in the Sea of Galilee, because these mythic landscapes suddenly feel too concrete, as though making these places and those who inhabited them *specific* somehow diminishes their imaginative force. But the holiness of the place emanates from a deeper well than geography or architecture. The collapsing of past, present, and future time can be perceived by a deliberate and contemplative slowing down and is missed by many pilgrims who, eager to pack as many sacred sites into their itineraries as possible, run where Jesus walked. As Father Thomas Stransky, a Roman Catholic priest who once directed the ecumenical Tantur Institute in Jerusalem and now lives there as a hermit, told me, "I have learned where to sit in the Holy Land."

For generations, archaeologists have sifted through meager evidence to anchor biblical texts, which themselves yield scant verifiable historical data. The determination of the physical location of the Annunciation and Incarnation, as well as those of the key events in Jesus's life, rests largely on conjecture. We owe the delineation of these most revered sites in Christendom—notably the Church of the Nativity in Bethlehem and, in Jerusalem, the Basilica of the Holy Sepulchre and the Church of the Pater Noster—to Helena Augusta, the mother of the Roman Emperor Constantine the Great (r. 306–337). Constantine espoused Christianity after a conversion experience in 312 during the Battle of Milvian Bridge, the victory that ultimately gave him sole control of Rome. Sometime after 326, under the auspices of her son, Helena, though "advanced in years . . . hastened with youthful alacrity to survey this venerable

land" with the express purpose of marking the sites important to early Christian history.

A holy relic, or any structure, has an emotional resonance and identity beyond its physical dimensions. To test this idea, imagine the home of your childhood and the street you grew up on. Whether house, apartment, or farm, whether urban, suburban, or rural, and even if you can't remember where your car keys are, it's a good bet that you could draw a detailed map of your first home and neighborhood. Such internal maps last a lifetime. The emphasis on the physical place of the Incarnation points to the ways that places become holy: We take what we know—our community, our home, our table—and use it as a means of crafting individual meaning within a larger religious concept.

Does it really make a difference if one is standing on the exact place where history transpired? The overwhelming numbers of pilgrims to the Holy Land over twenty centuries suggest the ongoing appeal of these "authenticated" places of biblical history, despite the lack of proof supporting such designations. Whether the place of the Annunciation, Nativity, wedding at Cana, or the Crucifixion, these sites have been chosen from a dozen possible locations, all of uncertain provenance. Moreover, the legends that have sprung up at these locations have been embroidered over time by guides who used their imaginations to appease the flood of pilgrims' questions—a good story has always sold and been retold. Ultimately, the validity of these spots is not established by indisputable geographic fact but by the provision of a place, one place, where the faithful of centuries have gathered to recall and find new meaning in these ancient events. In other words, it is best to leave cynical logic at the door and take on faith the message that appears on signs throughout Palestine: *This is a holy place.*

• • •

The Annunciation, 1980
Raphael Soyer (1899–1987)
Oil on linen
56⅛×50⅛" (142.5×127.3 cm)
Smithsonian American Art Museum, Washington, D.C.

After emigrating from Russia in 1912, Raphael Soyer and his family settled in New York City. His family included a twin brother, Moses, and a younger brother, Isaac, who were also artists. Frequently, the subjects of their work were residents of New York City and other urban areas. Soyer painted *The Annunciation* at the end of a career spent documenting the isolation and toil of working women in a realistic yet tender style.

Soyer puts the annunciatory event in a contemporary context. Mary stands to the left, wearing a light-blue shift and holding a white towel, which implies she is a modern-day washerwoman. The bare room, stark washbasin, and few clothes hanging on the right of the painting underscore Mary's limited means. Her hands, opening upward underneath the towel, recall the *orans,* a prayer gesture of supplication.

The angel has caught Mary unawares, and Mary casts her eyes downward. Soyer depicts Gabriel as a woman, a choice that was not out of character for the artist, who made women the subjects of most of his work. The angel is clad in shades of violet, a color that is associated with royalty as well as the church draperies of the Passion Week. Violet here indicates Gabriel's regal nature and foreshadows the eventual Passion of the child Mary will soon bear.

The angel is barefoot and tentative. Her weight appears to shift from one leg to the other and she looks apprehensively at Mary. We realize that the angel is awaiting Mary's response, and in a sense the room is too, for even the line of the wall behind the sink leans toward her in anticipation. Soyer is showing us the moment of Mary's deciding, when the world held its breath.

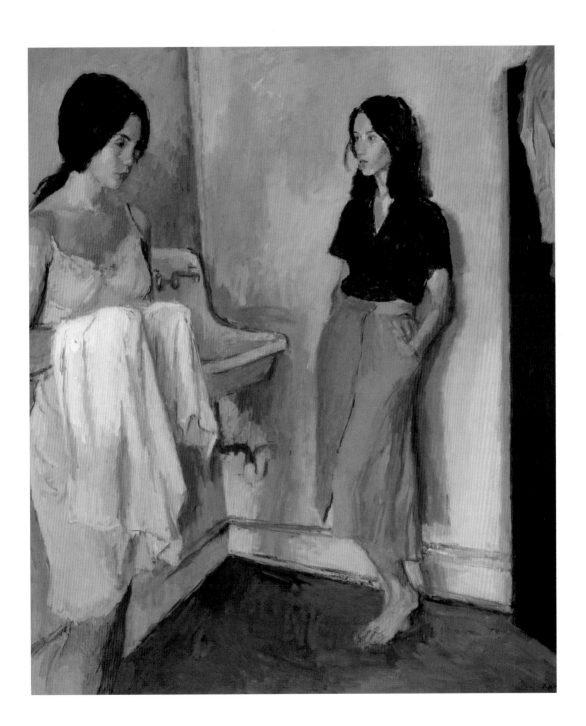

A genealogy of Jesus Christ, the son of Miriam, the daughter of
 Anna:
Sarah was the mother of Isaac,
And Rebekah was the mother of Jacob,
Leah was the mother of Judah.
Tamar was the mother of Perez.
The names of the mothers of Hezron, Ram, Amminadab, Nahshon
 and Salmon have been lost.
Rahab was the mother of Boaz, and Ruth was the mother of Obed.
Obed's wife, whose name is unknown, bore Jesse.
The wife of Jesse was the mother of David.
Bathsheba was the mother of Solomon,
Naamah, the Ammonite, was the mother of Rehoboam.
Maacah was the mother of Abijam and the grandmother of Asa.
Azubah was the mother of Jehoshaphat.
The name of Jehoram's mother is unknown.
Athaliah was the mother of Ahaziah,
Zibiah of Beersheba, the mother of Joash.
Jecoliah of Jerusalem bore Uzziah,
Jerusha bore Jotham; Ahaz's mother is unknown.
Abi was the mother of Hezekiah,
Hephzibah was the mother of Manasseh,
Meshullemeth was the mother of Amon,
Jedidah was the mother of Josiah.
Zebidah was the mother of Jehoiakim, Nehushta was the mother
 of Jehoiakin
Hamutal was the mother of Zedekiah.
Then the deportation to Babylon took place.
After the deportation to Babylon
the names of the mothers go unrecorded.
These are their sons:
Jechoniah, Shealtiel, Zerubbabel,
Abiud, Eliakim, Azor and Zadok,
Achim, Eliud, Eleazar,
Matthan, Jacob and Joseph, the husband of Miriam.
Of her was born Jesus who is called Christ.
The sum of generations is therefore: fourteen from Sarah to David's
 mother; fourteen from Bathsheba to the Babylonian deportation;
 and fourteen from the Babylonian deportation to Miriam, the
 mother of Christ.

—ANN PATRICK WARE, *A Genealogy of Jesus Christ,* ca. 1990

Mother Goddess

W HEN PAUL THE Apostle arrived in Ephesus in 52 C.E., as part of his missionary travels, one of the most impressive sites that he would have encountered was the colonnaded temple honoring Artemis, the goddess of fertility and protection, who reigned supreme in that city and beyond. Visitors to her shrine regularly swelled the city's already large population, which historians estimate at 250,000. Demetrius, an Ephesian silversmith who was in the lucrative trade of making silver souvenir replicas of the Temple of Artemis, feared that "this Paul" would ruin business with his talk that gods made with hands were not gods. Enraged, the silversmiths and crowds of others in the city's streets began shouting in unison, "Great is Artemis of the Ephesians!" The silversmith riot that ensued makes it clear that Paul had his evangelical work cut out for him. Not as evident over much of Christian history, however, are the strong parallels between Mary and the archetypal goddesses of the distant past.

Less than four centuries after Paul, the grounds of devotion had shifted considerably. In 431, Christian clerics convened in Ephesus to debate Christ's earthly and divine natures. When they officially proclaimed Mary "Theotokos"—the very Mother of God—the Ephesians erupted in joy, shouting "Praised be Theotokos," just as they had once hailed Artemis. The Church's designation of Mary as the Mother of God was a continuation, within a patriarchal context, of the concept of a goddess–creator. The idea that Marian piety was the natural outgrowth of ancient goddess cults of fertility and motherhood, with the early Christian Church absorbing many Greco–Roman mythological elements and replacing them, in effect, with Mary, has been a subject of controversy for centuries: ignored, disputed, and championed. The unbroken and clearly discernible line from the goddess worship of the ancients to the reverence paid to the Virgin Mary, as historian Stephen Benko suggests, has

As Christianity confronted religions in which not only gods but goddesses were central, it had in Mary a way of simultaneously affirming and yet correcting what those goddesses symbolized.

—JAROSLAV PELIKAN, *Mary Through the Centuries,* 1996

The architect says: I want
a 22-foot mother. She's done

the calculations, considered
the engineering needed—given

her own dimensions—to install
herself comfortably, at 53,

inside her Ubermother's lap.
In a pinch, she admits,

19 feet would do.
But she doesn't want

an average-size mother, doesn't crave
an average-size lap. The vastness

of her longing is evident
in the way she gazes

at anyone vacating chairs.
The exodus of laps

is endless and astonishing.
There is no consolation,

only lamentation, only going
back to the drawing board.

She repeats: I need 22 feet,
though 23 would be ideal.

—ANDREA COHEN,
22-Foot Mother, 2009

· · ·

Peace, 13–9 B.C.E.
Ara Pacis Augustae
Carrara marble relief panel
Rome

The Ara Pacis, or Altar of Peace, was considered the apogee of art and storytelling during the age of Caesar
Augustus, the first Roman emperor. Used for ceremonial animal sacrifice, the large altar was contained
within a larger walled structure. One of the outer walls portrays this impressive yet beneficent goddess, said
to be *Pax Augusta,* the "Peace" from which the altar takes its name. Variously identified as Saturnia, Tellus,
Ceres, Venus, and Mother Earth, she is thought to be a composite portrait of the many goddesses revered by
Romans. Dressed in a clinging gown that emphasizes her maternal fecundity, she holds two children, who
look up at her adoringly. With the exception of the second child, this could be a portrait of the Madonna and
Child. It portrays the attributes of beauty and fertility associated with ancient goddesses that were later
assimilated into Marian imagery. Reeds, poppies, and ears of corn sprout up beside her. Figures representing
the winds flank her. Below, we see a contented cow and a sheep that drinks from the spring bubbling up
from her throne.

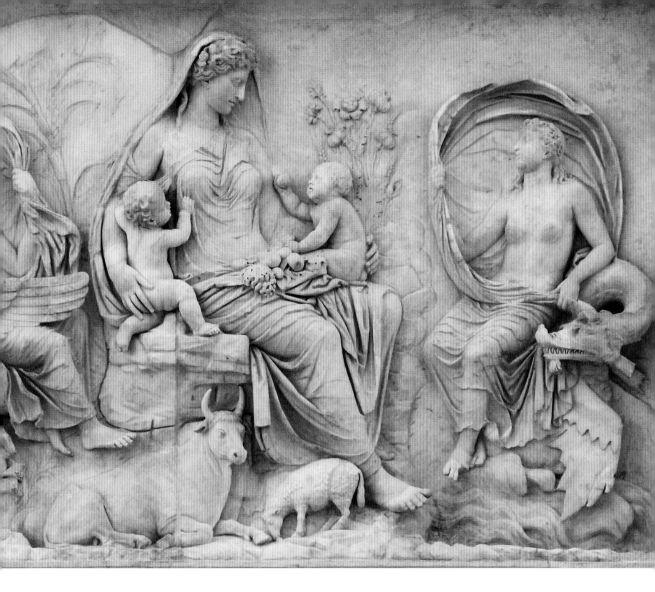

Augustan scholar Karl Galinsky notes that the Ara Pacis was part of an architectural complex that the Romans built to convey the message that the empire's peace and prosperity were the result of their military victories, which had been achieved with the help of divine beings, such as the goddess portrayed here. Portraits of the imperial family are depicted along with celestial gods and goddesses and long processions of family and Senate members. The altar carvings were inspired by the timeless themes of love, war, and enduring loyalty to Roman divinities, and they express the many dimensions of Augustan peace.

Originally built in the first century on the Field of Mars to commemorate Caesar Augustus's return from Spain and Gaul, the altar was slowly covered by rising ground levels and was lost for nearly a millennium. It was unearthed in the sixteenth century and since then has been repeatedly restored. Mussolini moved it to its present location on the banks of the Tiber in 1938. The altar is now contained in a structure designed by the architect Richard Meier, which opened in 2006.

provided expanded insights on Mary through the cumulative efforts of theologians, feminists, paleoarchaeologists, anthropologists, and environmentalists.

Like the ancient goddesses, Mary reestablishes the primordial unity between heaven and earth, as the first humans imagined it in their creation myths. Just as Gaia, earth, was impregnated by Ouranos, heaven, in pagan mythology, Jesus's incarnation was the result of a union between heaven and earth—the Holy Spirit and the Virgin Mary. During Christianity's earliest centuries, however, the fathers of the Church avoided attaching such mystical association to Mary's maternity, fearing that people would make dangerous connections between her and pagan goddesses like Artemis, the Egyptian mother goddess Isis, Demeter, Cybele, and others whose cults persisted into the fourth century and beyond.

Well before the beginning of Christianity, the figures of Artemis and Isis became fused in popular worship. Both were mighty queens and perpetual virgins who governed fertility as well as protected virginity; held sway over animal and vegetable kingdoms; were associated with the moon, the sea, and the underworld; and intervened in human affairs when all other means of salvation had failed. In her role as protective mother, Artemis maintained her prominence in the Greco–Roman world for centuries because of the adaptability of her image, which would change to suit the new religious sensibilities within the popular culture of any given period. Similarly resilient, Mary's image—as virgin, mother, bride, intercessor, queen—has changed over centuries and continents to meet the cultural and societal needs of her devout.

While Mary's role in salvation can be detected in writings before the Council of Ephesus, the title Theotokos is from Isis, who had been called both the "Mother of the God" and the "Great Virgin." Isis's popularity, in fact, peaked in the eastern Mediterranean just as Christianity began to spread. When Mary replaced Isis in popular devotion, she also assimilated her symbols, an appropriation that can be observed frequently in the formation of Christian iconography. The familiar description of Mary from the first-century Book of Revelation as a woman who is "clothed with the sun, with the moon under her feet, and on her head a crown of twelve stars,"

Delilah and Judith, Aspasia and Lucretia, Pandora and Athena—woman is at once Eve and the Virgin Mary. She is an idol, a servant, the source of life, a power of darkness; she is the elemental silence of truth, she is artifice, gossip, and falsehood; she is healing presence and sorceress; she is man's prey, his downfall, she is everything that he is not and that he longs for, his negation and his raison d'être.

—SIMONE DE BEAUVOIR, *The Second Sex,* 1949

correlates closely to a second-century description of Isis, who emerges from the sea, her ringlets crowned with a diadem, on her forehead a moonlike disc, and wearing a mantle scattered with stars and a full moon that radiated flames of fire. (This is also how Our Lady of Guadalupe would appear, centuries later and half a world away, on Juan Diego's cloak.) A favorite portrayal of Isis shows her nursing her son Horus, the sun god, on her lap, an image that would be subsumed into the Madonna and Child portraits that were painted in imitation. Isis's name seems to have meant "throne," and medieval artists would later portray Mary as the regal "Throne of Wisdom." Isis's titles—Isis *lochia*, or "she who brought forth a newborn babe," and *soteria*, or savior, who delighted in healing humanity—and many acts of compassionate beneficence acted as metaphoric stepping stones to later Marian associations.

The most powerful association Mary inherited from earlier goddesses was the archetypal role of the Great Mother. Her unconditional love of her son mirrors the love most women have for their own children, a love that is not the love of a father, a love that comes as effortlessly as breathing. This bond is the fundamental building block of human society. There has been a persistent human need to identify a goddess figure to fill this role throughout history. In his classic study on goddess figures in world culture, Erich Neumann explains that just as children first experience their mothers as the archetypal Great Mother—the all-powerful numinous woman on whom they depend for all things, and not the objective reality of their personal mothers—so the human psyche creates metaphoric symbols to describe these powerful unconscious associations.

Many of the ancient goddesses were virgins, not in the physical sense but in their autonomy from male dominance. Similarly, Mary's virginity models alternative ways of being, other possible routes of empowerment that do not depend on men. Discussion of what psychoanalysts and poets have called the "divine feminine," or the female aspects of the Creator, is an ongoing debate in feminist theology. On one hand, perceiving in God the qualities that are typically associated with women—fecundity, receptivity, nurturance, inclusivity—allows many women to see themselves as closer

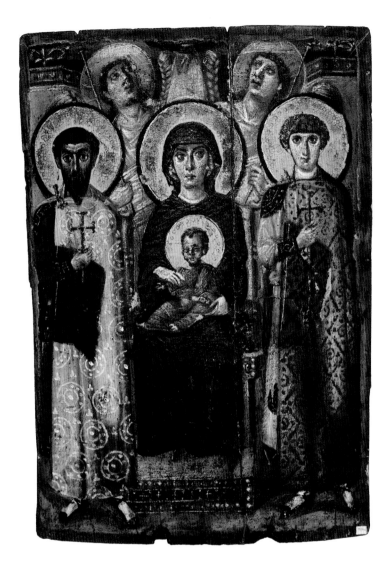

In the icon, we are not talking about dramatic gestures that underline a point, but rather about the journey the eye has to take *around* the entire complex image: wherever you start, you are guided by a flow of lines, and the path traveled itself makes the "point"—though "point" is quite the wrong word, suggesting as it does that the icon has one simple message to get across, rather than being an invitation to a continuing action of contemplating.

—ROWAN WILLIAMS,
Archbishop of Canterbury,
Ponder These Things, 2002

to God and to claim their own power. On the other, as feminist theologians argue, explicitly defining God as either female or male keeps in play the historic patriarchal divisions between men and women. The idea that men alone embody the fullness of God's image has spiritually, psychologically, and politically impoverished women's understanding of themselves as an *imago Dei* and, for all, limited our conception of God, who is without gender.

In more recent years, an understanding of our Blessed Mother that is older and broader than the New Testament is emerging, as

• • •

Virgin and Child with Archangels and Two Saints, 6th cent.

Artist unknown

Encaustic on wood panel

27×19.6″ (68.5×49.7 cm)

Monastery of St. Catherine, Mount Sinai, Egypt

Portrayals of Mary changed after the Church declared her Theotokos, the Mother of God. One of the earliest images of the Theotokos is this panel painting at the Monastery of St. Catherine in Egypt. Enthroned on a chair studded with pearls, she wears purple shoes, the color of royalty. This formal hierarchical representation is animated only by the figures' expressive eyes and the stamped gold haloes and patterned draperies. Mother and child are flanked by two figures (thought to be saints Theodore and George), and two angels in the background look upward as the hand of God descends in a beam of light.

The Monastery of St. Catherine is the oldest continually operating Christian monastery, founded in the sixth century by the Byzantine emperor Justinian. Dedicated to the Mother of God of the Burning Bush, it is located at the foot of Mount Sinai, where Moses saw the bush aflame but not destroyed—an Old Testament prefiguration of Mary, who contained God without being destroyed. The painting owes its near miraculous state of preservation to its desert home: Thanks to the dry climate and isolated geographic location, it was spared destruction by moisture and by iconoclasts, even as many such works in Constantinople were destroyed (726–843). Consequently, the monastery possesses an extensive collection of some of the earliest and most profound examples of Christian art.

people are reawakening to an awareness that the environment is a series of exquisite interconnections. The new, and very ancient, wisdom that we are just one part of nature and exist interdependently with it has been expressed eloquently by the historian and self-described "geologian" Thomas Berry as the "great work" of our generation. Green sisters, or environmentally activist Catholic nuns, have reclaimed Mary as a cosmic matrix, just as they have reclaimed the earth as Holy Scripture, making it clear that they don't worship Mary or the saints, or nature itself, but rather believe that God resides in the world and all creation resides within God. The divine is seen as life-giving energy—in, through, and under all things—that seeks to re-create relationships of mutuality with one another and with the earth.

Like exiled queens, the goddesses of the past have begun returning to collective awareness, bearing with them the fundamental wisdom accumulated in their personas. That the role of the

divine feminine has been marginalized and subject to patriarchal control for much of recorded history has been a great loss—not only for women but for many men, who have also suffered from the historical, often spiritually disenfranchising privilege accorded them. Just as a healthy natural system abhors uniformity, there is room for multiple interpretations and uses of our shared mythos and the generative energies it honored. These ancient goddesses shed light on how Mary functions within the archetypal human psyche and enable us, creatures of both heaven and earth, to retrieve, reclaim, and integrate our fullest human and spiritual potential.

The Book of Judith

THE LIVES OF the great matriarchs of the Old Testament provide a prophetic foreshadowing of Mary's story. Vulnerable, humble, and pious, they nonetheless readily abandoned these traditional hallmarks of femininity when called upon by God, proving their courage and self-reliance. Mary's literal and metaphoric story begins with Eve, who is most notorious perhaps for initiating the Fall but is also the mother of all humanity, and whose original sin Mary, the new Eve, would eventually redeem. Mary mirrors the obedience of Sarah, whose son, Isaac, was to be sacrificed at God's demand; the leadership of Esther, who saves her people from annihilation; the kindness and steadfastness of Ruth, who stays with her mother-in-law, Naomi; and the grief of Rachel, who mourns her children. She shares the unexpected fertility of Sarah, Hannah, Rebecca, and Rachel. For sheer panache and drama, however, none of Mary's Old Testament forebears matches the forthright Judith, who, like Mary, crosses societal boundaries to save her people.

Like the Books of Ruth and Esther, the Book of Judith is an allegorical work of fiction, thought to have been written in the second century B.C.E. The story is set in the Israelite town of Bethulia, which has been captured—along with its vital water supply— by Holofernes, the commander of the vast Assyrian army. The Israelites, who were "collapsing in the streets" from fear and thirst, have decided to give God five days to intervene before they surrender. Hearing this, the prosperous widow Judith, who has been living in pious respectability, emerges from her solitude, with moral guns blasting: *Who are you to put God to the test today, and to set yourselves up in the place of God in human affairs?* (Jdt. 8:12)

This is a woman with a plan—*Listen to me. I am about to do something that will go down through all generations of our descendants*—and a confidence that recalls the Magnificat, Mary's hymn of prayerful conviction. That evening, Judith praises God, whose *ways are prepared*

in advance, illuminating the idea of divine destiny in which Mary, too, would later participate. Taking off her widow's garments, she beautifies herself in order to seduce Holofernes. Judith washes the ashes from her face and anoints herself with precious oils. She combs her hair, puts on a tiara, and dresses herself in the festive attire that she used to wear before she was widowed. She puts on all her jewelry—anklets, bracelets, rings, and earrings. *Thus she made herself very beautiful, to entice the eyes of all the men who might see her.* She has been endowed with striking, God–given beauty so that she might effect change.

Remaining steadfastly pious, as well as planning her eventual escape strategy, she packs a knapsack filled with ritualistically pure, or kosher, foods, including wine, oil, roasted grains, dried fig cakes, and bread, and heads for the city's gate. The Bethulian men, seeing her transformation, are astounded by her beauty, but Judith, un-fazed, remains focused on her mission and tells them to open the gate. Confident in God and secure in her plan, Judith never falters.

When she is stopped at the enemy camp by Holofernes's min-ions, she assures them that she is fleeing her people and wants to see their commander to tell him how he can capture the Jews. Cap-tivated by her countenance, they provide one hundred men to ac-company her to the tent where Holofernes lies on a bed under a canopy shot with gold, emeralds, and other precious stones. Judith stays with Holofernes for three days, strategically establishing a prayer schedule that would allow her to periodically leave the en-campment. On the fourth night, intending to seduce her, Holofernes invites her to join him. *Have a drink and be merry with us!* She accepts, bathing him in flattery, telling him *today is the greatest day in my whole life,* recalling the beguilement of Samson by Delilah, another biblical siren. (Naturally, the great general believes these fine words, entirely missing her many ironic double entendres.) Holofernes is intoxicated by her compliments and the wine, de-scribed as *much more than he had ever drunk in any one day since he was born,* and soon passes out in a drunken stupor. Judith quickly takes his sword, decapitates him, and stuffs his head into her knapsack.

Carrying the head, Judith and her maid are allowed to exit the enemy camp, under the pretense of leaving for their regular

prayers. They return triumphantly to Bethulia, where King Uzziah praises Judith as blessed by God *above all other women on earth,* echoing the praise that would be later heaped upon Mary. But Judith's plan has one final step: She instructs Bethulia's army to seize the enemy outpost in a surprise attack. The Assyrians flee in panic, and the avenging Israelites chop them down.

Afterward, in Jerusalem, Judith is crowned with an olive wreath and leads all the women in a post–victory dance and hymn, followed by the men, who also sing and dance. In thanksgiving, Judith sings a triumphal song to God, echoing the songs of her Old Testament sisters, including Hannah, Miriam, and Deborah. The joy and power of their voices will be heard again when Mary sings the Magnificat, a rousing cry that the Messiah promised by God has arrived to vanquish his enemies and restore the faithful.

The story ends in fairy-tale fashion. Judith grew *more and more famous* and was honored for the rest of her life. Many wanted to marry her, but she declined. She set her faithful maid free, a telling detail about freedom's complex nature for the faithful. Before dying at the ripe old age of 105—old age being a sign of wisdom and God's favor—she gave away her possessions. While she lived, and for a long time after her death, *no one ever again spread terror among the Israelites.*

Judith's spectacular murder of Holofernes has long captivated artists, including the painters Caravaggio, Botticelli, Donatello, Artemisia Gentileschi, and Lucas Cranach, and continues to move novelists, musicians, and filmmakers inspired by this ambiguous tale of feminine liberation. New Testament scholar and self-described "Yankee Jewish feminist" Amy–Jill Levine examines the text's feminist, psychoanalytical, and folkloric interpretations and observes that Judith's story reinforces and also challenges gender-determined theology.

Although women tend to be the first and most important evangelicals, teaching their children about religion around the dinner table, the women who assert their spiritual authority in the gospels are rarely included in the Catholic liturgy. It is eye–opening then to rediscover Mary's precursors, the cloud of heroic Old Testament matriarchs who, like Judith, embody a dynamic spirituality. Judith's

cold-blooded act serves the higher cause of redemption and au-thenticates God's willingness to work through individuals in unex-pected ways. Divinely emboldened, Judith subverts the accepted rules to inaugurate a new order. She is willing to cross boundaries—literal, geographic boundaries by moving back and forth between the two camps; gender boundaries by asserting her dominance over male authority; and societal boundaries by putting aside her widow's mourning to become the seductress. In other words, she becomes an agent of change by her own willing-ness to adapt as necessary to meet new situations. By letting go of her identity as she has comfortably known it, she is able to re-spond to God's deeper invitation with great courage. Mary, like Ju-dith, will be divinely empowered to burst free from the ordinary limits of human possibility.

Listen to me, Lord. I have a list.
You said to Abraham:
Go, leave your fathers' graves! To me,
no word. You promised him,
toothless at ninety-nine, a son. A son
of ours? We laughed. Sixty years
you locked my womb and then
told Abraham you would unbolt it.
To me, no word. Would Abraham
grow fat, shriek, spread his legs
across the birthing stool? Is he the eagle,
I the guttersnipe, that his lordship's
wedded spouse must overhear the news
hidden behind a tent flap?
Do I exaggerate? You turned your face
to this old woman only
to accuse me of a niggling lie. Note!
The single time you spoke to me.
Do I exaggerate? The promise,
tell me! Where's the seal? In the snip
off Abraham's foreskin, but no mark
upon my breasts. And who consulted me
when you bid him burn my son
on Mount Moriah? Still I exaggerate?
Why did your hand-picked Abraham
twice turn me over to the harem of kings?
Am I a cow in heat needing to be mounted?
Why did I not see light in your light?
Why did your truth not set me free?

—Kilian McDonnell, O.S.B.,
Sarah's List, 2009

Mary in Art

MARY, AS THE woman *par excellence* in the history of art, architecture, and ideas, has inspired an astonishing outpouring of visual veneration. In the twenty centuries since the peasant girl Maryam walked the earth, her image has been encrusted, bejeweled, and enthroned—but also bitterly contested. From the fourth century onward, artists have rendered the milestones of her life with such sensuous and theological force that they have become landmarks of visual history. Indeed, it is no stretch to say the entire history of Western art can be told solely through pictures of Mary. Although the golden age of Marian art has peaked, its influence remains pervasive, because depictions of Mary continue to be displayed, protected, and honored at churches, in museums, and in photographs. Her image retains a sublime and timeless liminality, changing in physical appearance over the centuries to meet the expectations and needs of a given time and place.

Mary's veneration is intimately tied to her physical image. The intersection of art and faith has long been an uneasy one. It has been shadowed by iconoclasm, or icon destruction, from the very beginning, given Christianity's emphasis on the spirit and one God, who suffered no other gods. That hovering paradox, coupled with the notion that art serves as mere illustration of the texts, or acts as a "Bible of the Unlettered," overlooks art's capacity for sophisticated theological expression and its symbiotic relationship with worship and dogma. In fact, the power and persuasiveness of Mary's image in the minds and memory of ordinary people buttressed the proclamation of her two key doctrines, the Immaculate Conception and Assumption. More recently, feminist theologians have examined how traditional religious patriarchy has exploited Mary's image in ways that deter women from becoming fully independent and whole. Beyond the visual representations of Mary, the creative

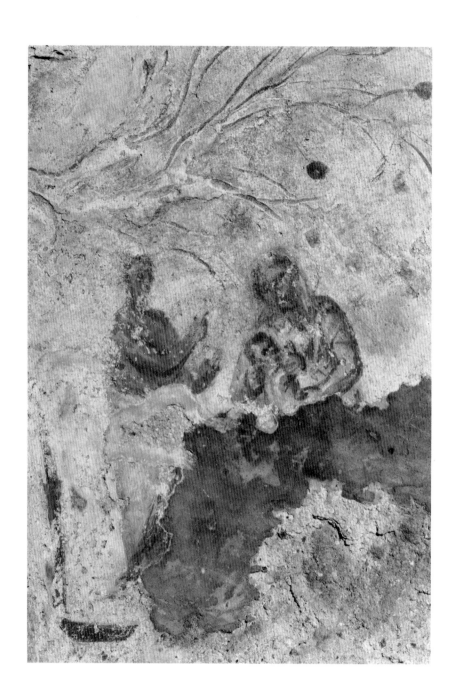

• • •

Madonna and Child, 3rd cent.
Fresco
15.7×10.6″ (40×27 cm)
Catacomb of Priscilla, Rome

The earliest surviving Christian art appears in Roman sarcophagus carvings or wall paintings found in catacombs, vast underground cemeteries. Created in the third to fourth centuries, before there was an official Church position on art, these were private expressions of faith that depicted themes of baptism, communion, and, befitting a cemetery, hope for immortality in the next world. In these works, dramatic episodes of divine intervention from the Old Testament—such as Jonah's escape from the whale, the sparing of Isaac, and the deliverance of the three boys from the fiery furnace—accompanied New Testament images, such as Christ healing the blind man or the hemorrhaging woman, and established the Jewish roots of the New Covenant.

Although the identification is disputed, some believe that this image of seated figures in a wall painting from the Catacomb of Priscilla (named for a Christian noblewoman) includes the first known depiction of Mary. A veiled woman sits with a child on her lap, possibly nursing him. The man who gestures to a radiant star above them is thought to be either Balaam or Isaiah, both Old Testament figures who prophesied a light that would herald the Savior. The portrayal of mother and child is tender and naturalistic. Mary hugs her son to her chest, as her curious baby turns to the gesturing man. Despite its deteriorated state, the image still succeeds in affecting the viewer; it is exhilarating to see Jesus's eyes widen as he contemplates the scriptural prophet, literally looking to his destiny. Yet the Virgin also understands the burden placed on her son's shoulders, though she does not need to see the prophet to comprehend it. Instead, she inclines her head toward her baby, seeing in his face the fate that awaits him.

imagination wielded by both artist and believer provides new doorways into her ongoing social and ethical relevance. Encounters with images of Mary transform looking itself into a devotional activity.

Given her enormous influence, it may be surprising to learn that Mary was rarely portrayed by early Christians, making her first verifiable appearances only in Roman catacomb paintings and tomb carvings of the late third to early fourth centuries. Once the Council of Ephesus (431) recognized Mary as the Mother of God, she was portrayed as a universal mother who was at once sovereign and accessible, resulting in a cult of the Virgin that reached an extraordinary pitch by the seventh century. Marian relics, statues, icons, and holy objects proliferated, polarizing Christians into two camps. Some believed that people were venerating the icons themselves instead of what they represented—which would be idolatry—while others argued that Christ's incarnation not only legitimized his visible reproduction in paint but demanded it, a justification that extended to representations of Mary. The ensuing battle over iconoclasm raged during much of the eighth and first half of the ninth century. The Second Council of Nicaea (787) was convened to address this violently contested issue. It was decided that since Christ had come into the world of visible realities, with his humanity building a bridge between the visible and the invisible, that the Church would recognize icons, as long as it was the person portrayed, and not the icon itself, that was venerated.

This decision, however, hardly ended the debate. In *Mother of God: A History of the Virgin Mary,* Miri Rubin documents the many periods when the veneration of Marian imagery was deemed close to idolatry or blasphemy. The fifteenth century saw the greatest production of artworks, as well as liturgies, processions, and feasts honoring Mary, yet it was also a time when critical voices were raised loudest, anticipating the religious revolution of the next century. In 1517, Martin Luther posted the *Ninety-Five Theses* on a church door in Wittenberg, Germany, sparking widespread religious reformation and the birth of Protestantism. While he is often considered the instigator of the iconoclasm that followed, Luther, in

fact, had a sensual appreciation of the arts. What he objected to was the sale of indulgences used to fund, among many causes, the enormous gilded confection that would be the new St. Peter's in Rome.

When the fermenting rage against the practices of the Church in Rome finally boiled over, there was widespread destruction of altarpieces, statuary, stained glass, relics, and other cultic objects, beginning with the first church "cleansing" in Zurich, Switzerland, in 1524, and spreading over the years to other cities, including Bern, Basel, and Geneva. Iconoclasm would have a far-reaching, irrevocable impact on Christian art. One significant cultural change effected was a masculinization of piety: Once images of Mary and other female saints—thought to have constituted nearly half of church art in medieval time—were removed, the richly symbolic, feminine aspects of devotion were replaced by those of a transcendent but overtly masculine God.

The determinedly iconoclastic reformer John Calvin (1509–1564) had a keen sense of the beauty of music; of language, as evidenced by his own lapidary prose; and of the natural world. While he did not object to the visual arts, nor was he opposed to human self-expression, he condemned the veneration of visual images, claiming they diminished the singular glory of God and the Word of God. He excoriated the sensual paintings of his era, like the lactating Madonnas dandling plump infant redeemers, wrapped in rich brocades and surrounded by clouds of nude cherubim, which were standard fare in southern Europe. He considered these examples of the "most abandoned lust and obscenity . . . brothels show harlots clad more virtuously and modestly than the churches show those objects which they wish to be seen as images of virgins." While northern artists painted less overtly religious subjects, they did so in settings that nonetheless were crammed with sumptuous, photorealistic details that still evoked feelings of desire and covetousness. At a time when more than half the population died before the age of twelve, believers must have found extraordinary solace in gazing at Mary and the face of her eternal child. From this perspective, Calvin's war on images can be construed as a failure of love. Despite their iconoclasm, however, Luther, Zwingli, Calvin, and other Protestant reformers did not sweep aside Marian

God did not self-reveal in the words of Scripture alone; God also appeared in a visible, physical form, with weight and mass, color and texture. The notion that theological insight can come through an artist's creative expression is justified at the very center of our confession of faith.

—ROBIN M. JENSEN,
The Substance of Things Seen, 2004

I may fill the lacuna with the
 exact color
between child and crown
 there on her throne
and think to be part of that
 eternal art,

I may write a poem because
 of her stare
alone in the musty solvent
 smells of work
leaving me to ponder what
 it's worth,

her glance may juggle time
 with eternity
making light the intricacies
 of death
because she survived the
 centuries,

but the lacuna between her
 eyes and mine
cannot be filled with words
 or song
or painted dabs of a master's
 hand

for perhaps it is in that miss-
 ing space
where humanity's eternal
 struggle with art
can never depict the lacuna
 of life.

—Lily Prigioniero, *Restora-
tion of an Icon,* 2009

devotion; if anything, Mary exemplified the principle of *sola fide*—
"by faith alone"—as the Reformation redefined it.

During this period of upheaval, the Roman Catholic Church
also sought reform. The Council of Trent (1545–1563) was convened
to define Catholic doctrine. An effort to renew the faith and re-
move abuses, the council would influence Catholic practice for the
next four hundred years, until the Second Vatican Council (1962–
1965). The question of religious imagery, one of many issues dis-
cussed at the council, didn't arise until the final session. Well aware
of the power of images to generate emotion, the council affirmed
the decrees of the Second Council at Nicaea. Images of the Virgin
Mary (along with images of Christ and other saints) were to be
venerated, not because they possessed any inherent divinity or
virtue but because the honor shown to them is that due to those
represented. The veneration of the Virgin would anchor Counter-
Reformation piety.

The extraordinary artistic flowering of the Renaissance and the
growing interest in humanistic values saw the creation of works of
impossibly beautiful verisimilitude. Our awareness of both our
spiritual ineptitude and potential transcendence inspires searing
admiration for a work like Michelangelo's *Pietà* (1497–1499), a
touchstone of Western art. It seems miraculous that the artist was
able to sculpt this evocative portrait of mother and child, with its
rippling lines as mesmerizing as the sea, from a block of cold mar-
ble. In contrast to this sweeping vision, portrayals of Mary by
Michelangelo's contemporaries in Northern Europe were character-
ized by meticulous delineation of individual, naturalistic details.
Northern Renaissance painters lavished as much care on the depic-
tion of Mary's crown or the lilies at her feet as on her face. In this
way of seeing, no one thing is more or less important than any
other thing, resulting in a democratic blurring of hierarchies, rais-
ing everything to a higher plane. One cannot help but reflect that
if a painted lily—like the lilies of the field—is exalted, then are we
not as well and more so? Such works inspire the viewer to see the
world outside the picture frame more intensely, and they under-
score art's incomparable ability to evoke deep emotion, whether in
a religious or secular setting.

Once inextricably linked, the relationship between art and religion had sunk by the twentieth century into a moribund mediocrity. Father Marie-Alain Couturier (1897–1954), a French Dominican priest who was trained as a painter, developed a radical plan to renew ecclesiastical art. His daring vision was that art did not have to be created by believers, just by true artists, who had their own mysterious lines to the transcendent. He worked with many artists, including the modern masters Georges Braque, Henri Matisse, Fernand Léger, Marc Chagall, and Georges Rouault, only one of whom was a practicing Catholic; the remainder shared varying degrees of distrust of institutional religion. Couturier was responsible for the commissions that resulted in Le Corbusier's chapel at Ronchamp, his monastery at Audincourt, and a small chapel in Assy, France. Widely publicized in popular magazines like *Life*, Assy stirred up controversy centered not around the art but on the fact that the artists were nonbelievers. Soon after the chapel's opening, Couturier was castigated in a series of attacks launched from the Vatican and scores of lesser clerical bodies. Before he was censored, however, Couturier obtained for Matisse (1869–1954) a commission that many consider his masterpiece, the exuberant Chapel of the Rosary in Vence, which was consecrated in 1951.

More recently, Mary's image has been both renewed and homogenized. Widespread popular devotion to Our Lady of Guadalupe has spurred the creation of formal and familiar portraits of her that have pervaded secular culture, offering the hope that *La Virgen*'s immense influence will inspire other such lively iterations of Mary's presence. On the other hand, contemporary standards for Marian imagery, like much that passes for religious art, continue to plummet, dragged down by the easy availability of ersatz reproductions from catalogs and, more broadly, by an educational system that does not encourage creativity or visual literacy. In *God's House Is Our House: Re-imagining the Environment for Worship*, the Reverend Richard Vosko advocates for pastoral training in the visual arts, a potentially transformative component of worship that has been largely neglected in the past century.

In the modern era, the roles of both religion and art have changed, and religion no longer has the power to establish the

• • •

Madonna and Child, ca. 1890
John La Farge (1835–1910)
Opalescent leaded-glass window
92×33″ (233.7×83.8 cm)
Salve Regina University, Newport, Rhode Island

The multitalented artist John La Farge seemingly mastered every visual medium—from painting to design to illustrated books. In 1875, he took up stained glass, when the tradition barely existed in America, and within a few years virtually reinvented the art form. His innovative use of opalescent glass allowed him to incorporate brilliant color in semitransparent layers that evoked a sense of three-dimensionality. With stained-glass pieces such as those he designed for Trinity Church in Boston, La Farge gained a reputation that rivaled—some say bested—that of Louis Comfort Tiffany.

This shimmering window, based on the *Sistine Madonna* painting by the Italian Renaissance master Raphael, was one of a suite of thirteen windows that La Farge created in 1890 for the Caldwell family chapel in Newport, where the artist lived off and on from 1859 until his death. When the Caldwell estate was demolished, the windows were moved to St. Patrick's Convent in Fall River, Massachusetts. When the convent met the same fate as the original chapel, Newport gallery owner William Vareika spearheaded efforts to preserve the windows as an ensemble and bring them home. Specifically, Vareika hoped they could be installed at Salve Regina University, whose Newport campus includes architectural treasures of the Gilded Age designed by firms such as Henry Hobson Richardson; McKim, Mead & White; and Peabody & Stearns, making it a living laboratory for cultural and historic preservation. Enthusiasm for the windows snowballed and inspired Salve Regina to construct a new chapel to house the windows, which were restored to their original glory. The La Farge windows are now the centerpiece of the Our Lady of Mercy Chapel and Mercy Center for Spiritual Life (2010), designed by the distinguished architect Robert A. M. Stern.

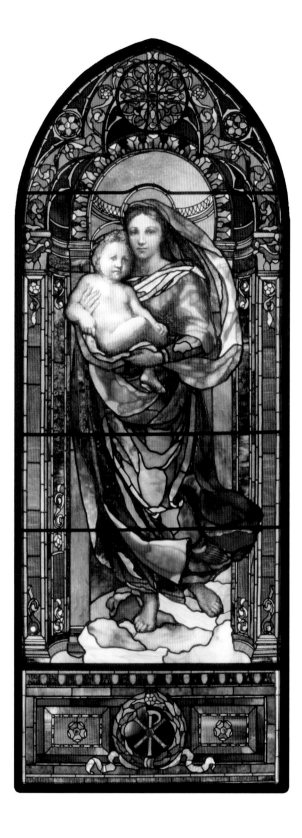

The tremendous power that the image of Mary has wielded in the human imagination . . . has been operative despite all the efforts to domesticate it—despite the simpering plaster statues, the saccharine prayers, sermons, poems, and hymns, and the sexist theology that has "explained" it.

—MARY DALY, *Beyond God the Father,* 1973

ethos of the whole community. At a time when the fundamentalist right has corralled the public face of Christianity and when scientific theory trumps all, discussions of the sacred seem to be conducted in voices that are either strident and self-righteous, or reticent and ineffectual. Art, now typically the province of the elite rather than the product of belief, has become, as many have observed, the religion of contemporary culture, and museums the new cathedrals. Even for those who do believe, the impact of religious art and architecture has lessened in an age of unprecedented personal wealth in the developed world. We who live as royalty once did, comfortable with our cars, homes, and global shopping baskets, cannot experience the transcendence of a medieval cathedral's stained glass, for instance, in the same way a thirteenth-century peasant did.

Some part of art's power to mediate the ineffable can be recovered by considering the nature of creativity and the artist. Cennino Cennini, the fifteenth-century painter best known for *The Craftsman's Handbook*, his 'how-to" book on Renaissance painting, wrote that painting "calls for imagination, and skill of hand, in order to discover things not seen, hiding themselves under the shadow of natural objects, and to fix them with the hand, presenting to plain sight what does not actually exist." In other words, the artist's task is to become exceedingly familiar with how things look, or might look, in order to represent them in a way that transcends the material world.

Whatever its subject matter, authentic art is born of an essential reverence. Along with the other arts, the visual springs from flashes of creativity that are similar, if not identical, to those moments of insight that illuminate our understanding of God and our role in the divine plan. Creativity at its most transcendent—when there is no separation between maker and object, when the artist is being re-formed by the very thing he or she is making—is comparable to the mystical state of prayer. Both exist in this place of imaginative fusion—in the intersection of our human and divine selves. Transcendent art has a direct and immediate contact with the beauty of the world, contact that has the nature of a sacrament. This is not limited to observation of forms and lines but encompasses color,

light, shadow, scent, touch, time, and memory—all information that is processed by the artistic sensibility, consciously and unconsciously, and calls forth a new creation. In this way, the work of art affirms the courageous *labor* of art, which Heidegger said "lets truth originate."

The least tangible and most profound aspect of the labor of art is the sense of nonjudgmental openness that the artist must maintain in relation to what is visible. As Simone Weil understood, "This way of looking is first of all attentive. The soul empties itself of all its own contents in order to receive into itself the being it is looking at, just as he is, in all his truth. Only he who is capable of attention can do this." Just as creativity requires giving attention to what does not yet exist, love is empowered to see what is invisible and to bring that invisible quality, whether justice, mercy, or compassion, into the concrete world through action. Art expands our wisdom and ability to love because it requires contemplating, like Mary, the truth of the world outside ourselves.

· · ·

Korsunskaya Effeskaya (Mother of God of Korsun), 2009
Helen McIldowie-Jenkins
Egg tempera and gold leaf on panel
12.8×10″ (32.4×25.4 cm)
Collection of the artist

The evocative panel paintings used from the fourth century onward in the devotional practices of the Orthodox Church provide some of the most enduring portraits of Mary. Tradition attributes this soulful icon of the Mother of God of Tenderness to St. Luke and holds that the original was brought to Kiev from the town of Korsun by Prince Vladimir the Great in the late tenth century. This contemporary copy of an undated Russian icon is similar to seventeenth-century examples from the Black Sea region.

Most unusual is the cupping gesture of the Virgin's hands, which protect as well as cherish. Primitive, but full of grace, Mary's larger hand points to the child and evokes the Virgin Hodegetria, or "she who shows the way." Mother and child merge to form one body, implying that one is of the other. Christ is shown as a *puer-senex,* or a child possessing the wisdom of an adult, but he affectionately touches his mother's chin as any child would. Each figure's mouth is closed to evoke the blessed silence of contemplation and acceptance. The Virgin's pensive eyes are asymmetrical: one gazes at the viewer and the other outward into eternity.

About eighteen years ago, having been given some loose gold leaf, artist Helen McIldowie-Jenkins created an icon on a whim; today she receives commissions from religious institutions around the world. The artist, who is a Roman Catholic convert, told me that she feels her "role is to mediate and explain this art form to those in Western Christian churches," while painting in a medieval-icon style that conforms to Orthodox Christian tradition. She begins her work with prayer, including one for icon painters: *Guide my hands that I might portray worthily and perfectly your image, that of your Holy Mother, and of all the angels and saints.* She painted the *Korsunskaya* icon especially for this book.

The Annunciation According to Luke

IN THE SIXTH month the angel Gabriel was sent by God to a town in Galilee called Nazareth, to a virgin engaged to a man whose name was Joseph, of the house of David. The virgin's name was Mary. And he came to her and said, "Greetings, favored one! The Lord is with you." But she was much perplexed by his words and pondered what sort of greeting this might be. The angel said to her, "Do not be afraid, Mary, for you have found favor with God. And now you will conceive in your womb and bear a son, and you will name him Jesus. He will be great and will be called the Son of the Most High, and the Lord God will give to him the throne of his ancestor David. He will reign over the house of Jacob forever, and of his kingdom there will be no end." Mary said to the angel, "How can this be, since I am a virgin?" The angel said to her, "The Holy Spirit will come upon you, and the power of the Most High will overshadow you; therefore the child to be born will be holy; he will be called Son of God. And now your relative Elizabeth in her old age has also conceived a son; and this is the sixth month for her who was said to be barren. For nothing will be impossible with God." Then Mary said, "Here am I, the servant of the Lord; let it be with me according to your word." Then the angel departed from her.

—LUKE 1:26–38

The Annunciation According to Matthew

NOW THE BIRTH of Jesus the Messiah took place in this way. When his mother Mary had been engaged to Joseph, but before they lived together, she was found to be with child from the Holy Spirit. Her husband Joseph, being a righteous man and unwilling to expose her to public disgrace, planned to dismiss her quietly. But just when he had resolved to do this, an angel of the Lord appeared to him in a dream and said, "Joseph, son of David, do not be afraid to take Mary as your wife, for the child conceived in her is from the Holy Spirit. She will bear a son, and you are to name him Jesus, for he will save his people from their sins." All this took place to fulfill what had been spoken by the Lord through the prophet: "Look, the virgin shall conceive and bear a son, and they shall name him Emmanuel," which means, "God is with us." When Joseph awoke from sleep, he did as the angel of the Lord commanded him; he took her as his wife but had no marital relations with her until she had borne a son; and he named him Jesus.

—MATTHEW 1:18–25

• • •

Annunciation (detail), 1393
Ilario da Viterbo
Oil on wood panel
Porziuncola Chapel, Basilica of S.M. degli Angeli
Santa Maria degli Angeli, Italy

The immense dome of the Basilica of Santa Maria degli Angeli (Our Lady of the Angels) shelters the Porziuncola, a diminutive stone chapel restored by St. Francis of Assisi that stands, in its entirety, in the center of the basilica. As reported by his early biographer, Thomas of Celano, Francis was enthralled by this "church of the Blessed Virgin Mother of God that had been built in ancient times and was now deserted and cared for by no one." At this little oratory, located below the town of Assisi, the Franciscan order was born in 1209; it is also where St. Clare made her religious vows of obedience and poverty. Now housed within the basilica, the chapel is removed from the sun, snow, trees, and birdsong that Francis so loved, yet its walls were rebuilt by his hands and his devotion to Mary. Standing inside the chapel, a visitor's gaze is drawn immediately to this luminous Annunciation, the centerpiece of a multi-part altar screen painted by the priest Ilario da Viterbo. The painting shimmers, seemingly lit from within, and is enlivened too by the decorative patterning of the brocaded fabrics, rugs, and frescoes that adorn the structure housing Mary and the angel Gabriel.

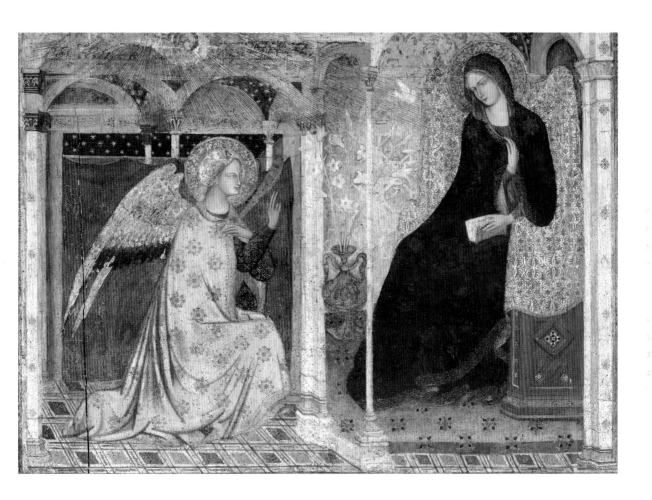

Ave Maria

MARY'S CONSENT TO become the Mother of God, an event called the Annunciation, reveals the utter strangeness of God's interventions in human history. "Terror of all terrors that I bore the Heavens in my womb" is how the poet William Butler Yeats aptly described this transforming event. The Annunciation, the linchpin of historical and contemporary Mariology,

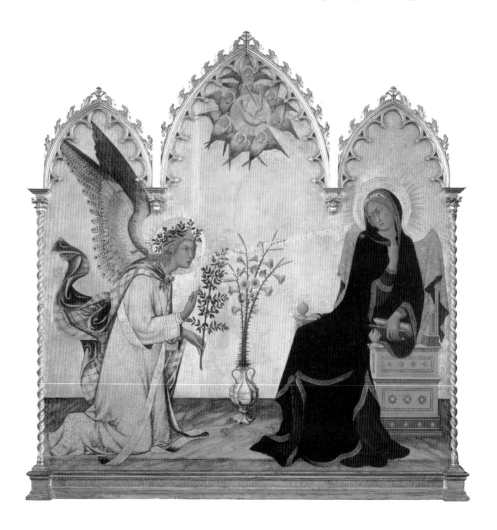

marks the earthly onset of what would come to be known as Christianity. For believer and nonbeliever, it mirrors the essential mystery surrounding conception and the beginnings of life. For Christians, especially Roman Catholics, it embodies the spiritual mystery that bridges belief and scientific fact, embodied in Mary's virginal motherhood. Mary's divine maternity, freely chosen and effected by her faith, is not merely a biological occurrence but an opening for the world to receive God's saving grace.

Two scriptural passages record Mary's "yes" to God, Joseph's decision to marry her, and the workings of the Holy Spirit in both of their lives. Luke's gospel account, thought to have been written in 85 c.e., says that the angel Gabriel appeared to Mary, a virgin from

Annunciation (detail), 1333 (restored, 19th cent.)
Simone Martini (1284–1344)
Tempera and gold leaf on wood
72.4×82.7″ (184×210 cm)
Uffizi, Florence

Created for the Saint Ansano Chapel in Siena Cathedral, this altarpiece depicts Mary seated on a lavish throne next to a vase of blossoming lilies, symbolizing her purity. We experience the shock of Gabriel's arrival along with Mary, whose gestures convey her surprise: She pulls her cloak to her face, averts her eyes, and puts down her book. According to medieval tradition, at the time Gabriel appeared, the Virgin had been meditating on a verse from Isaiah: *Behold a virgin shall conceive, and bear a son.* Gabriel's golden words—*Ave Maria, gratia plena*—float toward her, the literal Word of God that will through her become the incarnate Christ. Gabriel wears a crown of olive leaves and holds an olive sprig, the symbol of peace, alluding to the peace God will broker with humanity via the fruit of Mary's womb. The shimmering gold background emphasizes the mystical nature of this sacred event.

The frame of the painting employs pinnacles, pointed arches, and twisted columns—architectural elements that convey the sense of being inside a church or cathedral. Since these sacred structures, as well as the institution of the Church itself, were thought to symbolize the Virgin's body, we are in effect witnessing Christ's Incarnation taking place within both Mary's physical body and the metaphoric body of the Church.

Little documentation survives concerning the life of Simone Martini, but it is known that he was born in Siena around 1284 and worked under Duccio di Buoninsegna. Martini's work exemplifies the International Gothic style popular in Europe during the late fourteenth century. It is likely that his brother-in-law, Lippo Memmi, painted the saints flanking the central panel. The *Annunciation* is the last known painting that Martini executed before moving to Avignon in 1339 to work for Pope Benedict XII, an appointment that indicates how highly his work was regarded.

Nazareth who was engaged to a man named Joseph. It is not known what form the angel took—whether a ball of light, a cloud, a sunbeam, a flame—only that he appeared and spoke to her in a way that she could understand. He assured her, *Do not be afraid*, before revealing the startling news that she would bear a son who would reign over the house of Jacob forever. Mary asked the question that has flummoxed the doctors of the church, clergy, scholars, and the rest of us ever since: *How can this be, since I am a virgin?* In this version of the story, Gabriel lets Mary know that she would be the mother of God—nothing is impossible with God. In fact, her pregnancy had been a fait accompli for all eternity. He did not demand her acquiescence but asked if she would allow time to stop, and begin, within her body. With Mary's consent—*Let it be with me according to your word*—Jesus became physically incarnate, and humanity transcended the idea of itself as merely mortal. Through this embryonic Christ, humanity could partake in the divine.

In contrast, Matthew's brief gospel narrative, written between the end of the first and beginning of the second century, focuses not on Mary but on Joseph. Appearing in a dream, an angel reassures Joseph, who was ready to quietly leave Mary, that the child conceived in her was from the Holy Spirit.

It is the apocryphal *Protoevangelium of James* and not the New Testament that captures the universal roller coaster of emotions provoked by pregnancy, especially an unplanned one, and the age-old suspicion generated by an unconfirmed paternity. We are present as Mary becomes aware—as pregnant women are—of those strange, simultaneous feelings of connection and isolation brought on by the alien new life. The account limns the impact of this most common and yet most profound aspect of human life from multiple points of view, deftly capturing nobility as well as foible with a cast of archetypal characters: Mary, proud to be chosen, yet afraid; Joseph, the apparently cuckolded widower, unwilling to take on a pregnant young wife and anxious about what his family and neighbors will say; the kindly, elderly Elizabeth, to whom Mary flees for comfort; and Zechariah, Annas, and the other temple priests who wish to determine the will of God and enforce religious regulations.

Mary is our pattern of Faith, both in the reception and in the study of Divine Truth. She does not think it enough to accept, she dwells upon it; not enough to possess, she uses it; not enough to assent, she develops it; not enough to submit the Reason, she reasons upon it; not indeed reasoning first, and believing afterwards, with Zacharias, yet first believing without reasoning, next from love and reverence, reasoning after believing.

—JOHN HENRY NEWMAN, *Sermon* excerpt, 1843

Throughout her life, Mary was animated by the action of the Holy Spirit, from the first moment of Christ's conception, when she was "overshadowed" by the Spirit, to Pentecost, when the Holy Spirit descended upon her and her son's disciples, a moment that provides the last mention of Mary in the New Testament. On numerous occasions between these milestone events, Mary was guided by the Spirit's transfiguring power, suggesting that we, sharing her humanity, can participate in a similar *metanoia*, or transformation of the heart.

Imagining Gabriel

ONSIDER THE SPACE between Gabriel's appearance and Mary's eventual "yes." We do not know if a moment, an hour, or a day elapsed. More abstractly, we wonder what shape did such an opening between an ethereal and a human being take? There is no way to describe the interaction between the two, but it was elastic and porous enough to capture the imaginations of royals, ordinaries, and artists for two thousand years. Being a practical yet remarkable girl, Mary had the composure to ask the angel, "How can this be?" A natural-enough question for a virgin. But those four words do not convey what must have been an extraordinary shock. The first shock was simply the appearance of Gabriel—an

...

Annunciation, 2006
Tanja Butler
Oil, acrylic, and gold leaf on panel
10×5×2" (25.4×12.7×5 cm)
Private collection

This intimate diptych is constructed of two five-inch-square panels; the bottom panel provides the Annunciation's historical narrative, while the upper panel describes eternity, symbolized by the gold background. In the lower panel, the angel Gabriel, wearing street clothing ruffled by a breeze and looking like a friendly salesman, announces God's offer of redemption to humanity through Mary. Mary is poised just beyond the portal of the door of salvation, which had been closed since the fall of humanity, referred to in the upper panel by the withered Tree of the Knowledge of Good and Evil. Now a ladder stretches between heaven and earth. Apple blossoms, spring crocuses, and bursting pomegranates herald new life. Byzantine and medieval theologians likened the Incarnation to the image of the burning bush confronted by Moses: Like that miraculous bush, Mary contained God in her physical body but was not consumed by the divine flame. The contemporary Noguchi paper lamp, nearly hidden behind Mary, also evokes light and fragility.

Tanja Butler's paintings are visual meditations on the intimacy of God's love. With exuberance and disarming candor, her works combine elements of Latino and Russian folk art with the prismatic geometries explored in the Cubist and Suprematist movements. Her ecumenical approach weaves together the diverse artistic traditions of Western, Byzantine, and Islamic art.

In the sixth month the angel
Gabriel . . .
(Luke 1:26)

Giotto has it wrong.
I was not kneeling
on my satin cushion
in a ray of light,
head slightly bent.

Painters always
skew the scene,
as though my life
were wrapped in silks,
in temple smells.

I had just come back
from the well, placing
the pitcher on the table
I bumped against the edge,
spilling water.

As I bent to wipe
it up, there was light
against the kitchen wall,
as though someone had opened
the door to the sun.

Rag in hand,
hair across my face,
I turned to see
who was entering
unannounced, unasked.

All I saw was light,
white against the timbers.
I heard a voice
never heard before
greeting me. I was elected,

the Lord was with me.
I would bear a son
who would reign forever.
I pushed back my hair,
stood afraid.

Someone closed the door
And I dropped the rag.

—Kilian McDonnell, O.S.B.,
In the Kitchen, 2009

otherworldly angel with great beating wings appearing in an ordinary field on an ordinary day. As Mary came from devout Jewish stock, she would have heard stories upon stories about the miraculous appearances of angels. But that was in the distant mythic past, not now, not in Nazareth. Angels appeared to her mighty forefathers—Moses, Daniel, Elijah—not to impoverished young girls, certainly not to her.

How must she have felt when the angel appeared? We can imagine the sudden voiceless chill that claimed her body, accompanied by a surface tingling, a sensation that was almost heat, as the urge to flee raced through her. The aftershocks were scored to Gabriel's words, sounds that slowly gained volume as she returned to the present moment: *You, a virgin, living in the backwaters of Jerusalem, will become the Mother of God.* Her body, before the penetration of these words: mindless, shuddering, vulnerable, pliant. Then, in a few minutes, after checking the earth with her toe, touching a tree, a rock, something to confirm that her world was still there, her thoughts kicked in—bumping, fractious thoughts—shouldering up to one another, shoving other thoughts aside, all of them racing toward understanding what this heavenly being was saying. She was no longer spellbound. The words *shame, risk, reproach,* and *scandal* were forming in her head. In time, this moment would raise Mary from a handmaiden's lowliness and would cause all ages to call her blessed, but for now it was a blind leap into the unknown.

Once or twice she had used the word "pregnant," whispering it to her reflection in the mirror, but she had never put herself and the word "baby" in the same sentence. Instead she began to imagine him . . . as large and fish-like with eyes blinking in the cloudy film of her womb. At times he provided her with comfort in the quiet of her bedroom, but she had been vigilant about not thinking of him as remotely belonging to her.

—LAURIE FOOS, from *Bingo Under the Crucifix,* 2003

Tekton

I N A RARE flash of biographic color, Matthew tells us that Jesus
was a carpenter. This memorable piece of Christology, men-
tioned only once in the Bible, is one of the few things people far
removed from the pews can recall about the man. And, for most,
that calls to mind the modern occupation—the work of someone
who measures, cuts, chisels, saws, hammers, and nails wood into
submission and knows the arcane rituals of the Home Depot lum-
ber department. But Jesus was not a carpenter as we understand it,
nor was his adoptive father, Joseph, but a *tekton*, a Greek word that
exists along an extended spectrum of meanings ranging from car-
penter, to joiner, to woodworker, to craftsperson, and, stretching
the line still longer, to scholar, author, and any of those professions
that call for skilled dissection, exacting measurements, and cunning
assembly and disassembly, activities that eventually come together
to form a bed or a gallows, the frame of a house, or that of spirit, a
phrase, a sentence, an argument. The balance hangs on words.

Showing Up: Joseph

U NTIL I MARRIED a widower with an infant son, I didn't give much thought to Mary's husband. Joseph was merely a shadowy figure in the margins and out of mind except on his feast day in March, which my family celebrated by eating *zeppole*, Italian cream puffs. But when I became Brendan's mother—first his step-mother, and then, by adoption, his legal mother, and now, through love and grace, just plain old Mom—I began to ask Joseph, the ultimate stepparent, to show me how to love this child, not born of my body, as my own. Over time, Joseph's guidance in my spiritual life has expanded to become the means of understanding the sanctity of marriage, the dignity of all work, and the nobility of the creative quest. I'm fairly certain that Woody Allen wasn't thinking of Joseph when he quipped that "Eighty percent of life is showing up," but that's what Joseph did and the reason why he is beloved.

Because Joseph utters not one word in the gospels, we must use our imaginations to fill in the eloquent silences of his life. Yet his story can come to bear quite powerfully on the bedrock issues of contemporary married and family life. The first thing we learn about Joseph is his obedience: *he did as the angel of the Lord commanded him* (Matthew 1:24). Mary and Joseph bonded together through their mutual understanding that the seed she carried within her womb was divine. He shared in this salvific event, overcoming his initial reluctance and natural suspicion to accept the divine design of her motherhood. The birth of their extraordinary child required both of them to step outside the circle that defined, then as now, traditional societal boundaries. What trust must have existed between these two newlyweds, nearly strangers, to accept a situation on faith that was impossible by every known standard and to walk hand in hand into the unknown future! In that same spirit of deference, the couple obeyed Joseph's prophetic dreams, the first in conjunction with Mary's pregnancy, and, later, the dream that

helped them escape Herod's wrath by traveling to Egypt, their second long journey together.

Joseph embodies the humility, fidelity, and mutual respect that undergirds the holiness of marriage and family. The pillar of the Holy Family and the earthly symbol of a benevolent father, he also stands in for every human being. We gain access to the Holy Family—a place at their table, as it were—through his all-too-human figure. Together, Mary and Joseph saw to life's quotidian details. They shared in the daily joys of parenting Jesus, tenderly described in *Josephina*, an epic poem written about Joseph in 1418 by the mystic and theologian Jean Gerson: "He rushes into their embrace when called/Lifting his little arms he wants to hang on the necks of his parents/With tender embrace to give chaste kisses/He places his hands in yours, Mary and Joseph/And with his uneven step/He follows you all over the house." With full fatherly authority, Joseph also met the paternal religious obligations of Jesus's naming, circumcision, and education in Judaic law. He taught him his own trade. Through the lens of Joseph's selfless love we can see how Jesus's humanity, which was inseparably linked to his divinity, developed.

The eternal ties beyond those of physical love, which is subject to the vagaries of time and inclination, come into focus through Joseph's chaste marriage and his respect for Mary's perpetual virginity. Contemplating the nature of marriage, saints Augustine and Thomas Aquinas describe it as an "indivisible union of souls," hearts that are bridged by the willing gift of freedom from and to each spouse. This seems to me to be marriage's highest calling.

Episodes inspired by the apocrypha in the fifth century provide more biographical details that begin to appear in pictorial art, notably the marriage of Joseph and Mary and Joseph's dream, which are illustrated in mosaic on the triumphal arch at Santa Maria Maggiore in Rome (page 70). In *The History of Joseph the Carpenter*, a Greek text from ca. 400, we learn of Joseph's death and burial, as narrated by Jesus, at the age of 111. He rarely appears in Christian art before the early Middle Ages, and then only as a kind of comical figure— a clueless old man, sulking or puzzled, who sits off to one side or tries to be helpful by warming the soup, pouring water into the

baby's bathtub, or holding up a light. Deeper into the medieval age, more textual and visual portraits of Joseph emerge that depict the Holy Family's daily life.

In his homilies on Mary, Bernard of Clairvaux frequently commented on Joseph, extolling his humility and wisdom as "God's only and most faithful coadjutor in his great plan on earth." He asks his twelfth-century listeners to imagine what sort of man Joseph must have been to be entrusted to care for God's only son. By the fourteenth century, the person of Joseph gained visibility and interest in Europe through the influential writings and preaching of Gerson and his contemporary in Italy, Bernardino of Siena, both of whom reflected on Joseph's many unsung virtues and urged devotion to him. These works, along with other fourteenth-century meditations such as the *Life of Christ* by Pseudo-Bonaventure, encouraged the formation of Josephine cults, which

• • •

The Glovemaker, 2004
Karen Ostrom
Chromogenic print
40×40" (102×102 cm)
Collection of the artist

The isolated fishing villages and experimental communities of the Pacific Northwest have inspired the work of photographer Karen Ostrom. Conceptually following in the footsteps of her Swedish grandparents, who were part of the nineteenth-century wave of utopian-minded immigrants who settled in Canada and fished its waters, Ostrom founded her own virtual online fishing village in a project called the *Holiday in Hope*. This fictional village is portrayed in a series of epic photographic tableaux that depict the residents of Hope engaged in various activities. All of its citizens, male and female, are exclusively played by Ostrom, who deploys her own body as a primary tool of visual investigation.

In this image, we see one such resident, the Glovemaker, who toils relentlessly making gloves. Ironically, his job is about to become obsolete, because many items once made by hand are now made by machines. Nonetheless, he is hard at work in his small shop, literally breathing life into the gloves, or hands, that will create still other works. According to the artist, she originally conceived the Glovemaker as a secondary character who labored on the periphery of the fishing village. Because of his craftsmanship and dedication, however, he emerged as one of the most important characters in Hope. Like Joseph, he is the humble, earthly manifestation of the cosmic artisan.

revered Joseph as an industrious foster father. Such groups gained new members as the virtues of hard work and the notion of labor itself expanded. No longer viewed as elderly and ineffectual but as young, vigorous, and capable, Joseph also evoked the strong family unit, which was considered a defense against the plagues, famines, wars, economic troubles, and societal upheavals that roiled European households in the late Middle Ages. The cult of Joseph was

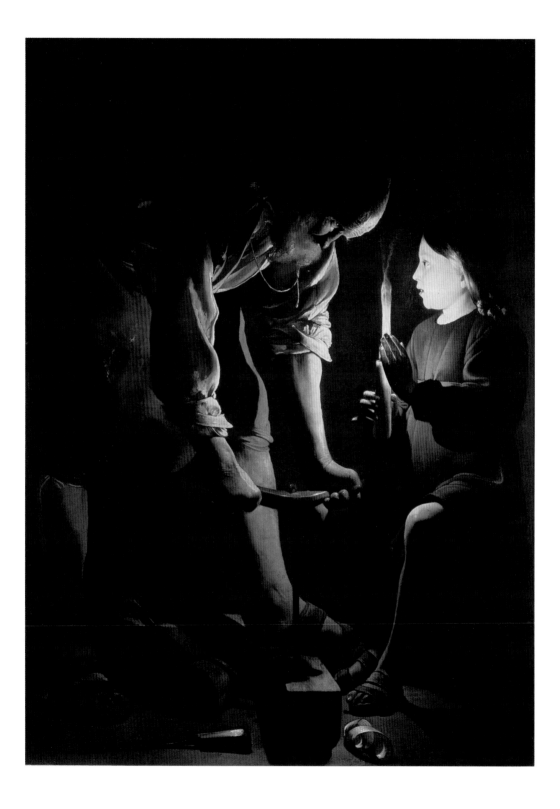

• • •

Saint Joseph the Carpenter, ca. 1642
Georges de La Tour (1593–1652)
Oil on canvas
54×40" (137×102 cm)
Musée du Louvre, Paris

In this painting, the eye moves from the darkness of the periphery to the luminous center of the picture, where light emanates from the living relationship between father and son. La Tour provides a dramatic close-up of Joseph in his carpentry shop. Bent low over his work, he drills a hole with an awl in a thick plank of wood, which makes reference to his work as an artisan but also prefigures Christ's coming crucifixion on a wooden cross. Jesus's mouth, slightly open, suggests that he is speaking. The child's expression as he engages in ordinary conversation with his father betrays no fear, implying that he is at peace with his destiny. Although still at work, Joseph pauses. His eyes are on his son. Jesus holds a candle, a hallmark of La Tour's dramatically lit paintings and the sole source of light. It illuminates the gentle expression on Joseph's face as well as the strength of his arms. Jesus's own face and hands are also luminous, so radiant that they seem to be lit by an internal, divine light, which the artist intimates is stronger than that of a temporal candle.

Such juxtapositions of earthly and divine light in La Tour's paintings are a metaphor for the relationship between the spiritual and the secular—a lifelong fascination for the artist. Captivated by the religiosity inherent in daily life, he peopled his canvases with common folk who look like those he may have encountered at the local fish market. Though his imagination was engaged by the "existential isolation of poverty," as the curator Philip Conisbee aptly put it, his works never deny human dignity or the possibility of transformation through faith and repentance. Created during the Counter-Reformation, La Tour's paintings explore with breathtaking virtuosity the desire to find new images of human holiness, embodied in the person of Joseph, that characterized that period.

slow to catch on, however, and it was not until the next century that he gained a firm foothold in popular pious imagination.

St. Teresa of Avila, the mystic and great reformer of the Carmelites, was largely responsible for Joseph's growing popularity in the sixteenth century. With her encouragement, the Spanish friar Jerónimo Gracián wrote the *Summary of the Excellencies of the Glorious St. Joseph, Husband of the Virgin Mary,* which enumerates in five books the saint's many gifts of grace. First published in 1597, it became the most widely circulated work on Joseph in Europe and had a formative influence on how he was portrayed in such paintings as Georges de La Tour's monumental *St. Joseph the Carpenter* (ca. 1642). By 1621, the Feast of St. Joseph, celebrated on March 19, was de–

clared a holy day of obligation and many countries claimed him as their patron, including Austria, Italy, Belgium, China, Peru, and Canada. His veneration in the New World had taken root even earlier, by the early sixteenth century, thanks to the Franciscan brothers who taught Native Americans Christian theology, as well as fine arts and handicrafts, under Joseph's patronage.

St. Ambrose's fourth-century commentary on the Gospel of Luke memorializes Joseph as *faber*, an artisan, and draws a parallel between human industry and divine Creation. Joseph mirrors the image of God we first encounter in Genesis, the powerful Creator of heaven and earth and all things, visible and invisible, in between. It made sense that Jesus's earthly father was an artisan and that his heavenly Father was the Artisan of the soul. Joseph constructed tangible objects, whether tables, chairs, or, memorably in the *Mérode Altarpiece*, mousetraps. Portrayals of him in his workshop remind us that human beings are created to create, whether works of art or science or necessary utility. In his role as *faber*, he serves as an inspiration to creative artists who often struggle for recognition in society's margins. Joseph is the laboring everyman who literally builds the structure that will frame and protect his wife and child.

Willing to do those small things that make a great difference in daily life, Joseph shows us the dignity of work. He is the proof that there is no need to do great things, as Paul VI wrote in 1968; it is enough to cultivate the simple, authentic human virtues. Look around and notice the unsung individuals who, like Joseph, show up at their jobs every day to make or make available what's needed to live. This is no small thing! We are ordinary beings, blessed occasionally with the spark of the divine but more often simply going about our day, hoping that our efforts have lasting meaning.

I was reminded of this truth not long ago. My daily commute is forty feet long. I work in my backyard on the second floor of a building that once was a hay barn and now, renovated, is my studio. I spend so much time up there that my poetic neighbors, seeing the light on at all hours, have nicknamed me Juliet, after Shakespeare's character. One neighbor suffers from occasional bouts with agoraphobia, the fear of being out in the world. Lately,

I've been so preoccupied with life's busy-ness that I haven't been particularly neighborly. But one day we had a cup of coffee, and I learned that her agoraphobic fears had returned. I apologized to her, ashamed by the realization that I was spending so much time writing about human kindness that I was oblivious to what was happening literally in my own backyard. "Oh, no, you've helped me, a lot," my neighbor insisted generously. Leaning towards me over the coffee cups, she told me how many times she'd looked up to my studio and, just seeing the light on, knowing that I was there and there was someone to call if things got bad, calmed her down.

We finished our coffee and I returned to my studio, my heart softened by the miraculous alchemy that can transform one oblivious human being into a beacon of consolation for another. Could it be that the work that keeps my studio lights burning—the self-contemplation, the self-presentation—is the secondary thing and not the primary thing? Most of us get so caught up in what we're doing that we forget what's far more important is how we are *being*. All those days when I thought that only my efforts counted, that everything depended on my *doing* something, someone else was counting on me just to show up.

Content to provide love from the margins, willing to be wholly invisible, Joseph reminds us that, whatever our occupation, it is worthy of our respect, worth showing up for. It is worthy of the respect of others. He asks us to see our efforts—however unacknowledged, menial, or difficult—as a necessary part of a larger whole. His life illuminates the pathway that assures us of things hoped for and the conviction of things not seen, as the Book of Hebrews so memorably describes the nature of faith.

Mother of God, the Council of Ephesus

ONCE EMPEROR THEODOSIUS declared Christianity the Roman state's official religion in 380, the number and diversity of Christians grew exponentially. It became, therefore, increasingly important to define what the Church believed. The most vital question concerned Christ's uniquely mingled nature, which necessarily included speculation about the circumstances of his birth. In 431, the Church convened a Third Ecumenical Council meeting of some two hundred Christian bishops in Ephesus in Asia Minor, now western Turkey. The council was called to settle the nuanced, ongoing dispute concerning the human and divine natures of Christ, a debate that also called into question the nature of Mary's maternity: If Jesus was God, then she who bore him must also be the Theotokos, the Mother of God.

Though condemned in two previous ecumenical councils, the heretical beliefs of Arianism (which did not question Christ's exalted status but denied him divinity on par with God's) and Apollinarianism (which held that Christ had an ordinary human body and soul but a divine spirit) still persisted in the minds of churchmen and theologians. That is, Christ's true and full deity needed to be defended against Arianism, and his true and full humanity against Apollinarianism. To counter these claims, Nestorius, the patriarch of Constantinople, preached a series of sermons stressing that Christ was not fully divine, because he had a human mother; while Mary was the mother of Christ's human nature, his divine part was of God, and not born of her. Moreover, in Nestorius's opinion, Mary could not be God's mother, because God had been from all eternity. Also troubling was the title itself—Theotokos would imply Mary was a goddess, like those worshiped by pagans. In response, Cyril, the patriarch of Alexandria, energetically repudiated the Nestorians, stressing that in order to redeem humanity, Christ would have to assume all aspects of humanity, par-

ticularly its capacity to suffer. According to Cyril, Christ's two natures were in fact united, not mixed, in one divine person. Also entering into these debates was the issue of Mary's virginity, which earlier Christian thinkers had denied altogether, or considered a temporary state that ended once she gave birth to Christ, or deemed perpetual. For the bishop of Alexandria, Athanasius (d. 373), who insisted on Mary's perpetual virginity and upheld it as the ideal of holiness, the virginal conception was proof of Christ's divinity, and, reciprocally, Mary's divine motherhood demanded her perpetual virginity.

After prolonged arguing between Nestorius and Cyril, the emperors Theodosius II and Valentinian III summoned the Council of Ephesus. Ultimately, Nestorius's view was condemned for a variety of theological, political, and personal reasons, and Cyril's doctrine was upheld. Because of political machinations, however, a final doctrinal statement was never achieved at Ephesus and would not be ratified until the Council of Chalcedon in 451. From that time on, Christ was proclaimed both fully human and fully divine, and these natures, unblendable yet unbreakable, were inseparable.

While the esoteric debates at Ephesus would have been lost on the vast majority of Christians, most would have understood that Nestorius tried to deny Mary a title that reflected her close relationship with God, and his denouncement affirmed Mary's great popular appeal as well as her high status in the Christian pantheon. Although Christ's birth from a human mother had never been disputed, and Mary had been referred to as the Mother of God earlier, it was not until Ephesus that her most comprehensive and, for some, most problematic identity became doctrine: She was not merely the mother of Jesus but Theotokos (literally "God-bearer" but usually translated as "Mother of God"). The decision represented a quantum leap in the history of thought about Mary and underscored the deepening need to identify a human person who was the crown of creation, once the council declared that to be an inadequate description for Jesus Christ.

Despite the Church's continued efforts to define Mary's subordination to God, some view her declaration as Theotokos as the opening wedge in her veneration as a substitute mother goddess,

. . .

Triumphal Arch and Apse, ca. 432–440

Artists unknown

Mosaic

Basilica of Santa Maria Maggiore, Rome

Santa Maria Maggiore, the crown jewel of Rome's more than two dozen churches dedicated to Mary and one of the city's four papal basilicas, was constructed during the pontificate of Sixtus III (r. 432–440). Construction commenced a year after the Council of Ephesus concluded, and the church reflects Mary's new status as the Mother of God. Of particular significance are the mosaics on the triumphal arch framing the altar and the upper nave walls, which are thought to be the oldest surviving ornamentation in a Christian church. The nave walls depict Old Testament scenes illustrative of God's covenant with Israel, while the triumphal arch is peopled with characters from the Old and New Testaments in scenes that emphasize Christ's incarnation and Mary's divine motherhood as proclaimed at Ephesus. The *Coronation of the Virgin*

Mary continued to demarcate the difference between Christians and Jews, and by the early fifth century also helped to define the style of official imperial religion. Forms of address and forms showing religious dignity, especially those of imperial women, were applied to Mary with increasing ease.

—MIRI RUBIN, *Mother of God,* 2009

(ca. 1296), the central apse mosaic created by the Franciscan friar Jacopo Torriti, is believed to be a copy of an earlier mosaic that also represented Mary enthroned.

The basilica's magnificent interior features forty columns, thought to have been salvaged from an earlier structure, which create a visual rhythm that is matched by the expansive circular patterns of the marble Cosmatesque floors. A coffered ceiling designed by Giuliano Sangallo and completed by his brother, Antonio, is leafed with gold from Peru, said to be the first gold brought back from the Americas. Thanks to the nave's spatial arrangement and decoration, one's eye is drawn immediately to the central altar beneath a canopied baldachin designed by Ferdinando Fuga, who also redesigned the exterior façade. In a crypt under the altar lies the celebrated relic of the infant Christ's bed, known as the Holy Crib; it is housed in an ornate crystal and silver reliquary. Tradition has it that the earlier church built on the site was inspired by snow falling on that spot in August, an event that is recalled annually on August 5. During the solemn celebration of the Miracle of the Snows, white flower petals are dropped from the ceiling onto the congregation below.

at least in popular devotion if not in official dogma. Marian veneration surged after Ephesus and would continue to develop enthusiastically. She was endowed with the qualities associated with the "universal mother" that were borrowed from the pagan mother divinities, including the celebration of new feasts of the Virgin on the feast days of the old goddesses. Icons and relics became the means of adding concrete historical proof to her scant biographical detail. The visual response to her new title also yielded the imperial images closely associated with Byzantium, which depict her in a regal, full frontal position with a queen's imperturbable, detached stance. Mary's identity in word, art, and devotion, however, would change again, and yet again. As Theotokos, Mary would be an anathema to Islamic revelation in the seventh century; denounced pictorially during the iconoclasm of the ninth century; made more nurturing, emotional, and familiar during the Middle Ages; given a pomegranate and placed in a meadow during the Renaissance; and relegated to the role of genial housewife by the Reformers, before she reemerged, officially recognized by Catholics as the Queen of Heaven, with the assertion of the dogma of the Assumption. But that would come in time. For the moment, jubilant Ephesians ran through the streets, past the great temple of the goddess Artemis, rejoicing in the Mother of God.

The Church of St. Saviour in Chora

I STANBUL IS BUSY, beautiful, and filled with the sounds of life, living, prayers. Minarets, everywhere, point to the sky. Though Islam is not my faith, I thrill every time I hear the *adhan*, the Muslim call to prayer, and remember that the faithful are acknowledging our utter dependence on God. *There is no god but God*, as the *adhan* affirms. Say "Istanbul" and mother-of-pearl comes to mind, the lustrous color of the Golden Horn, the slim thread of river on which the city's fortunes over the millennia were built and swept away. Say "Constantinople"—as the city was named in 330 after the Emperor Constantine claimed it for his own—and the obelisks and walls of its former glory, now mostly ruins, come into sharper focus. But say "Byzantium," intoned with a musky, muted voice of what is past, or passing, and yet to come, and it is Mary who comes most vividly to mind.

Once, the entire city was dedicated to Mary. After the miracle of 626 c.e., when a precious piece of her robe saved the city from invaders, Constantinople's streets filled regularly with processionals in which Marian icons were carried aloft, and some five hundred churches were built. During the 626 attack, the relic of the Virgin's tunic was paraded around the city walls for protection; thus the chant for the Feast of the Deposition of the Virgin's Robe, which is still celebrated by the Orthodox Church on July 2, reads: "O Mother of God, ever Virgin, protection of all peoples, you have given to your city your Robe and cincture as sure protection." Mary saved the city several times in the intervening centuries. After the siege of the Rus in 860, the Patriarch Photius spoke of her miraculous tunic, emphasizing its enfolding nature: "It embraced the walls . . . the city put it around itself . . . the city bedecked itself with it."

Built to emphasize Mary's singular role in the salvation of the city's inhabitants and all of humanity, the Church of St. Saviour in Chora is a gem. Tucked away a few miles north of Istanbul's

better-known monuments, it preserves some of the finest examples of late Byzantine art and is considered a cultural treasure second only to the Hagia Sophia. On nearly every square inch of its walls and ceilings, stories about the Holy Family's life are told in mosaic and fresco and recounted sequentially, as one would read in a book. The Virgin Mary is the foundational metaphor on which its art, architecture, and liturgy rests. Thus cloaked with Marian imagery, the Chora is a limitless space of enchantment.

The Church of St. Saviour in Chora is also known by its Turkish name, *Kariye Camii*, so named after it was turned into a mosque in the sixteenth century. Since 1945, when it was decommissioned and secularized, it has been called the Kariye Museum. No trace remains of the original church. Although the site may have been

• • •

Presentation of the Virgin in the Temple, ca. 1316–1321
Artists unknown
Mosaic
Church of St. Saviour in Chora, Istanbul

Mosaic, made of small pieces of cut glass or stone called tesserae, was ideally suited to pave the Chora's idiosyncratic, curved structure. This mosaic from the Life of the Virgin cycle is indicative of the full-to-bursting compositions of the Chora's art program. The *Presentation of the Virgin in the Temple* shows Mary leaving her parents to enter the Holy of Holies. It is purposely located in the vault above the nave entrance, where the clergy enter the holiest part of the sanctuary. The scene's circular procession was designed to mimic the clerical procession taking place below. In the background, an angel presents Mary with a round piece of holy manna, a reference to the Eucharist.

At the Chora, one is constantly recalling what one has just seen and, through the vistas artfully constructed by the church's multiple arches and doorways, anticipating what one will see next. This de-centering of the present moment extends to the imagery, which recalls past Biblical events but recontextualizes them in the present through the performance of the liturgy. As the clergy physically moved through the liturgical spaces, they were surrounded by Old and New Testament protagonists who, animated by the mosaicist's art, also move through the stagelike sets. The effect is to dissolve the perception of the specific, historical moment and release the viewer into *kairos,* or ahistorical divine time.

consecrated as early as the fourth century, and there are archaeological remains from the sixth, the church as we see it today was built between ca. 1316 and 1321 under the patronage of the humanist and statesman Theodore Metochites, who described it as "a work of noble love for things good and beautiful." The Chora's importance derived from its proximity to the Blachernae Palace complex, where the piece of Mary's tunic, the city's most sacred relic, was kept.

The church gained the appellation "in Chora," which translates from the Greek as "in the country," because it was built in the rural area outside the walls erected by Constantine. After the site was encompassed by additional protective walls built by the Emperor Theodosius in the fifth century, the name was still used but gradually acquired a more expansive, mystical meaning. Christ came to be known as the *chora ton zoonton,* or the "land of the living," from Psalm 116:9 (*I walk before the Lord in the land of the living*), while the Virgin Mary was the *chora tou achoretou,* or the "dwelling place" of the

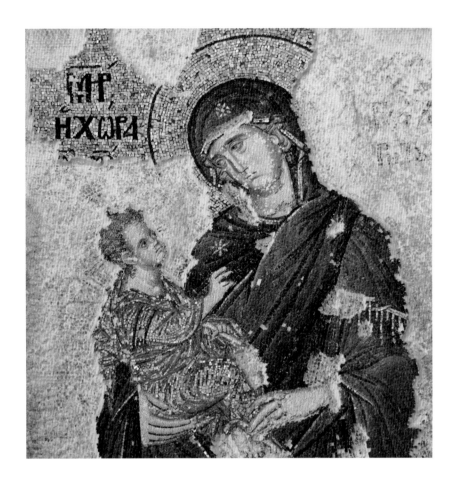

• • •

Virgin Hodegetria (detail), ca. 1316–1321
Artists unknown
Mosaic
Church of St. Saviour in Chora, Istanbul

Icons, especially those depicting the Virgin, were densely woven into the rituals of Byzantium. This portrait and one of Christ flank the templon screen that separates the Chora's nave from the bema-apse. Here the Virgin is portrayed as the Hodegetria (from the Greek for "one who shows the way"), a Marian iconic type. During the Ottoman conquest, the Virgin Hodegetria icon that the citizens once carried for protection along the nearby Theodosian walls was stored at the Chora for safekeeping, but it was destroyed during the invasion. The Hodegetria is traditionally shown with a starburst on each shoulder and one on her forehead to symbolize her virginity before, during, and after Christ's birth. As noted in Liz James's study of color in Byzantine mosaics, more important than hue or saturation was color's reflective qualities—what mattered was obtaining glittering, iridescent, gleaming effects that would convey a sense of exultation and enhance the perception of the mystical qualities of light.

Uncontainable, from the Akathistos, the exuberant Byzantine hymn written in her honor ("Rejoice, container of the Uncontainable God"). The Chora's inside/outside location relative to the city's walls became the keystone of its theological identity.

The idea of Christ and the Virgin as *chora*—an embodied place—is expressed by the concentric design of the church's structural elements and site. The larger monastery grounds were dedicated to the Virgin. The church itself is dedicated to Christ and the Virgin. Within the church, the outer narthex corridor that portrays scenes from Christ's life contains the inner narthex portraying Mary's life, and that in turn contains the central nave, also dedicated to Christ. This structural concentricity, also seen in the art program, reflects the supernatural mutuality of Christ and his mother as the instruments of salvation. At every turn, their images (or those of their ancestors) confront, interact, contrast, and balance each other.

Above all, Metochites wants to tell us a story. In encyclopedic fashion, the mosaics and frescoes in his church narrate the wide story arc between incarnation and salvation. Laden with intensely observed human, geographic, and architectural detail, the mosaics re-create a paradise inhabited by heavenly beings who possess the earthly trappings of abundant prosperity and security—the promised land of the living. Nearly two hundred scenes rendered in mosaic illustrate the Infancy and Ministry of Christ and the Life of the Virgin. The frescoes in the *parekklesion*, or funerary chapel, depict Old Testament prefigurations of the miraculous virgin birth and a Last Judgment scene that is considered one of the greatest examples of late Byzantine painting.

Eighteen vignettes from the Virgin's life illustrate the inner narthex corridor, which has the largest amount of art preserved from the original church and most closely approximates its grandeur. The Life of the Virgin cycle opens with *Joachim's Offerings Rejected* (because he and Anna were childless) and concludes with *Joseph Reproaching the Virgin* (because he was suspicious as to how she became pregnant in his absence). The Infancy of Christ cycle commences with the *Dream of Joseph*, in which an angel assures him that the Virgin conceived through the Spirit, followed by the *Jour-*

ney to Bethlehem and a rare depiction of the *Enrollment for Taxation* episode, which shows Mary and Joseph in Bethlehem and recalls that Metochites was the minister of the treasury and responsible for tax collection. The Infancy cycle concludes with *Christ Taken to Jerusalem for Passover*, setting the stage for the opening Ministry image of *Christ among the Doctors* (at the Temple).

The narratives of the lives of Christ and Mary overlap and interlock. Their life stories are paralleled in the narthexes, and their images are paired in numerous works. Like characters in a book, they appear to be in conversation with each other, thanks to the ingenious positioning of their figures within the architectural framework. This is evident in the Deesis (literally, "entreaty"), the large dedicatory mosaic at the entrance, in which Mary's eyes and hand gestures toward Christ invoke her pleading on humanity's behalf. Over the entrance, the Blachernitissa—a Marian iconic type that takes its name from the Blachernae Palace, where the tunic relic was once stored—shows Mary with the infant Christ inscribed in an oval shield over her womb; this mosaic is on an axis with the nave's Dormition scene, which shows Mary as an infant in Christ's lap. Two flanking works in the nave, known as the Templon panels, illustrate Mary and Christ, while the Anastasis fresco in the *parekklesion* shows Christ as the new Adam and Mary as the new Eve.

Through these visual representations of events from the lives of Christ and the Virgin, worshippers were transported from temporal, linear time into eternal divine time. The Chora presents a space that exists out of time, suspended between *chronos*, which refers to the chronological time that can be measured by a clock or calendar, and the more abstract notion of *kairos*, which refers to "in between time" or "sacred time." Considering the two different roots of the word *kairos* provides new understanding of the Chora's double roles as a liturgical space and a theological library. The first meaning of *kairos* derives from archery and refers to the "right or opportune moment," an opening, or, more precisely, the long tunnellike aperture through which the archer's arrow passes. This linear progression of time parallels the path of the Chora's liturgical processions as they moved from the entrance into the nave. As Eric Charles White notes, the second meaning of *kairos* derives from the

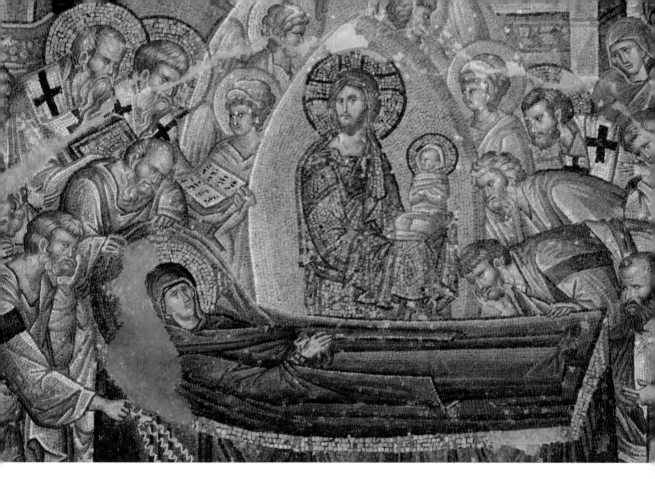

• • •

Koimesis (Dormition of the Virgin) (detail), ca. 1316–1321

Artists unknown

Mosaic

Church of St. Saviour in Chora, Istanbul

The only extant nave mosaic at the Chora depicts the Koimesis, or the "falling asleep in death," of the Virgin, a scene that began to appear in Byzantine art by the tenth century. Mary is shown on a bier surrounded by angels, the apostles, and three bishops, who wear the *omophorion,* or mantles adorned with large crosses. Just as the Virgin bore the infant Christ, she now is carried to heaven by Christ, who holds her soul, portrayed as an infant, on his lap.

After Constantinople fell to the Ottoman Turks in 1453, the Chora was all but forgotten. The mosaics and frescoes were whitewashed or covered over and, effectively hidden, avoided the mutilation of explicitly Christian subjects by Muslim conquerors. American archaeologists Thomas Whittemore and Paul Underwood, under the auspices of the Byzantine Institute, undertook an extensive preservation program between 1948 and 1958.

art of weaving, referring to the "critical time" when the weaver draws the yarn through the gap that momentarily opens in the warp of the cloth being woven. Putting the two meanings together, one can understand *kairos* as the passing instant of a human life, in which an opening—the reception to the divine—occurs. Within the arenas of the past, represented by scenes from the Old and New Testaments, and the future, suggested by the apocalyptic Last Judgment scene in the funerary chapel, the viewer becomes the hinge—the present moment—and moves through the spaces, guided by the narratives, gestures of the figures, and multivalent connections between individual scenes.

If I had a wish for you, Reader, it would be to spend time alone in a church you love. Having obtained permission to enter the Chora on a day when it was closed, I went with my camera and tripod, hoping to capture some of Byzantium's mystery. Being alone in the deep quiet provided a profound sense of the church's intricacy and elusive nature. After a few hours photographing, however, my head was spinning and, fainting, I fell to the floor. In retrospect, my physical distress was not caused by the difficulty of photographing the church's tightly choreographed spaces. Nor was it solely the result of being visually overwhelmed. It was the visceral experience of the impact of the church's combined spatial, visual, historical, and theological programs. My stark and astonished encounter with *it* resists theorization. More than a series of single notes, the Chora is a polyphonic composition that juxtaposes powerful but conflicting intentions: stability, absolutism of faith, and wholeness against asymmetry, the incompleteness of earthly life relative to eternal life, and our human aspiration to salvific wholeness. It literally brought me to my knees.

After experiencing the Chora's kaleidoscopic complexity, I thought about Wallace Stevens's "Thirteen Ways of Looking at a Blackbird." His classic poem presents thirteen glimpses of the elusive bird, using images that appear to have the randomness of snapshots but that, taken together, fuse to form a portrait that is truer than any one angle could reveal. The Chora invites Stevens's way of looking. Seeing its mosaic art involves looking up, a literal

and metaphoric turning to higher things. When one gazes upward, the divisions between the distant bits of stone disappear, fusing the whole, dissolving divisions, and welcoming harmony. A greater Order is implied by the arrangement of things equal and unequal in patterns that assign to each their proper position in the larger scheme. The like and the unlike come together and allow us to ex-perience ourselves as singular individuals, while affirming our place in the larger cosmic scheme.

Rejoice, O seer of the ineffable Will.
Rejoice, O surety of those praying in silence.
Rejoice, you the Preface of Christ's miracles.
Rejoice, you the Pinnacle of God's commandments.
Rejoice, O heavenly Ladder, by which God descended.
Rejoice, O Bridge leading those from earth to Heaven.
Rejoice, O Miracle, much marveled of Angels.
Rejoice, O trauma, much dirged of demons.
Rejoice, you who ineffably gave birth to the Light.
Rejoice, you who revealed the mystery to none.
Rejoice, O knowledge superseding the wise.
Rejoice, You who enlightens the minds of the faithful.
Rejoice, O Bride Ever-Virgin.

—Excerpt from the *Akathistos,* ca. 626

The Color Blue

ONLY RELUCTANTLY DOES the earth yield blue, the color that has become indelibly associated with Mary. Blue, specifically ultramarine blue, was most frequently used in her depictions not because it echoed the overarching sky that covers the earth as a metaphoric Marian mantle, as might be supposed, but simply because ultramarine blue was the most costly of pigments, once made from lapis lazuli, a semiprecious stone. To honor Mary, Renaissance artists and their patrons opted for the most expensive paint. Until recently, the privilege of surrounding oneself with blue was reserved for the wealthy. For those from the lower rungs, the color blue was only visible in the sky or the sea. The poor of Nazareth, where Mary is said to have been born and where she raised her son, had only the sky, being inland and far from the diamonded waters of the Mediterranean.

Mary's most authentic color is not blue—not even close. Her world was full of the whites, blacks, and browns of garments woven from rough linen cloth; they were brightened by those colors that could be made from madder juice, which produces red, and kaolin clay, which makes yellow. It was the color of the parched Palestinian landscape, a geologic bed of Jerusalem limestone, a white stone that is veined like a map with spidery coral-red lines. The ruler of the time, Herod the Great, who had a genius for both cruelty and architecture, used this stone in his massive building campaigns; Israeli builders, by law, still use it today. If Mary is pale stone, then she must also be desert. If she is desert, then she must also be oasis, those green respites that magically emerge from Israel's unforgiving sands. And if she is stone, desert, and oasis, then she must also be water, because those phenomena, like everything on earth, are born from water.

The blue color is everlastingly appointed by the Deity to be a source of delight.

—JOHN RUSKIN, *The True and the Beautiful*, 1859

• • •

Basket of yarn
Nazareth Village, Nazareth

A basket of yarn, colored with dried onion skins, pomegranates, and saffron, show the colors that would have been available to Mary and her kin during the first century. The yarns were made at Nazareth Village in modern-day Nazareth. The historic reconstruction re-creates a small Jewish village of approximately 500 to 1,000 inhabitants who farmed grapes and olives. Visitors can gain some sense of everyday life at the time when Jesus lived by strolling through the village's stone buildings, including homes, a synagogue, and a carpentry shop, all set within an excavated terraced site. Costumed interpreters demonstrate agrarian and domestic activities, such as winemaking, olive pressing, and weaving.

The village was created in 1996, after the discovery of an ancient winepress less than a mile from the site of ancient Nazareth. Lead archaeologist Stephen Pfann, president of the University of the Holy Land, and other distinguished archaeologists and architectural reconstructionists excavated the remains of a terrace farm, a site that was subsequently reconstructed in meticulous detail as Nazareth Village. Using primary literary and archaeological sources, as well as secondary ethnographic and anthropological studies, the team labored for nearly two decades to provide a scholarly foundation for a typical Galilean village that would allow contemporary visitors to more fully imagine the birthplace of early Christianity.

On Beauty

THE BEAUTY OF the world, as Simone Weil memorably observed, is a way for God to penetrate us. Our souls, opened and transformed by beauty, are able to witness ever greater and nuanced expressions of beauty, and by loving the world's beauty, we imitate the divine love that created the world. Mary's physical and spiritual beauty mirrors the abstract concept of beauty, both its contemplation and creation, which can incite us to tangible acts of goodness, justice, and love.

Understanding beauty as an attribute of faith and ethical living has long fallen out of favor. Suppressed for much of Christian history as a suspect accomplice to the sinful pleasures of the flesh, the worship of false idols, and the enjoyment of present earthly life in disregard of the future joys of heaven, beauty has been made the beast. The inwardness demanded by the experience of the transcendent, the triumph of spirit over matter, suggests that the intangible spiritual dimension not only takes precedence over the physical, sensible expression of the sacred but needs to preserve its distance from it. When God took bodily form, however, the gap between spirit and body closed, allowing the transcendent into the realm of the visible. Redemption takes place in the world, and that means the physical world—whether a cathedral, song, or spider's web—is always a part of it. Because all of creation is a resplendent, experiential, and embodied sign of the Creator, beauty can be suppressed but never eliminated—it is a fundamental characteristic of faith.

Beauty is not simply a value-added extra to life; on the contrary, human beings are made for beauty, as they are for goodness and truth. The idea that beauty is a visible form of the good, just as the good is the metaphysical condition of beauty, was embraced by the ancient Greeks, who fused the two concepts and coined a term that embraces both: *kalokagathía,* or beauty-goodness. Plato's classic

Symposium renders beauty as "absolute, separate, simple, and ever-lasting," unlike the earth's temporal and perishing pleasures. He maps beauty's arc as a journey that ultimately leads to love and "fairness," in the sense of being both beautiful and just:

> And the true order of going, or being led by another, to the things of love, is to begin from the beauties of earth and mount upwards for the sake of that other beauty, using these as steps only, and from one going on to two, and from two to all fair forms, and from fair forms to fair practices, and from fair practices to fair notions, until from fair notions one arrives at the notion of absolute beauty, and at last knows what the essence of beauty is.

Beauty resists easy definition, because it rests on the particular as well as the elusive. Thomas Aquinas provides a start. He characterized beauty as having three essential qualities: integrity, or the state of being whole, perfect, and complete; proportion, referring to the arrangement of individual parts as well as the relationship between them; and clarity, or the outpouring of transcendent qualities in a way that makes the essence of an invisible thing visible, or "utterly visible," as the poet Seamus Heaney expressed it in *Seeing Things*.

Beauty, for all its mystery, is not abstract; it attaches to the specific and the comprehensible, whether faces, flowers, hymns, or paintings. Paradoxically, beauty is sourced in each individual in a unique way: Beauty is truly in the eye of the beholder, because its perception, its very life, originates in the individual. It relates to sensory perception: We call something beautiful because it delights our particular senses and mind. Beauty is not merely an attribute of the material world, however, but rather a relationship of the world to our human sensibility, which in turn relies on our senses and psychic awareness. In other words, human beings experience the epiphany of beauty in ways that are understandable and inspirational to our species. We cannot know of the beautiful universe of, say, insects or wind currents.

On the other hand, beauty creates a sense of limitlessness, in

[Beauty] dances as an uncontained splendor around the double constellation of the true and the good and their inseparable relation to one another. . . . Beauty demands for itself at least as much courage and decision as do truth and goodness, and she will not allow herself to be separated and banned from her two sisters without taking them along with herself in an act of mysterious vengeance.

—HANS URS VON BALTHASAR, *The Glory of the Lord: Seeing the Form,* trans. 1982

which measurements, whether of time, space, or physical dimensions, prove inadequate. Decidedly not an analytic exercise, the perception of beauty is marked by a "mindless" state, or the involuntary suspension of thought that characterizes the transcendent experience of extraordinary beauty. Beauty fills the viewer with a wordless certainty that is akin to truth. This willingness to let ourselves be overcome by beauty, and by the joy it releases in us, relates to the inherent human need to connect to the transcendent, even as our world is being ever more decisively defined by technology and science. Born with the fundamental need to find meaning in our brief time on earth, no matter what our religious beliefs, we recognize in beauty a way to satisfy these unfulfilled spiritual longings. Beauty inspires us, causes us to rise up above our quotidian existence and, from that higher altitude, seek to find and examine that thing we lack. In a world crammed with glitzy images and empty experiences, what most of us are missing, and what we need to complete ourselves, is a sense of the exalted. Discovering it through beauty, we can claim some portion of the eternal, the part of us that is immortal.

Just as Mary's image is continuously reinvented through cultural interpretations that bring into being that which did not previously exist or had been overlooked, a thing of beauty carries the sense that it is without precedent, conveying the "newbornness" of the world. Upon perceiving such beauty, the mind travels back in time, looking for precedents, until it reaches something that has no precedent and is immortal. From this impression of beauty as being incomparable, rare, and "other" flows the idea that it is sacred (from the Latin *sacer*, "untouchable"). As Elaine Scarry describes it in her meditation *On Beauty and Being Just*, beauty "adrenalizes. It makes the heart beat faster. It makes life more vivid, animated, living, worth living." It gives us an intensified appreciation of the beauty of what the poet Gerard Manley Hopkins called the "dearest freshness deep down things." William James claims that this love of life—the "onrush of our sanguine impulses" and "sense of the exceedingness of the possible over the real"—is, in fact, the religious impulse.

The relationship we have with beauty is reciprocal: If beauty

makes us feel more alive, it also shows us the life in an inanimate object, a perception that is bound up with the urge to protect it. Humanity has preserved ancient works of art because we believed their beauty and rarity merited such protection. Similarly, perceiving another person's inner, authentic beauty alerts us to the value of all beings and our human and moral obligation to others. Beauty inspires awareness and equality in all directions. Consider the sunset: Its egalitarian nature makes it available to all everywhere, gratuitously, and without judgment—qualities beauty shares with ethical fairness.

Beauty *is* the power of the object to draw forth a response of love. It awakens the moral response: "Beauty is necessary if we are to preserve the connection between contemplation and action, or between truth perceived and truth done." Beauty impels us to act, and, in acting, we ourselves become beautiful, or, as Augustine preached, by loving we are made beautiful. Beauty inspires us to drop our preconceived notions and egoistic needs, what many theologians and philosophers describe as "de-centering" of the self, and orient ourselves to others. This ethical self-transcendence—moving beyond oneself into empathy and concern for another's welfare—is, in fact, experienced as joy, a joy that characterizes faith. Mary's perfect reception to the Spirit required such a de-centering, a surrendering to a Will beyond her own. Similarly, our "yes" to the world, provoked by beauty, causes us to move beyond ourselves and open our eyes to still more beauty, in ourselves and in others.

Mary in the Qur'an

A bridge joins more than just two banks of a river, it connects people to each other and to their dreams.

—LINDA FIGG, I-35W Bridge designer, 2008

D AYS AFTER MY return from a 2007 trip to Jerusalem, the timeless city that is sacred to the three great Abrahamic faiths—Christianity, Judaism, and Islam—the I–35W Bridge in Minneapolis collapsed, taking thirteen souls. Soon after, I was asked to help with the new bridge that would rise in the wake of the tragedy. It had to be built quickly, with epic speed, to restore this vital link over the Mississippi River. During discussions about the design of the new crossing, it struck me that the first conversations about a bridge do not concern materials, construction methods, or budgets—at that stage, the hows are less important than the whys. The first, fundamental understanding is that a bridge is not just a crossing but a means of joining together what had previously been separate. Even a destroyed bridge recalls the two sides it once united. A bridge, therefore, must begin with its creators listening, intensely, to what people who live on both sides are really saying about their communities.

One of Mary's most profound and persistent roles has been as a bridge builder. She joins together what had once been separate, whether traditions, cultures, or peoples, with perhaps no bridge more momentous than the one stretched tenuously between Christianity and Islam. Mary, included among Islam's "four perfect women," is the only female named in the Qur'an, its central holy text. Muslims venerate Mary for her holiness and purity, and, in some schools, as a prophet. Allah, the angels said, preferred Mary *above (all) the women of creation.* (Q 3.42). There is more about Mary in the Qur'an's 114 *sura,* or chapters, than in the New Testament: thirty-four Qur'anic verses identify her specifically, and the nineteenth *sura* bears her name, variously titled in translation as Mary, Maryam, Mariam, Marium. The recitation of *Sura* 19, a piety practiced especially by Muslim women, is believed to impart blessings on both the speaker and the listener. This chapter is adapted from

the Gospel of Luke, which provides most of Mary's biographical detail, and the *Protoevangelium of James*, the most important non-canonical Marian account, which was used heavily in the Near East before and around the time that Islam emerged.

Islam is the faith of more than a fifth of the world's population. Younger than Judaism and Christianity, Islam links to both religions in the shared belief in the same God and recognizes both as valid religious traditions. It perceives itself as the completion of the line of prophecy that began with Abraham, both in its revelatory message and the person of the Prophet Muhammad. The sect that eventually came into being was called *Islam* (surrender), while a *Muslim* was a man or woman who had submitted their lives entirely to Allah (the word simply means "God"). For Muslims, praying prostrate toward Mecca five times daily is a means of putting aside pride and serves as an embodied reminder that before God we are nothing. Giving alms and fasting, as Karen Armstrong notes in *Islam: A Short History*, are reminders of the privations of the poor and underscore the key Islamic virtues of social justice and practical compassion.

Complex, poetic, often misunderstood, the Qur'an is one of the most influential works of prophetic literature. For Muslims, it is the infallible Word of God as it was revealed to Muhammad in a series of revelations beginning in 610—while he was on retreat near Mecca, in what is today Saudi Arabia—until his death in 632. It includes numerous references to Judaism and Christianity, according Christians and Jews special status as the "people of the Book" in recognition of both the Torah and the New Testament, although some Qur'anic verses suggest that these scriptural works, in the Muslim perspective, are "distorted."

Mary makes her appearance in the third *sura* while still in the womb. Her mother, thinking she was a boy, dedicated her to Allah, who accepted her and *made her grow in purity and beauty* (Q 3.37). Orphaned at an early age, Mary was entrusted to the care of Zechariah. Whenever Zechariah entered the temple, he noticed that Mary had food. When he asked her how she managed to have plenty to eat at all times, Mary, with the good cheer of those who believe, replied, *It is from Allah. Surely Allah gives to whom He pleases*

Mary saves us from denying the kinship among Judaism, Christianity, and Islam: All three live in her spiritual presence.

—CHARLENE SPRETNAK, *Missing Mary*, 2004

without measure (Q 3.37). This verse is almost always written in a mosque's *mihrab*, or prayer niche, when it is decorated with calligraphy.

The Annunciation is narrated at length. When Mary asks, *How shall I have a son, seeing that no man has touched me, and I am not unchaste?* (Q 19.20), the Lord replies, *It is easy for me*, and says her son will be *a revelation for mankind* (Q 19.21). By classical and modern Islamic consensus, Mary was a virgin when she conceived from God's spirit. Withdrawing to a remote place, Mary labors under a date tree, wishing she had died before any of this happened. To ease her agony, God provides her with fresh dates and clear water; this is the only part of the conception and delivery story that has no known Christian origin. When she gives birth to Jesus, he is described as the "son of Mary," because Muslims do not recognize Jesus as the Son of God, although he is venerated as a prophet. The infant Jesus, still in the cradle, nonetheless speaks, describing himself as a *servant of Allah who has made me a prophet* (Q 19.30), and says of his destiny that *peace [is] on me on the day I was born, and on the day I die, and on the day I am raised to life* (Q 19.33).

Saint Mary (2007), an Iranian film about the life of Mary, illustrates the rich Judeo–Christian ground that was already in place when Muhammad received his revelation. Available for viewing online, it is a straightforward re-creation told in Farsi with English subtitles; however, it provides a view of Mary in a context that is not readily available to Westerners. Watching the movie, what becomes clear are the inextricable links among Judaism, Christianity, and Islam, the monotheist religious traditions born in the Middle East. Christianity arose from Judaism, and Islam from them. By the time the Qur'an was received, more than five hundred years of post–New Testament theology had been formulated during five ecumenical councils, in which Mary figured prominently because the relationship of the divine and human natures in Christ's one person was the burden of so much of the doctrine. Consequently, for Christian orthodoxy, and in an antithetical way for Muslim orthodoxy as well, the key to understanding Jesus was through Mary, his mother.

In a 1952 essay, Archbishop Fulton Sheen opined that Mary

chose to appear in the sleepy backwater of Fatima, Portugal, in 1917 as a "pledge and sign of hope to the Moslem people." Despite the evangelical nature of Sheen's opinion at the time it was made, the idea of reconciliation through Mary is worth considering anew. Muhammad, who had tirelessly warned Muslims not to deify him, embodied his faith, virtue, and surrender to God so wholeheart‐ edly that he forged in his own person a living link between heaven and earth. Like Mary, his will was only to do God's will. At a time when the need to reconcile differing cultural traditions has never been more urgent, there has probably been no symbol or concept in Christendom that can mediate and build bridges with more suc‐ cess and amplitude than Mary.

When a cast concrete bridge is being constructed, sections that have been previously cast are hoisted into place, one at a time, reaching out from each bank and eventually meeting in the mid‐ dle. The final section that seals the gap between the bridge's two arms, however, is unique. It is not manufactured on land, not made on either side of the divide. Instead, in midair, high above the earth, new concrete is poured in place, finally joining the two arms of the bridge. That near miraculous moment of union, accompa‐ nied by the raucous joy of the construction workers, has the sa‐ credness of a sacrament.

Trees of Life

THE RELATIONSHIP OF the Virgin Mary and Christ to their Old Testament forebears gained its most potent visual symbol—a branching tree—in the early twelfth century. Known as a Tree of Jesse, the symbol visually represents Christ's royal lineage as a stylized tree or vine that typically grows from the reclining figure of Jesse, the father of King David. From Jesse branch the names or images of Old Testament figures, culminating in the Virgin, from whose body Christ blossomed. The medieval religious imagination, grounded in the natural world as a matter of survival, adopted the image of a tree as a means of mapping relationships between people and expressing them chronologically.

Also known as the Jesse Tree, Stirps Jesse, and Stem of Jesse, the symbol was inspired by Isaiah's prophetic vision of a growing tree: *A shoot shall come out from the stump of Jesse, and a branch shall grow out of his roots* (Isa. 11:1). This prophecy, understood as a foretelling of Christ's birth, would become intertwined with the lineage of the Holy Family in interpretations by early Christian theologians such as Tertullian, who wrote "the root of Jesse is the house of David, and the stem from the root is Mary." In 443, Pope Leo the Great gave a Christmas sermon that described Mary as the rod foreseen by Isaiah, which would bring forth Christ, the "new flower of human flesh." By the Carolingian period, the gospel reading for the Feast of Mary's Nativity (September 8) was changed from an account of the Visitation to Matthew's account of Christ's genealogy; the epistle reading was Ecclus. 24:16–22, which describes the flowering vine of wisdom: *I spread out my branches, and my branches are glorious and graceful. Like the vine I bud forth delights*—thus creating a Marian context for the lineage and tree imagery that would be later mined by Jesse Tree designers.

Mary's story unfolds in the context of Christ's genealogy, provided in the Gospels of Matthew and Luke, which would become

increasingly important as early Christians sought to establish an identity. Christ's ancestry spans forty-two generations of patriarchs, kings, and unknown personages who trace back to Abraham and end with Joseph, husband of Mary. Through its choice of female ancestors, Matthew's genealogy sets the stage for the Annunciation and Mary's unconventional marriage to Joseph. To branch out a bit from the trunk of this story, there are four Old Testament women who merit inclusion in the Matthean lineage, but three of them—Tamar, Rahab, Ruth—are not Israelites, and the fourth, Bathsheba, is the wife of Uriah and not a Jew. Biblical scholar Raymond Brown suggests their mention was a means of making the Gospel message inclusive of non-Jewish audiences, who were ripe for conversion. All four women have "irregular" unions with their spouses, which they enter into as willing instruments of divine providence. Thus is created acceptance for the circumstances of Mary's extraordinary conception, which is reflected as well in the passage's long line of "begots" that suddenly break at the end of the genealogy: not "Joseph begot Jesus" but "of Mary was Jesus begotten." An alternative reading suggests that what makes Matthew's genealogy unusual is that the named women are not Old Testament exemplars, such as Sarah and Rebecca, but are instead prostitutes (Tamar and Rahab), an elderly widow (Ruth), and an adulteress (Bathsheba)—women who, like Mary, threatened the status quo.

The tree became an immensely popular ecclesiastical motif after it was monumentally depicted in the stained-glass window at France's Basilica of St.-Denis (1137–1144). Soon, tree designs proliferated in stained glass, altarpieces, and other sculpted elements of church architecture, as well as in manuscript illuminations, candlesticks, and embroideries. Historian Sara Ritchey coined the term "spiritual arborescence" to describe how trees operated symbolically in the medieval Christian imagination, deepening their sense of being part of a whole, each one a branch in which individual and community, incarnation and transcendence, were inseparable.

A sign of perpetual renewal, the tree is a metaphoric icon of rebirth and resurrection in every religion in the world, a symbolism that was easily grafted onto Christian theologies of sacrifice and immortality. Consequently, the Jesse Tree also brought about new

· · ·

Jakobs Traum (Jacob's Dream), 2008
Anselm Kiefer
Oil, emulsion, acrylic, resin-coated ferns, clothes, wire, sand, ashes, clay
on cardboard on plywood under glass
75×56" (191×141 cm)
Private collection

Jacob's dream of a ladder stretched between earth and heaven, with angels ascending and descending it, became a metaphor for Mary, the ladder by which humanity could attain heaven. Mary is described as the "heavenward ladder by which God came down" in the Byzantine Akathistos hymn, and the Old Testament account of Jacob's vision is a standard reading on feast days of the Theotokos.

In this painting, the artist Anselm Kiefer uses unconventional, densely layered materials to suggest the processes of birth, death, and rebirth, and the possibility of transformation. A blood-red ladder, its color an allusion to Christ's Passion, rises tenuously from a primordial earthly landscape. The fluttering dresses of varying sizes that hang from the ladder are actual dresses and act as stand-ins for both Jacob's angels and the Virgin Mary, their mottled fabrics creating a sense of woundedness and suggesting the passage of time. The ideas of fragility, strength, and time are also emphasized by the delicate ferns, one of the most ancient life forms, which, like fossils, are encased in resin.

Nature and the weight of the past are central themes of this celebrated artist's work, in which layers of meaning culled from ancient Jewish, Christian, and contemporary German history accumulate like the strata of leaves on a forest's floor. *Jakobs Traum* was one of thirty works inspired by Marian history and doctrine included in a 2008 exhibition at the Galerie Thaddaeus Ropac, entitled *Maria Durch ein Dornwald Ging* ("Maria Walks Amid the Thorn"). Its name is taken from a popular German Christmas carol.

understandings of earlier biblical trees, most notably the fatal Tree of Knowledge in the Garden of Eden, which in turn was connected to the wood of the cross on which Christ died to redeem humanity's fall. The tree image partook as well of primeval, archetypal images of the *axis mundi* (literally, the world axis, but also the cosmic axis, World Tree, Tree of Life, Yggdrasil, etc.), which refers to the vertical line—of connection and communication with the divine—that exists between heaven and earth. Societally, the Jesse Tree influenced how Europeans understood themselves, with royals adapting the branching-tree motif to organize and tout their genealogies; that influence comes down to us today as the family tree.

Mary's equation with Jesse Trees, as well as with flowers and fruits, suggests ways of building ecumenical bridges and fostering greater stewardship of the environment. One inspired example of how contemporary ecological concerns can be connected with ancient arboreal symbols is provided by the Jewish holiday of Tu B'Shvat. Historically, Tu B'Shvat marked the "new year for trees" that was once used to calculate a tree's age and to levy taxes on its fruit. At the beginning of the twentieth century, secular Israelis adapted the traditional observance into a Festival of Trees. The celebration was marked by tree planting, a ritual intended to underscore the new nation's historic legitimacy and to restore Israel to its former glory as the biblical land of milk and honey. The Tu B'Shvat seder, a festive repast of many different types of fruits accompanied by songs, which was based on mystical Kabalistic symbolism, was resurrected in the late 1960s and mirrored the "get back to the garden" sensibility of the nascent earth movement.

A few years ago, I took part in a memorable Tu B'Shvat seder at the home of my friend Julie, who is part of a group that has been celebrating Shabbat services in their homes for nearly three decades. These home services, called *chavurah* and presided over by a rabbi, provide an alternative way of worshipping outside the synagogue setting and recall the early Christians, who worshipped in private homes, a practice that is also being resurrected. The Tu B'Shvat celebration was simply wonderful. About thirty of us sat in a large and unruly circle, as various fruits, nuts, and wines were

blessed and passed out. We sang a lot and talked about the beauty of nature. The children were asked what could be done to stop global warming, and, fortunately, they had plenty of ideas. We said a prayer by Rabbi Nachman of Bratslav: *Creator of the Universe, grant me the ability to be alone; May it be my custom to go outdoors each day among the trees and grass, among all growing things, and there may I be alone, and enter into prayer, to talk with the One to whom I belong.*

That seder evoked Judaism's many prayerful, potent references to nature and suggests ways that Christians can take a prayerful role in environmental stewardship. Now is the time to create Marian devotional prayers and liturgies that would incorporate her nurturing compassion and multiple associations with the natural world as a means of inspiring ethical action in the face of escalating environmental loss. More than an imaginative historical illustration, the Tree of Jesse is a visual recapitulation of Mary and Christ's lineage, one that shows us ways of opening up to Mary's presence in our lives. By emphasizing the interdependence of all living things, it instills both the humility of the leaf and abundant confidence in the possibility of spiritual growth. Through its branches, leaves, and crowning flower, the Jesse Tree teaches how grace can be accessed communally and individually, as expressed in both the forest and the individual tree.

• • •

Madonna and Child with the Birth of the Virgin (Tondo Bartolini), ca. 1452
Fra Filippo Lippi (ca. 1406–1469)
Oil on panel
Diameter 53″ (135 cm)
Galleria Palatina, Palazzo Pitti, Florence

This type of painting is known as a tondo, an Italian word derived from the Latin *rotundus,* which here delineates an object of art, often a painting, in a circular form. Frequently of a religious nature, tondi were often placed in private homes to be used as devotional images. Lippi's is the first one of Mary painted in tondo form in Florentine art. The focus on Mary is not unexpected, as the artist was ordained in 1421 into the Carmelite order, which has a long history of Marian devotion.

The painting has a threefold composition: In the far background we see the promise of Mary's arrival, in the middle her birth, and in the foreground her destiny fulfilled, as she presents her son to the world. The Virgin sits at the center of the frame and looks directly at the viewer. On her lap, the baby Jesus looks up at his mother as he makes a gesture of blessing. The two curious scenes unfolding in the background establish a visual genealogy of Mary's parents and conception and, by extension, all of Jesus's earthly ancestors. On the right and in the far background, Mary's father, Joachim, is greeted at the door by Anne, Mary's mother. This scene, taken from one of the apocryphal gospels, depicts Joachim returning home after forty days spent fasting in the desert and pleading with God to cure his wife's barrenness. He and Anne had both received angelic visions on the same night, promising that a child would soon be born, and the next day Joachim returned home. Closer to the viewer, Anne sits in a bed surrounded by attendants as she strokes the face of the infant Mary. The rich interiors, with an elaborate tile floor and coffered ceiling, combined with the sheer number of attendants—seven—reinforce the material wealth of Mary's parents.

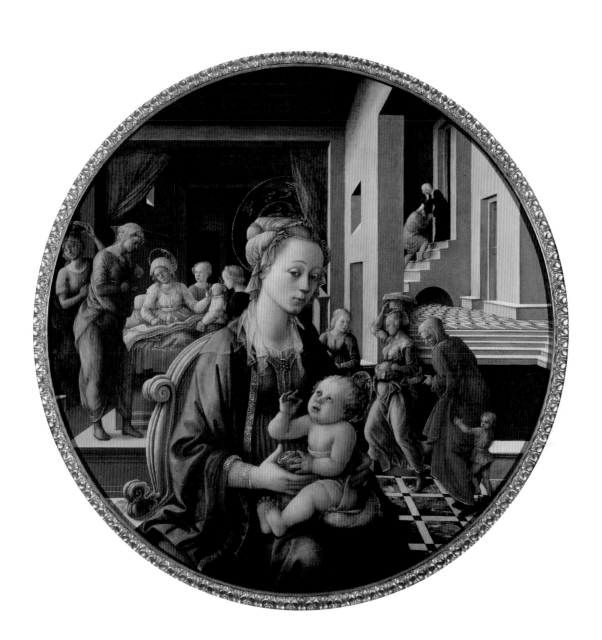

Her Immaculate Conception

ALTHOUGH THE CANONICAL, or universally accepted, gospels say nothing about the circumstances of Mary's birth, it was understood from early on that as Christ's mother she was uniquely and eminently holy, and therefore her conception had to differ from that of other human beings. As descendants of Adam and Eve—who received the fullness of holiness from God but lost it, for themselves and for us, by committing the first sin—all human beings inherit the stain of "original sin," or the deprivation of God's grace, which was restored by Christ's death. The doctrine of the Immaculate Conception, the culmination of centuries of theological debate, decrees that Mary was born without original sin and was redeemed from the first instant of her conception.

Central to the issue of Mary's conception and the controversy that attended it was one of redemption. If humanity's sin was redeemed through Christ's death, how could Mary, born earlier, be without sin? Those who objected to the idea that Mary was conceived without sin included the saints Bernard of Clairvaux (ca. 1090–1153) and Thomas Aquinas (ca. 1225–1274). Bernard had no doubt that Mary was holy before she was born and received an extra dose of grace, but he thought that she, like others, was redeemed through the divine gift of sanctification. Aquinas, too, believed that Mary, conceived as all others, inherited original sin and also suggested that if she lacked original sin she would not need Christ's redemption. Two generations later, the Franciscan friar Duns Scotus (ca. 1266–1308), who along with Aquinas is considered one of the great medieval theologians, provided a defense of Mary's Immaculate Conception that would support the dogma's development. As Scotus saw it, Mary needed redemption but required a different form of Christ's mediating grace. She was exempt from original sin by virtue of her sanctifying grace, through which she received Christ's *retroactive* redemption.

The acclamation of Mary as the New Eve and New Ark of the Covenant, and the archangel Gabriel's proclamation that she is "full of grace," are rooted in the time of the apostles and teachings of the early Church fathers. The *Protoevangelium of James* emphasizes Mary's sacred purity from the moment she suckled on her mother Anna's breast to her entrance, at the age of three, into the temple, where she was "nurtured like a dove and received food from the hand of an angel." The seventh-century theologian John of Damascus also defended Mary's absolute purity, albeit based on the virginal birth of Christ. Mary's sinless conception was celebrated in the East by the eighth century, in Ireland by the ninth, and, increasingly, elsewhere in the tenth and eleventh centuries. In the twelfth century, the English monk Eadmer of Canterbury outlined the necessity of Mary's conception without sin in his *De conceptione sanctae Mariae*, and the feast of her conception, already celebrated in the monasteries, was incorporated into the English liturgical calendar in 1139 with papal approval. St. Francis of Assisi (1182–1226) was profoundly devoted to Mary, the patroness of the order he founded. He espoused the Immaculate Conception centuries before it was declared dogma, and the peripatetic Franciscans would spread that truth around the world. The first papal statement on the Immaculate Conception was made by Sixtus IV (r. 1471–1484), who is perhaps best remembered for commissioning his eponymous masterpiece, the Sistine Chapel, which is dedicated to the Immaculate Conception. In two Apostolic Constitutions of 1482 and 1483, both titled *Grave nimis*, Sixtus deemed belief in the Immaculate Conception "acceptable," although it was not yet presented as a dogma of faith.

Encouraged to define "an honor which the widespread piety of the Christian people so fervently desires to have accorded to the Most Holy Virgin," Pius IX delivered the 1849 encyclical *Ubi Primum*, advising Catholic clergy that a committee had been convened to examine the efficacy of declaring the Immaculate Conception doctrine and asking them to communicate their own views and those of their congregations in this regard to the Apostolic See. Mary's Immaculate Conception seemed to be a fait accompli in the minds of the ordinary faithful of the nineteenth century, when her pres-

[Mary's] purity, praised in the most glowing terms in the East, especially in Syria, finally raises the question of her exemption from original sin, which is stated with increasing clarity from the end of the seventh century.

—Hilda Graef, *Mary: A History of Doctrine and Devotion*, 1963

ence began to make itself known emphatically through apparitions. The Medal of the Immaculate Conception, struck in 1832, was credited with so many miracles that it became known as the "Miraculous Medal," and was then, as now, in widespread currency. When Mary appeared in Lourdes, France, in 1858, four years after the doctrinal decree, she identified herself as "the Immaculate Conception" and set aflame a devotion that has yet to subside. The Catholic Church proclaimed Mary patroness of the United States in 1846 under the title of the Immaculate Conception. Today, the Feast of the Immaculate Conception is a Catholic holy day of obligation, observed on December 8.

Pope Pius IX confessed the dogma of the Immaculate Conception in the 1854 papal constitution *Ineffabilis Deus*:

> The most Blessed Virgin Mary, in the first instance of her conception, by a singular grace and privilege granted by Almighty God, in view of the merits of Jesus Christ, the Savior of the human race, was preserved free from all stain of original sin . . .

Through the "splendor of an entirely unique holiness," Mary was "redeemed, in a more exalted fashion, by reason of the merits of her Son," and remained free of all sin, whether original sin or other sins, throughout her life. The doctrine of Mary's Assumption, coming almost a century later in 1950, cannot be considered apart from her Immaculate Conception: She was assumed bodily into heaven because, immaculately conceived, she was without sin and not susceptible to bodily corruption. Describing Mary's grace-filled life from its first instant, the theologian Karl Rahner observes that we, too, are implied in the doctrine. The Immaculate Conception shows that the "beginning of each spiritual being is important, and is laid down by God. God gives the beginning . . . in which the whole is already contained, despite all the freedom and individual responsibility and creativity of humans, despite all that is unexpected and surprising."

And what if a soul
fall into a body . . .

And if it gaze into pure
 light . . .
And if something grow into
 life . . .

As the spider spins its web
she spins him of herself,

AND LEAVES A MEMORY

life-bestower, nurturer,

agent of futurity

 oh, woven child
you must not unravel

she webs and warps
with finest, strongest yarn

—ANNA RABINOWITZ,
from "The Woven Child,"
2006

The Virgin of Chartres

I N PART INSPIRED by the writings of monastic theologians such as Bernard of Clairvaux, the cult of the Virgin grew exponentially in Western Europe during the twelfth and thirteenth centuries. Mary was *the* saint among saints, divine mediator, and, importantly, "blessed among women," at a time when few of her sex were exalted. Mary was worshipped as the Bride of Christ, personification of the Church, Queen of Heaven, and intercessor for the salvation of humankind—veneration that found its most splendid expression in French cathedrals. Chartres Cathedral, the most complete and glorious example of this Gothic art, redirected the course of architecture not merely because of its innovative physical form but by virtue of its spiritual authority: It was built when people still believed in miracles.

Chartres's aura emanates from Notre-Dame, the Virgin Mary, to whom it is dedicated. The *sancta camisia*, a silk tunic that legend holds Mary wore either on the day of the Annunciation or the night of the Nativity, was brought from Constantinople by Charles the Bald, Charlemagne's son, and given to the church in 876. It was not the only such Marian relic—similar vestiges of Mary's holiness, including her clothing, hair, nail parings, and wedding ring, flooded medieval treasuries and were zealously guarded at other sites in Europe. Because Mary's particular bodily and spiritual integrity made her the supreme medium of human healing, curing the supplicant with one touch of her relic, the prestigious tunic at Chartres inspired pilgrims by the tens of thousands to visit the town, increasing its prosperity and fame as a religious center. Also fanning the power and endurance of Mary's cult at Chartres were the devoted efforts of its bishop, Fulbert of Chartres (ca. 952–1028/1029), who uncovered, reworked, and expanded traditional Marian materials in his sermons and litanies of praise, keeping her alive and essential in the hearts of the pious. Most

influential was his Tree of Jesse responsorial, which provided Mary with genealogical credentials based on the prophecies of Isaiah in lovely, evocative language that quickly spread throughout Europe.

Built on the highest point in a small town southwest of Paris, the cathedral emerges from the encircling yellow wheat fields, over and above everything that surrounds it, both visible to and appearing to watch those approaching from miles away. Its spire, 345 feet (105.2 meters) high, is the equivalent of a thirty-story skyscraper, a feat barely comprehensible given the medieval builders' rudimentary tools—straightedge, compass, and string. Raised by the efforts of nine successive and unnamed master masons, it is a radical, innovative structure connected to both earth and wind. Malcolm Miller, the cathedral's legendary tour guide, attributes its architectural, structural, and iconographic unity to the remarkable speed—less than thirty years—with which most of Chartres was reconstructed after catastrophe struck.

When a fire in 1194 destroyed most of the church and much of the town, the townspeople were most distraught over the loss of the Virgin's silk tunic. When it was learned that the reliquary holding the robe had been removed to a lower crypt and saved from the fire, the villagers wept for joy at Mary's miraculous intercession and immediately set to rebuilding her church. Praying, chanting, and celebrating, people came from great distances, dragging carts loaded with stones and other materials for the new cathedral.

The reconstruction retained the original architectural elements that were spared by the fire: the three monumental carved doors of the west façade, which is called the Royal Portal (ca. 1145), and the two towers. With the exception of the elevation and the very wide transept, the dimensions of the new church were determined by the foundations of the crypt of the earlier church, which itself stood on the ruins of older churches. Most of the construction was completed by 1220. The transept and apse had yet to be finished, but this was not an unusual state of affairs: In many cathedrals, which typically took many lifetimes to complete, Mass was said accompanied by the thud and squeal of construction taking place nearby. By the time Chartres was dedicated in 1260, most of the sculpture and glazing had been completed.

• • •

Chartres Cathedral, ca. 1194–1260
North Porch, Central Portal
Builders unknown
Limestone
Chartres, France

The tympanum of Chartres's north portal depicts the coronation of the Virgin. Mary, bowing, lifts her hands toward Christ, who holds a book and raises his hand in blessing. Angels surround them; the two above swing censers. Beneath the tympanum, the left lintel shows Mary on her deathbed, arms folded across her chest, surrounded by the apostles. Christ, indicated by the halo, holds Mary's soul, depicted as a child, on his left arm. In the right lintel, angels gather up the folds of Mary's burial shroud, ready to assume her into heaven. The innermost archivolts are carved with angels, while the second and fifth archivolts depict Old Testament prophets, many holding scrolls. The figures wreathed in foliage in the third and fourth archivolts are Christ's royal ancestors, as recalled by the Jesse Tree.

As marvelous as it appears today, modern eyes and hearts can-
not fully appreciate Chartres. Though its sheer physical immensity
continues to provoke awe, can we possibly imagine the response of
the peasant who lived in a hut without windows and, having trav-
eled by foot for days or weeks, at last encountered its extraordinary
windows or sculpted art? As the esthete Henry Adams marveled,
seeing it for the first time in 1898, even the palaces of earthly
queens seem like hovels when compared to the palace of the
Queen of Heaven at Chartres—or Paris, Laon, Reims, Amiens, or
Rouen, to name just a handful of the many Marian edifices in
France.

Entering the cathedral, visitors are first confronted with its
immense piers and bases, which dwarf human dimensions. This
immediate, physical confrontation with the building at the ground
level maximizes the otherworldly impression created by the
vaulted ceilings and stained glass overhead. Standing at the point
of the transept crossing, one can see all three great rose windows at
once. Located over the west, south, and north portals, the rose win-
dows depict, respectively, Christ's second coming; Mary enthroned
with her son; and Mary as the instrument of God. They seem to
float in the black space surrounding them, spinning like cosmic
orbs, and place the viewer squarely at the center of the universe.
Echoing this notion of a cosmic spiritual quest is the labyrinth in-
laid in the nave floor, on an axis with and having the same dimen-
sions as the western rose window. The labyrinth is shaped like a
giant rose, Mary's flower, and is just one of many in the veritable
bouquet of roses carved into Chartres. People traverse its concen-
tric path as a meditative practice, following it to the six-petaled
center and out again.

The external structure is revolutionary. "To want a Gothic
church without flying buttresses," said E. E. Viollet-le-Duc, the great
nineteenth-century architectural theorist and Chartres's structural
apologist, "is to want a boat without a rudder." Without the flying
buttresses, massive external arches springing from even more-
ponderous lower buttresses, Chartres's interior spatiality and up-
ward structural leap would not have been physically possible. The
buttresses permitted the structural shell to be pierced with vast ex-

panses of glass that allowed in light and expanded its metaphoric possibilities, as initiated earlier by Abbot Suger (ca. 1081–1151) at St.-Denis, the French abbey where the history of Gothic stained glass began. The goal was to let in as much divine light as possible. It is this light, as gold as autumnal sunbeams, that bathes Chartres's stones and softens the hearts of those who touch them.

Chartres also represents the apogee of the art of stained glass. Its large stained-glass windows give the interior its overall impression of weightlessness; the window, now liberated from the wall, became a structural force in its own right. Astonishingly, the original glass—the most fragile part of a cathedral, after the roof—has been retained nearly intact. Forty-four window groupings, delirious with color, depict a vast array of Old and New Testament scenes, particularly the lives of Mary and Jesus. The window of Notre-Dame de la Belle Verrière in the south choir and the three windows over the west portal date from the twelfth century. Medievals had a metaphysical understanding of the light pouring through stained glass that eludes contemporary grasp. For them, the shimmering colored light was not merely beautiful, although it is, nor a structural accomplishment, although it is that too. The light was an analogy for the Incarnation, when the "light of the world" was conceived. Light, like Christ, was understood as the medium that unifies all things, fulfilling that longing for ultimate unity and reconciling the multiple into the one, which was the essence of their experience of beauty, as it is of faith.

The cathedral's abundant statuary and reliefs show a progression from the robust but static forms of earlier Romanesque sculpture to the tender, subtly balanced idealism and realism of the Gothic. The technical and artistic mastery of the many sculptors who worked there served a complex iconographic program, the purpose of which was to teach as well as preach. This was accomplished by the provision of several hundred carved figures culled from scriptural sources, which look as though they are capable of stepping down and conversing with the viewer. Throughout the cathedral, there is evidence of the period's nascent humanism that Chartrain artists expressed by closely observing life. Human figures are animated and emotive, with differentiated facial expressions,

Symbol or energy, the Virgin had acted as the greatest force the Western world ever felt, and had drawn man's activities to herself more strongly than any other power, natural or supernatural, had ever done; the historian's business was to follow the track of the energy, to find where it came from and where it went to; its complex source and sifting channels; its values, equivalents, conversions.

—Henry Adams,
*The Education of
Henry Adams,* 1906

hairstyles, and poses. Carved hands and feet are softly rounded and they gesture as they might in real life. A variety of workers are pictured—from fiddlers to butchers—as are pigs, donkeys, and dogs, each delineated with great inventiveness and many with considerable humor.

The realism of the art mirrored life at the time. Most were rural farmers who, steeling themselves against the ever-present threat of famine and natural disaster, believed in relics and were also known to invoke fertility goddesses to assure the fruitfulness of their fields. Peasant folklore and practices intermingled images of Mary and the mother goddess, seeing in them both the qualities of mercy that were embedded in earlier polytheistic cultures.

The multitude of the faithful at Chartres, joined by nearly ten thousand carved and glazed saints who seem like family by virtue of their familiar features, gather in the nave in the darkness of the mythic forest created by the upwardly reaching piers. Above them all, filtered through immense fields of brilliant stained glass, is Mary, who, through and with her son, reflects the presence of God.

Mother as Creator, Creator as Mother

IN THE OPENING centuries of the second millennium, Mary's veneration blossomed and her image was made anew in literature, music, and the visual arts by the devotional practices and theological reflections of European monastics. Marian metaphors were embedded in the rich spiritual life of monasteries for both men and women, where life's most quotidian details were filtered through a pious lens. Female monastics, especially, were empowered by the cloister setting, which allowed them to learn how to read, write, and receive training in theology and the liberal arts, resulting in large numbers of faithful women who were also literate. Their constant practice of prayer stimulated piety as well as the spiritual imagination. Thus immersed in the Word and the earth-centered cosmology of the age, many medieval women, including the mystics Hildegard of Bingen and Julian of Norwich, brought forth powerfully new understandings of both God and humanity, especially as they were embodied in the flesh and legacy of Mary.

The *Rule of Benedict*, which St. Benedict wrote in ca. 540 as a guide for monks living in Italy, had, by the ninth century, permeated the spiritual and material aspects of life in most European monastic communities. In particular, the scriptural injunction to "pray without ceasing" shaped the monks' lives, most evidently by the "Divine Office." These prayers based on the psalms and other parts of Scripture were recited or chanted daily at specific times, from lauds (morning prayer) to vespers (evening prayer), mirroring the natural rhythms of sunrise and sunset. By the mid-eleventh century, the Divine Office had spawned others, including the Office, or Hours, of the Virgin, which honored Mary. To meet the private (as opposed to communal) devotional needs of ordinary persons who wanted to deepen their spiritual lives, compilations of prayers, often called a Book of Hours, were created. Some were magnificently illuminated, as in the case of the *Très Riches Heures du Duc de Berry*, a classic example

How great and powerful is
 the man's side,
out of which God brought
 forth the form of a
 woman,
he made her as the mirror of
 all his beauty,
as the loving embrace of all
 his creation.
And so the heavenly instru-
 ments sound in harmony,
and all the earth marvels
 that God loved you so
 much,
O Mary, worthy of praise.

—HILDEGARD OF BINGEN,
from *Symphonia,* ca. 1150

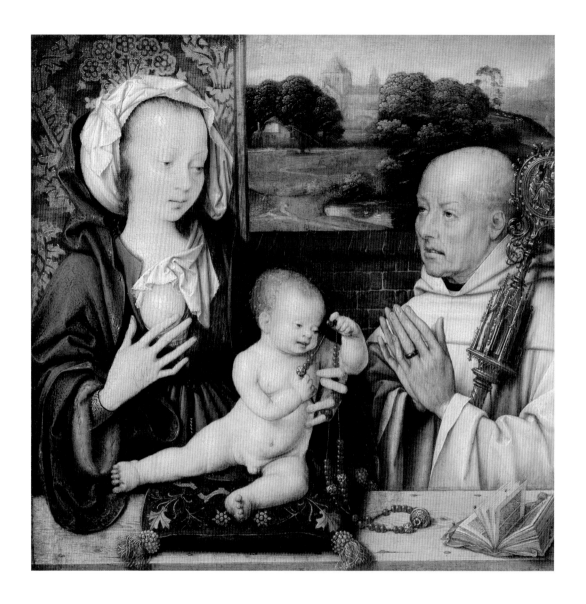

of a medieval Book of Hours made for a wealthy patron. Such
books included the Hours of the Virgin, in which milestones of
Mary's life were recollected at each liturgical hour: Matins (Annun-
ciation), Lauds (Visitation), Prime (Nativity), Terce (Annunciation to
the Shepherds), Sext (Adoration of the Magi), None (Presentation in
the Temple), Vespers (Flight into Egypt), and Compline (Coronation
of the Virgin). The language of the Virgin's Hours, such as one sung
at vespers—*From the beginning, before all the ages, I was created, and until the*

• • •

The Vision of Saint Bernard, 1505–1510
Joos van Cleve (ca. 1484–1540/1541)
Oil on panel
11.4×11.4″ (29×29 cm)
Musée du Louvre, Paris

The Cistercian monastic order was devoted to the Virgin Mary, none of their number more passionately than "Mary's troubadour," Bernard of Clairvaux (1090–1153). His Marian writings were so renowned that in the *Divine Comedy,* written more than a century later, it is Bernard who presents Dante to the Virgin so that she might supplicate on his behalf, enabling Dante to have an unmediated vision of God. In one of Bernard's visions, Mary wetted his lips with a few drops of milk from her breasts, the "Miracle of Lactation." The image of the nursing Virgin (*Virgo lactans*) has a long history but became a prominent devotional theme in Western Medieval art, thanks in part to Bernard. In this work, Bernard wears the Cistercians' white robes and his hands are clasped together in prayer. His mouth is slightly agape, reflecting his intense concentration. Mary, the most prominent figure, exposes her right breast and locks eyes with Bernard. Jesus's head is turned away from his mother as he plays with a string of prayer beads. The painting's choreography makes it clear that Mary is offering her sustenance to Bernard and not to her son. It does not record a physical event but a spiritual one, where strength and affection passed from Mary to one of her most devoted followers.

age to come I shall not cease to be—emphasized Mary's all-encompassing role in creation, from carrying God in her womb to reflecting, like nature, God's indescribable glory.

The *Rule of Benedict* also prescribed *lectio divina,* or sacred reading, in which scriptural works were read in a contemplative, experiential fashion as a means of entering imaginatively into the Word and deepening one's spiritual life. This ancient practice, which has enjoyed a contemporary resurgence, is primarily an exercise in love, not intellect. It creates an opening for an intimate dialogue with God that can lead to what Benedict XVI described as "a new spiritual springtime." *Lectio divina* requires slowing down and savoring individual passages, sentences, and words and reflecting on the images that emerge. The texts are preferably spoken aloud, mouthing and tasting every word, and equally slowly digesting its meaning. The physicality of both *lectio divina* and the Offices—rhythmic movement of the mouth, tongue, and lips; the passage of air from lungs to lips; hearing one's own voice and those of others; and the serotonin-producing pumping of the diaphragm to produce breath and

sonorous sound—made the Word an embodied experience, especially as it was experienced in community. Hearts, minds, and bodies moved in tandem.

As sensuously and emotionally processed in such medieval devotional practices, the potent metaphors in the gospel parables, epistles, psalms, and, especially, the Song of Songs became a living text from and through which theological interpretations were made. Few made more explicit and joyful use of its metaphors of flowering and fertility than the theologian Hildegard of Bingen (1098–1179), whose extraordinary learnedness was matched by no one of her century. By any measure, the multitalented Benedictine abbess was a powerhouse—a prophetic seer, philosopher, biologist, herbalist, playwright, artist, and musician. She was more interested

• • •

The Coronation of the Virgin, from *Les Très Riches Heures du Duc de Berry,* 1411–1413
The Limbourg brothers (b. 1385–1388; d. 1416)
Illuminated manuscript
Approx 11.4×8.3″ (29×21 cm), trimmed
Musée Condé, Chantilly

The Coronation of the Virgin shows Mary glorified as the Queen of Heaven. Here in heaven she shines: Her luminous gown is embroidered with gold fleurs-de-lis, and her lavish cloak befits a queen. She is greeted with heavenly music played by angels celebrating her assumption to her heavenly throne. Yet she retains her humility, bowing before Christ. Christ sits on a throne of golden angels, crowned and holding a sphere symbolizing his authority. Angels hold three crowns above him, proclaiming the Trinity. He invites his mother to join him as ruler of heaven, blessing her before a multitude of saints.

Scenes of the Coronation often closed the Hours of the Virgin, a set of prayers that established a relationship between Mary and the supplicant, who would ask for Christ's mercy through her intercession. The Coronation typically accompanied prayers for Compline, said in the evening before retiring. Asking the Queen of Heaven to advocate for the soul's salvation after death took on a sobering immediacy as darkness fell and the faithful prepared for sleep—known since ancient times as the brother of death.

Details concerning the births of the Limbourg brothers are unclear. They were likely born between 1385 and 1388 in Nijmegen in present-day Flanders. From 1402 they were artists for the Burgundian court, and in 1408 they were invited to work for Jean of France, Duke of Berry. The brothers produced several works for the duke, but their crowning achievement is the so-called *Très Riches Heures,* a devotional collection of texts, prayers, and psalms. Work on the manuscript halted in 1416, the year Jean of Berry died; there is no word of the brothers again. Perhaps plague claimed them as well as the duke. The French illuminator Jean Colombe completed the *Très Riches Heures* between 1485 and 1489.

in goodness, and its many nuances, than in evil. Taking Mary as a literal and metaphoric model, Hildegard believed that everyone who breathes is an epic character, every life is an epic journey, and every soul can be impregnated and give spiritual birth to Christ.

Hildegard's knowledge of nature and the human body founded her confidence in the possibility of spiritual change: Just as nature dies only to be reborn, the resurrected body can attain wholeness and perfection. She used the language of natural growth and process—speaking of the soul, for instance, as the sap that runs through a tree—to conjure the psychosomatic unity of body and soul as well as the holistic nature of spiritual progress achieved by both body and soul. Her many written, visual, and sonic compositions honoring the Virgin emphasized the generative power of Mary's body. More than just a human vessel for Christ, the Virgin's body and its actions dictated the procreative events in nature. Through Mary, the world is reborn: "Dry herbs resurge in vivid green . . . the birds build their nests . . . the whole Earth rejoices." Through the central mystery of the Incarnation that was accomplished through Mary, God stoops to humanity and humanity aspires to God.

Hildegard's awareness of the generative power of the feminine that characterizes her visionary writings and other vigorous pursuits combated the misogynistic and androcentric attitudes of the time. At the age of forty-two, having experienced visions since girlhood, she began to write the first of her three major visionary books, *Scivias* ("Know the Ways of the Lord"), in about 1141. A ten-year endeavor, *Scivias* was inspired by twenty-six visions, or illuminations. These were documented in daring, colorful drawings that suggest Hildegard's intensely visual and visceral experience of the Spirit, which nonetheless was grounded in her knowledge of the concrete world. Since the original *Scivias* manuscript, known as the Rupertsberg Codex, disappeared during the Second World War, the illuminations now exist only in facsimile. Although Hildegard herself may or may not have painted the images, it appears that she supervised their production closely. One illumination describes the City of God, or the Church in the fullness of its divine and human reality, as a vast allegorical edifice inhabited by a host of women,

the Virtues. Embodying both divine grace and human community, the Virtues give form to Hildegard's conception of salvation as the joint effort of God and humanity. While the Virgin guides the devotions of the faithful through her grief, for Hildegard she is also *Salvatrix*, female savior, and, in the opinions of some, appears just as powerful as her son.

"All shall be well, all shall be well, and all manner of things shall be well." These words, which have been a constant mantra of comfort for many over the centuries, were written by Dame Julian of Norwich (1343–ca. 1416), an English mystic and theologian who lived in seclusion as an anchoress, or type of hermit. Living at a time when war and plague roiled Europe, she was surrounded by suffering. People would come by the window of the anchorhold—a small cell built onto St. Julian's Church, in which she lived and from which she took her name—and pour out their heartache. She would listen and repeat their words back to them, now leavened with hope and a message of divine love. Somehow, they were able to hear themselves differently through her. She is best known for her text *Revelations of Divine Love* (1413), a written account of her visions of Christ's life, in which God's love for humanity is revealed. Aside from Christ, Mary is the only holy figure that Julian names and "watches" in *Revelations*, seeing the Virgin "marveling with great reverence" at the Annunciation; grieving at the Crucifixion, where "her pain surpassed that of all others"; and "high and noble and glorious" in heaven. Mary was the ideal Christian: possessing perfect human nature, sharing and co-suffering in Christ's merciful sacrifice, and, finally, attaining ultimate perfection through grace. Mary's agony at the foot of the cross was a template upon which Julian, and many other Christians, would model their own devotions and desire to suffer along with Jesus: "Here I saw a great oneness between Christ and us, for when he was in pain, so were we." In Julian's understanding, Christ's incarnation was an historical event that reached its timeless, definitive purpose only when he hung on the cross and took on the whole of what it means to be human.

Rachel Fulton's inspired book, *From Judgment to Passion: Devotion to Christ and the Virgin Mary, 800–1200*, argues that if debating the

The fullness of joy is to see God in everything.

—JULIAN OF NORWICH, *Revelations of Divine Love*, ca. 1373

• • •

The Virgin and Child before a Firescreen, ca. 1440 (restored, 19th cent.)
Robert Campin (ca. 1378–1444)
Oil with egg tempera on oak with walnut addition
25×19″ (63.4×48.5 cm)
National Gallery, London

Virgin and Child before a Firescreen, a work currently attributed to Robert Campin, reveals the sacred aspects of everyday life. Mary sits in a well-appointed home in a typical Flemish town, while outside a man thatches a roof and people ride horses through the streets; life goes about its normal pace. Yet we receive a privileged view. We catch the Virgin nursing the baby Jesus, milk droplets falling from her breast. Wearing a bejeweled and fur-trimmed robe and seated with an illuminated manuscript, Mary is portrayed as a well-to-do young woman. Still, this quiet interior betrays hints of the divine. While the rattan screen behind Virgin and Child protects them from the fire, it also recalls the golden halo the Virgin wears in much Christian art. The cup on the table (a nineteenth-century addition) recalls the chalice of wine at Mass, reminding us that this tender moment between mother and child is a precursor to the Passion.

Devotion to the *Virgo lactans* ("lactating Virgin") appears in Western Europe in thirteenth-century devotional texts such as the *Stimulus amoris,* where Mary's breast milk holds the same saving qualities as Christ's blood: "Let me be worthy to drink the milk from her breast. Then I will mix the mother's milk with the son's blood and make for myself the sweetest of drinks." In this way, the breastfeeding Virgin was traditionally associated with the Queen of Heaven, intercessor for the faithful, making Campin's painting all the more touching. The person who commissioned this painting would see the Queen of Heaven, not glorified among the angels and saints, but quietly nursing the Savior in a household much like his or her own.

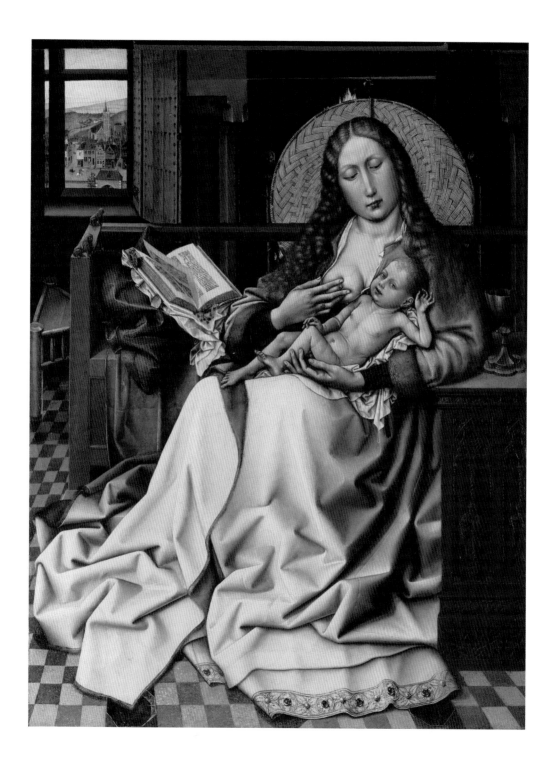

Eucharist showed medieval Christians how to discern the relationship between experience and understanding, between observable natural phenomena and their logical, inner realities—in other words, how to *think*—then praying to Mary and her crucified son, in contrast, forced them to forge new tools with which to *feel*. Through texts and artistic images, as well as interior practices of memory, meditation, and prayer, they were "grounded in the conviction that translation from one reality to another (human to divine, person to person, text to mind, image to archetype) was, in fact, possible if mediated through love." Among the many forces that stirred Hildegard and Julian's visions of maternal love, two in particular are worth noting: the Offices and *lectio divina*, which were both context and launching point for new spiritual understanding; and the humanistic insights that were aroused by their witnessing the horrible miseries wrought by plague and war and, undoubtedly, by countless acts of social compassion to alleviate that suffering. In both kinds of imagination, Mary, in all aspects of her maternity, played a catalytic role.

Their theophanies were not the first to incorporate transcendent images of motherhood. Notable medieval precedents from a long Judeo–Christian tradition include Anselm of Canterbury (d. 1109), whose three prayers to Mary connect the fatherhood of God to the motherhood of Mary. Bernard of Clairvaux's use of maternal imagery to describe male figures, including Jesus, Moses, Peter, Paul, and himself, is more extensive and complex than that of any other twelfth-century figure. Almost without exception, he elaborates the maternal as nurturing, particularly suckling—to him, breasts were a "symbol of the pouring out toward others of affectivity or of instruction." Independent from the world and dependent on God, cloistered monastics such as Bernard used maternal imagery to express the intense emotional dependence of the soul on God, just as a child's life depends on a mother's milk. The intimation that God has a maternal dimension as well as the paternal one more commonly imagined is a view that continues to distinguish the Roman Catholic religious sensibility from all others.

At the center of Hildegard's theology of the feminine is Mary's maternity, preexisting with her son from all eternity and, together

with him, the supreme revelation of God's will. While contemporaries such as Bernard interpreted Mary as the Bride of Christ, the personification of the Church, Hildegard's was a more cosmic view: Mary was the world itself, wedded to its Maker, whose purpose was to manifest God on earth. Taking a positive view of women's religious role and capacities, one that was based in a sense of female otherness from male authority, Hildegard's feminine images of divinity referred to the inspiration of the Spirit, or to the creative work of the entire Trinity. Julian's view was similarly revolutionary. The image of Christ as a mother was at the very heart of her theology: In and through Christ, God is a mother—not *acting like* a mother, but a mother. By virtue of his incarnation, Christ becomes our mother in the fullest sense: our mother who suffers the pains of labor in his passion and who, because he shares our humanity, redeems us with the tenderness that characterizes a mother–child relationship. Humanity is enclosed in Christ, our mother who births us to eternal life, and is also enclosed in Mary, in whose physical womb Christ was enclosed; in these onionlike layers of enclosure, humanity is nourished within mother Christ, who is nourished within mother Mary.

By expanding the timeless metaphor of motherhood as a mirror of God's love and creativity, Hildegard and Julian revolutionized the *imago Dei* as one bearing feminine characteristics. Engaged body, mind, and soul in the practice of prayer and anchored in the realities of nature and their historical eras, both women tilled themselves as fertile grounds that were receptive to the revelation of Mary's maternity and to all motherhood, whether physical or creative. The fruits of their faith both defined and distinguished generative female power, energizing the female anima and empowering us to think of the Creator in ways that are beyond gender and any one metaphor.

Light and the Mérode Altarpiece

LIGHT IS THE generator of space and form. Without light, space and form cease to exist, at least sensorially, for most of us. Throughout history, light has been equated with transcendence, whether secular or spiritual, and so universally employed to express the inexpressible that it seems to be a natural symbol of the divine. About 1,500 years ago, an anonymous philosopher and mystic known as Pseudo-Dionysius adapted light symbolism for Christian purposes, and illumination—whether direct, diffused, applied in paint, or bounced off mosaics—has been a primary motif of Christian art and architecture ever since.

Light is the primary means of evoking the Annunciation—the revelation to the Virgin Mary that she would conceive the Son of God. With the angel Gabriel's announcement and Mary's agreement, Christ became physically incarnate, and humanity transcended the idea of itself as merely mortal and could partake, through Christ, in the divine.

The Annunciation Triptych, popularly known as the Mérode Altarpiece, was painted in the early fifteenth century by Robert Campin, who some believe painted works attributed to the Master of Flémalle. This masterwork depicts the imminent Christ as a homunculus—a miniature, cross-carrying humanoid—who flies in through a window on divine rays of light without breaking the glass, an impossibility that suggests both Mary's purity and miraculous insemination. But Campin aims for a far more profound portrayal of the impact of this *lux nova*—the "new light" of the Christian faith—which he achieves by creating a circular composition of light that radiates from Mary's womb.

Mary, solidly planted on the floor and awash in the folds of a rippling red gown, reads a prayer book, as yet unaware. A starburst, created by highlights on the folds of Mary's dress over her womb, indicates the impending Incarnation. The eye travels along

a circular path of light limned with white lead paint that moves from the starburst to the cloth protecting Mary's book, back to the patch of sunlight on the bench and windowsill, across to the prayer shawl on the back wall, down to the gleam on Gabriel's forehead, down further to his white robe, before it returns to Mary's womb. Inside this circle is a central circle created by the round table on which sits an open Bible—visually and theologically, the Word.

The double-circle composition sits within a third, outer circle created by the protective arcs of Gabriel's wings, dark foreground floor, and fireplace mantel. This triple-circle configuration is tightly placed within a square frame so that the images seem to burst forth from its center, a radiating fullness that is amplified by the shallowness of picture frame and the sheer number of objects crammed into the bourgeois Flemish home. That bursting quality, traced over and over by the eye, speaks to the fullness of the moment—literally, a pregnant pause—before Mary utters the agreement that will change the course of humanity. Most significantly, this concentric blossoming echoes that of Christianity itself, which pours forth from the seed of Christ's human incarnation. A new and essential world arose.

Campin collapses time to express the timelessness of this newly lit world. The present is conjured by the interrupted moment before us. Many iconographic references to Judaism intimate the past: the Jewish prayer shawl, washbasin for ritualistic ablutions, and pseudo-Hebraic inscription on the lily pot. Christ's death in the relatively near future is foreshadowed by the cross carried by the tiny Christological avatar; the extinguished candle; and Mary's red dress, the color of which references the Passion. The painting is full of allegorical meaning, saturated with symbols that suffuse the image with intimations of the divine. Campin's ability to coax such numinous narrative detail from paint, and the way he evokes human frailty and fallibility through those details, is mesmerizing.

In the right panel, we see Joseph, who is shut off from the event unfolding on the other side of the wall and who also makes reference to future time. A perennial but secondary supporting member of the Holy Family cast, Joseph makes a rare appearance in this Annunciation scene (art historian Meyer Shapiro knows of only

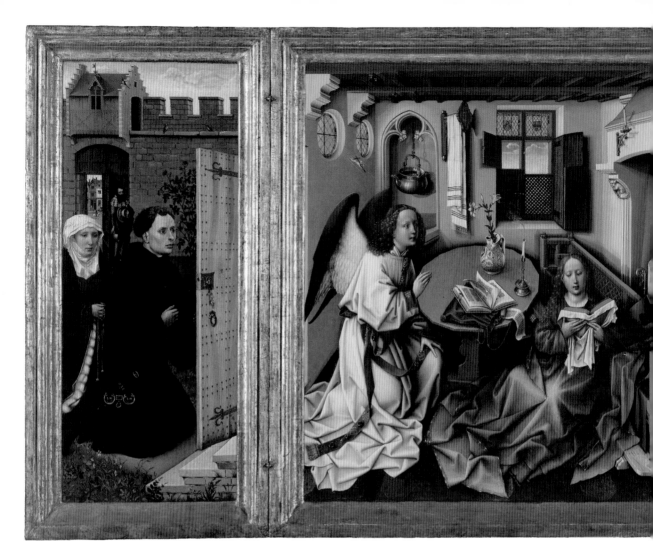

•••

Annunciation Triptych, ca. 1425
Robert Campin (ca. 1375–1444)
Oil on wood
Overall (open): 25.4×46.4" (64.5×117.8 cm)
Metropolitan Museum of Art, the Cloisters Collection

This altarpiece was originally used for private devotion. The intimate piece, never intended to be seen by the public, allowed the artist's imagination free rein. The three-panel work, rendered with sensuous color and precise brushstrokes, creates a teeming yet harmonious portrait of a cozy bourgeois home. We are present at the first moment of Christ's human incarnation, the painting's most literal and obvious narrative, through the monumental figure of Mary. She is absorbed in reading and unaware of the imminent arrival of both Gabriel and Christ. The home's interior is juxtaposed against the distant vistas seen through the many windows,

It strikes me now as the ultimate testament to the power of her presence that I had not a doubt in my mind about her reality, not then and not since. I knew from the very beginning that it was really her: Mary, Mother of God, Queen of Heaven, Our Lady of the Angels. . . . She was not a fantastical specter or a figment of my feverish imagination. She was as solid and sturdy as either my neighbor at the grocery store with a cart full of food and the kids clinging to her legs or the fir tree in the front yard dropping needles and cones all over the grass.

—Diane Schoemperlen, *Our Lady of the Lost and Found,* 2001

heightening the sense that we are eavesdropping on a specific moment and place but one within life's larger continuum. The windows in the two side panels look out to bustling Flemish urban scenes, while those in Mary's quarters open to clouds, infinite space, and the eternal. The interior is so masterfully detailed that it becomes a world unto itself. Such verisimilitude fosters the sense that this particular place existed and so this particular episode must have occurred. Nonetheless, it transcends its surface busy-ness and invites the viewer into the heart-stopping moment that preceded Mary's decision to say "yes."

Like many fifteenth-century Flemish artists, Campin remains a puzzling figure. There is evidence that a Robert Campin lived in Tournai, trained the painter Rogier van der Weyden in 1426, and died in 1444. There is little other confirmed information, and attempts to attribute or de-attribute works to Campin or those who worked in his studio have fueled one of the more contentious debates in art history. For art historians, determining an artwork's creator or provenance is a battle over connoisseurship, while for others, it's just a good mystery begging to be solved.

two other occurrences of his presence at this event—one in Giovanni de Paolo's painting of the same period and one in a Reims tapestry made in about 1530). Joseph unconcernedly goes about his work—in this case, drilling holes in a board—in a workshop containing a wonderful assortment of carpentry tools: plane, chisel, hammer, file, and nails.

Art historians have focused less on Joseph as a figure of veneration and more on questions about what he is making. Some say he is drilling holes for a winepress strainer; others see the pierced board as a visual corollary to the screen in Mary's adjacent sitting room, which stands before the hearth where the fires, literally and sexually, have been extinguished. According to Shapiro, he is making a mousetrap, a reference to St. Augustine's comparison in his Sermon CXXX of Christ's sacrificial cross to a mousetrap: "For our ransom he held out his Cross as a trap; he placed in it as a bait his Blood." Augustine employs the mousetrap metaphor to explain the Incarnation as a means of atoning for humanity's sin. And Joseph himself, as Mary's stand-in husband and guardian, can be understood as bait to deceive the devil and thwart anyone who might hurt her. More significant than any one interpretation of his occupation, however, is his hardworking presence, which reflects the strong cult of Joseph at the time Campin's work was made, particularly in Flanders, and anticipates the ascetic Protestant insistence on the moral value of industriousness.

In the left panel, Mr. and Mrs. Ingelbrecht, the couple who commissioned the painting, kneel at the door that opens to Mary's chamber. We know they are pilgrims because a medal of St. Christopher, patron of travelers, hangs from Mrs. Ingelbrecht's rosary. By the time the Mérode Altarpiece was painted, pilgrimage to sacred sites was commonplace, whether through actual participation or vicariously in literary accounts. Campin himself was sentenced in 1429 to an enforced pilgrimage to St.-Gilles, Provence, for his part in a revolt against the local government, since such journeys were also considered an effective way of rehabilitating petty criminals. The devout would receive apparitions—visions that launched them into a sort of cosmic time travel to witness events of sacred history. Medieval theologians taught that the value of a

painted image lay in its ability to stimulate such ethereal visions; praying before a devotional image such as this one paralleled the physical pilgrimage to a sacred shrine. Here, the Ingelbrechts have received a mystical vision of the Annunciation, returning back in time to more fully experience the sacred in the present moment.

Though surprisingly small in scale, the painting compels the viewer to greater faith in a way that cannot be explained by an analysis of its technique or iconography. Today, the altarpiece is enclosed in glass and displayed in an honored position at the Cloisters. This northern Manhattan branch of the Metropolitan Museum houses the museum's medieval masterpieces in a building constructed from architectural components culled from several medieval French monasteries, allowing the work to be viewed in a sympathetic context. The location, historically and geographically excised from its original context, extends Campin's metaphor of timelessness.

The Visitation According to Luke

IN THOSE DAYS Mary set out and went with haste to a Judean town in the hill country, where she entered the house of Zechariah and greeted Elizabeth. When Elizabeth heard Mary's greeting, the child leaped in her womb. And Elizabeth was filled with the Holy Spirit and exclaimed with a loud cry, "Blessed are you among women, and blessed is the fruit of your womb. And why has this happened to me, that the mother of my Lord comes to me? For as soon as I heard the sound of your greeting, the child in my womb leaped for joy. And blessed is she who believed that there would be a fulfillment of what was spoken to her by the Lord."

—LUKE 1:39–45

Among Friends: Mary and Elizabeth

A WISE WOMAN once taught me that life is organized by both steps and belief. She said, "We get to a step around the age of fifteen when someone else has to *believe* us onto the next rung," emphasizing the verb to convey belief's power to move us. "We take a series of steps—learning, discovering, becoming familiar with how things work—and then there comes a time when we have to leave the safety of what's familiar and take a leap of faith." Someone believes in us, shows us the light, and on we go until the next leap of faith. There's a name for these beacons of light and belief. They are called friends.

When Mary learned she was pregnant, she ran to the arms of her trusted relative Elizabeth. Who better to go to when you're a frightened teenager, pregnant, unmarried, with the risk of death by stoning? *She made haste.* Her encounter with Elizabeth radiates the great warmth and energy that is generated when two kindred spirits meet. Their emotional reunion is matched by the scene's physicality and movement: Mary climbs up to the Judean hill country; Elizabeth's child leaps in her womb for joy; Elizabeth is filled with the Holy Spirit. Once shared, their joy is magnified. The world is vibrantly alive. Both women are pregnant, unexpectedly, miraculously, and outside convention: Elderly and barren, Elizabeth has been disgraced by her community for failing to conceive, while Mary's pregnancy occurs out of wedlock and by mysterious means. When they meet, Elizabeth is six months pregnant with her first child, who will be called John the Baptist, the herald of Christ's ministry.

Elizabeth greets Mary with the words that will provide the bedrock of the Hail Mary prayer: *Blessed are you among women, and blessed is the fruit of your womb.* The two women enfold each other in an embrace, their pregnant bellies touching. Once in Elizabeth's comforting arms, Mary's fear dissolves and she experiences a

It is impossible to have too much confidence in Mary.

—M. Eugene Boylan, *This Tremendous Lover*, 1947

metanoia, a transformative change of heart. Elizabeth's sheltering belief has freed Mary's voice and she bursts into song: the Magnificat, the most she will say in any of the gospels. The ecstatic poetry of the Magnificat expresses conviction borne of happiness, humility, gratitude, and clarity. She articulates the new order that will come forth through her child, in which the proud will be scattered and the lowly lifted.

The women's momentous encounter has been irresistible to artists through the ages, captured memorably by Fra Angelico, Hans Holbein, Domenico Ghirlandaio, Jacopo Tintoretto, Rembrandt van Rijn, to name a handful, and by many anonymous masters who painted, carved, and illuminated manuscripts. The site of their meeting in Ein Karem, a beautiful hillside oasis outside Jerusalem, is marked by the Church of the Visitation, in whose courtyard a contemporary bronze sculpture portrays Mary and Elizabeth, belly to belly, and captures the delight of the Visitation. Behind the sculpture is a wall of ceramic tiles that spell out the Magnificat in many languages.

"Visitation" is a word that pops up in other contexts as well. As anyone who has had children and has endured divorce knows, "visitation" refers to one's right to see one's children. It always struck me as incongruous to see this word, which conjures the joy and hope of the meeting of Mary and Elizabeth, heartbreakingly adrift among the "witnesseths," "whereases," and articles of a custody agreement. That word kept me going as I plowed through unintelligible legal papers during my own divorce, and it made me grateful for those friends who stood by me during that crucible. Nothing quite reveals the divide between friendship and mere acquaintance like divorce, which can strip an individual—often the female spouse—of social identity and poison every happy memory of the past. We divorced women with children who have more years behind us than before us know—like Mary, like Elizabeth—how quickly social approbation can turn cold.

Fortunately, God is not a distant entity but works through human beings, right here—in the space between you and me. God works through our friends, or, as the poet Rainer Maria Rilke wrote of the meeting of Mary and Elizabeth: "Each, filled with her

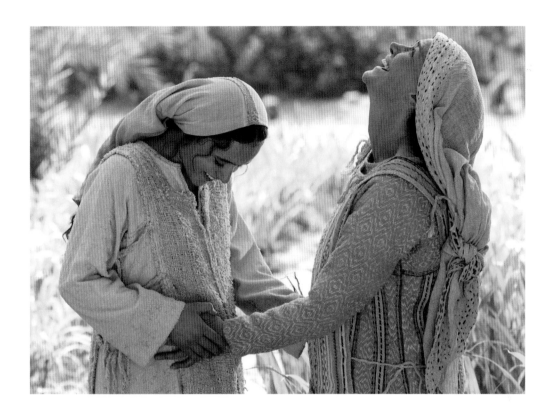

• • •

The Nativity Story, 2006
Jaimie Trueblood, photographer
Still photograph
New Line Cinema, distributor

Mary and Elizabeth meet joyfully in the Visitation scene in the film *The Nativity Story.* Primarily derived from the Infancy narratives in the Gospels of Matthew and Luke, the movie gives color, sound, and warmth to the beloved story of Christ's birth. Its sandals-and-dust authenticity is carried through costumes and sets that imaginatively conjure the humanity and emotion of the miraculous birth. Some of *The Nativity Story* was filmed in Matera, Italy, as homage to Pier Paolo Pasolini's iconic *Gospel According to St. Matthew* (1964), which was also shot there, and in Ouarzazate, Morocco, which shares Nazareth's gritty but luminous landscape. *The Nativity Story* premiered in 2006 at the Pope Paul VI Hall at the Vatican, the first feature film to be so honored.

sanctuary,/protected herself with her woman kin." Mine believed me onto that next rung. Although it would be hard to characterize their widely differing qualities—one listens endlessly, while another jumps in with advice; one is a kind and simpatico traveling companion, and another is willing to dream big; another is so funny we cry laughing; and one is perfectly at home throwing on a lei, planting some flamingos in the yard, and luau-ing the night away—these friends share Elizabeth's gift of nonjudgmental presence. They offer their open hearts, outstretched arms, and willing ears, even though they have heard it all before, even as they see me making a mistake, even if I'm being a jerk, and they remind me, once again, about the unconditional and liberating nature of love. This, for me, is the essence of Elizabeth's meeting with Mary. Through her, love is liberated and can find its physical expression in the world.

The Magnificat

And Mary said,
"My soul magnifies the Lord,
and my spirit rejoices in God my Savior,
for he has looked with favor on the lowliness of his servant.
Surely, from now on all generations will call me blessed;
for the Mighty One has done great things for me,
and holy is his name.
His mercy is for those who fear him
from generation to generation.
He has shown strength with his arm;
he has scattered the proud in the thoughts of their hearts.
He has brought down the powerful from their thrones,
and lifted up the lowly;
he has filled the hungry with good things,
and sent the rich away empty.
He has helped his servant Israel,
in remembrance of his mercy,
according to the promise he made to our ancestors,
to Abraham and to his descendants forever."

—LUKE 1:46–55

Kathisma (On Waiting)

I N THE HOLY Land, where seemingly every event recounted in the gospels has found physical expression in the landscape, there are ruins of an ancient church that honors the spot between Jerusalem and Bethlehem where Mary experienced her first labor pains. Called the Kathisma, from the Greek meaning "seat," the fifth-century church was one of the earliest if not the first major church dedicated to Mary. It was discovered in 1992 when the Hebron Road was widened and a bulldozer accidentally uncovered a mosaic floor. When I visited, the site consisted of a suggestive assortment of broken columns and capitals that were strewn on the

ground erratically, like an outline needing imagination to fill out the picture. Although I later learned that the church ruins were excavated and then covered up again to protect them, this solution feels unsatisfying, if only because the place seems to be pregnant with untold stories. Just beyond the church there is a grove of olives trees with thick trunks and protruding burls that mark their advanced years. Others, more slender, appear to be about three hundred years old, give or take a century or two, not old in any case by olive tree standards. Olives can live for thousands of years.

Cars and buses whiz by this sacred spot, spewing exhaust and heat, the road having long since become a major traffic artery between the two biblical cities. Foolishly, I wore sandals that day, and every step landed me in nettles, hurting my feet. I sat for a long while on the gnarled roots of one of the trees, shaded from the

• • •

The Church of the Seat of Mary (Kathisma), 422–458 C.E.
Builders unknown
Jerusalem

In about 456, according to Cyril, a Palestinian monk, a church was built to enshrine the spot where Mary, pregnant and traveling from Nazareth to Bethlehem, went into labor. Dated to the fifth century, based on the discovery of ancient coins beneath the church floors, the Church of the Seat of Mary was restored in the sixth century, converted to a mosque in the eighth century, and destroyed shortly afterward. For a millennium, nothing more was known about the church. Then, accidentally, construction work on the road between Jerusalem and Bethlehem dislodged the remains of a mosaic floor, revealing the ancient site once more. Beginning in 1992, an archaeological dig led by Rina Avner under the auspices of the Israel Antiquities Authority uncovered the remains of a large orthogonal church and adjacent monastery. Thus far, they've unearthed the "seat," the large rock that emerges from the center of the place where Mary is thought to have stopped and rested. This is framed by an octagonal church with an interior ambulatory around its perimeter and a horseshoe-shaped apse on one end.

The church's size and sophisticated plan indicate its considerable importance. The central stone was framed by an inner ambulatory, or walkway, from which the faithful could view the seat, and an outer ambulatory contained four chapels, also dedicated to Mary. According to Avner, the Kathisma is probably the earliest church in the Holy Land dedicated to the Theotokos, or the Mother of God, as she was recognized in the ecumenical councils held in Ephesus (431) and Chalcedon (451). Moreover, Avner believes that the Kathisma plan also influenced the octagonal plan of the Dome of the Rock in Jerusalem. Later, the site served as a rest stop for pilgrims traveling the *sacra via* between Jerusalem and Bethlehem.

beating sun, and wondered about Mary's experience. Like any mother, especially a first-time mother, she must have been excited and yet afraid of the impending birth experience—mysterious under any circumstances but more so for Mary because of the supernatural circumstances surrounding the conception of her firstborn. Perhaps she thought she would give birth to a little crowned deity! Or maybe one with wings! Though I imagine her physical distress in dusty Palestine, where stones emerge overnight from the soil, must have exceeded her curiosity about what her baby would look like.

As I sat, I noticed others had passed by here recently. Caught in the thorny nettles were tufts of brown and white sheep's wool, the only softness in this stony landscape. With my one bottle of water, I decided to wash off what remained of the floor mosaics that once ornamented the nave. Since the site was littered and overgrown with weeds, I figured my interventions wouldn't make an egregious impact on whatever restoration was planned for the future. Sprinkling drops of water that evaporated quickly in the heat, I could clean only a small section of the mosaics at a time. Slowly, they emerged. First their coral, white, blue, and yellow colors appeared. The larger puzzle came together more reluctantly. Some tiles are placed in braided helixical bands, while others are stylized, with curvilinear patterns that recalled the curl of waves just before they hit the beach.

An hour of perspired wiping brought me back to the miraculous but dirty job of giving birth, whether to an idea or a baby or a baby who is a savior. The gospels gloss over the labor pains, the water breaking, the bloody mess of it all, and skip right to the adorable child in swaddling clothes, kindly shepherds on night watch, and angelic choirs heralding peace and goodwill. Even the stars are beaming. The timing of Mary and Joseph's trip to Bethlehem is misleading as well: There is no historical evidence for the worldwide Augustinian census that required, as the familiar story goes, Joseph to return with his family to his ancestral town to register. The census is merely a literary device used to place the couple in Bethlehem, the town of David, to emphasize Jesus's royal lineage and hint at the worldwide significance of his birth.

In the *Protoevangelium of James*, we learn that en route to Bethlehem, Mary sees two people; one is weeping and the other rejoicing, which surely summarizes the long emotional arc of maternity. But still, they say nothing of those labor pains. When the time came, Joseph left Mary in a cave in the company of his two sons and went out to find a midwife. When he returned, an incandescent cloud overshadowed the cave's darkness, and Jesus was born. The only anatomical reference is delivered by an earthy character named Salome who, hearing from the midwife that a virgin had given birth, demands proof of her unbroken state. Like doubting Thomas, she satisfies her curiosity with her fingers and, after doing so, her hand drops off, until it is restored by the touch of the infant Christ. Apparently, the only thing we can be certain of is that Mary had a terrific backache from traveling by donkey on the long journey from Nazareth.

The next day, in nearby Bethlehem, I lit a candle at the Milk Grotto, a beautiful church constructed of pale limestone that remembers the place where Mary stopped and breastfed Jesus. As she did, a drop fell and turned the stones at her feet milk-white. Over the years, women wanting a child, and folks just needing to believe in life, have gone there for spiritual sustenance. The interior is softly lit and enormous with hope. My awareness of my own doubts made me squirm in the pew.

Too much of the time I find myself functioning as an atheist, meaning that I pray for God's help yet rely on my efforts alone to power me to some unknown point and uncover the patterns that I so desperately want revealed. There's an incompleteness, a not-yet-ness, that pushes me—maybe you too—to keep searching for the path or at least the map that will show how to transmute the desire for wholeness into wholeness itself. The journey can seem endless. Most days, it's all I can do to summon the patience, the devotion, to keep on keeping on in spite of the psychic birth pangs that overwhelm me. The emptiness feels like a chasm that I'm trying to cross, all the while despairing of my inability, some inherent weakness, that keeps me from passing over the stony landscape I lug along inside me. And why do I have to cross that stony landscape anyway? Why can't I just be content with whatever small

steps have already been taken, accept my limitations, be a mere mortal, and let it be? What is it that wants to be birthed so insistently from the darkness? And where is the stopping point? I realize I am less like an olive and more like one of those trucks blasting furiously down the road to Jerusalem. God can really drive you crazy with the waiting, the wondering, and the wandering. I don't like navigating by what seems like the flame of a match, but sometimes that's the only available light. Life doesn't proceed according to our schedules. It asks us to wait, as Mary did. Sometimes it calls for the patience of pregnancy and sometimes for the longer patience of an olive tree.

When Mary says, "Let it be with me according to your word," what she is really saying is, "Lead me on, Lord. You have more in store for me than I can possibly imagine." And I think we know deep down, despite so much of our reflexive hoping and planning and managing, that Mary has it about right. That a life we control and manage ourselves is actually a life in Hell. That our deepest joys come to us in ways we could never ask for or imagine. Could you have ever designed or custom-ordered the faces or the voices of the people you love the most? Could you have scripted the words and the wisdom of the best teachers you have ever had? "Let it be with me according to your word." The faith of Mary is a faith that has no interest in bending the world to one's personal control. The image of Mary that fascinated me when I was five or six—Mary standing on top of the world as if balanced on an enormous beach ball, her sandals covering the Arctic Circle and most of northern Canada, the green serpent crushed beneath her feet—is about humankind being made new. Jesus and Mary replacing Adam and Eve. And the Annunciation signals that replacement: faith, mutuality, and receptivity replacing worried striving, isolated independence, and the restless will to have it all our own "damned" way.

—THE REV. PATRICK C. WARD, from a 2008 sermon on the Annunciation, St. Anne's in-the-Fields, Lincoln, Massachusetts

The Nativity According to Luke

IN THOSE DAYS a decree went out from Emperor Augustus that all the world should be registered. This was the first registration and was taken while Quirinius was governor of Syria. All went to their own towns to be registered. Joseph also went from the town of Nazareth in Galilee to Judea, to the city of David called Bethlehem, because he was descended from the house and family of David. He went to be registered with Mary, to whom he was engaged and who was expecting a child. While they were there, the time came for her to deliver her child. And she gave birth to her firstborn son and wrapped him in bands of cloth and laid him in a manger, because there was no place for them in the inn.

In that region there were shepherds living in the fields, keeping watch over their flock by night. Then an angel of the Lord stood before them, and the glory of the Lord shone around them, and they were terrified. But the angel said to them, "Do not be afraid; for see—I am bringing you good news of great joy for all the people: To you is born this day in the city of David a Savior, who is the Messiah, the Lord. This will be a sign for you: You will find a child wrapped in bands of cloth and lying in a manger." And suddenly there was with the angel a multitude of the heavenly host, praising God and saying,

> "Glory to God in the highest heaven,
> and on earth peace among those whom he favors!"

When the angels had left them and gone into heaven, the shepherds said to one another, "Let us go now to Bethlehem and see this thing that has taken place, which the Lord has made known to us." So they went with haste and found Mary and Joseph, and the child lying in the manger. When they saw this,

they made known what had been told them about this child; and all who heard it were amazed at what the shepherds told them. But Mary treasured all these words and pondered them in her heart.

—LUKE 2:1–19

Francis's Crèche

"DO YOU NOT see that my house is in ruins? Go and restore it for me," God said to Francis of Assisi one day. In reply, Francis, with his usual velocity of heart and body, built three churches—stealing from his father, begging the neighbors for stones, handing hammers to friends and strangers—before it occurred to him that God might have had something other than apses and ambos in mind. And so he turned.

Yet Francis loved the world—one suspects the mud even more than the sky—and understood that what was visible had its own sanctity and power. In 1223, aflame from a recent pilgrimage to Bethlehem, Francis decided to build a crèche, to see for himself the babe on the hay, warmed by the breath of the ox and sheep. So, at Christmas, in Greccio, a village on a mountainside near Rome, he built one. The townspeople climbed the hill because they wanted to see what Francis saw. By the light of their torches, they watched him pick up the Child of Bethlehem, who came alive and patted the saint's cheek, a miracle Giotto reported later in fresco. If the infant could talk, he might have said something along the lines of, "Good job, Francis! Now my people have a picture of home to hold in their hearts."

Six years later, Thomas of Celano wrote about the happenings of that night in his first biography of Francis. His words paint a vivid scene of adoration, replete with hay and live animals, where "simplicity was honored, poverty was exalted, humility was commended, and Greccio was made, as it were, a new Bethlehem. . . . The people came and were filled with new joy." Francis, who embodied Christ in his loving kindness, evangelical poverty, and—through his later stigmatization—woundedness, similarly had the ability to make gospel events come alive. By giving these stories material form and investing them with emotional realism, he captured the religious imagination of the laity, whose veneration of

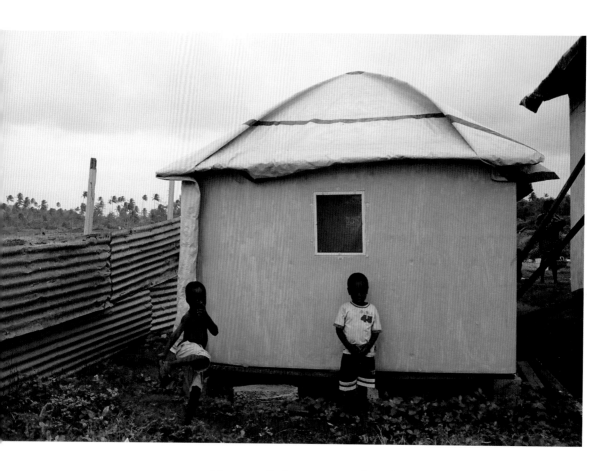

Mary was tied to events such as the Nativity, which made her a real person in their minds and their own homes a potential place of holiness. This tangible artifact of the intersection of the divine and the human made the cave at Greccio a place of pilgrimage, and Franciscan monks popularized such mangers by re-creating them in churches all over Europe.

Although Francis's Nativity scene was not the first, it is the one we remember best. The humble image of Mary and Joseph caring for the newly born Jesus in a rough cave is deeply embedded in our earliest childhood memories and remains the most beloved tradition in Christianity. Yet we are called, as Francis was, to look at the world as it really is—that one in seven people lives in a slum or refugee camp—and to see that God's house is in ruins. Many families today are in the same dire circumstances that Mary and Joseph confronted two thousand years ago.

. . .

Global Village Shelter, 2001
Ferrara Design, Inc.
Laminated corrugated cardboard
90" (228.6 cm) high, 67 sf (6.25 sm), 170 lb (77.3 kg)
Installation in Grenada

When Hurricane Emily devastated Grenada in 2005, Dan Ferrara and Mia Ferrara Pelosi, a father–daughter architectural team based in Morris, Connecticut, were ready to help. Some homeless Grenadian families were provided with Global Village Shelters (GVS), which the Ferraras developed as disaster-relief housing. The simple, innovative design of the shelter, here painted a brilliant blue, allows them to be assembled using common tools in less than a half hour. Manufactured by Weyerhaeuser, the paper company, the houses are made of laminated corrugated cardboard that is waterproof, fire resistant, biodegradable, and can withstand most climates for at least eighteen months. As architectural types they are unique, having greater stability and offering more privacy than tents but costing a fraction of other temporary shelters now on the market. They are one solution to a situation that defies easy answers.

GVS have since been used as transitional homes and health clinics in Pakistan and Afghanistan, with installations planned for numerous other locations. They have been exhibited at the John Michael Kohler Arts Center, Aspen Ideas Festival, Washington D.C.'s National Building Museum, and the Cooper–Hewitt Museum, and are part of the Museum of Modern Art's permanent collection. During the Christmas season of 2006, six GVS were installed on Sterling Quadrangle at Yale Divinity School in lieu of a traditional crèche.

As simple as the Christmas crèche may appear, such accommodations would be considered a profound luxury in most refugee camps. Typically, refugees live in open fields without sewage facilities. Food arrives sporadically and is distributed, like all resources, amid violent struggle. For the lucky ones, home is a ragged plastic tarp that provides little defense against rain or running waste. For most, the notion of shelter escapes even abstraction: Hundreds of thousands of people, surviving shoulder to shoulder with strangers, have long since lost those proximal bonds and comforting parameters that define our sense of family and home.

During the Christmas season of 2006, I curated a Nativity project at Yale Divinity School. The outdoor installation of temporary shelters on Sterling Quadrangle was in lieu of a traditional manger scene. We hoped the contrast would raise social consciousness about refugee living conditions and help those who would eventu-

• • •

A Sudanese child sleeping on the ground in the morning after a night with heavy rains, 2004
Christoph Bangert
Digital C-Print
Bredjing Refugee Camp

Bredjing is a sprawling refugee camp in eastern Chad, close to the Darfur region of Sudan. It is the most populous of twelve camps in the region that have become a temporary home to nearly a quarter of a million Sudanese refugees, who have fled to escape death, mayhem, and ethnic cleansing. Thus displaced by violence and in poor condition after the journey from Darfur, mostly on foot, the refugees arrive at the overcrowded camps, where brutal physical hardship is exacerbated by cholera, malaria, and other highly infectious diseases. And yet even in the midst of this misery arises the hope of the Nativity, exemplified by a perfect newborn, asleep in a colorful quilt.

Christoph Bangert, a photojournalist who went to Chad and Darfur in 2004 to document the situation, wrote to me about his photograph: "I visited the Bredjing refugee camp on an early morning after a night with heavy rains. Many people in the camp still hadn't received any tents or food aid, like the mother of this baby. She and her baby were new arrivals to the camp, in dire need of help, but not particularly welcome by the other refugees. The blanket, the ground, and everything else was soaking wet. You can see the water in the mother's plastic shoes next to the child. There was great misery all around, but still, there was this beautiful baby in the midst of it all."

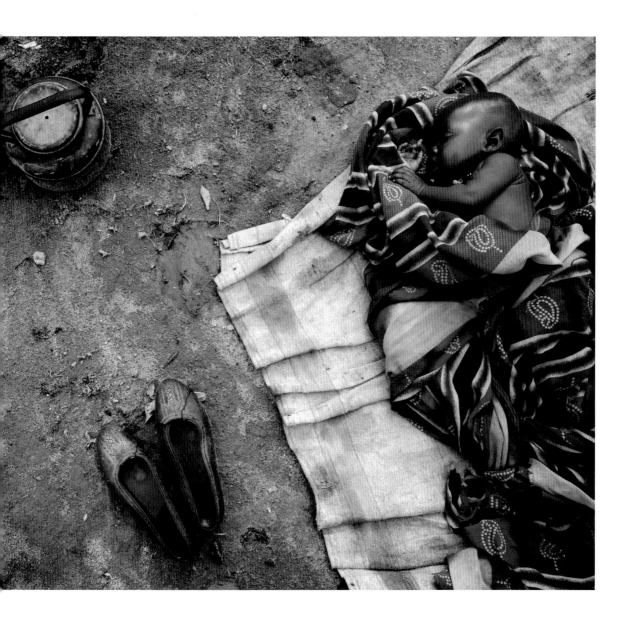

ally work overseas or domestically with the world's poorest com-
munities become familiar with the possibilities, limitations, and
scarcity of such shelters. Installing not one but several refugee
houses visually implied the growing number of populations that
are in need of basic shelter.

Dan Ferrara and Mia Ferrara Pelosi, who designed the shelters,
donated six of them for the installation, which opened during Ad-
vent and continued into February. Like a cunning piece of origami,
the white cardboard shelters unfold to form the archetypal shape
of a home, with four walls and a peaked roof, looking a lot like the
little houses in a Monopoly game. When used in the field, the
shelters ordinarily are bolted to wooden platforms and further sta-
bilized by roof tarps, but to achieve the stark visual effect I wanted,
I decided to forgo these stabilizers and merely staked down the
shelters with rope.

It was an exceptionally mild winter, and there were plenty of
people who wanted to help maintain the shelters on the quad. But
their numbers dwindled just as the weather turned bitterly cold
and the ground froze solid. Ferocious winds whipped around the
shelters and ripped up the stakes and ropes that held them in the
ground. As my scientist father later explained, the enclosed quad
possesses the perfect wind conditions in which the Bernoulli effect
(the aerodynamic principle that lifts and keeps planes in the air)
thrives. At the same time, my own metaphoric and literal home
was under attack: Just as January turned frigid, my husband told
me that he wanted to divorce.

The Ashley Book of Knots is a classic volume by Clifford Ashley
about tying knots. Ashley drew some 7,000 illustrations of both
good knots and bad and devised symbols for identifying classes of
knots: Those designated "Easy to untie" are given the symbol of a
pretzel, and those deemed "Difficult to untie" are marked with a
wedding ring. His drawings came to mind, morning after morning
on the quad, as I was on my knees, untangling the ropes that held
down the shelters and reattaching them to the stakes with knots
that were difficult to untie, while doing my best to untie those
same difficult knots at home. Once the ropes were knotted, I had
to hammer the stakes back into the ground, no small feat in the

dead of a New England winter. I wailed on those stakes, with every stroke of the hammer vowing, when I wasn't weeping in frustration, that these houses would stand. It wasn't, of course, just about the art. Given that I had no idea of where my kids and I would be living, and how I would manage to maintain a home for them on a writer's income, the timing of the shelter show was illuminating.

Later on, when all was said and done, I had a long conversation with a friend of mine appropriately named Grace. She pointed out that cardboard shelters—any temporary shelters—*are* hard to maintain. So are the marital homes we've built, visible symbols of the sanctity of marriage, foundations we thought would last forever. The Yale installation was a creative and intellectual enterprise—what if my home actually was a box, and I had to spend every waking moment trying to keep it battened down to protect my family? My struggles to keep the shelters standing forced me to acknowledge that I had been given the strength to navigate my personal trials. It brought the gift of understanding that my troubles, relatively speaking, were small. These winter reflections gave insight into what Mary and Joseph endured and what displaced persons, the indigent, the lost, still endure. The meaning of the Christmas crèche changed for me too. That year I let the Nativity set stay on the living room mantel long after January 6, the Feast of the Epiphany and the date when Christmas displays customarily are taken down in Western Church tradition. It was nearly spring before I could wrap in tissue the wooden hut and tiny cradle, the holy figures of Mary, Joseph, and the infant, along with the kings, the angels, the shepherds, as well as the sheep, and relinquish them for another year.

• • •

Adoration of the Shepherds, ca. 1644
Georges de La Tour (1593–1652)
Oil on canvas
42×51.5″ (107×131 cm)
Musée du Louvre, Paris

Many of La Tour's biblical scenes exude a meditative quality, and his nocturnal scenes in particular embody the essence of private spiritual devotion. His *Adoration,* rather than taking place within an expansive landscape, transpires in an intimate confined space where we join the Holy Family and three shepherds, including a somewhat rare depiction of a shepherdess. Darkness imbues the interior with quiet urgency, and La Tour's emphatic use of red creates visual warmth. While Joseph's candle provides a source of light, the slumbering baby in swaddling clothes radiates an even stronger source of illumination. Joseph gazes tenderly at his divine charge, the Light of the World, while the shepherds observe him in awe and wonder. One appears to have just finished playing a recorder, and we can almost hear the last strains of his song drifting out into the still night. Even the earthly lamb marvels at Christ, the true Lamb of God. Yet the Virgin's face betrays a more somber mind. She clasps her hands in prayer and looks not at her sleeping baby, or indeed at anything occurring in this room, but into the distance, to the future, to her son's destined sacrifice. Amid her husband and the shepherds, Mary alone knows the full significance of her son's life and the hardships that await them both.

La Tour is considered one of the foremost masters of the tenebroso (literally, "shadowy") style and was strongly influenced by Italian masters such as Caravaggio. Most of his career was spent at Lunéville, in the then-independent duchy of Lorraine. By 1639, the elegant painter was in Paris by order of the king of France. In addition to serving the king, La Tour also created a number of paintings for the governor of Lorraine. Although La Tour created works for the dukes of Lorraine, Louis XIII, Cardinal Richelieu, and La Ferté-Sénectère, as well as for religious houses and private patrons, his grand reputation waned almost immediately after his death and would not experience a resurgence of interest until the twentieth century.

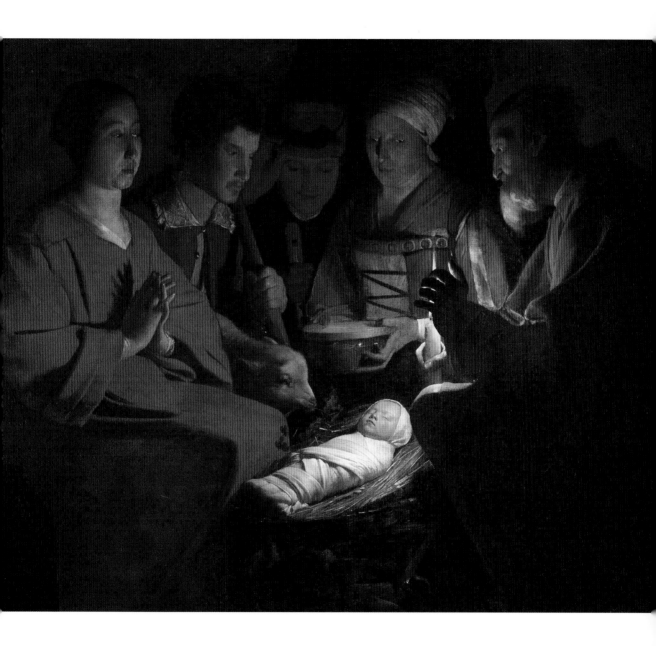

Basilica of the Holy Nativity, Bethlehem

CROSSING THROUGH BETHLEHEM'S Manger Square approaching the Basilica of the Holy Nativity—the air filled with the sound of church bells chiming, the intonation of the Muslim call to prayer, and Israeli teenagers chatting on their cell phones, dressed in olive fatigues and carrying machine guns—anticipation boils up like the strong black coffee sold from urns on the streets. The Church of the Holy Nativity, now honored as a basilica, marks the spot where Jesus was born in a humble cave two thousand years ago. It has provided spiritual sustenance over the past two millennia to the pilgrims who crossed the globe to be at the spot where Mary's child, Jesus, the delight of the world, took his first breath.

In the fourth century, Christianity emerged from persecution to become the preferred, protected, and, through its churches, highly visible religion of the Roman Empire. The churches built or begun by the Emperor Constantine in the East included, most memorably, the Church of the Nativity, the Basilica of the Holy Sepulchre in Jerusalem, and the Hagia Sophia in Constantinople. Tradition has it that the Church of the Nativity was built at the request of Constantine's mother, Helena, who was inspired to commemorate the site during her visit to the Holy Land in 326–327. However, her role in their actual foundation was most likely minor. Regardless, Helena's presence bolstered the visibility of imperial Christianity in the fourth century.

Pilgrims might have seen a structure on the Nativity site as early as 333, as its walls, but not its decoration, had been completed by then. The square basilical building had an octagonal structure on its eastern end that sheltered the place where Christ was born, with an opening in its roof that connected the spot of his birth with the sky, to which he had risen. The original Constantinian structure was destroyed and replaced by the Emperor Justinian in the sixth

• • •

Basilica of the Holy Nativity, ca. 565
Bethlehem, Palestine

The first church to mark the site of Christ's birth was built after Queen Helena, mother of the Emperor Constantine, pilgrimaged to the Holy Land in the fourth century to visit sites sacred to Christian remembrance. That church, destroyed during the Samaritan rebellion of 529, was soon rebuilt and enlarged by the Emperor Justinian in the sixth century and is the basis of the contemporary structure. During an attack in 614, Persian marauders are said to have spared the church, moved by an interior mosaic that portrayed the Magi wearing Persian dress. This ancient house of birth in the still older city of Bethlehem has been an adamantly inviolable presence over the millennia, withstanding onslaughts by Persian, Byzantine, Muslim, Crusader, Mamluk, Ottoman, Jordanian, British, and Israeli forces. Today, the church is administered jointly by the Greek Orthodox, Roman Catholic, and Armenian Orthodox authorities, all three of whom maintain monastic communities on the site.

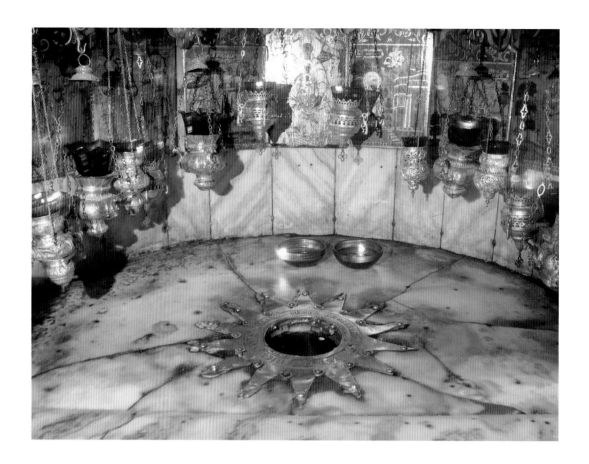

· · ·

Grotto of the Nativity
Basilica of the Holy Nativity, ca. 565
Bethlehem, Palestine

Below the upper level of the Church of the Nativity is the rock-hewn cave that enshrines the site of Christ's birth. The spot is marked with a fourteen-pointed silver star, which is set into a semicircular niche of white marble and inscribed *Hic de Virgine Maria, Jesus Christus natus est* ("Here the Virgin Mary gave birth to Jesus Christ"). Now filled with brilliantly colored hanging lamps and woven tapestries, the intimate birth cave has a festive Christmaslike appearance year-round, belied by the pious devotions of the faithful who crowd the small room every day to pray, cry, and sing. The Chapel of the Manger, in an adjacent stone niche, commemorates the place where the infant Jesus was laid. About six miles away, in Jerusalem, is Golgotha, the place of his death.

century with the present structure, but vestiges of its foundational walls and mosaic floors remain. Sections of a mosaic pavement, thought to be from the original church, were discovered about two and a half feet under the present floor by the Byzantinist William Harvey while he was inspecting the church's foundations after an earthquake in 1929. Now visible through a trapdoor on the nave floor, the mosaics depict abstract scrolls, sunbursts, and stars, as well as pomegranates, grapes, and vines, rendered in mellow shades of terra-cotta, rose, cream, and green.

The church's original monumental entrances have been filled in, and the only remaining door is small—four feet high—and requires one to stoop, in humility, to enter. Inside, the air is cool and heavy with the scent of incense and candle wax. A double colonnade of ten columns on either side of the nave first leads the eye up to the arched clerestory windows and then down the sanctuary's axis to the chancel at the church's eastern end. Fragments of twelfth-century Byzantine mosaics can still be seen on the upper walls, and the columns bear traces of saintly icons painted during that same period.

As one approaches the chancel, the view gets more intricate. Massive chandeliers dripping with crystals and ornaments hang from the ceiling, along with a dizzying profusion of oil lamps with colored-glass globes. The light fixtures are laced together with thin metal chains—hundreds of them—that crisscross the nave like a sacred spiderweb. Suspended within this web are large ostrich eggs, symbols of rebirth but also a reminder in Greek Orthodox tradition to keep one's eyes fixed on God, just as the eyes of the mother ostrich never leave her vulnerable egg. The altar furniture is heavily carved and gilded—and seems to melt into the towering iconostasis, which is covered with holy icons. The main attraction, the Grotto of the Nativity, is beneath the chancel and reached by steep stone stairways on either side of the choir.

The massive limestone structure, with a façade devoid of ornamentation except for its many buttresses, looks more like a fortress than a church, an analogy that surfaces when conversation comes around to its politicization by the three Christian sects that control it and by the governments that control the land it stands on. Three

groups—Greek Orthodox, Roman Catholic, and Armenian Orthodox—control and occupy various parts of the church, their rights and privileges protected by the Status Quo of the Holy Places (1852), known simply as the Status Quo. The Greek Orthodox have majority possession of the Church of the Nativity, which on the north side leads to the Church of St. Catherine of Alexandria (1882), which is in turn controlled by the Franciscan order of the Roman Catholic Church. A number of chapels below St. Catherine's have been cut into the lower limestone caves, including one that honors St. Jerome, who is said to have translated the Bible from Hebrew and Greek into the Latin Vulgate, starting in the year 384. The contention among the three groups, who have battled over every square inch of the church over the centuries, is contributing to its deteriorating state: When the World Monuments Fund placed the basilica on its 2008 List of the 100 Most Endangered Sites, the citation encouraged its custodians to work together to preserve it. These include, beyond those governed by the Status Quo, the Israeli government and the Palestinian Authority.

The divisions become most vividly apparent during Christmas, which is celebrated on three different days. The Greek Orthodox, who rely for ecclesiastical purposes on the Julian calendar, celebrate on January 6; the Roman Catholics broadcast Christmas Eve services from St. Catherine's on December 24; and the Armenians celebrate in their wing of the church on January 18. Throughout it all, though, the humble birth cave below is always filled with faithful who, with prayers and tears, daily recall the reasons why the church was built at all.

O Little Town of Bethlehem

T IME IS DIFFERENT in the Middle East and seems to have no meaning at all in Bethlehem, where I spent several hours one day negotiating for a crèche set. It is not unusual for negotiations to take so long—the Arabs' elaborate ritual of bargaining has developed into a high art form. Nothing is tagged with a price, which makes casual browsing impossible. The sellers come at you with a high price, superhigh for "stupid rich Americans," then you make a counteroffer, and this waltz goes back and forth until a price that makes you both happy materializes. This could take the better part of an afternoon. It almost always involves drinking coffee with storekeepers and sometimes means meeting their families and even going to their homes. Used to shopping in a New York minute, I find the process very time consuming. Advantage: Arabs, who have little store traffic. Tourism has plummeted since the 2000 intifada, and Bethlehem's once crowded stores are shuttered.

Everyone, it seems, knows Johnny, the owner of this store that sells Nativity sets. Johnny is an older man who has persevered through the hard times, and he cheerfully stands by as we peruse his shelves of thousands of Marys, baby Jesuses, Josephs, convoys of Magi, and enough shepherds, sheep, and camels to fill Grand Central. Each figure is carved from deeply grained olive wood, which gives them their peculiar beauty and facial idiosyncrasies; unfortunately, the crèche set I liked most included a cross-eyed Mary and a king with a lopsided face. When I asked about replacement figures, Johnny's nephew, Michael, went to the "back room" to see what he could find.

You may think that a back room is just out back. In fact, "back room" in Israel means anyone you know who might have what you need, within the radius of a two-hour trot. So, while Michael was out, my shopping companion, Lisa, and I had plenty of time to contemplate every single item in Johnny's store. He offered us

coffee—Turkish coffee spiced with cardamom—and more coffee. Yum. Then Johnny insisted that I try on an embroidered caftan made by the Bedouin, a minority within the Arab minority, who still shepherd their flocks over Israel's shifting desert hills. Convincing me to play dress-up ate up some more time, but there was no resisting. Lisa snapped my picture. Tons of fun, once you erase the concept of time from your mind.

Michael finally returned with a beautiful Mary and a slightly better king, who, given that he and his companions had a two-year journey over rough desert terrain to get to the baby Jesus, was entitled to look a little weary. Having experienced the heat and grit of this place, I presume their brocaded robes and heavy crowns stayed packed in the camel bags until they encountered the infant.

But the deal was not yet over. Johnny insisted that we eat with him. Michael went out again, this time to his mother's house, and came back—after showering, changing, and grabbing his sister's sweater for me because I was getting cold. This blue sweater, a gift from a young woman who had little yet willingly consented to share, is a treasure now—yes, mine. Michael also brought *sveeha* (an Arabian pizza the size of a small flat pita, covered with ground meat, spices, peppers) and *zabouzi* (a pastry turnover filled with feta cheese and zatar, a spice that is used daily here that tastes like oregano). Just made, they were delicious. However, because nothing is simple or played out according to Western rules, we did not eat them in the shop. We took them to a local restaurant, where Johnny ordered falafel, hummus, and salad to supplement the offered repast. Now that we were friends, Johnny said that Lisa and I must have wine with him at a fabulous local bar frequented by the Franciscans.

"Bar" is not quite the right word to describe the Casa Nova Restaurant on Manger Square, next door to the Church of the Nativity and the newer, adjacent Church of St. Catherine, the latter ruled over by the powerful Franciscan brothers, who sweep about the place in their long brown robes with the authority and wealth of kings. Imagine an outdoor sunken plaza of warm yellow Jerusalem limestone with soft lights, fountains, ferns, flowers, and dozens of scampering cats. While we had drinks, the six Francis-

cans who were seated in a raised niche—literally above the rest of us—were having dinner. At one point, one of the younger monks marched across the patio, holding at arm's length a scraggly cat that had interrupted their dinner, his face puckered in distaste. When he was far enough away from the Franciscan throne, he threw the cat against a wall, vigorously wiped his hands together, mission accomplished, and returned to his table.

Lisa, who has almost no impulse control, making her a sort of devilish angel, jumped up and shouted, "Hey, Brother Francis, why did you throw that cat against the wall? Is that what Francis would do? Would he?" The entire restaurant grew silent, mouths agape, no one's jaws lower than those of the Franciscans. Who dared speak against the Roman royalty? Lisa and I left the bar, laughing so hard that we cried. We ran through the dark streets until we found a taxi that took us, along with our crèche sets and memories of the kindly older man, the generous girl, the wandering shepherds, and some tired kings, back home.

O little town of Bethlehem.

Blue Christmas

THE CHRISTMAS SEASON was tough this year for many in my circle—a suicide, a diagnosis of cancer, infidelity exposed, unhappy parents, unhappy children, a home foreclosure. Many decent and talented people lost their jobs. In the televised news, brokenness, bloodshed, corruption, and natural disaster racked the globe. It was the end of the year, and everything seemed to be ending at once. Every phone call and email brought more bad news, more requests to help, to listen, to fix—just as I was trying to cope with a painful loss of my own, wishing there was someone to hold my hand, all the while aware that my holiday blues paled in comparison to what others were managing.

It is easy to feel that the whole world is awash in good cheer and sleigh bells, while you are alone and the only thing glistening are the tears on your cheeks. Facing a first Christmas without a loved one at the table, or while in the midst of acute illness, desolation, or any one of the traumas that life unexpectedly serves up, is hard. Some of the heaviest grief borne during the celebration of the Savior's birth is invisible—the unmet longing of couples who are unable to conceive or have endured miscarriages, or that of parents who have seen their hopes for their children undermined by illness, addiction, or apathy. Divorce, of course, bumps about the holidays like a Ghost of Christmas Past, but marriages, too, can be laced with unspoken misery. It hurts coming to grips with the extent of one's pride, especially when it comes to money, especially during the holidays, when gifts are expected. Sadness may spring from the inability to afford presents for one's children, the ones they really want. Classic holiday movies like *It's a Wonderful Life*, with its dark and profoundly human core, can underscore the loss of our own childhood innocence, when Christmas encircled our world like a magical ring, and life, at least as we remember it, was shining, hopeful, complete.

Such feelings are exacerbated by the sheer energy that is mobilized in the name of Christmas. This year, like Scrooge, I'm inexplicably annoyed by my neighbors who have strung lights over every square inch of their properties, even though they do it every year and I usually delight in it. The 24/7 holiday soundtrack on the radio grates. By early December, I've come down with SPD, seasonal perfection disorder, brought on by comparing myself to those who have baked sixteen kinds of perfectly frosted Christmas cookies and by others who boast that not only was their shopping done in September, but the gifts are wrapped as well. Surely there is a special place in hell for that last group. In any case, it requires a lot of energy to keep pace with ebullience.

For those who long to keep Christ in Christmas, the unavoidable commercialism of the holiday stirs up feelings of melancholy that the season's true meaning is not only buried under mounds of wrapping paper and bows but that its holy roots are no longer acknowledged or even known. This is the sadness that can accompany faithful witness. We remember that Christ was born at midnight, in darkness, when no one knew a redeeming light was about to appear.

In the past decade, new liturgies have emerged that minister to those who are grieving, suffering, alone, or in some way feeling removed from the glittering holiday celebrations. Called a Blue Christmas service, a Service of Solace, or the Longest Night service—the last held on December 21, the winter solstice and literally the day with least daylight—the services open with a warm welcome and an assurance to those in the pews that their feelings are valid and that it is okay to be where they are instead of where they feel they should be. Candles, burning in remembrance and symbolizing unwavering hope, focus attention on the light in the darkness while acknowledging just how dark the dark can be. Lutheran minister Monika Wiesner explains the Longest Night service at her church in this way: "We invite people to light a candle for whomever, or whatever, they are grieving. It can be a person, loss of a home, divorce, death, job loss, loss of one's health— anything that keeps you from having a ho–ho–ho Christmas." Songs such as "O Little Town of Bethlehem," "It Came

As we grow older, let us be more thankful that the circle of our Christmas associations and of the lessons that they bring expands! Let us welcome every one of them, and summon them to take their places by the Christmas hearth. Welcome, old aspirations, glittering creatures of an ardent fancy, to your shelter underneath the holly! We know you, and have not outlived you yet. Welcome, old projects and old loves, however fleeting, to your nooks among the steadier lights that burn around us. Welcome, all that was ever real to our hearts; and for the earnestness that made you real, thanks to Heaven! Do we build no Christmas castles in the clouds now? . . . Welcome, everything! Welcome, alike what has been, and what never was, and what we hope may be, to your shelter underneath the holly, to your places round the Christmas fire, where what is sits open-hearted!

—Charles Dickens, "What Christmas Is as We Grow Older," 1851

Upon a Midnight Clear," and "Silent Night" speak more to the mood than more triumphal favorites such as "Joy to the World" and "Hark! The Herald Angels Sing." However delivered, the message is the same: You are not alone, and it is possible to transform suffering by relinquishing it to the bonfire of hope.

During Advent, those weeks of longing and expectation leading up to Christmas Day, we wait with Mary for a baby who is blessed but born to die. The occasion of Christ's joyous birth has always been bittersweet, never separate from his destiny on the cross. Paintings of the Nativity often allude to the Passion by the inclusion of blood or the color red, a cup representing the cup of the Passion, a plank of wood or a tree recalling the crucifix, or even an actual cross in the manger setting. But contemplating the less overtly sorrowful events of Mary's life can also provide a comforting sense of solidarity for those experiencing a blue Christmas. From the moment of the Annunciation, when she lost her fundamental identity, continuing through the physically difficult journey to Bethlehem when she was nine months' pregnant, and after the loss of her home when the Holy Family was forced to emigrate to Egypt, Mary models how to cope with a world that seems turned upside down. Throughout her life, she carried the knowledge that her heart, too, would be pierced. Closest to God and yet still asked to bear absolute pain, Mary does not passively surrender to grief but defies it through and in faith, a model that can sustain us during the Christmas season and into the new year.

The Visit of the Magi According to Matthew

IN THE TIME of King Herod, after Jesus was born in Bethlehem of Judea, wise men from the East came to Jerusalem, asking, "Where is the child who has been born king of the Jews? For we observed his star at its rising, and have come to pay him homage." . . . Herod secretly called for the wise men and learned from them the exact time when the star had appeared. Then he sent them to Bethlehem, saying, "Go and search diligently for the child; and when you have found him, bring me word so that I may also go and pay him homage." When they had heard the king, they set out; and there, ahead of them, went the star that they had seen at its rising, until it stopped over the place where the child was. When they saw that the star had stopped, they were overwhelmed with joy. On entering the house, they saw the child with Mary his mother; and they knelt down and paid him homage. Then, opening their treasure chests, they offered him gifts of gold, frankincense, and myrrh. And having been warned in a dream not to return to Herod, they left for their own country by another road.

—MATTHEW 2:1–2, 7–12

The Gifts of the Magi

AS SEEN ON third- and fourth-century Roman sarcophagi carvings and catacomb wall paintings, the Adoration of the Magi is the only event from Christ's infancy that is re-created in early Christian art. These far-come and famous kings who honored the Christ child were Persian astrologers and priests of the cult of Mithras. They followed a star, a common device used in the Greco-Roman world to designate the birth of a hero. According to the Gospel of Matthew, they stopped in Jerusalem to ask the ruler Herod—indicating they were powerful enough to merit such a meeting—how to find the newborn king of the Jews. Arriving in Bethlehem, they paid homage to the infant Christ, and, warned by an angel not to return to the scheming Herod, went home. While it is unlikely that the Magi story transpired precisely as recorded in Matthew, the account likely contains a kernel of truth that was embellished over time as it underwent Christian interpretation.

• • •

Still from *Birdsong* ("El Cant dels Ocells"), 2008
Roman Ynan, still photographer
Albert Serra, filmmaker
Capricci Films, distributor

In his film *Birdsong,* Catalan filmmaker Albert Serra portrays the Magi's trek toward the Holy Family. The introspective black-and-white film unfolds like a relentless dream, capturing the internal journey of the kings as they stumble through a bleak landscape toward their mythic goal. Other than their crowns and robes, they lack regal trappings. They move through a minimal yet monumental landscape that is monochromatic and, except for the sound implied by the title, silent. By stripping away the opulence ordinarily associated with the Magi, their essential humanity—at times clumsy, comic, or serious—is allowed to come through. Although the sky is starless, the kings are led, slowly, patiently, awkwardly, by a vision: "We're awestruck with the beauty of things," one remarks. After nearly an hour of cinematic wandering, they finally reach the Holy Family and prostrate themselves before the newborn and his parents. Eventually, they trudge off, saying, "We won't be coming back—we've had enough of this sand." It's a funny line but also a poignant reminder of the singular nature of their journey and their willingness to take it.

In early Roman imagery, the Magi are portrayed identically, wearing their pointed Phrygian caps, and likely served as models of reverence and charity to early Christians who wished to earn God's grace. We don't know much about these regal visitors. Matthew says only that "wise men" stopped where the star stopped, overwhelmed with joy and, most memorably, bearing gifts, specifically treasure chests containing gold, frankincense, and myrrh. While Matthew neglects to specify the number of Magi, the mention of three gifts led to the assumption that there were three men, although their number and gender is debated.

Over time, the image of the Magi was embroidered to serve a wide variety of social, political, and spiritual agendas. They acquired names—Balthasar, Melchior, and Gaspar—as well as exotic clothing, such as the fabulous leopard-skin leotards they wear in the sixth-century mosaic at the Basilica of Sant'Apollinare Nuovo in Ravenna, Italy. Much was made of their magical powers and astrological insights. Additional scenes were developed in the medieval period, illustrating their meeting with Herod, journey under the guiding star, dream of the warning angel, and other portrayals that mirrored the legitimacy and royalty of the newborn king. In some images, the Magi appear as Eastern political prisoners bowing before Christ, the seat of Roman power. Such political and dynastic overtones persisted throughout the medieval period, when the three kings were thought to represent the entire (then-known) world—Africa, Asia, and Europe. In other instances, the Magi were of different ages to represent the three stages of life and show that neither the strength and beauty of youth nor the wisdom and experience of years can supplant Christ's authority. Balthasar, although previously described as a black man in the early medieval text *Excerpta et collectanea*, was not portrayed as such until the fifteenth century, when depictions of the kings' exotic foreignness reached an apex. While all three men still wear opulent Eastern-style clothing, the black magus often exhibits additional accoutrements, specifically earrings. Despite such distinctions, they are almost never recognized as individuals: Their power and personality emanates from the collective.

The gift-bearing kings are a fixture of annual Christmas pageants. Sir Ken Robinson, who has spent a lifetime exploring how creative gifts can be encouraged, related this story about one such performance: "The three boys came in, four-year-olds with tea towels on their heads, and they put these boxes down, and the first boy said, 'I bring you gold.' And the second boy said, 'I bring you myrrh.' And the third boy said, 'Frank sent this.'"

I love this story because it makes the point that children will take a chance and step up with an original solution—because they're not frightened of being wrong. In adulthood, the fear of being wrong, of making a shameful misstep, prevents us from taking any steps, much less wandering around the desert for two years following a star, as the wise men did. The larger message of the kings' journey is about courage and the willingness to take an impossible journey, whether it consists of one step or many, as Mary did.

It is also a story about gifts. Whatever your situation, it is empowering to realize that everyone, the poor as well as the rich, has the capacity to give *something*, and it strengthens the soul to do so. But the most sought-after gifts are not those that can be contained in a jeweled chest and loaded onto a camel's back. Most of us spend a good deal of time, if not a lifetime, wanting to find that special gift of ours that will make sense of our lives and lead us forward. But that gift is not one that we have so much as the one we are given—God's grace—which allows us to discover and fulfill our human destiny.

O womb more spacious than a city!
O womb wider than the span of heaven!
O womb that contained him
Whom the seven heavens do not contain.
You contained him without pain
and held in your bosom him
who changed his being
into the smallest of things.

—Gospel of Bartholomew, 4th cent.

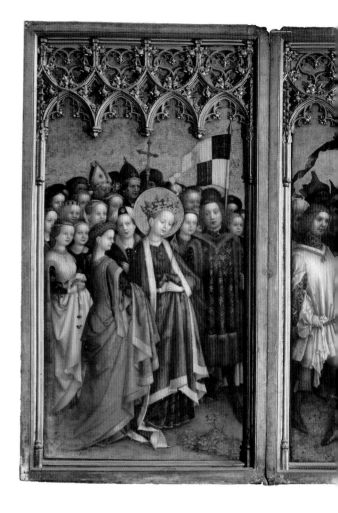

• • •

Altarpiece of the Patron Saints (detail), ca.1445
Stefan Lochner (ca. 1400–1451)
Tempera on oak
102×185″ (261×469 cm), open
Cologne Cathedral, Germany

Stefan Lochner's *Altarpiece of the Patron Saints* emphasizes Cologne's place in Christian history and weaves
it into the story of salvation. In the center panel, the delicate facial features of the enthroned Virgin and Christ
child contrast with the intricate embroidered robes worn by the Magi. The gold background and the cloth of
honor held aloft by angels emphasize the Virgin and child's royal status, yet the two are portrayed with
tangible humanity. The chubby baby Jesus blesses one of the Magi with his plump hand, as his mother
cradles his tiny foot and lowers her eyes in modesty.

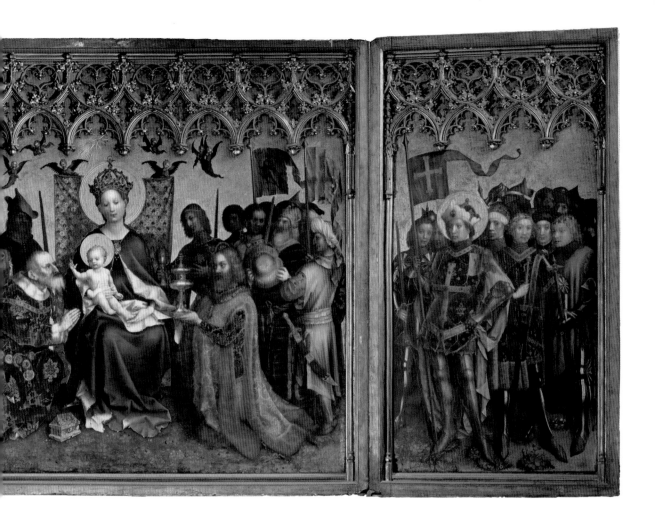

Lochner's Magi range from young and long-haired to old and balding, and their attendants bear standards showing their continent of origin. In medieval tradition, the three kings were variously aged to represent the three stages of life and were identified with the three continents known at the time (Africa, Asia, and Europe), thereby representing the entire world. Their luxurious robes emphasize their own regal status, yet they kneel, subject to Christ. The relics of the Magi, given to the cathedral by the Holy Roman Emperor Frederick Barbarossa in 1164, reside in the cathedral's chancel, where they continue to attract pilgrims to the present day.

Lochner was born in Meersburg near Lake Constance around 1400 and settled in Cologne as a young man. Few of Lochner's works survive. The *Altarpiece of the Patron Saints* is considered his most significant work, although recently its attribution has been questioned. Indeed, Lochner did not sign or otherwise document the creation of any of the works credited to him. The most famous artist of medieval Cologne, he died impoverished in 1451, a victim of the plague.

The Palestinian Hair Salon

I WOKE UP in Jerusalem this morning to the sound of cats fight-ing. It's a huge noise, and not one heard in calmer places. The cats remind me that there's so much about this month in the Holy Land that will be forgotten once I'm back home and the mad daily routine takes over. I realize how closely our sense of a place is tied to intimate, evanescent details. The guidebooks tell about the land-marks, yet the way a bowl of hummus tasted, the touch of the warm gnarled trunk of an ancient olive tree, how the sun rises over Bethlehem and rakes across the separation barrier one concrete plank at a time, are what make up these days.

Mary's presence continues to make itself felt in the most unex-pected ways. Yesterday, I spent the day at the Church of the Nativ-ity in Bethlehem, running my hands over every surface of its ancient umber and yellow stones, worn as smooth as an animal's flank by fourteen centuries of pilgrims before me. Later on, I was supposed to join my study group on a bus tour of Jerusalem's outer neighborhoods. I wasn't worried about getting to the bus on time. I figured I'd glide through the Israeli checkpoint, as Ameri-cans most always do. That day, however, was different.

Ahead of me in the pastel-colored processing building was a group of five Palestinians who were being questioned and repeat-edly asked to put their hands in the handprint reader, one of the many Israeli security measures at the Wall, or separation barrier, as it is more formally known, that cuts off Bethlehem from the rest of Israel. I was hopelessly at the end of the line, wanting to knock on the Plexiglas window and wave my big blue American passport in the faces of the guards, which usually works like a charm. But after spending hours at the humble cave of the Nativity and walking Bethlehem's now-empty streets, I figured I would bear for once some of the ignominy that the Palestinians suffer daily.

I stood in line impatiently, staring at the guard who, like a cat playing with a mouse, seemed to be deliberating toying with those ahead of me. The place of Jesus's birth is a literal prison for thousands of Palestinians, both Muslim and Christian. Most, particularly unmarried males under the age of thirty-five, cannot leave. Many have not been to Jerusalem, six miles away, in years.

When I finally got through the line, I ran chuffing up the hill, only to see the bus disappearing into the distance. I was furious at the rigidity of the tour director. That petty clock-watcher! My head filled with score-settling comments that I planned to deliver in dulcet tones at precisely the right moment. It's funny how grace and vengeance walk hand and hand.

However, all the anger in the world wasn't going to bring the bus back. Deciding to make lemonade from lemons, I went to a nearby Palestinian beauty salon, which, having the geographic good fortune to be located on the Israeli side of the Wall, was not subject to the vagaries of the checkpoint. This was a Western-style salon, full of women in spaghetti-strapped tops with flowing hair streaked with blond highlights. Nothing could be further from the hermetic intimacy of the traditional veil, or *hijab*, worn by their Muslim sisters.

The salon was jumping, abuzz with young women having their hair twisted, curled, and braided into elaborate, spiced confections for a wedding taking place that night. Weddings are extravagant here—a guest list of five hundred is not unusual. In addition to the wedding beauties, the place was full of women of all ages and sizes having their hair done. It looked even more crowded because of the mirrored walls, multiplying everything like those at Versailles. I half-expected Marie Antoinette to show up with a handful of toy ships and temples to adorn her updo.

Most of the shop's stylists spoke very little English, but Jacqueline, the owner, understood in the universal language of the salon that I wanted her to transform my hair. After days of desert hiking, it was snarled and looking like a flock of goats moving down the slopes of Gilead. Good hair being my one splurge, I was nervous

about being in a place so different from the exclusive Westchester County salon I usually frequent. Yet before she applied the color, the assistant took special pains to dot the edges of my hairline and nape with cream so that the dye would not stain my skin—*Wow*, I thought, *they take far more care here than my own salon does.* She then applied the color slowly, strand by strand. She washed my hair, twice, generously lathering it with scented shampoo and finishing with a luxurious head massage. Once that was done, Jacqueline glided in with the assurance of a prima donna and expertly snipped my hair with the kind of hands–deep knowledge and finesse possessed only by masters.

Two hours later, my initial anxiousness had been long since replaced by that meditative, relaxed state that comes about in beauty salons. Another woman, named Danah, the mother of four children, arrived to blow–dry my mop, a job that has been known to stymie even the best salonist. Halfway through this labor, she looked deeply into my eyes, her own as blue and round as lapis beads, and asked me where I was from.

New York.

Oh, she said, delicately choosing her words, then you are not Greek, and continued the drying with the same careful attention that the other women had showered on me.

Moments later, I realized that "not Greek" was a kind way of saying, Oh, then you are a Jew, or, perhaps, you are an American Jew, or, most fundamentally, you are an American, the friend of my enemy, the proxy government by which Israel has the authority to imprison us and take away our lands, livelihoods, and children's futures. You are my enemy. Like many in the Holy Land, she and the rest of my caregivers must have assumed I was a Jew with my dark sad eyes, unruly curls, and, after three decades in New York, a good bit of brash confidence.

Danah's comment opened a floodgate of understanding. I recalled that today, July 22, was the feast day of Mary Magdalene, celebrity stand-in for the many Biblical bad girls who had courage enough to let go of their demons, seduce Holofernes, engage the stranger at the well, or anoint and dry Jesus's feet with their hair—

to do the right thing, the holy thing, and show great love. Here, in this Palestinian beauty salon, my hair—for many cultures the most intimate expression of femininity—was being lovingly tended by holy women who ministered to me, a stranger and, by most political measures, their enemy.

Saturday Mornings at Church

AS A GIRL, I spent many Saturday afternoons working in the sacristy of St. Augustine Church in Providence, Rhode Island. My chores there felt much more important than those at home. I ran back and forth between the sacristy and altar, removing dead flowers, dusting the saints, and picking up stray threads on the rug. With a step–on–a–crack–break–your–mother's–back kind of terror, I carefully genuflected before the main tabernacle each time I passed in front of it. A statue of Mary, open–armed and poised atop a pedestal, had a pensive smile that never changed. The janitor was there too, polishing the long center aisle so that it gleamed like a bride's face. The older women were entrusted with the more crucial tasks of caring for the priests' embroidered vestments and polishing the gold chalices and sleek patens, but I was close and could admire their intricate, forbidden beauty.

Everything about church in those Saturday hours felt significant. All was still. There was a richness to the silence, a great sadness in the silence, as though the church's bones couldn't hold any more sadness or happiness or even silence itself. I was aware of being surrounded by a vast intention far older and greater than myself, but I believed some part of its mystery was addressed to me.

During the many years when I didn't attend church regularly, I often visited Manhattan churches to sit with my darkness in a place that had borne witness to others' sorrows and joys. The building itself was a comfort. The worn pews, the sensual carvings of saints, the faint scent of candle wax, and the glowing stained glass all extended a benediction. Like Mary, a church is in many ways a shell, a physical container for transcendent exchange. Unlike any other structure, its sole function is to provide human beings with a space in which to contemplate, individually and in communion with others, their immortal dimension. Churches are born of passion. Their construction is fueled by a deep love of God,

the Trinity, and Mary, and, in the case of some patrons and builders, a zealous desire for one's own immortality. Reaching deeper into the layers of passion that come together in a church, one becomes aware of the art that adorns the structure—these personal meditations upon God by individual artists, most of them anonymous, who wrote their faith in stone, wood, and glass, unceasingly, knowing that they would reap no glory from these magnificent unsigned works that they sent into the future.

I had read a lot about the fashions and frivolity of Paris. These were in evidence in every street, but the churches stood noticeably apart from these scenes. A man would forget the outside noise and bustle as soon as he entered one of these churches. His manner would change, he would behave with dignity and reverence as he passed someone kneeling before the image of the Virgin. The feeling I had then has since been growing on me, that all this kneeling and prayer could not be mere superstition; the devout souls kneeling before the Virgin could not be worshiping mere marble. I have an impression that I felt then that by this worship they were not detracting from, but increasing, the glory of God.

—MAHATMA GANDHI, *My Experiments with Truth: An Autobiography*, 1927

The Flight into Egypt According to Matthew

AN ANGEL OF the Lord appeared to Joseph in a dream and said, "Get up, take the child and his mother, and flee to Egypt, and remain there until I tell you; for Herod is about to search for the child, to destroy him." Then Joseph got up, took the child and his mother by night, and went to Egypt, and remained there until the death of Herod.

—MATTHEW 2:13–15

• • •

Rest on the Flight into Egypt, 1879
Luc Olivier Merson (1846–1920)
Oil on canvas
28.3×50.5" (71.8×128.3 cm)
Museum of Fine Arts, Boston

The *Rest on the Flight into Egypt* offers a humanized holy family. As Joseph sleeps on the sand under an expansive starless sky, the Virgin lies with the Christ child, resting briefly during their escape from Herod's murderous edict. Mother and child are cradled in the stone arms of the Great Sphinx, an arresting convening of civilizations. The desert setting is harsh and austere, yet this only amplifies the beauty of the scene. The slumbering baby Jesus radiates in his mother's arms with the promise of salvation. He is literally the light in the darkness and the living water that will quench the desert in the soul. The Sphinx peers knowingly into the infinite night, seemingly privy to the ancient mysteries of the universe.

Rest on the Flight into Egypt is an example of Orientalism, a style that began in early Netherlandish painting and flourished between the late-eighteenth and late-nineteenth centuries, when Europe began to colonize the Middle East. Many European artists and photographers traveled to Egypt and the Holy Land—places that held a certain mystique due to their role in Christian history—while others consulted travelogues and their own imaginations for inspiration. While some Orientalist works depict Eastern lands and people as decadently corrupt, often emphasizing the nude female form, works such as Luc Olivier Merson's deploy them as backdrops for a nascent Christianity.

Merson, who adhered to the ideals of Romanticism and Neoclassicism, was appointed a professor at Paris's famed École des Beaux-Arts in 1894 and left in protest when the école developed a program in modern-art studies. Merson enjoyed a diverse career, even designing French currency and postage stamps, and was honored with the Prix de Rome in 1869 as well as a gold medal and the Grand Prix at the 1889 and 1900 Expositions Universelles, respectively. He was made Chevalier, Officier, and Commandeur de la Légion d'Honneur in 1881, 1900, and 1920, the year of his death.

The Slaughter of the Innocents
According to Matthew

WHEN HEROD SAW that he had been tricked by the wise men, he was infuriated, and he sent and killed all the children in and around Bethlehem who were two years old or under, according to the time that he had learned from the wise men. Then was fulfilled what had been spoken through the prophet Jeremiah: "A voice was heard in Ramah, wailing and loud lamentation, Rachel weeping for her children; she refused to be consoled, because they are no more."

—MATTHEW 2:16–18

Holy Innocence

W E SELDOM REFLECT that the birth of Jesus was accompanied by excruciating violence and that Mary's joy was steeped in the maternal grief of others. Upon hearing that a rival king had been born, Herod, whose wrath and paranoia is well documented, went into a rage. He ordered that every male child under the age of two living in Bethlehem and its vicinity be killed, an event known as the Slaughter of the Innocents. Artists throughout the centuries have taken on this horrific subject, but perhaps no depiction is as tumultuous as the one seen in the floor mosaic in the Duomo in Siena, Italy. The scene is a confusion of soldiers, screaming women, butchered infants, and rearing horses. The nightmarish carnage forces us to face the broad, ubiquitous palette of suffering—the pain of the women who lost their children to Herod's madness reminds us, as well, of contemporary parents who have had to flee murderous political regimes, or those who wait and wonder if their soldier spouses will return home to their families.

The slaughter of innocent children throughout history is remembered on the Feast of the Holy Innocents, which the Church celebrates on December 28, three days after Christmas. Many of us pay scant attention to this feast day, hungover after the holidays and still making inroads into the cold roast beef and chocolates. We're oblivious to the cost and luxury of our relative safety in the modern world, and the cost of our own oblivion. And, when we do act, we quickly become aware of the limits of our help in the face of the world's deep need. When the holy monks of Christian antiquity described Mary as "the table at which faith sits in thought," they were calling attention to her own practice of reflection—*Mary treasured all these words and pondered them in her heart* (Luke 2:19)—and also her ability to inspire that same kind of reflection in us. Study-

The Crouching Venus
The Louvre
Roman copy after an original of the 3rd cent. B.C.
Marble, height 96 cm

The history of art is full of
 pain:
sometimes within the work,
 sometimes inflicted
on the body of the work
 itself
by acts of god or vandals,
 acid rain,
or fashion (later versions
 have rejected
seven of her belly's folds
 and creases,
smoothed her girth, sucked
 out her attribute
as goddess of inevitable
 birth
and left her slim, alone).
 Here, missing pieces
are not missed: coy arms
 that convolute,
her curly head, may sit upon
 a shelf.
But on her back, as if to
 budge the earth,
a tiny hand is still attached.
 I'm wild
with sudden grief. I have to
 find that child.

—MEREDITH BERGMANN,
2004

ing her example is a way to reconcile one's own vulnerability and confusion and find peace. Healing the strife that has marked the human condition since time immemorial is not possible for any one individual, and in that very impossibility we find an invitation to a deeper faith.

• • •

Slaughter of the Innocents, 1481
Matteo di Giovanni, designer (1435–1495)
Marble
Cathedral of Siena (Duomo), Italy

The extraordinary marble mosaics that cover the entire floor of the Siena Duomo comprise fifty-six panels of varying shapes and sizes depicting biblical scenes, sibyls, and allegorical subjects. The pavement, begun in 1369 and completed in the late fifteenth century, encompasses a century of artistic styles. In their original conception, this labyrinth of scenes was intended for the viewer to walk on, in, and through, becoming woven into the vast program; today, visitors can still see the pavement, although it is roped off. The panels in the transepts and apse are kept under protective coverings except for a period from late August to late October.

Following the layout of the pavement, the viewer journeys through the story of the Christian faith. One first encounters the pagan prophet Hermes Trismegistus, who medieval Christians believed foretold Christ's coming. A number of Old Testament scenes follow, depicting figures who were considered prefigurations of Christ and his sacrifice, such as Elijah, Samson, King David, and, immediately before the high altar, the Sacrifice of Isaac. At the north transept of the cathedral lies the Slaughter of the Innocents. King Herod directs his men to kill the children, and they pour into the streets with bloodthirsty élan. Mothers cling protectively to their infants and watch in horror as they are wrenched from their arms and hacked to pieces. Yet, just as Moses escaped Pharaoh's wrath, Christ, the new Moses who would lead his flock to the ultimate Promised Land, was spared from Herod's wicked edict.

Baby Clothes

ONE DAY, WHEN my son Emmet was four, I spent the day sorting through his baby clothes—three bags full, or, as he once sang the nursery rhyme, three bag fool. I was a three-bag fool, all right, weeping from the outset of this unavoidable rite of maternal passage.

The sentimental favorites were still scented with the perfumed paper that once lined his bureau drawers. There was a soft hat embroidered with a heart, his first gift, which was impossibly small and strangely alien to this first-time mother. *Oh,* it occurred to me when I received this present, *this thinglet inside will need clothes!* There was another hat, a jaunty cobalt-blue-and-yellow number, that Emmet wore on a walk one day in autumn, the glorious season of his birth. A fire-red leaf dropped into his carriage, alighted on the blue hat, and created an effortless, sublime work of art. I've kept it for the memory of that moment. And then there is a little green sweater, the most precious item of all.

On the second day of Emmet's life, the day we learned that he had sustained brain damage during delivery, four doctors crowded my hospital room, covering their lack of a prognosis with a numbing display of gray films showing the inside of my son's head. All I heard was that he might never walk or ride a bicycle. After dropping this bombshell, they urged my husband and me to go out for a walk, to physically remove ourselves from the place that suddenly had become hell.

I wobbled down to the lobby, where tables full of hand-knit sweaters were on sale to support the hospital. A miniature green sweater with Venetian glass buttons caught my eye. I picked it up and put it down repeatedly. What need was there for an expensive sweater when everything was on hold? Then something fierce and ancient bloomed in me. Bikes or no bikes, my son would have a good life, with leaf-green cardigans and all the kisses he could

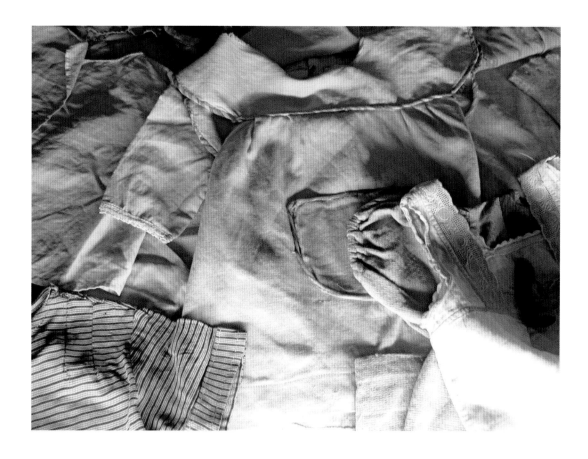

• • •

Baby's Clothes, Auschwitz, 2004
Judith Dupré
Digital print
Auschwitz–Birkenau Memorial and Museum, Oswiecim, Poland

Those who survived the selection process at Auschwitz, which determined immediate death or a slower one through malnutrition, excruciating labor, and disease, were tattooed with identifying numbers. Once reduced to the random string of bluish digits pierced into their forearms that indicated when they had arrived at the camp, individuals were stripped of everything else—their clothes, hair, dignity—and became like any one of a billion stars, which are so numerous that most are numbered and not named. An estimated one to one and a half million individuals, some of them children, were murdered at the Auschwitz–Birkenau concentration camp. The infant clothing displayed in the Block 5 barrack, now a museum, evokes the memory of the innocent children who once wore them and the anguish of their mothers.

stand. No matter what. It was the one thing that I could control in an unpredictable world. Two days after giving birth, I had become a mother.

Years later, these memories tumble back at the sight of the infant clothes encased in Auschwitz, Block 5. They are delicately embroidered and smocked. The deported mothers, after all, had been told to take along their best things in their suitcases, which, like the fathers of their children, were wrested from them upon arrival at the concentration camp. The fragility and size of the outfits lacerates the heart, but my mourning wells up from understanding that these mothers lost something far more precious to them than their own lives, if that can be imagined. They lost their maternal right to protect their beloved sons and daughters, many of them babies still in their first clothes. Words are helpless to describe what they must have suffered.

Jesus in the Temple According to Luke

GUIDED BY THE Spirit, Simeon came into the temple; and when the parents brought in the child Jesus, to do for him what was customary under the law, Simeon took him in his arms and praised God. . . . And the child's father and mother were amazed at what was being said about him. Then Simeon blessed them and said to his mother Mary, "This child is destined for the falling and the rising of many in Israel, and to be a sign that will be opposed so that the inner thoughts of many will be revealed—and a sword will pierce your own soul too." —LUKE 2:27–28, 33–35

NOW EVERY YEAR his parents went to Jerusalem for the festival of the Passover. And when he was twelve years old, they went up as usual for the festival. When the festival was ended and they started to return, the boy Jesus stayed behind in Jerusalem, but his parents did not know it. Assuming that he was in the group of travelers, they went a day's journey. Then they started to look for him among their relatives and friends. When they did not find him, they returned to Jerusalem to search for him. After three days they found him in the temple, sitting among the teachers, listening to them and asking them questions. And all who heard him were amazed at his understanding and his answers. When his parents saw him they were astonished; and his mother said to him, "Child, why have you treated us like this? Look, your father and I have been searching for you in great anxiety." He said to them, "Why were you searching for me? Did you not know that I must be in my Father's house?" But they did not understand what he said to them. Then he went down with them and came to Nazareth, and was obedient to them. His mother treasured all these things in her heart. And Jesus increased in wisdom and in years, and in divine and human favor. —LUKE 2:41–52

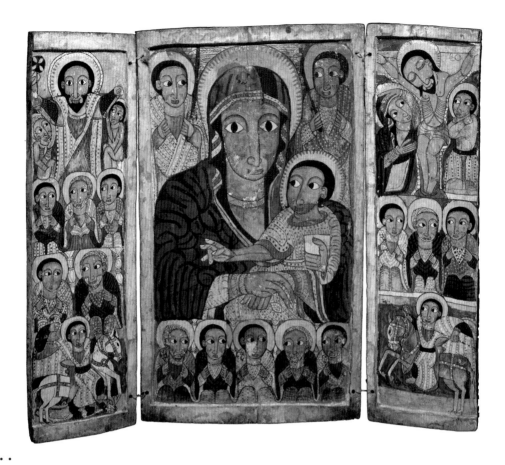

• • •

Mary and Her Son and Christ Teaching the Apostles, late 17th–early 18th cent.

Anonymous (Ethiopian)

Tempera paint on wood

Center panel: 15×8.75″ (38.1×22.22 cm)

Walters Art Museum, Baltimore, Maryland

Mary gazes at us with huge, watchful eyes in this lyrical, haunting African triptych. Mother and son are flanked by angels, Sts. George and Mercurius on horseback, and by the apostles, who are seated in rows on the central panel and wings. The figures' expressive eyes animate the piece, as do their stylized speckled robes. In the upper left corner, the resurrected Christ holds a cross, symbolizing victory over death. Aksum (now Ethiopia) was a Christian kingdom since the fourth century c.e. The East African kingdom established trade ties with nations around the Mediterranean, which opened the culture to broad religious and artistic influences. Ethiopian artists absorbed these outside influences in their works but infused them with a unique and exuberant sense of color and pattern. By the fifteenth century, when Emperor Zara Yaqob—a zealous defender of the faith—made veneration of Marian icons mandatory, Ethiopian painters had developed an iconic tradition that rivaled those in Byzantium and Russia. That living tradition is still practiced today. The Walters Art Museum, where this piece is held, has one of the largest collections of Ethiopian art outside Africa.

A New Understanding

MARY'S EXPERIENCES AS a mother, her intense joy as well as her unfathomable grief, shed light on the un-avoidable fate of all parents—to love but lack the ability to ever fully understand, or protect, their children. This is particularly evident in two temple scenes reported by Luke, which illuminate Mary's growing realization of her child's unique destiny. In Chapter 2, Mary and Joseph bring the infant Jesus to be circumcised eight days after his birth, as was customary under Jewish law. They are met at the temple by the elderly Simeon, who tells Mary, "*A sword will pierce your own soul,*" words that foreshadow the anguish of the crucifixion and also describe the unspoken but ever-present fears for one's child that are implanted in a mother's heart, seemingly at the moment of delivery, if not sooner.

In the second scene, twelve years later, the Holy Family has been in Jerusalem for the annual Passover celebration. Since they are returning home with a large group, they don't notice that Jesus is missing. It both astonishes and annoys his parents when, after three days of searching, they find him back in the Jerusalem temple, discussing weighty theological issues with the elders. Here we witness a rare, justifiable spark of maternal impatience from Mary, who chastises her son for leaving the group. Jesus, speaking for the first time in Scripture, professes surprise that his parents were not aware that he *must be in my Father's house,* the first indication of his messianic authority. His parents, however, fail to understand the implications of his words. Mary is learning, as she will again and again over the years, that her child has a singular path.

A few years ago, I received a letter from my friend Meredith that cast the nuances of the temple narratives in a new light. While her note specifically addressed a breakthrough for her teenage son, Danny, who is autistic, it also illuminated the idea of staying power and the kind of parental endurance that requires drawing on one's

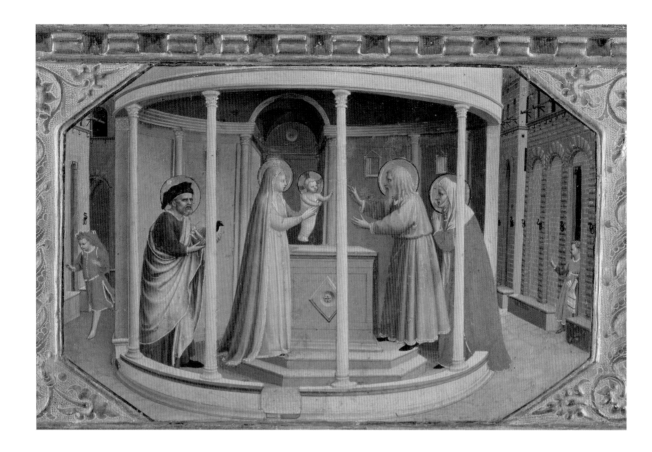

untapped spiritual resources. After spending years looking for a program that would help their son, Meredith and her husband found one that finally, for the first time, enabled him to communicate his thoughts to them. They were amazed to learn that not only could Danny spell words like *liquid* and do arithmetic, but he had opinions about the presidential candidates, wanted to know about war, and wished he had a canary, something his parents had never discussed. From then on, month by slow month, his parents learned things about their child that they could not have imagined during what Danny has since dubbed his "mute period."

In subsequent conversations with other parents of autistic children, the wide spectrum of autistic behaviors emerges, as do the strains caused by the unpredictability of these behaviors, high cost of treatment, and unrelenting toll it can take on siblings and mar-

The Annunciation (detail), ca. 1427
Fra Angelico (ca. 1390–1455)
Tempera and gold on panel
13.8×9″ (35×23 cm)
Museo del Prado, Madrid

Little is known of the life of Guido di Pietro before he traveled to Florence to study manuscript illumination, where the monk Lorenzo Monaco, the leading Florentine illuminator and painter at the time, may have helped train the young artist. Pietro eventually joined the convent of St. Dominic, taking the name Fra Giovanni. In time, he would pioneer many of the artistic developments of the early Renaissance; due to his skill and influence he became known posthumously as Fra Angelico, the "Angelic Brother."

This picture is a predella, one in a series of small panels illustrating the life of the Virgin at the bottom of *The Annunciation* altarpiece. Intended to be viewed closely, the intimate piece allowed the artist to indulge in a degree of detail impossible in the larger, attention-grabbing image above it. Here, Joseph and Mary have brought Jesus to the temple to be circumcised. Joseph walks behind Mary, carrying birds for a ritual sacrifice. Approaching from the right are Simeon, in red, and Anna, an aged prophetess, in green. Two unidentified figures, one on either side of the frame, balance the composition.

Joseph, Mary, Simeon, and Anna's halos mark them as saints; Jesus's halo includes a cross, which in Western art is a feature unique to members of the Trinity. The colors of Mary's and Joseph's clothing mirror each other; they are clad in the sumptuous color blue, setting them apart and signaling their importance. The stiffness of Mary's body is difficult to miss; she is the only person who does not bend or appear to be in motion. She hesitates to hand her son to the man who will introduce her to Jesus's destiny. This is not simply a presentation of Jesus to be circumcised but also the moment when Mary glimpses her son's fate.

riages. Some autistic children need constant supervision, while others can dress and groom themselves. One little boy, whose drawings look like those produced by professional engineers, lacks an understanding of the rules of social interaction, and cannot bear to deviate from established routines—protesting, for instance, when his parents take an alternate road to a destination. One teenager is learning how to hold a job and navigate her community with the help of trained personnel, but, as her mother observed, "Her reality is different than mine. I know her as much as she allows me to know her." All parents spoke about their tenacious search for the right doctors, therapists, programs, interventions, and funding that would help their children.

It's a process of hanging on, but also one of letting go. One mother, Leslie, said, "You have to let go of the hopes you had—of

your child going to college, of becoming grandparents," adding that, "even more letting go is going to have to happen as my daughter gets older." As Kate put it, "When we received James's diagnosis, I thought of my father, who died suddenly in the prime of his life. At that time, a priest told us we were 'mourning a dream of what was never going to be.' That's how it felt with James, although he has brought us so many other gifts." Susan, whose son, Peter, is moderately autistic, said, "For a long time, I prayed for the magic pill/therapy/school that would change things—my knees are arthritic from prayer—but now I see that it is I who have changed. I see myself in a different light because of the way the world views my son. Through Peter, I've learned that my faith needed some work. His disorder is about not being in control of anything, while we typically healthy people think we are in control of everything. You have to give that control back to God."

One can imagine, almost, the joy of daily small victories that allow both child and parent to scale autism's invisible walls. The gratification that comes from such faithful patience may not be immediate but rather is that more-rare happiness that arises from pulling long and hard from a place deep within oneself. There is a profound connection between children's blossoming and their parents' steadfast courage. Like Mary and Joseph, these mothers and fathers love their exceptional children, even as they cannot always follow where they lead.

Here we are, each of us a tiny universe that can only glimpse the universe of the other, even when that "other" is our own child. We cannot know the inner recesses of another person's soul, those mysterious gulfs that mark the inevitable distance that exists between individuals. As parents or caretakers, we plan, hope, and nurture, but the day comes when our children let go of our hands and venture forth into the world to taste it on their own terms, and that world—their world—is not ours to know. For parents of autistic children, there are additional layers of surrender. Often they can do no more than stand by and try to manage the frustration arising from the mutual inability to enter the other's world. They bear the burden of watching their children suffer from the inability to express what they sense and know about the spectrum of human reality.

In *The Siege* (1967), the first book-length account by an American mother about the emotional and physical burdens of raising an autistic child, Clara Park eloquently observes that her daughter "moved, every day, among us but not of us, acquiescent when we approached, untouched when we retreated, serene, detached, and in perfect equilibrium. Existing among us, she had her being elsewhere." Park's description of the "terrible imperative of the assault of love" echoes Mary's experience so long ago. She, too, was called to trust the ways of the child who was hers but not hers. She had to grapple with her own lack of comprehension and, later, that of the crowds who did not grasp what her son was trying to say. Once Christ's ministry was under way, she heard him preach about the larger family of God, as reported in three gospel accounts, and listened as her son appeared to diminish her singular maternal role, telling those gathered that anyone who does the will of God was his mother. We have no way of knowing how often Mary bore such silent witness, but her brief appearances in Scripture indicate that she frequently did so. Although neither she nor the gathered crowds could always understand her son's actions and words, she entrusted herself, and him, to God and to the seeming darkness that precedes the light of a new understanding.

Me Judah's daughters once caressed,
Called me of mothers the most, the most blessed.
Now fatal change, of mothers most distressed.
How, how shall my soul its motions guide?
How, how shall I stem the various, various tide,
Whilst faith and doubt my laboring soul divide?
For whilst of thy dear, dear sight beguiled,
I trust the God, but oh! I fear, but oh! I fear the child.

—NAHUM TATE, from *The Blessed Virgin's Expostulation,* 1693

Who Is My Mother? According to Matthew, Mark, and Luke

WHILE HE WAS still speaking to the crowds, his mother and his brothers were standing outside, wanting to speak to him. Someone told him, "Look, your mother and your brothers are standing outside, wanting to speak to you." But to the one who had told him this, Jesus replied, "Who is my mother, and who are my brothers?" And pointing to his disciples, he said, "Here are my mother and my brothers! For whoever does the will of my Father in heaven is my brother and sister and mother."

—MATTHEW 12:46–50

THEN HIS MOTHER and his brothers came; and standing outside, they sent to him and called him. A crowd was sitting around him; and they said to him, "Your mother and your brothers and sisters are outside, asking for you." And he replied, "Who are my mother and my brothers?" And looking at those who sat around him, he said, "Here are my mother and my brothers! Whoever does the will of God is my brother and sister and mother."

—MARK 3:31–35

THEN HIS MOTHER and his brothers came to him, but they could not reach him because of the crowd. And he was told, "Your mother and your brothers are standing outside, wanting to see you." But he said to them, "My mother and my brothers are those who hear the word of God and do it."

—LUKE 8:19–21

The Wedding at Cana According to John

ON THE THIRD day there was a wedding in Cana of Galilee, and the mother of Jesus was there. Jesus and his disciples had also been invited to the wedding. When the wine gave out, the mother of Jesus said to him, "They have no wine." And Jesus said to her, "Woman, what concern is that to you and to me? My hour has not yet come." His mother said to the servants, "Do whatever he tells you." Now standing there were six stone water jars for the Jewish rites of purification, each holding twenty or thirty gallons. Jesus said to them, "Fill the jars with water." And they filled them up to the brim. He said to them, "Now draw some out, and take it to the chief steward." So they took it. When the steward tasted the water that had become wine, and did not know where it came from (though the servants who had drawn the water knew), the steward called the bridegroom and said to him, "Everyone serves the good wine first, and then the inferior wine after the guests have become drunk. But you have kept the good wine until now." Jesus did this, the first of his signs, in Cana of Galilee, and revealed his glory; and his disciples believed in him. After this he went down to Capernaum with his mother, his brothers, and his disciples; and they remained there a few days.

—John 2:1–12

[Mary] stands in solidarity with women around the world who struggle for social justice for themselves and their children, especially daughters. "They have no wine," nor security from bodily violation, nor access to education, health care, economic opportunity, nor political power, nor cultural respect because of their race or ethnic heritage, nor dignity due their persons as created in the image and likeness of God herself. Uttering these words, women can be empowered to turn away from socialized lack of self-esteem and docile acceptance of marginalization to engage instead in critical praxis on behalf of their own good. Every step to secure these human blessings, starting with the cry "we do not have it, we should have it," shares in God's own compassionate desire to establish the divine reign of justice on this earth.

—ELIZABETH A. JOHNSON,
Truly Our Sister, 2003

• • •

The Wedding Feast at Cana, 1562–1563
Paolo Caliari, known as Veronese (1528–1588)
Oil on canvas
22′2″×32′6″ (6.77×9.94 m)
Musée du Louvre, Paris

Paolo Caliari, known as "Veronese" after his native Verona, was a painter of the Venetian school in the sixteenth century. The son and grandson of stonecutters, Paolo began his artistic training around the age of thirteen with Antonio Badile before being taught by Giovanni Caroto, both painters in Verona. By the early 1550s, he was taking commissions for work outside Verona.

In 1562, Veronese was commissioned to execute a canvas for the newly built refectory, or communal dining room, designed by Andrea Palladio for the Benedictine monastery on the Venetian island of San Giorgio Maggiore. The result was the massive *Wedding Feast at Cana,* which is two stories tall, more than seven hundred square feet in area, and depicts 130 figures. The work's enormous size is attributed to the monks' request that it fit the entire back wall of the refectory.

Veronese has relocated the wedding feast to Venice, with Doric and Corinthian columns framing the scene. Corinthian columns were popular in Venice at the time, thanks to Palladio's influence, and could be

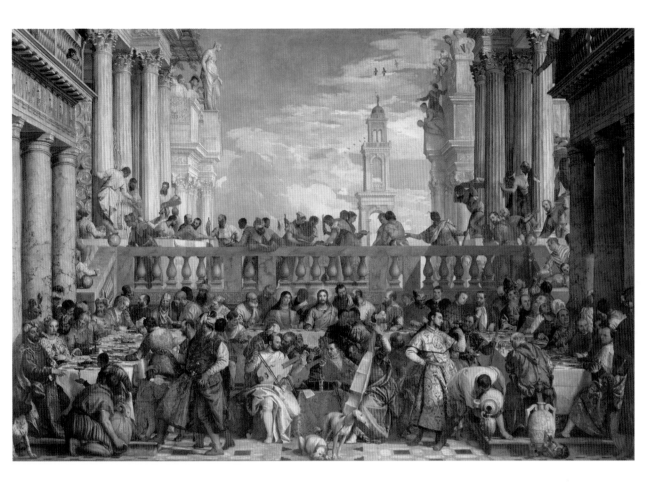

found throughout the city. Jesus is in the center of the table and stares directly at the viewer, his face highlighted by the aurora around his head. Mary, in a blue robe and black veil, is seated to Jesus's right; she too has an aurora but it is dimmer than her son's. The other attendants at the feast are dressed in styles from a variety of eras and locations: Turbaned men from the Orient sit near figures in Biblical dress and modern-day Venetians. Legend has it that the artist painted himself as a musician in white holding a viola da gamba. Dogs, multiple birds, and a cat add to the sense of chaotic activity.

Jesus and Mary are present within the action but removed from it; they are serene in the midst of revelry. In the center of the painting, directly above Jesus's head, are a group of servants butchering an animal, a foreshadowing of the Passion. The significance of the painting's contemporary setting, confirming the timeless nature of Christ's ministry, would not have been lost on the monks who daily sat for meals below an image of Christ and Mary doing the same.

The Holy House of Loreto

IN 1969, THE historic Apollo 11 mission that landed on the moon carried a medal imprinted with the image of Our Lady of Loreto, who had been declared the patroness of aviation in 1920. Charles Lindbergh hung a similar medal in the *Spirit of Saint Louis* while making the first nonstop transatlantic flight in 1927 and later recalled in his memoirs the gentle tapping of the medal against the cockpit, which kept him company during his voyage.

Those who travel through air and space place their trust in Our Lady of Loreto because of the unusual origin of her eponymous shrine, the Holy House of Loreto. That structure, which pious tradition says is the house where Mary was born and the Word became incarnate, was miraculously transported by angels from Nazareth in 1291. It alighted at various, ultimately unsuitable locales, before eventually landing permanently in 1294 atop a hill overlooking the Adriatic coast of central Italy. The more literal-minded think it was likely moved by human means, possibly by Crusaders.

Translatio Miraculosa Ecclesie Beate Marie Virginis de Loreto, the earliest-documented narrative of the house's journey, or "translation," was written in the early 1470s by the shrine's guardian, Pietro di Giorgio Tolomei, who was called Teramano. According to his account, flights of angels whisked Mary's house away from Nazareth to save it from destruction after the last Christian stronghold in the Holy Land, Acre, fell to the Saracens in 1291. The angels carried the humble dwelling first to a hill near Fiume, now Rijeka, in Croatia, then, in 1294, to the province of Recanati, where they twice unsuccessfully attempted to relocate the house. Finally finding a preferable spot, also in Recanati, the angels settled the house on the hill where it stands today. The relic's cautious itinerary served to spotlight the virtue of Loreto's citizens and the notion that a sacred place was different in some substantial way from other places.

Beginning in the late thirteenth century, various experts in diverse scientific fields conducted tests to verify the house's authenticity. Its measurements were compared against the house foundations that remained in Nazareth, and the composition and origin of the stones used in its construction were analyzed. Much was made of the fact that the house at Loreto lacked a foundation, which corroborated with the remains in Nazareth, where the church above Mary's house had been destroyed. Verification of these structural correspondences affirmed not only authenticity of the relic itself but the explicit connection that existed between the Loreto site and the Palestinian cradle of Christianity. At a time when connections to the Holy Land were becoming tenuous, if not lost altogether, the translation of the relic also transferred to the West the sacred memory of the Holy Land, assuring it would not be lost to the collective consciousness but rather reborn to new generations of devotees.

The growing theological importance of Loreto was underscored by the attention lavished on the site by a string of popes, beginning with the pontificate of Paul II and continuing under the Renaissance pontiffs, especially Sixtus IV, Julius II, and Leo X. Julius II (r. 1503–1513) officially sanctioned the translation of Mary's home to Loreto in his 1507 bull, *In sublimia,* and commissioned Donato Bramante (1444–1514) to design the basilica to house it, the realization of which would galvanize the talents of the greatest artists and architects of the time. The remains of the one-room stone and brick house, measuring twenty-eight feet by twelve feet six inches, are encased in an elegant white Carrara marble shell designed by Bramante in 1509 and executed by Andrea Sansovino (ca. 1467–1529). Later, major artists, including Sansovino and Francesco da Sangallo (1494–1576), created the half columns, friezes, statues, and sculptural reliefs that adorn its exterior. The deep furrows on the floors around the marble chamber were made by centuries of pilgrims, who moved on their knees around the enclosure before entering the Holy House itself.

The Litany of Loreto, a hymn of praise and supplication that invokes Mary's many honorific names, was sung at the shrine and

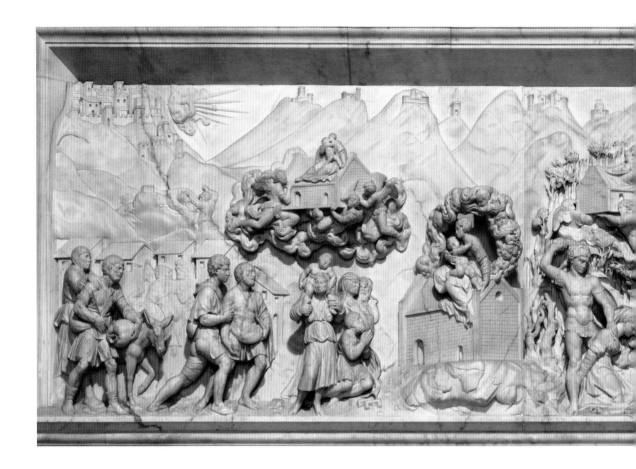

• • •

Translation of the Holy House, 1530

Holy House *rivestimento,* ca. 1509–1587 (restored 1993)

Donato Bramante (designer), Francesco Sangallo and Niccolò Tribolo (sculptors)

Marble

28×45′ (8.5×13.7 m)

Loreto, Italy

Sculptural reliefs on each face of the marble *rivestimento* that encloses the Holy House of Loreto depict key moments in the Virgin's life. Upon approaching the Holy House, the viewer first sees the Annunciation, which is the largest of the panels. Mary, startled, looks up from her reading as angels rush in from the left. The same sense of immediacy permeates the other reliefs: Mary tenderly attends to Christ in the Adoration of the Shepherds, and mother and son affectionately grasp hands in the Adoration of the Magi. Equally compelling is a depiction of the translation of the Holy House itself, in which Mary cuddles and kisses her son on the roof of their home.

 The Translation relief depicts the house's miraculous relocations in one continuous narrative. Angels float in from the right, carrying the cottage to a laurel grove in Recanati, Italy. Yet bandits set upon the devotees,

Indeed, the Holy House of Loreto is steeped in over five centuries of pious legend and sacred ritual. Its identification as the house of the Virgin, and site of the Incarnation, makes it unique to the Catholic tradition as a spatial relic where earthly and celestial domains converge.

—ADRIANNE HAMILTON, "Translating the Sacred," 2008

indicating that this location is unsuitable. The house is spirited away to a mountainous countryside, shown in the background, but this location also proves unacceptable, as the landowners there quarrel violently. In the left foreground, the Holy House is shown at its final destination, where Loretans venerate the home and its royal inhabitants. The Virgin and Child descend, their own peregrinations now complete, and greet the pilgrims.

Nearly a century in the making, the *rivestimento* was designed by Donato Bramante and completed in 1587, after his death; it was restored in 1993. Bramante designed a number of works that recall the architectural style of imperial Rome, most notably the initial structure of St. Peter's Basilica in Rome. The structure of the *rivestimento* visually quotes the archetypal form of the Roman triumphal arch, yet it also incorporates papal insignia, thereby implying that Christianity and the Holy See are heirs to the authority once wielded by ancient Rome.

from there was carried by pilgrims throughout the world. Its exact origins are unknown, but the litany was being sung at the shrine by the mid-sixteenth century; a printed version was available by 1558, although earlier aural versions existed. In the litany, Mary is named as a mystical rose, tower of ivory, house of gold, and morning star—natural and architectural symbols taken from the Old Testament. Each Marian invocation is followed by the phrase "Pray for us," creating an aural rhythm that mirrors the cyclical, ongoing cadences of daily life.

Loreto's miraculous pull intensified. It was the foremost Marian shrine in Christendom, inspiring other Loretan shrines to be built throughout Europe, until the promotion of Fatima in Portugal and Lourdes in France in the nineteenth century. In addition to the forty-seven popes who have honored Loreto's shrine, royalty have added their jewels to the mountains of glittering donations, and Mozart played the organ in its church. Unschooled pilgrims rubbed shoulders with the sainted Charles Borromeo and Ignatius of Loyola, scientists such as Galileo, and a wide circle of intellectuals including Michel de Montaigne. Even René "I think, therefore I am" Descartes, to whom we owe the philosophic shift away from faith to reason, is thought to have fulfilled his vow in 1620 to make a pilgrimage to Loreto after his dream of violent winds in 1619.

Inscribed *Hic verbum caro factum est* ("Here the word was made flesh"), the Loreto shrine enfleshes the mystical imagination as well. Although the house was a rough domestic structure, its crucial function was as a symbolic, centering device that focused its viewers on the theological mystery of the Incarnation and transported them, emotionally and mentally, to the *loca sancta*, holy sites, of Palestine. The image of the house sparked the imagination of the faithful. The resultant spiritual experience can be understood on a symbolic level: The structure was identified by the Loretan pilgrim not only with Nazareth and Mary's house but with the very body of Mary—at the moment she was impregnated. Thus activated by the physical structure of the house, the pilgrim participated in the biblical events of centuries earlier. While it is also true that the house at Loreto was used to underscore the authority of the

Roman Church by establishing a regional, soon universal, shrine that partook of the actual fabric of the Holy Land, the resonant power of the little cottage, however buried beneath marble and gilding, emanates from its ability to activate the topography of Christian remembrance.

Holy Mary, *pray for us.*
Holy Mother of God, *pray for us.*
Holy Virgin of Virgins, *pray for us.*
Mother of Christ, *pray for us.*
Mother of Divine Grace, *pray for us.*
Mother Most Pure, *pray for us.*
Mother Most Chaste, *pray for us.*
Mother Inviolate, *pray for us.*
Mother Undefiled, *pray for us.*
Mother Most Amiable, *pray for us.*
Mother Most Admirable, *pray for us.*
Mother of Good Counsel, *pray for us.*
Mother of Our Creator, *pray for us.*
Mother of Our Savior, *pray for us.*
Virgin Most Prudent, *pray for us.*
Virgin Most Venerable, *pray for us.*
Virgin Most Renowned, *pray for us.*
Virgin Most Powerful, *pray for us.*
Virgin Most Merciful, *pray for us.*
Virgin Most Faithful, *pray for us.*
Mirror of Justice, *pray for us.*
Seat of Wisdom, *pray for us.*
Cause of Our Joy, *pray for us.*
Spiritual Vessel, *pray for us.*
Vessel of Honor, *pray for us.*

Singular Vessel of Devotion, *pray for us.*
Mystical Rose, *pray for us.*
Tower of David, *pray for us.*
Tower of Ivory, *pray for us.*
House of Gold, *pray for us.*
Ark of the Covenant, *pray for us.*
Gate of Heaven, *pray for us.*
Morning Star, *pray for us.*
Health of the Sick, *pray for us.*
Refuge of Sinners, *pray for us.*
Comforter of the Afflicted, *pray for us.*
Help of Christians, *pray for us.*
Queen of Angels, *pray for us.*
Queen of Patriarchs, *pray for us.*
Queen of Prophets, *pray for us.*
Queen of Apostles, *pray for us.*
Queen of Martyrs, *pray for us.*
Queen of Confessors, *pray for us.*
Queen of Virgins, *pray for us.*
Queen of All Saints, *pray for us.*
Queen Conceived without Original Sin, *pray for us.*
Queen Assumed into Heaven, *pray for us.*
Queen of the Most Holy Rosary, *pray for us.*
Queen of Peace, *pray for us.*
—LITANY OF LORETO

The Mysteries

SAYING THE ROSARY is a way of praying that puts us in living communion with the same events that Mary is said to have pondered, and treasured, in her heart. Above all, Mary's contemplation of her son is a remembering. The rosary is structured around the joyful, sorrowful, glorious, and luminous events, or mysteries, in the lives of Mary and her son. It is a gradually unfolding prayer of praise, petition, and contemplative remembrance. In harmonious succession, those praying the rosary recall the principal salvific events accomplished in Christ, from his Incarnation to the Resurrection. The recollection of each mystery is followed by a litany of ten Hail Marys, placing the milestones of Christ's life in the context of his mother's faith journey. Thus rooted in Christ, "our peace," the rosary is a supplication for individual and collective peace.

The fifteen traditional mysteries are organized into three parts. They adhere to the chronology of events as they are recounted in the gospels but are organized as well by the emotions—glad, sad, awe-inspiring—that these episodes evoke. They are the Joyful Mysteries (Annunciation, Visitation, Nativity, Presentation, and Finding in the Temple); the Sorrowful Mysteries (Agony in the Garden, Scourging at the Pillar, Crowning of Thorns, Carrying of the Cross, and the Crucifixion), and the Glorious Mysteries (Resurrection, Ascension, Descent of the Holy Spirit, Assumption, and Coronation). An individual recites the rosary by meditating on a specific event from one set of mysteries followed by the Hail Marys. Some people assign days of the week to the mysteries, reflecting on the Joyful Mysteries on Mondays and Saturdays, for instance, although personal preferences may guide the choice of mysteries considered at any given time. In 2002, Pope John Paul II suggested that five new Luminous Mysteries (Christ's Baptism in

the Jordan, the Wedding at Cana, the proclamation of the King-
dom, Transfiguration, and the Institution of the Eucharist) be
added, to deepen the experience of this mystical path to holiness.
Taken together, the mysteries present the depth and breadth of
the gospel message.

Salve, Regina, mater misericordiae:
vita, dolcedo, et spes nostra, salve.
Ad te clamamus
exsules filii Hevae.
Ad te suspiramus
gementes et flentes in hac lacrimarum valle.
Eia, ergo, advocata nostra,
illos tuos misericordes oculos ad nos converte.
Et Iesum, benedictum fructum ventris tui,
nobis post hod exsilium ostende.
O clemens, O pia, O dulcis Virgo Maria.

—"Salve Regina," attributed to
Hermannus Contractus, eleventh century

• • •

Passion Painting, 1997
Patty Wickman
Oil on canvas
60×90" (152.4×228.6 cm)
Collection of Mary-Louise and Haig Injijian

While at a flea market, artist Patty Wickman was struck by the sight of a young woman wrapped in a blanket, sleeping at a card table while her father was setting up their booth. The image inspired this dreamlike, contemporary portrayal of Mary asleep on a patio in the suburbs of Southern California. It is not clear from the painting's equally enigmatic title if Mary is dreaming of the Passion her son will endure, if she has collapsed, exhausted, after witnessing his suffering, or, like the apostles who accompanied Christ to Gethsemane, she has fallen asleep despite herself. Symbols rooted in everyday life—a rooster, an overturned bowl, and a garden statue of a lamb—also make reference to the events accompanying Christ's last days. Just over the young woman's head, a passion-flower plant grows on a uterine-shaped trellis, an allusion to the destiny of the fruit of her womb and the new life it made possible. The dog, traditionally a symbol of faithfulness, has been alerted to something just outside the picture frame, possibly an intruder. His alert gaze makes us aware that the woman is both vulnerable and protected. That same sense of human frailty is expressed by the single finger, a thumb, that peeks out of the blanket. It also is a reference to the *Madonna of the Thumb,* a popular seventeenth-century devotional painting attributed to a follower of Carlo Dolci; according to the artist, reproductions of the painting show up at flea markets all the time.

Wickman's evocative but elusive imagery seeks to describe a moment of revelation, a transformative instant when everything is about to change. A practicing Catholic, she began to explore spiritual themes in her work about a decade ago, feeling the need to synthesize her spiritual and artistic lives. She has said that she is "drawn to figures and situations that manifest a weakness, vulnerability, or brokenness—situations in which the possibility of grace and redemption are most present."

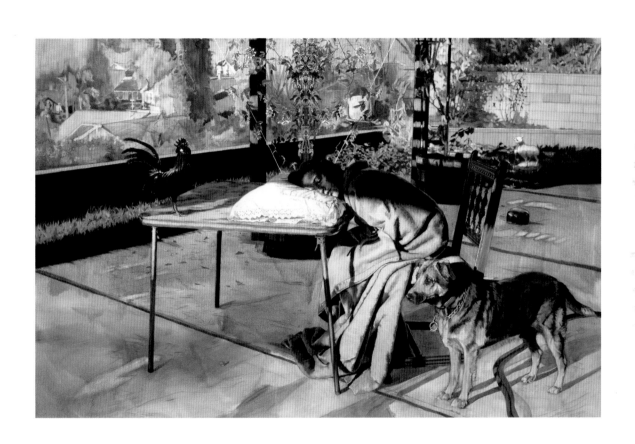

The Power of Prayer: Saying the Rosary

Hail, holy Queen, Mother of
 mercy,
our life, our sweetness, and
 our hope.
To you we cry, the children
 of Eve;
to you we send up our sighs,
mourning and weeping in
 this land of exile.
Turn, then, most gracious
 advocate,
your eyes of mercy toward
 us;
lead us home at last
and show us the blessed
 fruit of your womb,
Jesus:
O clement, O loving, O
 sweet Virgin Mary.

—"Salve Regina," U.S.
Catholic Conference of
Bishops translation

A LOT OF my time is spent driving between New York and New Haven on that little stretch of Route 95 that I call Dante's Ninth Circle, the very depths of hell that the poet described in the *Inferno*. My commute is at least an hour long, so there's plenty of time to think and pray; I stopped listening to the radio long ago. Feeling the pressure like everyone else to do, do, do, I decided to multitask while driving. One afternoon, using a rosary inherited from my grandmother—a delicate string of beads, each one no larger than an apple seed—I attempted to say the rosary while hurtling forward at seventy miles an hour. Somewhere between the second and third set of Hail Marys, Mary said, This is a really bad idea, Jude. I mean, really. You'd be better off listening to Neil Diamond.

As usual, she was right.

At its heart, the rosary is meant to be not just one task among others but a contemplative prayer, attuned to the lingering rhythms of memory and life. From the Latin *rosarium*, meaning "rose garden," this circlet of fifty-nine beads is meant to be fingered, one bead at a time. It consists of four prayers—creed, Lord's Prayer, Hail Mary, and doxology (the Glory Be)—that are said sequentially, starting at the crucifix, before moving through the sets of ten Hail Marys. Lingering at the single beads, one focuses on a particular mystery, or milestone, in Christ's life, as seen through the lens of his mother's heart. Saying the rosary as we know it today is a devotion that gradually took shape by the fifteenth century, but the practice waned after the Second Vatican Council flushed out what were considered theologically retrograde practices, causing what John Paul II called "a crisis of the rosary." In fact, praying with beads is an ancient meditative practice with deep roots in Hinduism, Buddhism, and Islam. As increasing numbers of people rec-

ognize the benefits of meditation and the simple joys of silence, the contemplative practice of saying the rosary has gained new adherents.

So, clearly, Route 95 at rush hour is no place to meditate with the rosary. But to defend my pragmatism, and the power of prayer in the minds and hearts of ordinary believers, let me tell you about my late great-aunt Mary, the practical prayer warrior in our family and one of the funniest and most faithful women on earth. Single-handedly, it seemed, she fed and educated the poor of Haiti with money she earned from her job and sent to the missionaries there. Her job? Praying. In exchange for a few dollars, she would say prayers of every sort—the classics, like the Lord's Prayer, but also anonymous prayers collected on snippets of paper that filled the margins of her life and were scattered between its lines. *There is no door that enough love won't open.* Her great devotion was to Mary, and her primary prayer was the Hail Mary, which she recited over and over again as she sprinted her way around the rosary like an athlete in training for paradise.

In her world, such intense Marian devotion was not unusual. She lived in Rhode Island, still a stronghold of Roman Catholicism, in a Providence neighborhood once populated by Italian American immigrant families headed by stalwart matriarchs, who wielded their power through unshakable faith and eggplant parmigiana to die for. Their rituals honoring Mary at times occupied the ambiguous territory between mystical belief and medieval superstition. Most were Neapolitans (sensuous red-sauce Italians, not to be confused with the elegant white-sauce Italians in the north) who spoke in proverbs, buried statues of St. Joseph in the front lawns of homes they hoped to buy, and prayed, unendingly. *With Mary, we cannot fail.* Prayer was not a Sunday thing; it was the only thing.

Aunt Mary carried a ledger wherever she went. In that big book was a careful accounting of those she was praying for, their heart's desires, and what they had paid her. Yes, this was holy commerce with a straightforward price list: a dollar for a general intention, five dollars for a good husband, twenty-five dollars for the impossible. In her mind, this was a simple exchange: If God gave

Hail, holy Queen, Mother of
 mercy;
our life, our sweetness, and
 our hope.
To you we cry,
poor banished children of
 Eve.
To you do we send up our
 sighs,
mourning and weeping in
 this valley of tears.
Turn then, most gracious ad-
 vocate,
your eyes of mercy toward
 us,
and after this our exile
show unto us the blessed
 fruit of your womb,
 Jesus.
O clement, O loving, O
 sweet Virgin Mary.

—"Salve Regina," traditional
English translation (North
America)

The Oblate presiding at my aunt Mary's funeral Mass said of her pepper biscuits, those crunchy miracles she wrought in her kitchen, "You just know each one of them was made with a Hail Mary." And, yes, she charged for her recipes, twenty-six cents each, oddly enough. Here's the recipe (make a donation where you will):

MARY D'AGOSTINO'S
PEPPER BISCUITS

2 c. flour
¾ c. olive oil
1 tbsp. salt and pepper
1 tbsp. fennel seed
1 tbsp. yeast
1 tsp. sugar
1 c. warm water, around 115 degrees
Egg wash (one egg beaten with a little water)

Dissolve yeast in warm water and add the sugar. Let it stand for five minutes. If it doesn't foam, start again with new yeast. Mix oil, pepper, salt, and fennel, and add yeast mixture. Add one cup flour to the wet mixture, and stir. Add one half cup of flour and, if the mixture is still sticky, add the remaining half cup of flour. Cover with cotton cloth and let sit for an hour and a half. Roll small pieces of the dough into pencil-thin ropes, each about fifteen inches long.

you something, then, in thanksgiving, you should give something back. *God only multiplies what you give, not what you receive.* Her bold confidence in heaven resonated profoundly with her neighbors and friends. At wakes, weddings, and christenings, people would seek her out, wallets open, hopes high. Or they'd knock on her apartment door, put two dollars down on the table, and ask her to start praying for their children, spouses, health, future. All right, she'd say, glancing at the wallet, but this is going to take a miracle. *Sometimes a no is an answer to a prayer.* Every month, she'd tote up the donations and send a check to Haiti to the Oblates of Mary Immaculate, a group of international missionaries who serve the poor, and the poor of spirit, whom Pope Pius XI once described as "specialists in difficult missions." They bought cribs, books, pigs, and cars with the money she had collected, without judgment, whether from the pious or from bookies grateful to have beaten the odds. To this day, almost twenty years after her death, people still send money in her name to the Oblates.

Prayer and money have had a long and uneasy relationship. Aunt Mary's income could be viewed as a throwback to the medieval practice of indulgences, where the unknown and the uncontrollable could be altered by buying slips of paper that entitled one to fewer days in purgatory. That practice started in the eleventh century and initially was a good thing—the money collected was used to build public works like hospitals, schools, and bridges—but it devolved by the sixteenth century into fuel for the extravagant lifestyle of the Catholic religious hierarchy. By 1517, the practice impelled Martin Luther to nail his ninety-five theses to the Wittenberg church door and divided Christianity into Catholic and Protestant camps. But I can't dispatch Aunt Mary's fund-raising with Lutheran indignation. For starters, unlike the gilded clergy of old, hers was a servant mentality. *We are here to serve God. The greatest riches in the world are the riches of love.*

What would our lives be like if, like my aunt, we believed that nothing was impossible with God, that every prayer would be answered? Does prayer *really* work? Dr. Mitchell Krucoff, a cardiologist at Duke University Medical Center, recently put that question to the test. From 1999 through 2002, he directed the MANTRA project,

which studied the impact of prayer as well as the bedside use of music, imagery, and touch on the health of 748 patients who suffered from heart disease. Although praying for the sick is an ancient healing practice, the MANTRA study was the first time rigorous scientific protocols were used to quantify the intangible therapeutic benefits of intercessory prayer. Buddhists, Muslims, Jews, and Christians of multiple denominations prayed, at a distance, for half of the MANTRA patients; they did not pray for the remaining half. Patients and their care teams did not know which patients were receiving prayers. In 2005, Krucoff's team reported—with regret, one senses—that prayer did not measurably improve the cardiac patients' health. However, Krucoff maintained that "examining the role of the human spirit in healthcare does not diminish its mystery, but it separates the mystery from the question of utility." Far from dismissing the efficacy of prayer, the researchers concluded that simply not enough was known about prayer and that the MANTRA study was "an early step, not a final one."

Said over the course of one's life, the familiar yet profound words of the rosary, which transform to meet the needs of the hour, the day, or the season, become, in themselves, a holy place of sanctuary. The tiny beads are kernels of truth, landmarks of the heart, that provide haven in moments of difficulty as well as joy. I've begun to think of prayer as an actual place, a graced space, that takes me, like Route 95, to where I want to be: in peace and at peace with life.

This takes patience and at least one Hail Mary. Fold the rope in half, and twist into a braid. Form the braid into a two-inch round circlet and pinch ends together. Place on nonstick sheet pan. Brush tops with egg wash. Bake in a 375-degree oven for twenty to thirty minutes, until dark golden brown. Cook longer for crunchier biscuits. Store in a brown paper bag. Makes about two dozen.

The Crucifixion According to John and Luke

IT WAS NOW about noon, and darkness came over the whole land until three in the afternoon, while the sun's light failed; and the curtain of the temple was torn in two. Then Jesus, crying with a loud voice, said, "Father, into your hands I commend my spirit." Having said this, he breathed his last. When the centurion saw what had taken place, he praised God and said, "Certainly this man was innocent." And when all the crowds who had gathered there for this spectacle saw what had taken place, they returned home, beating their breasts. But all his acquaintances, including the women who had followed him from Galilee, stood at a distance, watching these things.

—LUKE 23:44–49

. . .

Station Ten: Christ is stripped of his garments, 2002
David Michalek
Backlit photograph
40×30″ (101.6×76.2 cm)

In 2003, New Yorkers who had recently been homeless enacted Christ's Passion for David Michalek, who photographed the fourteen tableaux as contemporary Stations of the Cross. The resulting work, *14 Stations*, raises images of society's most vulnerable members to the realm of the sacred. Both men and women, of African American, Hispanic, and Caucasian descent, assume the role of Christ. In Station Ten, Christ is portrayed by a woman, making a profound connection between his suffering and that of his mother.

14 Stations intends to provoke thought rather than make a direct correlation to the historic Stations. The oversize photographs are mounted in industrial light boxes, the type ordinarily filled with brightly colored ads meant to capture the interest, however briefly, of passersby. The format calls attention to our often

unquestioned consumption of commercial imagery and to the inverse reality that such ads—along with the homeless on the streets—barely register in our consciousness.

Early Christians made a pilgrimage to Jerusalem at least once in their lives. Since travel to the Mideast was dangerous, the Franciscans developed pictorial representations of Christ's Passion in the fourteenth century, now codified as the Stations of the Cross, to allow the faithful to make virtual pilgrimages closer to home. Michalek's *14 Stations* calls us to that same spirit of pilgrimage, not in a distant place or time but today and in the place where we live. It invites us to open our eyes to the inhabitants of the contemporary Via Dolorosa who suffer indignity and deprivation and bear the weight of invisibility or judgment.

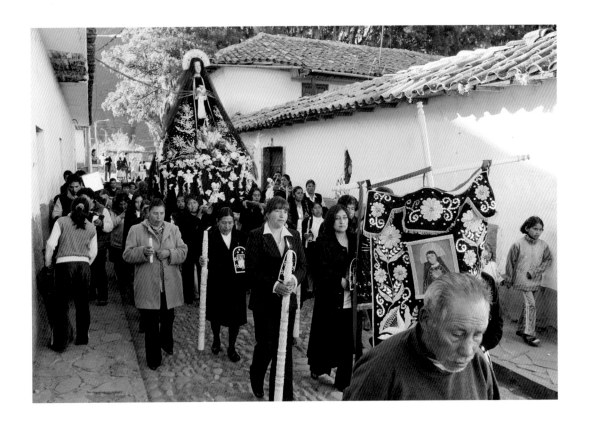

• • •

Our Lady of Sorrows Procession, 2008
Robert Lisak
Digital photograph
18×12"
Collection of the artist

In 2008, photographer Robert Lisak and art historian Jaime Lara chronicled the centuries-old Holy Week observances in San Pedro Andahuaylillas, a town high in the Peruvian Andes. These Easter rituals center on the seventeenth-century Church of San Pedro, which is popularly known as the "Peruvian Sistine Chapel" because of its splendid murals by the artist Luis de Riaño, ornamental School of Cuzco paintings, and opulent silver and gold altars and furnishings. As Lara has noted, Andahuaylillas is of particular interest because it has "maintained aspects of the medieval and Tridentine piety that were once typical of all of Latin America" in a pure form that is rarely seen.

Of reenactments held on Good Friday, when the church marks the Crucifixion of Christ, Lara says that there is "no office in the whole liturgy so peculiar, so interesting, so composite, so dramatic." Commencing

SO THEY TOOK Jesus; and carrying the cross by himself, he went out to what is called The Place of the Skull, which in Hebrew is called Golgotha. There they crucified him, and with him two others, one on either side, with Jesus between them. Pilate also had an inscription written and put on the cross. It read, "Jesus of Nazareth, the King of the Jews." Many of the Jews read this inscription, because the place where Jesus was crucified was near the city; and it was written in Hebrew, in Latin, and in Greek. Then the chief priests of the Jews said to Pilate, "Do not write, 'The King of the Jews', but, 'This man said, I am King of the Jews.' " Pilate answered, "What I have written I have written." When the soldiers had crucified Jesus, they took his clothes and divided them into four parts, one for each soldier. They also took his tunic; now the tunic was seamless, woven in one piece from the top. So they said to one another, "Let us not tear it, but cast lots for it to see who will get it." This was to fulfill what the scripture says, "They divided my clothes among themselves, and for my clothing they cast lots." And that is what the soldiers did. Meanwhile, standing near the cross of Jesus were his mother, and his mother's sister, Mary the wife of Clopas, and Mary Magdalene. When Jesus saw his mother and the disciple whom he loved standing beside her, he said to his mother, "Woman, here is your son." Then he said to the disciple, "Here is your mother." And from that hour the disciple took her into his own home.

—JOHN 19:17–27

at three in the afternoon, a life-size sculpture of the dead Christ is symbolically anointed, placed in a glass casket, and processed through the streets, accompanied by hymns and prayers in Spanish and Quechua. Behind the casket, the women of Andahuaylillas carry a life-size Virgin of Sorrows. The Virgin is dressed in a black dress embroidered in gold, her skirts pinned with flowers and bows. A veil covers her hair—a wig made of real hair given by a pious woman in the town, the donation of which is considered an honor. Her eyes are downcast, and she holds a flaming silver heart pierced by seven silver daggers that represent the anguish of the seven sorrows of her life. The statue moves through the narrow streets in a cloud of incense, while people throw the blood-red petals of the ñuk'chu flower, symbolizing Christ's Passion. At the conclusion of Holy Week, the Virgin's statue is returned to its niche in the Church of San Pedro.

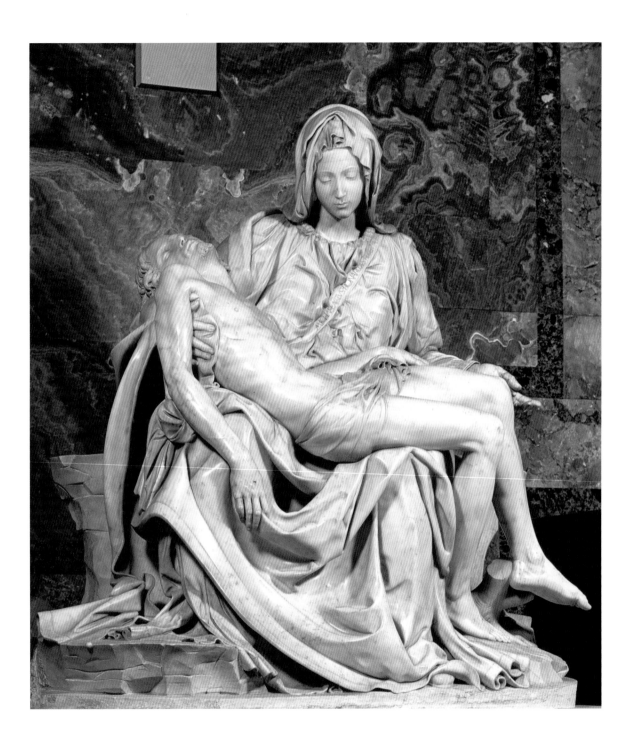

• • •

Pietà, 1497–1499
Michelangelo Buonarroti (1475–1564)
Marble
68.5″ high (174 cm)
St. Peter's Basilica, Rome

Carved from a single block of marble when Michelangelo was just twenty-five years old, the *Pietà* is heralded for its technical mastery as well as its emotional pull. The marble sculpture was commissioned by Cardinal Jean de Bilhères Lagraulas, who stipulated that it be the most beautiful in Rome, for his family's funerary chapel in Old St. Peter's. After the basilica's rebuilding and many renovations, it was removed to its current location in 1749.

The concept of *pietà* (pity) was often depicted in smaller wooden sculptures and paintings throughout Europe during the fifteen century. When Michelangelo advanced the genre with a life-size sculpture, he addressed the challenge of placing an adult Jesus on Mary's lap the way women often address size challenges—with strategically draped fabric. Mary's right knee props up her lifeless son, and the heavy folds of her robe establish a physical presence capable of bearing the body of a fully grown man. The storm of folds below Christ become calmer above him, as the twists in the exquisitely rendered cloth become lighter and more nuanced. The enormous attention paid to the draping of the cloth underscores the physical reality of death. A small line runs across Mary's forehead, simulating a veil. Noting her downward gaze, art historian William E. Wallace writes that Mary "avoids our look and internalizes her sorrow." Her left hand gestures upward, questioning the fate of her son and reinforcing her presentation of his body at the same time. The sash across Mary's torso bears Michelangelo's signature; the *Pietà* was the only work he ever signed.

Mary's youthful face reminds us of her purity and innocence. Michelangelo is said to have sculpted her face to reflect her age when she bore Jesus, because it was the only way to show her virginity. Some have suggested it might be the face of Michelangelo's own mother, who died when the sculptor was only five. At least two other theological possibilities explain Mary's youthfulness. Perhaps her age shows that the child she bore was already a condemned man when she bounced him on her knee. A related but rather different interpretation is found in Dante's *Paradiso,* a favorite literary work of Michelangelo's, which proposes that all persons, including Mary herself, are reborn in Christ. As St. Bernard addressed Mary in prayer, *Vergine madre, figlia del tuo figlio* ("Virgin mother, daughter of your son"). Many sculptors imitated Michelangelo in creating *pietàs,* but most "correct" it by aging Mary, a change that considerably alters the theology expressed by the sculpture.

Originally intended to be placed at ground level, where an observer could see it closely and touch its sensuous folds, the work now sits behind bulletproof glass, after a deranged man attacked it with a hammer in 1972. It left Italy for the first and only time when it was shown at the 1964–1965 World's Fair in New York.

Mater Dolorosa

FROM 2007 THROUGH 2008, the Metropolitan Museum of Art in New York exhibited three newly cleaned panels of the ten gilded bronze reliefs that Lorenzo Ghiberti created in the fifteenth century for the doors of the Baptistery of San Giovanni in Florence. As a friend and I meandered around that magnificent display of Ghiberti's fertile, idealizing imagination, so alive with emotional intensity and veracity, we were reminded of the artistic patience that's needed to see the truth beyond superficial appearances and express materially what is invisible. Most gripping among the dozens of images of Mary's face that we saw in the museum's other galleries that day were those that captured the paradoxical, peculiarly Marian mix of joy and grief, of concentration and acceptance. In the best of them, her face reveals that she recognized in her child a beginning as well as an end.

Like the Annunciation, the events of the Passion open a rare window onto Mary's inner life and a glimpse of her humanity. In

• • •

Deposition, ca.1435
Rogier van der Weyden (1399/1400–1464)
Oil on panel
87×103" (220×262 cm)
Museo del Prado, Madrid

The *Deposition,* commissioned by the Confraternity of Archers (note the tiny crossbows hanging from the corner tracery) for the main altar in the Church of Our Lady at Louvain in Belgium, embodies the drama that permeated much religious art of the later Middle Ages. Christians believed that the Virgin bore in her heart the wounds that Christ suffered during his crucifixion and, indeed, here Mary shares her son's pain. She has collapsed in grief, her body crumpled into the same undulating curves as Christ's. Her limp arms dangle in a pose identical to his; but for the visible nail hole in Christ's right hand, the Virgin's hands are an almost-perfect likeness of his. As Christ's body speaks its human torment, the Virgin's responds in kind.

The inverted "T" shape of the *Deposition* frame was commonly used for sculpted altarpiece scenes, and van der Weyden's decision to apply it to a painting is deliberate: He is implying that his painting is as

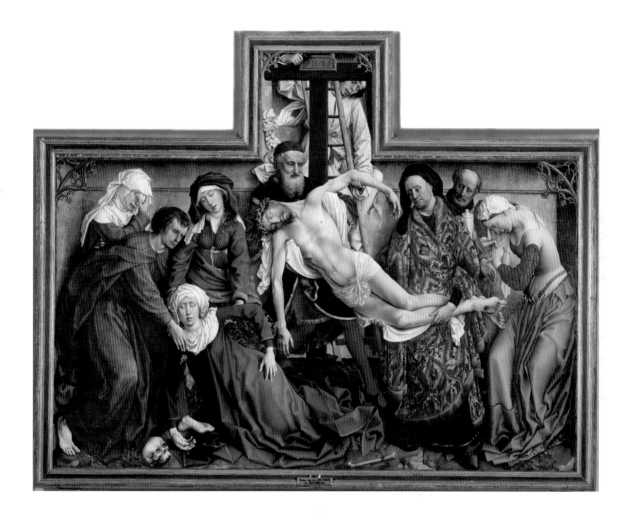

convincingly lifelike as any three-dimensional medium. Certainly the sense of movement, the expressive faces and bodies, and the artist's decision to fill the entire space, to the point where it seems cramped, suggest sculpture come to life.

Van der Weyden was born in Tournai, Belgium, around 1400. Although long thought to have studied under Jan van Eyck, who painted the Ghent Altarpiece, recent scholarship has found that he was an apprentice to Robert Campin, a founder of the Netherlandish school of painting. Van der Weyden moved to Brussels in 1425, becoming the city's official painter by 1435, and his workshop may have employed a young Hans Memling. Among van der Weyden's many remarkable achievements, the *Deposition* is considered his masterpiece.

artistic and religious imagination, she is there, hearing Simeon's prophecy that her soul would be pierced, hovering in the shadows of Pontius Pilate's judgment, meeting Christ as he makes his way to Golgotha, and, finally, in the company of John, grief-stricken at the foot of the cross. In these portrayals, Mary is imaged as the *Mater Dolorosa*, the "Mother of Sorrows," whose profound misery puts her in compassionate solidarity with all those who suffer.

In the Middle Ages, a time that saw a rise in popular piety as well as terror at the hands of the Inquisitors, the personal nature of Mary's sorrow inspired myriad works of art, music, drama, and lit-erature, as well as mystical visions, that were charged with human emotion. Mary was a sympathetic figure, with whom medieval be-lievers could identify and through whom they could prayerfully reenact the tragedy of the Passion. Whereas Christ's pain was phys-ical and spiritual ("My God, my God, why have you forsaken me?"), Mary's pain was the pain of remembrance—of caring for Jesus as a baby, seeing him grow to manhood, being present as he preached—a pain that more closely approximated the pain of ordi-nary persons than did Christ's, whose pain as God–man was ar-guably unique.

The evocative medieval poem *Stabat Mater Dolorosa*, which opens with these lines—"At the Cross her station keeping, stood the mournful Mother weeping"—exemplifies the human dimensions of Mary's grief. Widely known by the fourteenth century among all classes, and existing in several versions, the poem was set to music by many masters, notably Palestrina, Haydn, Rossini, Poulenc, and Penderecki, in distinctive ways that suggest the subtle shades of the anguished soul. In the visual arts, too, during this period, Mary began to be increasingly and graphically represented at the foot of the cross, convulsed in psychic and physical pain, her body recoil-ing, falling, and responding in ways that made her humanity more accessible. Mother and son, their bodies suffering as one, show their intimate connection and the emphatic role the Virgin played in the lives of the faithful. She is Queen of Heaven and grieving Mother, *salvatrix mundi*, co-redeemer and, as the *Deposition* by artist Rogier van der Weyden makes abundantly clear, co-sufferer with Christ. Such depictions provided a counterpoint between Mary's

• • •

Tenebrae, 1999
Melissa Weinman
Oil on canvas
156×72″ (396×182.8 cm)
Collection of the artist

In this triptych, darkness is used as a visual metaphor for grief. The moonlit waterscape with its blanket of dark, roiling clouds echoes Mary's sorrow on the day of Christ's death. Mary is portrayed twice, literally split in two by the ferocity of her sorrow. She convulses with grief in the foreground, and, in the background, throws her head back to utter a cry. The immense size of the canvas reflects the enormity of her emotion. The two smaller canvases that flank the central canvas form a cross, thereby alluding to the crucifixion without actually depicting it.

Weinman places the scene in a contemporary construction site, bounded by orange traffic cones and a barrier, to convey the feeling of being "torn up" by emotion and the chaos that precedes transformation. The hope and promise of the Resurrection are implied by the calm landscape, lit by brilliant light that leaks from the clouds. Tenebrae, from the Latin for "darkness," refers to the supernatural darkness that accompanied Christ's crucifixion: *From the sixth hour until the ninth hour, there was darkness over all the earth* (Matt. 27:45). During Tenebrae services, which are usually held on the evenings of Wednesday, Thursday, and Friday in Holy Week, lit candles are extinguished one by one, in memory of that darkness.

role as a holy mediator—the one who accepted Christ's mission and the necessity of his cross—and her human doubt and grief over the tragic loss of her child.

By giving these biographical events vivid, artistic life, those experiencing such works of art, music, and literature are able to imaginatively step into Mary's shoes. Augustine's directive—"Shake up your faith, bring the eyes of your heart to bear, not your human eyes"—enables the inconsolable, the discouraged, and the cynical to process Mary's sorrow and doubt, her living death, and so their own.

• • •

Mourning Parents, 1924–1932
Käthe Kollwitz (1867–1945)
Belgian granite
Figures: Mother 48" (122 cm); father 59" (151 cm)
German Military Cemetery, Vladslo, Belgium

Setting up the crèche, with the familiar figures of Mary, Joseph, and the Christ child, is one of the most sentimental tasks of the Christmas season. A folk tradition since at least the thirteenth century, the crèche today is often the only visible symbol in a home of the Nativity's twinned theological messages of incarnation and salvation. With Mary and Joseph hovering over the child between them, the Holy Family also represents the idealized nuclear family, mirroring us as loving parents and as beloved children.

The German Expressionist artist Käthe Kollwitz sculpted *Mourning Parents* as a memorial to her eighteen-year-old son, Peter, who was killed in battle in 1914, just ten days after entering the German army. It depicts Kollwitz and her husband, Karl, kneeling, arms wrapped around themselves, and hunched over the empty space between them. All who walk between the figures stand in for their son and for all sons and daughters lost to war.

One of the great storytellers of modern art, Kollwitz anticipated this memorial in a lifelong outpouring of expressionistic prints, drawings, and sculptures that depicted mothers cradling their dead children, grieving parents clinging to each other, and other gut-wrenching images of human suffering. This, however, is a quieter work of profound anguish. A great gulf separates Kollwitz and her husband, who are isolated in their grief. Together the couple installed the sculpture and returned the next day. Writing in her diary of that day, Kollwitz said, "I stood before the woman, looked at her—my own face—and I wept and stroked her cheeks. Karl stood close behind me—I did not even realize it. I heard him whisper, 'Yes, yes.' How close we were to one another then." Mary and Joseph are placed first in the crèche, early in Advent, around an emptiness. Like Kollwitz's figures, they wait. They hope. They believe in the promise of their child, which is eternal life.

He's resident now
on the green slope
of Elysium Path, past
the weathered, west-facing
stones with lichen fretwork.
Next to their austere,
neglected dwellings, his seems
a carnival, or the boy's
room that it is—
a chamber, albeit,
en plein air,
domain of the boy
dead at four.
His mother and sisters
tend him as if visiting
a boy in hospital,
or summer camp,
the graveside a glittery
litter of shredding pinwheels and teddy bears
in plastic, a red toy train,
a dump truck—which all boys love—
and then, for when he'd gotten
older: silver penknife,
build-it-yourself airplane,
remote-controlled race car
because boys like speed
and risk and making things.
On Independence Day,
they plant flags, on Halloween
they scatter chocolates,
on his sixteenth birthday,

they hang a set of fuzzy dice
from the slim yew tree.
Afterlife as life: if he came
to them disguised by time,
would they recognize him?
He'd have been eighteen
when the new war begins.
They paste yellow ribbons
to his headstone, in case
that would have been his fate.
They leave coins and roses,
even the photo of a starlet
they think he might have pined for,
imagining the course and trappings
of his life, the way
a young mother dresses
her only son in Sunday best,
meticulous in his presentation, praying
all doors will open for him,
whereas the boy's enamored
only of his secrets: what he keeps
in his pocket, treasures shifted
from trouser to trouser: sourballs,
matches, the blue rabbit's foot,
dried spider, sliver of quartz,
cat's eye shooter, rusty keys
to houses he'll never locate
or enter, the dust and dirt
which, like all boys, he inherits.

—ANDREA COHEN, "Worldly Things for
Danny B.," 2009

The Virgin in the Garden

THE SONG OF Songs, an ancient love poem, is often read as an expression of God's love for humanity voiced through the person of the Virgin Mary. Although the Song's lush imagery conjures everything that is natural, earthy, and erotic, it is also a prayer sent upward from humanity to God and an equally powerful message from the Creator to earth. The Song inspired the design of the Steinhausen pilgrimage church in Germany, a key monument of the exuberant eighteenth-century Bavarian rococo style. Beauty's last metaphoric gasp, this style burst forth on the eve of the modern age of enlightenment, when science and reason held sway over the Western mind and when religious devotion—especially as theatrically expressed in churches such as Steinhausen—was being dismissed as a throwback to the darker ages. Yet science has arguably done little to diminish Marian veneration, and, in fact, historic scientific breakthroughs can shed new light on our understanding of her mystery. Steinhausen rejoices in the temporal elucidations of an earthly paradise as described in the Songs and, using anatomical analogies, re-creates the Marian womb as a place of human transcendence.

The Song of Songs, also known as the Canticle of Canticles and the Song of Solomon, is thought to date from the fourth century B.C.E., although its literary roots are far older. Its provocative metaphors had emerged earlier in ancient Near Eastern love poetry, such as Mesopotamian marriage poems from the later third and early second millennium B.C.E. and, later, Egyptian love songs dating from the thirteenth and twelfth centuries B.C.E., the latter likely sung at banquets by male and female entertainers. By the second century C.E., the poem was considered a sacred text, but it was still sung in banquet halls and was also associated with harvest festivals in which young women would sing and dance, hoping to attract potential mates. Third-century Christian interpreters

Inseparable from the Marian piety of the Bavarian baroque and rococo is a sense of still being at home in nature. It is this that lets nature become a figure of the Virgin and of paradise, of the paradise that was and of the paradise to come.

—KARSTEN HARRIES, *The Bavarian Rococo Church,* 1983

understood the Bride in the poem as the Church burning with love for Christ; Origen (d. ca. 253) interpreted the love between the Bride and Bridegroom as the relationship between Christ and the Church and, more mystically, the individual's soul in love with the Logos or Word of God, double allegories that would persist until the medieval age. In the twelfth century, the heyday of commentaries on the Song, a new, more emotional approach had begun to color Marian devotion. Commentators such as the Benedictine Rupert of Deutz considered it a love song between Christ and Mary, as did a popular work, *Sigillum Beatae Mariae* ("The Seal of the Blessed Mary"), produced by a theologian known as Honorius Augustodunensis around the same time. Bernard of Clairvaux wrote some eighty-six sermons on the Song, in which the sacred and the profane overlap and Mary is identified as the Bride. The *Speculum humanae salvationis*, a richly illustrated book datable to 1324 and written in lively prose intended to appeal to the masses, pictures Mary as the "closed garden" and "sealed fountain" of the Song.

The Song's vivid, malleable imagery undoubtedly contributed to its longevity. Fragrant evocations of flowers—roses, lilies, and henna blossoms—mingle with images of fertility and plenty, including grapes, apples, pomegranates, and honey. The place described is full of animals—gazelles, goats, wild does, little foxes, and a stag—and birds, including doves, ravens, and turtledoves. Detailed descriptions of objects such as Solomon's cedar palanquin with its silver posts, a purple seat, and an interior inlaid with love, coupled with places identified by name—Jerusalem, Lebanon, Heshbon, Bath-rabbim, [Mount] Carmel, and Baal-hamon—lend veracity to the Song's idealized landscape and make what transpires there seem real. Its lines are laced in spices—nard and saffron, calamus and cinnamon, frankincense, myrrh, and aloes—that cense the profane and make it sacred. The natural and the handmade mingle in a series of erotic analogies: The beloved is a *bag of myrrh that lies between my breasts*, his body is *ivory work, encrusted with sapphires*, her channel is an *orchard of pomegranates*, and kisses are *like the best wine that goes down smoothly, gliding over lips and teeth*. These sensuous descriptions, coupled with the leitmotif of male and female carnal desire, resonate with archetypal power.

The Song of Songs is Mary's song because it is the song that celebrates the historical fact of her virginal maternity, the song through which her special relationship to the Lamb as his human mother is made clear. It is a relationship, above all, of consummate physical, fleshly identity.

—Rachel Fulton, *From Judgment to Passion*, 2003

Flowers, most likely the first thing that primitive human beings came to value that had no utilitarian purpose, would become an expression of that which is most sacred and ultimately formless. Lilies, violets, and, especially, roses have long been used as symbols of Mary's beauty, purity, and divine fertility. As Rachel Fulton notes, when the Song's Bridegroom says, *I am come into my garden,* almost all of the flowers that he encounters would, by the later Middle Ages, have been associated with Mary: alchemilla was "Mary's mantle," Canterbury bells or foxglove were "Mary's gloves," lungwort was "Mary's milk-wort," rosemary was "Mary's tree," narcissus or daffodil was "Mary's lily," ragwort was "Mary's bedstraw," Solomon's seal was "Mary's seal," and toadflax was "Mary's flax." More than mere symbols of Marian attributes, flowers also provide proof of those qualities—just as a lily is white, upright, and fragrant, Mary similarly possessed the qualities of virginity, purity, and attractiveness to God. Like the cyclical springtime appearance of fresh new leaves and flowers, she is evergreen. Not surprisingly, the month of May, when flowers are in full bloom, is dedicated to Mary.

Such botanical metaphors were easily adapted in the seventeenth and eighteenth centuries by pious Bavarians, who were devoted to Mary and, as is still evident today in the region's elaborate cultivated gardens, mad for flowers. Employing the image of the Virgin in and as the garden, heaven is recast in the Steinhausen church as a natural paradise. When the church was built, the faithful in southern Germany participated in elaborate public displays of devotion—pilgrimage, processions, liturgical festivals—many of them associated with the cult of the Virgin Mary. A dense necklace of pilgrimage shrines, which included churches, springs, wells, and trees, literally entrenched Catholicism in the Bavarian landscape. The fertile land itself became the framework for Marian piety and was transformed through the lens of that piety into a sacred place, as the faithful pilgrimaged from site to site.

While nature-based ornament is not unique to the Bavarian rococo church—consider the French cathedral of Reims (1211–ca. 1427) with its sculpted litany of flora and fauna—the Bavarian model expands the metaphor by making the boundary between the earthly

You have ravished my heart, my sister, my bride,
 you have ravished my heart with a glance of your eyes,
 with one jewel of your necklace.
How sweet is your love, my sister, my bride!
 how much better is your love than wine,
 and the fragrance of your oils than any spice!
Your lips distill nectar, my bride;
 honey and milk are under your tongue;
 the scent of your garments is like the scent of Lebanon.
A garden locked is my sister, my bride,
 a garden locked, a fountain sealed.
Your channel is an orchard of pomegranates
 with all choicest fruits,
 henna with nard,
nard and saffron, calamus and cinnamon,
 with all trees of frankincense,
myrrh and aloes,
 with all chief spices—
a garden fountain, a well of living water,
 and flowing streams from Lebanon.

—*Song of Songs* 4:9–15

• • •

Ceiling fresco, St. Peter and Paul, Steinhausen, 1729–1733
Johann Baptist Zimmermann (1680–1758), painter, stuccoist
Dominikus Zimmermann (1685–1766), architect, stuccoist
Steinhausen, Germany

Painted in atmospheric pastel colors, the decoration of the Steinhausen pilgrimage church in southern Bavaria recalls a garden in late spring, both the temporal Bavarian garden just beyond the church doors as well as the eternal garden described in the Song of Songs. At Steinhausen, paradise is recast as a garden in bloom. The ceiling fresco describes two gardens—the Garden of Eden at its western end, which would have served as a warning as people left the sanctuary about the temptations of the world, and, over the altar, the closed garden with its sealed fountain, a metaphor for Mary taken from the Song. The central ceiling fresco portrays Mary's Assumption into heaven, clouds swirling upward around her and the numinous name of God. The tops of the columns that surround the nave like massive trees are covered with decorative fruits and plants made of stucco. Some of the arched gables above the columns are made of stucco, while others are painted in fresco, creating a trompe l'oeil illusion that makes it unclear where earth ends and heaven begins. This ambiguity extends a sense that redemption is possible and heaven, portrayed just above one's head, is a reasonable hope. This reasonable hope is focused in Mary, whose glorification created a new relationship between heaven and earth.

garden and heaven ambiguous. Steinhausen's architecture, stucco, and fresco blur the boundaries between the church's structure and its ornament. The various fruits and animals referenced in the Song are rendered with high realism and proliferate with a frenzy that can be equated with the Song's implicit eroticism. Stucco flowers, foliage, fruit, and seashells cover the capitals of the nave columns and reach up into the ceiling fresco, where heaven is also depicted as a garden. This synthetic vision was achieved by the close collaboration between the painter Johann Baptist Zimmermann (1680–1758) and his brother, the architect Dominikus Zimmermann (1685–1766). The brothers came from a long tradition of artists who embellished churches, monasteries, and palatial residences with artful, fanciful designs inspired by nature.

A biological impetus can be ascribed to Steinhausen's blossoming structure as well. The church's structural shell metaphorically re-creates Mary's womb, while its profuse interior ornamentation literally and symbolically conjures the fruit she brought forth. The pregnant Marian womb that is praised in the Hail Mary—"Blessed is the fruit of thy womb"—is a key visual motif of Steinhausen's oval nave. Its ovate shape is distinctively female: Biologically, the uterus is the only organ of the body that is unique to women and has no anatomical equivalent in the male. Much like the enclosed Marian garden of the Song, the pregnant uterus was conceived as a flowering blossom in some seventeenth-century engravings (and, more recently, by contemporary artists such as Georgia O'Keeffe and Judy Chicago). The foliate ends of the fallopian tubes, those "flowers of flesh, the petals throbbing to the cadence of blood," recall the stuccoed foliage that characterizes the Bavarian rococo, an arboreal metaphor that extends to the uterus, which cyclically sheds its lining, like leaves from an autumnal tree.

Scientific inquiry, far from being the enemy of beauty, enhanced Steinhausen's artistry and meaning. When considering the church as a visual abstraction of Mary's womb, it is helpful to recall what was known about female anatomy at the time and what medical knowledge would have been reasonably accessible to the Zimmermanns. The anatomic norms for the illustration of bones and muscles, including the pelvic cavity, were established by

Vesalius (1514–1564), who is considered the father of modern anatomy. His research was sustained by his pupil, Gabriele Falloppio (1523–1562), of eponymic fallopian tubes fame. Vesalius's contemporary, Eustachius (1524–1574), a fellow genius in this golden era of anatomical discovery, provided the first correct picture of the uterus but, fearing excommunication, never published his opus of 1522, *Tabulae Anatomicae*; it wasn't published until 1714, when it became a bestseller. One of the most accomplished eighteenth-century surgeon–anatomists was Bernhard Siegfried Albinus (1697–1770) of Frankfurt, who, in addition to editing works by Vesalius and Eustachius, produced a number of atlases drawn by Jan Wandelaar—including one in 1749 of the gravid (pregnant) uterus—that remain renowned for their beauty and accuracy.

Also, in Nuremberg, the ivory turner Stephan Zick (1639–1715) was descended from a family who, for generations, had carved superb ivory decorative pieces for royals, as well as intricate anatomical models for medical demonstrations. Stephan specialized in female models that were small enough to hold in the hand, about seven inches long. The figures were shown in a state of pregnancy, with a tiny removable fetus enclosed in an ovate womb. In these three-dimensional sculptures, the human body became, literally and scientifically, graspable. In the works of artists such as Wandelaar and Zick, the body became more than a place of scientific discovery; it was transformed into a *living* object of aesthetic beauty. Although the cadaver no longer lives, rendering the body artistically and celebrating its physical beauty confers the immortality that characterizes art on even the most mundane, corporeal aspects of humanity.

This idea of an ennobled, regenerative anatomy is first signaled by the exterior windows at Steinhausen. The upper windows have a distinctive obcuneate shape that resembles the schema of the uterus, while the elongated lower windows have phallic proportions. Standing outside the church, in the secular zone, we see in these windows that phallus is about to meet cervix—we are present at the moment before conception. The windows announce the transition from the profane world, as originally described in the Song, into the interior realm of the sacred, just as the Song trans-

mutes the erotic impulse into a metaphor for virginal purity. Once inside the church, across the literal threshold into the metaphoric womb where the Incarnation is a fait accompli, visitors are immediately confronted with the virginal sealed fountain of the Song, in a fresco above the altar.

Mary's sanctity is proved by the deliverance of Christ from her physical womb. She redeems the ancient sin in Eden, the original paradisiacal garden, which is also portrayed in Steinhausen's ceiling fresco. The church's congregation, contemporary stand-ins for Adam and Eve, have partaken of the forbidden fruit but find redemption in the church, or the Church, which has become the new garden. Just as earthly abundance and sexual desire are fused in the Song, with the carnal and the natural connecting effortlessly, Steinhausen's sensual imagery is made innocent by the broad, indirect light that pours in from the windows—there are no dark or illicit corners, and all is as it should be. If the light coming in through the uterine windows, and piercing the nave, is symbolic of the divine inspiriting light that impregnated Mary, then the nave becomes her symbolic womb. Believers at Steinhausen, physically present within this flower-filled metaphoric womb, are also symbolically present at the moment of the Incarnation and perceive the paradise that it made possible: Mary's womb is re-created as the place of human transcendence. Our human reality as creatures comprised of both yearning spirit and desirous flesh are imaged in Steinhausen's program, which holds forth the promise—fulfilled through Mary's flesh and as certain as the return of springtime flowers—of salvation.

A Vision of Home

ANNE CATHERINE EMMERICH (Anna Katharina Emmerick) (1774–1824) was a German Augustinian nun and mystic, whose "material poverty contrasted with her rich interior life," as Pope John Paul II observed at her beatification ceremony on October 3, 2004. Although scholars have paid scant attention to her visionary narratives, her accounts have enriched the faith, often in unexpected ways—one text was even used to uncover a sacred destination, believed by many to be Mary's last earthly home.

Born into an impoverished family and often ill, Sister Emmerich understood her physical pain as redemptive and as a way of sharing solidarity with others who suffered. Among her many experiences of the miraculous, she received the stigmata, Christ's bodily wounds. After a transformative meeting with Sister Emmerich in 1818, the poet Clemens Brentano visited the bedridden nun daily for six years, determined to record her visions as she relayed them to him. He produced two books based on these dictations: *The Dolorous Passion of Our Lord Jesus Christ* (1833) and *The Life of the Blessed Virgin Mary* (1852). In both accounts, Sister Emmerich gives painstakingly detailed descriptions of the lives of Christ and the Virgin, right down to the shape of a table leg, even though, as reported by Brentano, she was groaning, writhing, and perspiring blood as she spoke.

The Life may be best known for its description of Mary's house in Ephesus, today in western Turkey, where pious tradition places Mary at the end of her life. This belief arose from Christ's directive as he hung on the cross to the apostle John: *"Here is your mother." And from that hour the disciple took her into his own home* (John 19:27). According to Sister Emmerich's vision, six years after Christ's Ascension, Mary relocated to the Ephesian countryside to a house that John had built for her. In her lengthy description, Sister Emmerich notes that the house was the only stone structure among all the

• • •

The House of the Virgin Mary, 1st–7th cent.
Builders unknown
Ephesus, Turkey

The House of the Virgin Mary gained prominence only at the end of the nineteenth century, after the Blessed Anne Catherine Emmerich, who had never left Germany, saw it in a vision and described it in minute detail. The house is in Ephesus, where some believe Mary went to live after Christ died. Now a sparely decorated chapel surrounded by terraced gardens, the original foundations of the diminutive stone structure are said to date from the first and fourth centuries, with other parts dating to the seventh; it was declared an official pilgrimage site in the twentieth century. Visiting once required an arduous climb up Nightingale Mountain, but a road was built in 1950 to accommodate increasing numbers of pilgrims. Popes Paul VI (1967), John Paul II (1979), and Benedict XVI (2006) have all visited, as have pilgrims from around the globe. The site is also revered by Muslims, and just outside the chapel is a display that includes excerpts from the Qur'an about Mary. On the lower garden level, pilgrims collect water diverted from Mary's sacred spring from four wall spigots and leave prayer requests on metal grates affixed to a long stone wall.

other houses in Mary's village. She even describes the shapes of the stones themselves as being "rounded or pointed at the back." She notes the placement of doors, the interior rooms, and the objects within them. Among the objects is a cloth that Mary used to wipe the blood from Christ's wounds, which Sister Emmerich equates with the cloth used to wipe the Eucharistic chalice, noting that the Virgin Mary acts "just as the priest does."

Reading these works makes it clear that Sister Emmerich was motivated by the simple and irresistible desire to express as fully as possible what she was seeing. More significant than the veracity or provability of her visions is their spiritual power in the here and now. Her observations redeemed Mel Gibson's controversial movie *The Passion of the Christ*, which used *The Dolorous Passion* as a source. Most gripping is the scene in which Pontius Pilate's wife, Claudia, having had a bad dream, urges him to pardon Christ, which Pilate is not willing to do. Sensing that the situation is completely out of her hands, she does what we all do when life is suddenly out of control: She does the small, doable thing. In this case, she gathers up a stack of perfectly white towels and, moving like a shadow through the columns, gives them to Mary and Mary Magdalene, who are standing in the courtyard where Christ was brutally scourged. Mary, also facing a situation that she cannot change, takes the towels. All that she can do at that moment is wipe up her son's blood, which is splattered over the stones and gathering in pools. With methodical tenderness, Mary wipes up the blood, the blood of her blood, making sure that not one drop is left on the stones. By staying intensely focused on that one task, she staves off her grief—not for long, but for that moment. Sister Emmerich's insistence on sticking with the minutiae of the moment teaches the value of staying in the now and contending with life's struggles by surrendering to the grace that accompanies letting go of those things that are out of our control.

The modern "discovery" of the house of Mary at Ephesus was due to the efforts of Sister Marie de Mandat-Grancey (1837–1915), who worked in nearby Izmir. She found Sister Emmerich's vision of Mary's home so compelling that in 1891 she enlisted the help of

two Vincentian priests, Fathers Henry Jung and Eugene Poulin, to find it. Using *The Life* as their compass, they found a small stone house on a "rocky hill from which one could see over the trees and hills to Ephesus and the sea with its many islands." It fit Sister Emmerich's description perfectly, both geographically and architecturally; the findings were later investigated and confirmed by the Vatican. Locals described the centuries-old devotion at the ruins of a nearby chapel called Panaya uc Kapoulou Monastiri, the "Monastery of the Three Doors of Panaya, the All Holy," after the three arches of its façade, which Greek Orthodox Christians believed to be Mary's last residence. In her vision, Sister Emmerich had seen a place that had been revered as sacred for a long time.

Today, Christians from around the globe visit the house and surrounding gardens, as do Muslims, who also have a strong devotion to Mary, or Maryam, as she is known in the Qur'an. Every August 15, on the Feast of the Assumption, Orthodox and Muslim clerics come together to conduct a service at this shrine, in perhaps one of the few places where Christians and Muslims can worship together without tension, testifying to the ecumenical unity that Mary's veneration inspires. Although scholars have paid little attention to this site, probably because of its relative newness and strange genesis in the mind of a bedridden mystic, it is a place where I, for one, felt Mary's presence and her desire for the world's spiritual wholeness quite strongly.

Several sites are honored as the spot where Mary is thought to have lived or died. While the faithful gather at Mary's birthplace in Nazareth and also in Loreto, Italy, where angels are said to have borne her house, and at her elaborate subterranean tomb in Jerusalem, Ephesus is the only site outside the Holy Land connected with Mary's historical, physical presence. The doctrine of her Assumption, when she was carried body and soul into heaven, makes Marian geography that much more complex, since no bodily relics or tombs can be ascribed to her. By their nature, tangible objects are mutable, always shifting, gathering, and ebbing in their ability to influence. Visions, in contrast, are intangible and not bound by physical parameters, rendering them at once more pow-

erful and more vulnerable than material objects. Visions such as Sister Emmerich's are liberated by the force of invincible faith and spiritual imagination. She, along with other religious mystics, emphasized different facets of Mary's identity, as she was understood, and needed to be understood, at a given place and time.

When Jesus fell down at the foot of the pillar, after the flagellation, I saw Claudia Procles, the wife of Pilate, send some large pieces of linen to the Mother of God. I know not whether she thought that Jesus would be set free, and that his Mother would then require linen to dress his wounds, or whether this compassionate lady was aware of the use which would be made of her present. At the termination of the scourging, Mary came to herself for a time, and saw her Divine Son all torn and mangled, being led away by the archers after the scourging: he wiped his eyes, which were filled with blood, that he might look at his Mother, and she stretched out her hands towards him, and continued to look at the bloody traces of his footsteps. I soon after saw Mary and Magdalen approach the pillar where Jesus had been scourged . . . they knelt down on the ground near the pillar, and wiped up the sacred blood with the linen that Claudia had sent.

—BLESSED ANNE CATHERINE EMMERICH, *The Dolorous Passion of Our Lord Jesus Christ*, 1833

• • •

Virgin and Child with Saint Anne and John the Baptist (Leonardo Cartoon), ca. 1499–1500
Leonardo da Vinci (1452–1519)
Black chalk and touches of white chalk on brownish paper, mounted on canvas
55.7×41.2" (141.5×104.6 cm)
National Gallery, London

The Leonardo Cartoon was a preparatory study for a large-scale painting. This painting was never begun and the drawing itself is unfinished, yet it radiates power and beauty. Seated in a roughly outlined landscape are the Virgin and Child; Mary's mother, St. Anne; and John the Baptist, Christ's cousin. The exchanges between these figures are sentimental yet mysterious. Anne smiles at her daughter, who is lost in the reverie of her own motherhood. Even as Christ is tenderly cradling John's chin, he and his grandmother are attempting to communicate to Mary and John the great destiny that awaits their family. Anne points emphatically to the heavens, and Christ raises his right hand in a sign of benediction, implying the new covenant made manifest in him.

Da Vinci's drawing recalls a popular theme associated with the late-fifteenth- and early-sixteenth-century cult of St. Anne. The *Anna selbdritt* (literally, "Anne three-in-one") depicts Mary holding the Christ child on her lap while she sits on Anne's lap. This motif stresses Anne as the source of Mary, and therefore Christ, and thus salvation. Yet Anne is not only Mary's mother but her precursor as well, as da Vinci portrays so eloquently; the bodies of mother and daughter appear to merge into one. They are intimately connected, more so than any other mother and daughter. Both women conceived through divine intervention—Anne via the Immaculate Conception, Mary via the Incarnation—and their lives were forever changed by their miraculous maternities.

While da Vinci possessed a highly technical mind, venturing into anatomy, physics, even military technology, much of his art is subtle rather than meticulously calculated, employing vagaries of light and shade to convey a characteristic sense of atmosphere. In his old age he resided in the Belvedere, a home on a hill above the Vatican Palace, a sign of his revered status as an artist. After he began working for King François I of France in 1516, he moved into the Clos Lucé, a manor house near the king's residence, where he lived until his death in 1519.

Seeing Mary

GOOGLING "VIRGIN MARY," one finds several million reports of her image appearing on grilled-cheese sandwiches, gasoline stains, factory walls, and the like. At first glance, such sightings may seem ridiculous, yet their sheer number and persistence points to the strong desire on the part of many to see, actually *see*, the Mother of God. Fortunately, Mary is not a distant saint but one of those rare heavenly occupants who makes frequent trips to earth. Over the centuries, there have been twenty thousand reported appearances by Mary at sites that have become places of pilgrimage—some of them well known, others obscure, church-sanctioned, or hotly contested. A look at some of the more controversial places of Marian apparition—La Vang, Vietnam (1798); Knock, Ireland (1879); Fatima, Portugal (1917); and Medjugorje, Bosnia-Herzegovina (1981)—illustrates the intersection of religious, political, and social conditions that brought these places into being and drew millions of pilgrims to them.

Through the Congregation for the Doctrine of the Faith, the Holy See office that safeguards Catholic doctrine, the Roman Catholic Church decides whether a Marian apparition merits "approval of supernatural character," and classes others variously as "not worthy of belief," "not contrary to the Faith," or "worthy of belief." Of the 386 apparitions reported since 1900, only eight have received the "supernatural" designation. Ecclesiastical authorities tend to remain skeptical about visionary claims and do not grant approval without substantial evidence: Repeated appearances by Our Lady in the seventeenth century to a woman in the town of Laus in the French Alps were not officially recognized until 2008. While approved apparitions cannot have any content contrary to the teachings of the Church, no one is obliged to believe in them, even those that have been officially recognized.

A staggering variety of tangible evidence—healing springs,

. . .

Basilica of Our Lady of Fatima
Fatima, Portugal

An enormous complex—a basilica, chapels, and other devotional sites—has been built in Fatima. The Chapel of Apparitions, an open-air structure built in 1919, has been constructed on the site where Mary appeared and is reached by a long, paved path, which many pilgrims traverse on their knees. The neoclassically styled Basilica of Our Lady of Fatima (1928–1953) includes fifteen altars, one for each of the fifteen mysteries of the rosary. Holy water pours from a fountain in the wide esplanade in front of the basilica. In 2007, the Grand Church of the Holy Trinity was completed, with a maximum capacity of 9,000 people—a fraction of the estimated 100,000 pilgrims who visit daily during the pilgrimage season from May to October. The *Via Sacre,* or "Holy Way," consists of fourteen chapels built in remembrance of Christ's Passion that were constructed in 1964 by Hungarian refugees who had fled Eastern Europe and felt a particular affinity for Mary's warnings about communist Russia. A fifteenth chapel marks Christ's Resurrection and was built in 1992, after Communism's fall. A segment of the Berlin Wall is also displayed at the complex.

• • •

Our Lady of La Vang, 2006
Giancarlo Buratti, artist
Franco Dolfi, marble cutter
Marble
Chapel of Our Lady of La Vang, Basilica of the National
Shrine of the Immaculate Conception, Washington D.C.

Numerous Catholic parishes in the United States with large Vietnamese populations are named after Our Lady of La Vang, including those in New Orleans, Houston, and Las Vegas. She is honored at the Basilica of the National Shrine of the Immaculate Conception, the largest Marian shrine in the Western hemisphere, in a chapel given by Vietnamese Americans and dedicated in 2006. Its centerpiece, illustrated here, is a statue executed in a rare multicolor marble technique that depicts Mary wearing a long blue mantle over an *ao dai* and a wide golden Vietnamese hat. Her child raises his arm, blessing all who enter.

clothing, statues, icons, tears, and, more recently, photographs and film footage—support the visionaries' claims. In *God-Sent*, Roy Varghese analyzes the evidence from Mary's verified appearances, including the 1987 televised apparition of the Virgin in Hrushiv, Ukraine; the weeping statue of Our Lady of Akita, who was shown crying in 1979 on Japanese national television; and the photographs that were taken during her appearance to hundreds of thousands of people in Zeitun, Egypt, in 1968. From Mary's first-century appearance to the apostle James in Spain to her later appearances in Walsingham, England (1061), Czestochowa, Poland (1382), Tepeyac, Mexico (1531), and Lourdes, France (1858), which I discuss elsewhere, her apparition at sites across the globe has provoked mass convergences of the faithful.

At La Vang, Vietnam's primary Catholic shrine, the Blessed Virgin is portrayed as a chestnut-haired Vietnamese woman dressed in an *ao dai*—a traditional high-necked, long-sleeved silk garment—holding the child Jesus. Mary, dressed in this way, appeared to crowds of beleaguered Catholic Vietnamese families in 1798, a time of intense Christian persecution. The struggle had been launched centuries earlier as local lords clashed with Spanish missionaries, and in the late 1700s a ruling dynasty began direct attacks on churches and followers. More than 100,000 Vietnamese Catholics were killed. Families took refuge in the La Vang rain forest in the mountains of central Vietnam, where they suffered from sickness and starvation, endured attacks by wild beasts, or died from bitter cold.

One night, as the refugees prayed the rosary, a beautiful woman surrounded by light appeared to them, holding a child in her arms and accompanied by two angels. The people recognized her as the Mother of God. They later reported that the woman spoke words of comfort and instructed them to boil the leaves of nearby trees to create medicine for the sick. She told them that anyone who came to the spot to pray would have their prayers answered. Mary is said to have appeared at La Vang numerous times over the next one hundred years of Christian persecution.

A small straw chapel was built in Mary's honor after she appeared in La Vang in 1798. Once overt religious persecution ended

Our Lady gave humanity to God as she gave the water to Christ at Cana, to be changed into wine. Human nature was to have the qualities of wine: it was to be colored all through with the splendor of the red blood of Christ; and it was to inebriate, to enliven, to exalt, so that people would infuse life and the sweetness of life into one another.

—Caryll Houselander, *The Reed of God,* 1944

nearly a century later, several larger chapels were built at the site. Miracles, cures, and favors granted there attracted throngs of pilgrims. In 1901, the local bishop proclaimed Our Lady of La Vang the patron saint of Vietnamese Catholics. Pope John XXIII raised the chapel to the rank of a minor basilica in 1961, but it was destroyed in 1972 during the Vietnam War. A smaller sanctuary now stands at the site, flanked by guesthouses, a retreat center, and an open area remarkable for its sculptures of the banyan trees that once crowded the jungle area. Although the Vatican has not officially recognized La Vang as a Marian apparition, Pope John Paul II repeatedly declared his affection for the site. In 1988, during canonization of 117 Vietnamese martyrs, the pope said that he hoped La Vang would become a symbol of the Church's new vitality and included the site in the list of significant Marian shrines worldwide. Huge numbers continue to make pilgrimages there in spite of heavy restrictions on the Catholic Church by the Republic of Vietnam's Communist government.

• • •

Apparition Hill, 2008
Judith Dupré
Digital print
Medjugorje, Bosnia-Herzegovina

At Medjugorje, the steep trail up Apparition Hill is punctuated with bronze relief sculptures of the fourteen Stations of the Cross and culminates at the place where the Virgin Mary is said to have appeared in 1981. Here a statue of Mary sits on a platform covered with papers scrawled with prayer requests. Some sing, others sit and contemplate in silence atop the slippery rocks now worn smooth by millions of feet.

Rising from the emerald topography of County Mayo in western Ireland is the village of Knock. It was from this county that came the first report of death from starvation from the Great Famine, and from here many Irish emigrated to the United States in the mid-nineteenth century, to escape its devastation. The evening hours of August 21, 1879, would shed a new light on impoverished Knock, bringing attention to the area while making it a popular pilgrimage site for Catholics in Ireland and, later, from abroad.

According to myriad reports, including one published by *The New York Times* in 1880, the Virgin Mary appeared, flanked by Sts. Joseph and John the Evangelist, in a blaze of light at the south gable of the Church of St. John the Baptist. Villagers, ranging in age from five to seventy-five years, reported seeing Mary clothed in white robes, eyes and arms raised heavenward, with a large crown upon her head. A golden rose in full bloom graced her forehead. To the left of St. John was a lamb on an altar with a cross behind it, bathed in radiant light. Mary did not speak, which was understood by some as an invitation to silent contemplation of the profound mystery of the Eucharist. Witnesses stood, rapt, in drenching rain for two hours, reciting the rosary. Later, they marveled at how the ground below the saints was left untouched by rain.

Visitors from all over Ireland began to travel to Knock, with its growing reputation for miracle healings, hoping to add their own cast-off crutches and bandages to the collection accumulating at the shrine site. Through the publicity and expansion efforts spearheaded by Monsignor James Horan, who worked at the shrine from 1963 until his death in 1986 while visiting Lourdes, the site

Our Lady of Knock, Queen of Ireland, you gave hope to your people in a time of distress and comforted them in sorrow. You have inspired countless pilgrims to pray with confidence to your Son, remembering His promise: "Ask and you shall receive, seek and you shall find." Help me to remember that we are all pilgrims on the road to heaven. Fill me with love and concern for my brothers and sisters in Christ, especially those who live with me. Comfort me when I am sick or lonely or depressed. Teach me how to take part ever more reverently in the holy Mass. Pray for me now, and at the hour of my death. Our Lady of Knock, pray for us.

—Prayer to Our Lady of Knock

became an international pilgrimage destination, attracting upward of 1.5 million visitors annually. Horan pushed for the creation of an international airport at Knock and initiated a major building campaign that saw the construction of a new church, Our Lady, Queen of Ireland, in 1976. In celebration of the shrine's centenary, Pope John Paul II visited *Cnoc Mhuire*, the "Hill of Mary," on September 30, 1979, and honored the new church with the designation of basilica, the first in Ireland. Mother Teresa also visited in 1993. The grounds today include souvenir shops, hotel accommodations, a health center, and a museum. Chapels and holy-water fountains dot the complex. Amid these modern developments, on the site of the original apparition, are statues that depict the Marian vision just as the villagers had described it long ago.

Portugal entered World War I in 1916, first giving naval assistance and then, by February 1917, sending 50,000 men to the West-

• • •

Holy House, 1931
Shrine of Our Lady of Walsingham
Little Walsingham, England

Richeldis de Faverches, a devout Saxon noblewoman, had a vision in 1061 in which the Virgin Mary showed her her home in Nazareth and asked her to build a replica of that house in Little Walsingham, England, providing its exact dimensions. While Lady Richeldis prayed one night, angel hands are said to have miraculously completed the house, which measured twenty and a half feet by twelve feet ten inches, and moved it to a new site about two hundred feet away. Lady Richeldis's son built a priory to contain the simple wooden structure, which became a preeminent destination for pilgrims, from kings to commoners.

By the thirteenth century, "England's Nazareth" was as important a pilgrimage site as Jerusalem, Rome, and Santiago de Compostela. Even Henry VIII visited, at the beginning of his reign. However, in 1538, after he broke with Catholicism and as part of his dissolution of the monasteries, the shrine was destroyed. It wasn't until 1921, when Father Hope Patten was appointed vicar of Walsingham, that Anglican interest in pre-Reformation pilgrimage was ignited. Patten led efforts to rebuild the shrine, which opened in 1931. Above the shrine's altar is a much beloved sculpture of Our Lady of Walsingham, carved in 1922 and copied from the seal of the medieval priory. Today, Mary is honored by two shrines in Walsingham. The shrine containing the Holy House is administered by the Anglican Church and the other, about a mile away, by Roman Catholics. The fourteenth-century Slipper Chapel, so called because pilgrims left their shoes there before walking barefoot the last "Holy Mile" to the Holy House, became the centerpiece of the Roman Catholic National Shrine of Our Lady of Walsingham in 1934.

ern Front. Soon afterward, on May 13, 1917, the Virgin Mary appeared atop an oak tree to three small children in Fatima, in central Portugal. Francisco and Jacinta Marto, brother and sister, and their cousin, Lucia de Jesus dos Santos, were in a pasture when Mary showed herself to them. In the next year, she would appear to the children five more times—four times on the thirteenth of the following months at the same spot, and once elsewhere, on August 19, when the young visionaries had been removed to a safe location by a local government official. On the fifth and final appari-

tion at Fatima, a crowd of about 70,000 people witnessed the sun making miraculous motions in the sky, as was reported in several newspapers at the time. Later, *The Miracle of Our Lady of Fatima*, a 1952 film, would cinematically re-create the dancing sun to dazzling effect.

At Fatima, the most prophetic of modern apparitions, Mary revealed three secrets to the children. As summarized by John Paul II in his "Message of Fatima" letters, the first and second secrets make reference to a frightening vision of hell, devotion to the Immaculate Heart of Mary, and the coming Second World War. Another prediction—of the immense damage that would come about by Russia's abandonment of Christianity and embrace of Communism—made Fatima something of an ideological shrine for anti-Communists during the Cold War. The third secret, written down in 1944 by Lucia and to be revealed in 1960, was withheld from the public. After decades of feverish speculation, during the beatification ceremony of Francisco and Jacinta on May 14, 2000, the Vatican disclosed this final secret, describing it as a vision of the 1981 attempt on the life of Pope John Paul II. John Paul II, who had dedicated his papacy to Mary, credited her with saving his life. During his 1982 visit to Fatima, he placed the assassin's bullet that had been extracted from his body among the jewels adorning the crown of a statue of the Virgin.

Medjugorje in Bosnia-Herzegovina gained worldwide attention after it was reported that the Virgin Mary appeared there on June 24, 1981. The multiple claims and controversies that followed would place this isolated mountain locale on the international map of contested sites of Marian apparitions—and attract millions to the little town. The pilgrims themselves, largely conservative Catholics, have polarized opinion of Medjugorje, which continues to be a stronghold for those who see themselves as upholding traditional values, particularly relating to sexuality, in the face of Christ's coming, judgmental wrath.

In the summer of 1981, while hiking up the hill of Podbrdo of Mount Crnica, six local youths reported that the Virgin Mary appeared atop the hill and spoke to them in Croatian. Stunned by

the vision, the group fled, only to return again the next day, when, according to their accounts, Mary appeared once more—this time, giving them a message. Beginning on the first day of the reported vision, the youths said they saw Mary and received messages from her on a daily basis, for years following, at the same location on what is now called "Apparition Hill."

Four of the original group continue to report daily Marian visions, though now, to protect them from skeptics, they receive Mary in a private room in the local church. Area bishops have been hesitant to officially validate the apparitions. Local government officials have also questioned the reports, at one time putting construction bans on building amenities and accommodations for the increasing number of visitors. Although the ban has been lifted, and the village has grown to include multiple souvenir shops and hotels, the government of Medjugorje still denies the apparitions. The Vatican has issued warnings that priests, nuns, and affiliated members of the Roman Catholic Church may not lead official pilgrimages there until the authenticity of the apparitions is verified. Given the anticipation of future apparitions at Medjugorje, which have been scheduled for specific dates and times, the Bishop of Mostar–Duvno expressed the Vatican's explicit concerns about their validity in his homily on June 15, 2006. In March 2010, in an abrupt turnaround, the Vatican established an international doctrinal commission to study the alleged apparitions.

Even through the dangerous years of the Bosnian genocide (1992–1995), more than a million pilgrims flock to Medjugorje annually, drawn by reports of the apparitions and miraculous healings. Indicative of the global surge in spiritual travel, ten times more people visit Medjugorje now than a decade ago. They come to pray in the local church and climb the steep, rocky trails up Apparition Hill. For some liberal Christians, the most challenging aspect of the site is not its unforgiving topography but its right–wing constituency, which makes itself known immediately and with force. Despite the politics and lack of an official Church stamp of approval, people make the long journey to the isolated town, which is jammed with traffic and stores selling rosaries, Marian

statuary by the acre, and small muslin bags filled with the lavender that covers the hills. Some are in search of a miracle, some in search of themselves, and still others search for the Church as they understand it in the place where, authenticated or not, the Virgin Mary is said to visit every day, bearing a persistent message of peace.

The apocalyptic nature of the messages given in modern Marian apparitions is balanced by a message of hope. At the same time, there is a consistent theme of suffering at the sites where the infirm gather, as though the land itself embodies and relieves the visionary's physical and psychic pain, as well as healing those who later journey there. The pilgrim community often begins to understand itself as suffering on behalf of the larger population, thus creating a path from meaningless to meaningful suffering. Pilgrimage to such sites is a means of opening oneself up not only to one's own unhealed wounds but to the pain of others, a practice that affirms one's humanity, regardless of supernatural experience or the manifestation of physical change.

Our Lady of Lourdes

O N FEBRUARY 11, 1858, Bernadette Soubirous, an impoverished, barely literate fourteen-year-old girl, had a vision of a beautiful girl, no larger than herself, who held a rosary, made the Sign of the Cross, and then disappeared. This apparition, the first of eighteen over the next five months, would soon single out Lourdes, a small village in the foothills of the French Pyrenees, as a holy site. Three days later, in defiance of her mother's warnings, Bernadette returned to the grotto set in a rock outcropping called Massabielle, where the radiant girl in white appeared again. Crowds began to gather. Later that month, those assembled would see Bernadette clawing at the ground, uncovering the spring at the grotto for which the pilgrimage site would become world renowned. Because the girl, whom Bernadette simply called *aquéro*, or an "indefinable being," directed Bernadette to "drink of the spring and wash yourself there," the water is believed to possess miraculous properties. Relative to other Marian apparitions, *aquéro* said few words, and those were heard only by Bernadette. However, on March 25, the Feast of the Annunciation, she told Bernadette, "I am the Immaculate Conception," which instantly identified her in the minds of most as the Virgin Mary. On July 17, Bernadette saw the girl one last time, now appearing across the river because authorities had cordoned off the grotto in an effort to control the crowds. Soon, a zinc basin with three spigots was installed at the site of the spring, and by 1883, the water cures there had become so numerous that a medical bureau was established to quantify the nature of both ailments and miracles.

Bernadette never wavered in her description of the vision—she was adamant that it was a young girl like herself with her hands folded at her chest in prayer. Once the apparition called herself the Immaculate Conception, however, her image morphed in the minds of the populace into the maternal image of the Blessed

I do not think our cures can compete with those at Lourdes. There are so many more people who believe in the miracle of the Blessed Virgin than in the existence of the Unconscious.

—Sigmund Freud, *New Introductory Lectures on Psycho-Analysis,* 1933

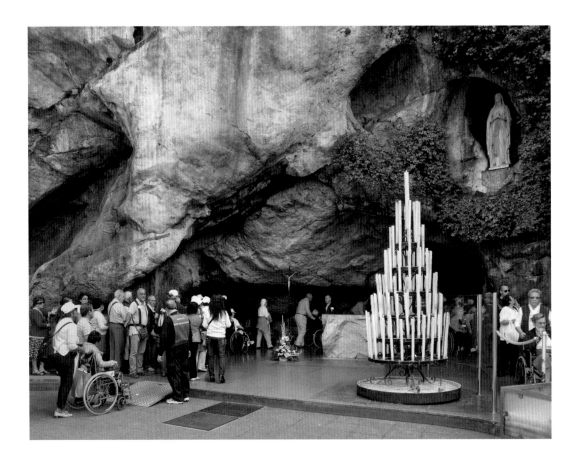

• • •

Grotto Shrine
Lourdes, France

The sanctuaries that sprang up around the grotto at Massabielle now cover 126 acres (51 hectares) and contain twenty-two places of worship. Standing in a niche among the grotto's stones is a statue of Mary, designed by Lyonnais sculptor Joseph Fabisch and installed in 1864. Mary holds a rosary in her right hand, with two yellow roses resting on her feet. Looming above the grotto is the original church, the Basilica of the Immaculate Conception (1864–1872), with a soaring spire of 230 feet (70 m) and large handicapped ramps that encircle the central plaza. Nestled below it is the Basilica of the Rosary (1883–1889), designed in a neo-Byzantine style. Seventeen marble bathing pools, eleven for women and six for men, allow visitors to immerse themselves in the grotto's waters. On-site volunteers help the sick and infirm bathe. The miracle cures reported from the waters are legendary and now number in the thousands, and the water is sold locally and exported throughout the world.

Mother. This was partly a result of an earlier apparition in Paris in 1830. There, on the Rue du Bac, Mary appeared twice to Catherine Labouré, a Sister of Charity and now sainted, and described a medal bearing her image that she would like to have made. It portrays Mary as a mature woman, crushing a serpent beneath her feet, with light pouring down from her outstretched hands. Around the perimeter is written, "O Mary, conceived without sin, pray for us who have recourse to thee." Struck in 1832, the Medal of the Immaculate Conception conferred so many physical, spiritual, and economic benefits upon its wearers that it became known as the "Miraculous Medal." Its immense popularity with the laity, along with the apparitions that inspired it, encouraged Pope Pius IX to eventually define the Immaculate Conception of Mary—"conceived without sin"—as dogma in 1854. Four years later, the confirmation at Lourdes of the dogma was so profound that the clergy and other elite Catholics rejected Bernadette's girlish description of the apparition because the pull of traditional images of Mary, as well as Catholic orthodoxy, was so strong.

Infamous among the scores of books written about the site is the novel *Lourdes* (1894) by Emile Zola. Not convinced of the miraculous healings there, Zola wrote a thinly veiled fiction that skewers the reports of cures, which he perceived as the illusory result of autosuggestion. Hugely successful, the book fanned the era's already rampant anticlerical sentiment and boosted the absolute authority of science over religion as the sole, supreme criterion for knowledge. In an effort to excavate the truth from the mountain of previous, highly subjective Lourdes narratives—which began to accrue ten days after the first sighting, when Bernadette was interviewed by Jean Dominique Jacomet, the Lourdes police commissioner—the Benedictine scholars René Laurentin and Bernard Billet compiled the seven-volume *Lourdes: Documents Authentiques* (1957–1966). During that same period, Laurentin produced *Histoire Authentique des Apparitions* (1961–1964). Suzanne K. Kaufman's *Consuming Visions: Mass Culture and the Lourdes Shrine* (2008) explores the relationship of piety and consumerism as they exist side by side at Lourdes (and at most pilgrimage sites) and demonstrates how the clergy used every commercial and industrial means avail-

Lourdes, the grotto, the cures, the miracles, are, indeed, the creation of that need of the Lie, that necessity for credulity, which is a characteristic of human nature. At first, when little Bernadette came with her strange story of what she had witnessed, everybody was against her. The Prefect of the Department, the Bishop, the clergy, objected to her story. But Lourdes grew up in spite of all opposition, just as the Christian religion did, because suffering humanity in its despair must cling to something, must have some hope; and, on the other hand, because humanity thirsts after illusions. In a word, it is the story of the foundation of all religions.

—ÉMILE ZOLA, Preface to *Lourdes,* 1893

able to transform Lourdes into an international phenomenon, including the rail system, popular press, and the techniques of contemporary advertising.

What was it about Lourdes, one of many places in France where Mary has appeared, that made this particular site take root and become an international phenomenon? In her majestic study, *Lourdes: Body and Spirit in the Secular Age,* Ruth Harris looks at the myriad colliding conditions that brought the site to prominence, beginning with the land itself, notably its strategic position on routes that since the Middle Ages led to the great pilgrim sites of Santiago de Compostela and Montserrat. Culturally, the apparition was bookended by the proclamation of the dogma of the Immaculate Conception and, in 1870, that of papal infallibility, two polarizing doctrines that straddle the gap between faith and fact. Lourdes shed strong light on the opposing camps of religion and science: adherents of Catholic mysticism, under fire since at least the Reformation, versus those, epitomized by Zola's viewpoint, who viewed the apparitions and subsequent cures as a hallucinatory throwback to the medieval age before scientific methods could be used to explain the unexplainable. Harris expands the notion of cure and how the body in pain can lead, then as now, to new notions of selfhood. She takes up the mantle of the feminist theologian Elizabeth Johnson, who looked to re-present the female image, which was typically constrained and often denigrated by traditional Marian imagery. Harris examines how Lourdes empowered women, poor and rich alike. That women were both the main workers and primary recipients of cures at Lourdes supported the notion of a "feminized Catholicism" in the nineteenth century but also points to something more than Catholicism's maternalist legacy. Lourdes provided the women who assisted the ill with a means of practical activism that often was denied them in secular culture, and it enabled them to view themselves, in body and mind, as healed, whole, engaged, and resourceful.

Our Lady of Guadalupe

I T HAS BEEN almost five hundred years since Our Lady of Guadalupe appeared to the Nahautl Indian Juan Diego in December of 1531, in Tepeyac, northwest of what is now Mexico City and then the far margin of the known world. Ten years earlier, the Spanish conquistador Hernán Cortés had taken Mexico in a bloody war that left those who survived traumatized, diminished, and sorely in need of comfort and encouragement. The dark-skinned Virgin who appeared to Juan Diego spoke to him in his language, and her person was encoded with the familiar symbols of the Aztecs. She asked simply for a house in which she could express her love for her children. When Juan Diego needed proof of her presence to convince others to honor her request, she furnished it with roses, blooming, impossibly, in winter and with her imprint on his cloak—an image that has become one of the most beloved portraits of Mary.

Two versions of this encounter were recorded, both well after the fact. One was written from a Spanish perspective, the other from an indigenous one, setting up the question that would come later: Who, if anyone, "owned" the persona of Guadalupe? The first known narrative was published by Father Miguel Sánchez in 1648, more than a century later, and recounts the Virgin's appearance in ways that empowered the *criollos*, or Mexican-born Spaniards. A second version came a year after that, in 1649. Known by its opening words, *Nican mopohua* ("Here is recounted"), it was written by Father Luis Laso de la Vega in Nahautl, the native pre-Columbian language. My retelling of the story below is based on the second version.

One Saturday in early December, Juan Diego, a recently baptized Nahautl of humble origins, was on his way to religious instruction. As he climbed Mount Tepeyac, an ancient site honoring the Mesoamerican mother goddess Tonantzin, the air was filled

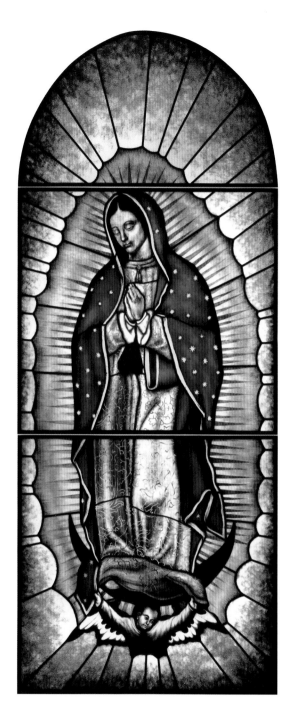

• • •

Santa Maria Guadalupe, 2009
Stained glass
36×95″ (91.4×241.3 cm)
Rambusch & Company, New York

This stained-glass window re-creates the original
image of Our Lady of Guadalupe that appeared
on Juan Diego's cloak in 1531. Working from a
copy of the Church-sanctioned digital version of
the original image, the artists made an exacting
replica in stained-glass that was painted, etched,
stained, and assembled with lead cames. The
goal of the studio was not to interpret but to
replicate the venerable original image as closely
as possible, which required painstaking
attention to subtle details. This is evident
especially in the Virgin's patterned tunic and
mantle, which are embellished in tones of
muted gold, and in the color gradations in the
rays of light surrounding her. The Knights of
Columbus, a Catholic fraternal service
organization founded in 1882, commissioned
the window for Villa Maria Guadalupe, an
international retreat center in Stamford,
Connecticut, which is directed by the Sisters of
Life. It was designed and fabricated by the
Rambusch company, one of the oldest and most
preeminent designers of religious art and
furnishings in the United States.

with beautiful birdsong. At the summit, he heard a voice calling him—*"Dignified Juan, dignified Juan Diego"*—and he "dared to go where he was being called." Before him was a woman shining like the sun, who said:

> "Know and be certain in your heart, my most abandoned son, that I am the Ever-Virgin Holy Mary, Mother of the God of Great Truth, Téotl, of the One through Whom We Live, the Creator of Persons, the Owner of What Is Near and Together, of the Lord of Heaven and Earth."

She instructed him to ask the bishop of Mexico to erect a building at the site, first describing what she wanted as a hermitage, or home for the homeless, then as a home, then as a temple—her structural request evolving and expanding to describe a sacred place in its charitable, personal, and institutional meanings.

Juan Diego hurried to Bishop Juan de Zumárraga, who, after making him wait interminably, put him off, telling him to come at another time. Returning to Tepeyac, he begged the Virgin to find another, more respectable person who could more effectively convey her message to the bishop. Denigrating himself, he said he was no more than the "excrement of people," who even if heard would not be believed. She insisted that he return, which he did, only to be told by the bishop that he needed a sign from the Virgin. On Monday, Juan Diego had to fetch a priest to hear the last confession of his dying uncle and skirted around Tepeyac, avoiding an encounter with the Virgin in order to save time. Watching this, she came down the hill and asked him where he was going. After hearing his explanation, she said:

> "Am I not here, your mother? Are you not under my shadow and my protection? Am I not your source of life? Are you not in the hollow of my mantle where I cross my arms? Who else do you need? Let nothing trouble you or cause you sorrow."

The symbol of Our Lady of Guadalupe is a matrix of meaning: she tells us something about who we are (in the Mexican-American women's case, that they are female, mother, *morena*, marginalized), and she tells us something about who God is: God is the source of all life, maternal, compassionate, and present, and protects the poor and marginalized.

—Jeanette Rodriguez, *Our Lady of Guadalupe: Faith and Empowerment Among Mexican-American Women*, 1994

A civilization of love engages reality. Like the barren Tepeyac that grew flowers out of the Virgin's love for man and attentiveness to Zumárraga's desire for truth, a civilization of love is the seedbed for truth. And like the hill-flower on the tilma, with its smaller flowers growing from the large flower, truth begets truth.

—CARL ANDERSON, *Our Lady of Guadalupe: Mother of the Civilization of Love,* 2009

Assuring him that his uncle was healed, she told Juan Diego, who had asked for a sign to bring to the bishop, to go to the top of the hill. There, though it was winter, he found fragrant, dewy flowers that looked as if they were "filled with fine pearls," which he gathered into his *tilma*, or cloak. When he opened his *tilma* before the bishop, the flowers, usually described as Castilian roses, tumbled out. Even more astonishingly, the inside of his tilma was emblazoned with a full-length picture of the Virgin, a "divine marvel," according to the *Nican Mopohua*, "because absolutely no one on earth had painted her precious image." This finally convinced Zumárraga, who ordered a church be built on the site. Juan Diego returned home to his now-recovered uncle, who said the Virgin had appeared to him as well and that the bishop would identify the tilma portrait as the Ever-Virgin Holy Mary of Guadalupe.

The young woman miraculously mapped on Juan Diego's cloak has dark skin, black hair, and downcast eyes. She wears an embroidered pink dress sashed in black—a sign she is pregnant. Its hem is upheld by the winged angel at her feet, and her turquoise shawl is sprinkled with gold stars. Standing on a crescent moon, she is doubly framed by a scalloped cloud bank and an oval mandorla composed of gilded sunbeams. The image pictures the woman foreseen in Revelation (12:1) who is "clothed with the sun, with the moon under her feet, and on her head a crown of twelve stars," which, by the sixteenth century, became the basis of portrayals of the Immaculate Conception. Significantly, these same symbols—sun, moon, and turquoise—evoked the Aztec cosmogony. Today, the tilma is framed under glass and hangs high above the heads of pilgrims who visit the Basilica of Guadalupe. Their numbers are so great that a moving walkway was installed under the holy relic to more efficiently handle the crowds.

Not immediately, but inexorably, Our Lady of Guadalupe came to legitimize Spanish colonial power. In the indigenous imagination, her image was equally powerful: It conflated the familiar personas of female Aztec goddesses, who oversaw both life and death with awesome dread, with the apocalypse wrought by Cortés's armies, who would carry images of the Virgin Mary into battle as protection and also place them on altars in pre-Hispanic temples.

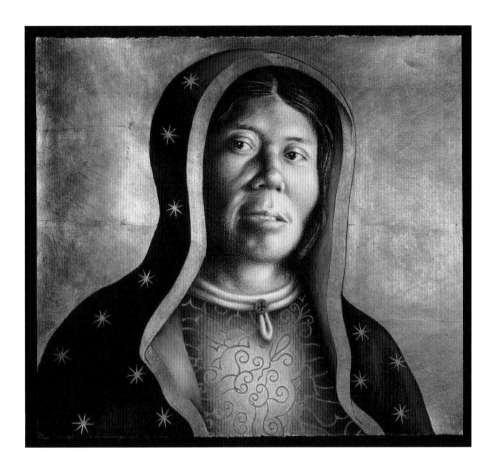

• • •

Retablo de la Virgen Indigena, 1995
J. Michael Walker
Color pencil and gold leaf on watercolor paper
22×24″ (55.8×61 cm)
Collection of Margarita Perez

Increasingly, artists are exploring Our Lady of Guadalupe's vigorous contemporary presence in portrayals that vary from the traditional image received on Juan Diego's cloak. In this portrait, the artist J. Michael Walker modeled Mary's face after that of an Indian woman from the Mexican state of Chihuahua. While her starry mantle and embroidered dress resemble those of the canonical cloak image, she has indigenous features and glances off to the side, as though something or someone has just caught her eye. Her lively, slightly bemused expression can be interpreted in many ways. After Walker experienced a vision in which Guadalupe freed herself from her iconic position, metaphorically coming down from her pedestal and entering the workaday world, he began a series of drawings that show her, as he puts it, engaged "in the myriad daily tasks by which women hold the world together." As La Virgen started to appear in the faces of women wherever Walker went, whether in Mexico or Los Angeles, she acquired a greater vividness for him.

While the maternal and compassionate Guadalupe symbolized everything that was not hierarchical, paternalistic, and Spanish, paradoxically, in her humility, she also modeled for the Indians meek acceptance of colonial authority. Her veneration by Spanish Catholics grew. Credited with saving Mexico City from a mysterious and deadly epidemic in 1736–1737, she was named the capital city's patroness in 1737. Mary's Guadalupe incarnation eventually eclipsed and subsumed other Marian figurations in the Americas, such as the Virgin of Los Remedios, the Virgin of Candelaria at San Juan de los Lagos, and the Virgin of Zapopan, as well as those of pre–Hispanic earth goddesses—Tonantzin, Coatlicue, Teteoinnan, Cihuacoatl, and Xochiquetzal, among them—and she emerged in the eighteenth century as the patroness of New Spain.

As with the gospels, any firm evidence supporting the strong

• • •

Guadalupe Street, San Antonio, Texas, 2005
Carol M. Highsmith
Digital print
Library of Congress, Washington, D.C.

This photograph, taken by American photographer Carol Highsmith, depicts a mosaic mural of the Virgin of Guadalupe, the beloved patron saint of the Americas. Entitled *"La Veladora* (Light of Hope)," the mural was designed by local artist Jesse Treviño. It features a three-dimensional tile depiction of La Virgen in the form of a half-candle relief grafted onto the exterior of the Guadalupe Cultural Arts Center, which fosters Latino and indigenous performing arts on San Antonio's Westside. Tapping into the Virgin's power as a cultural and spiritual icon, the mural was designed to reinvigorate hope and interest in the city's long-neglected downtown. It is said to be the largest depiction of the Virgin of Guadalupe outside Mexico City.

Treviño designed the work in the shape of a Mexican devotional candle, which is traditionally lit in prayer and meant to provide protection and solace. A light shines from its glass-covered top twenty-four hours a day. The artist sought to evoke the faith and sense of community that he found lacking in the darkened, dilapidated streets of his San Antonio neighborhood. Treviño survived his own struggle with faith after he lost his right painting hand in the Vietnam War; now Treviño's mural stands as a unique testimony, for the local community and beyond, of faith's power to rebuild and renew.

Highsmith's photographs document America's diverse geographical and architectural faces. This photograph was taken as part of a larger project on San Antonio, Texas, commissioned by the Urban Land Institute. Since 1992, Highsmith has donated her images to the Library of Congress and provides copyright-free access to them as a public service.

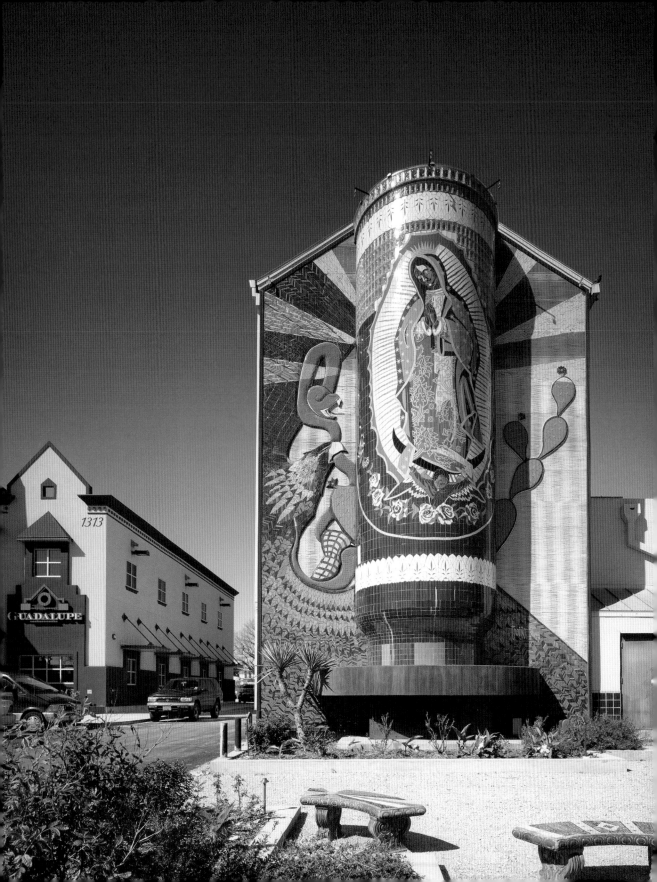

oral tradition that arose from the apparition of Our Lady of Guadalupe—variously known as La Virgen, La Morenita, Tonantzin, Star of the New World, and, diminutively, La Lupita—has been lost to time.

Undeniable, however, is the ubiquity of the *tilma* image, a kind of continuous apparition, which, according to pious tradition, is one of those rare images that has been divinely given rather than imagined by an artist. It has spurred numerous investigations over the years into such phenomena as the Virgin's eyes, in which some see the reflected faces of hundreds, and the fact that the *tilma* has not decayed, even though it is painted on an organic fabric made from the maguey cactus. The image was understood to be a sign, for the Spaniards and later for the mestizos, that Mary had selected Mexico for special divine favor. As Pope Benedict XIV (1675–1758) said of the portrait, "[God] has not done the like for any other nation."

Just as the Virgin's multiple roles—as protectress, intercessor, and evangelist—effortlessly merge, her mythic persona seems to dispel anything as quotidian as fact. The common assertion that Our Lady of Guadalupe was immediately embraced by the Indians as the miraculous incarnation of Tonantzin, was accepted as the new mother goddess, and inspired massive conversions in the aftermath of the apparitions, though disproved, shows no sign of abating. The *tilma* portrait, too, has been traced to the hand of sixteenth-century indigenous painter Marcos Cipac (de Aquino), thanks to Jeanette Favrot Peterson's strenuous research, but that revelation has had little impact on its perception as a miraculous relic.

Our Lady of Guadalupe's huge influence on contemporary art, thought, and politics indicates how many people love her, regardless of their positions on Catholicism or religious belief. Dozens of books, including this one, have been written to try to give voice to her supernatural inspiration, each as varied and private as a prayer.

Guadalupe Is Everywhere

"TAKE THIS," SAID a Jesuit friend, handing me a red rose some twenty years ago, "and this too," adding a holy card of Our Lady of Guadalupe. "She will help you with everything. She is your mother." Over the years, Our Lady graciously fielded my many requests, often with quick and witty responses that were accompanied by her trademark roses. Then, in 1996, things turned serious. My newborn son was diagnosed with brain damage. He might never walk, the neurosurgeons said. "Heal him," I begged her, and, miraculously, she did. His middle name is Guadalupe. Though the doctors still cannot explain his recovery, or how he became a star soccer player, I myself have no doubts.

Naturally, Guadalupe is at home in my home—on paintings, sculpture, jewelry, and even on a pot holder that shows her enjoying a breakfast cappuccino and croissant. But lately I have been seeing her everywhere—on hubcaps, T-shirts, bottles of hot sauce, and bumper stickers that read *In Guad We Trust.* Not just south but far north of the border, she reigns supreme in many churches and in roadside shrines, New Age enclaves, and Tex–Mex restaurants. Why, I wondered, is this particular image increasingly apparent in both sacred and secular visual culture? There is, indeed, something about Mary. Of her myriad cultural identities, none has captured the popular imagination as has that of La Virgen.

As written in 1649, the *Nican Mopohua* recorded Guadalupe's appearance in Nahuatl, the language spoken by Mexico's indigenous people. In this account, Mary describes herself to Juan Diego as the mother of Teotl, one of the venerable names of God as invoked by Nahuatl theologians before the Spanish conquest. Nahuatl theology was later discredited by the Spanish missionaries, yet the Aztec concept of *téotl,* or the underlying unity of all things, points to why she has crossed physical, political, and cultural borders around the globe.

Her image weaves together contradictions—different, competing, and occasionally combative elements—into wholeness. "Two cultures are reflected in her image, both indigenous and Spanish," said Dr. Arturo Chavez, president of the Mexican American Cultural Center in San Antonio, pointing out that her skin color "speaks to many people who are in a 'no-person's' place, those who are not Indian or Spanish but mestizo, a mixed-race people." Chavez, who has interviewed dozens of men—former gang members, addicts, and prisoners—who have La Virgen tattooed on their bodies, understands these markings as her image "incarnated" in human flesh. Her tenderness, in this case literal, and ability to melt the hardened heart are redemptive entry points for the disenfranchised.

Although gangs also use Guadalupe as a means of identification, even this speaks to her compassion. Chavez notes that such gangs are often the only place where these boys feel a sense of belonging.

• • •

Huexotzinco Codex, 1531
Ink and pigment on maguey paper
16.2×19" (41×48 cm)
Library of Congress, Washington, D.C.

In 1531, the Nahautl Indians of the Huexotzinco (or Huejotzingo) community in the present state of Puebla, Mexico, made eight pictographic images as evidence in a lawsuit brought by Conquistador Hernán Cortés against Nuño de Guzmán and other Spanish administrators who sought to usurp his property and power. The drawings gave a precise visual accounting of the massive quantities of goods and services the Spanish demanded of the Nahautl—tributes that Cortés believed were owed to him. Having assisted Cortés a decade earlier, when he conquered Tenochtitlán and overthrew Montezuma, leader of the Aztec Empire, the Nahautl believed that they should be exempt from additional, excessive taxation. Eventually, they were successful: King Charles of Spain ruled in 1538 that two-thirds of the tributes be returned to the people of Huexotzinco. The pictographs are part of a seventy-nine-leaf manuscript of the lawsuit proceedings, which provides rare and significant insights into the vibrant Nahautl culture and their assimilation within a new political and religious system.

This *Codex* sheet, depicting a banner of the Virgin Mary and the Christ child, is thought to be the first pictorial representation made of Mary in the New World. The Nahautl produced the image, gilded and framed in brilliant green quetzal feathers, for de Guzmán to carry aloft during a military campaign. Depicted around Mary are symbols of the costs associated with producing the banner, including nine bundles of feathers (above banner image), three circles representing the gold used (left of banner), and, below the banner, eight male and twelve female slaves sold to pay for the gold used in the banner's creation.

When Mary asked Juan Diego to build her a home, it was not a literal home, despite the lavish basilica that was erected in her honor at Tepeyac, but a metaphoric home, a place where one belongs and is cherished.

"She is the most perfect sign of acculturation," according to Alejandro Aguilera Titus of the Secretariat on Cultural Diversity in the Church at the U.S. Catholic Conference of Bishops. By using their language and symbols, she conveyed to the Nahautl that "the Christian faith is not here to obliterate you but to give you the message of the true God, a God who embraces you as his own." While she appeals to those who are powerless, she also empowers them.

And then there is her demure, unassuming beauty. "Guadalupe's face is one of the most beautiful that I've ever painted," according to Father John Giuliani, a Roman Catholic priest who also paints

La Guadalupana, 1999
Delilah Montoya
Archival digital print
24×16.5″ (61×42 cm)
Collection of Gilbert Cárdenas

In this photo, a handcuffed Latino kneels before the iron bars of a detention center. His back is tattooed with the image of Our Lady of Guadalupe, as it appeared on Juan Diego's cloak in 1531. The image draws multiple connections between Guadalupe and the ancient Nahuatl, exploring the areas where Nahuatl deities and rituals overlap with the forms and colors associated with Guadalupe, through whom the Spanish converted many native Mexicans.

The *señal,* or sign, that Juan Diego had spoken with Our Lady of Guadalupe was her graphic appearance on his cloak (*tilma*) and the appearance of roses in winter. For mestizos and gang members, the *tilma* has a dual meaning. In addition to its association with the Guadalupe miracle, it is seen as a second protective skin. While our actual skin embodies our nakedness, clothing, the second skin, conceals that state. In the Nahuatl culture, the second skin also recalls the ancient ritual involving the flaying and wearing of the skins of sacrificial victims to appease Xipe Totec, the Aztec god of death and regeneration, and the male counterpart of Tonantzin, the Aztec mother goddess of compassion. By sharing many of the qualities associated with Tonantzin, Our Lady of Guadalupe hastened Christianity's acceptance by the Nahuatl and other indigenous Mexicans. The tattooed man depicted in Montoya's work "wears" Guadalupe's image in reference to both Juan Diego's cloak and the rituals thought to assuage Xipe Totec, thus binding together past and present, pagan and Christian, and male and female energies.

iconographic portraits of Mary and the saints. "The painting has a life of its own." According to Giuliani, the image on Juan Diego's mantle that was presented to the skeptical Bishop Juan de Zumárraga as miraculous proof falls into the category of revelation: "It is a visual fact, the miraculous imprint of a revelation. While there is room for stylistic variations, the essential canon of the image is set. The image is. We don't have any visions of John the Baptist, of Francis of Assisi."

In a fractious world, La Lupita's image is calm and reassuring. The maternal familiarity she inspires is borne out by the Latino custom of dressing church statuary with actual clothing, the washing, ironing, and repair of which is part of a larger devotion. The clothing softens her image and recalls how her image was manifested—on pliable cloth, a cloak to warm and comfort. On December 12, her feast day, statues of Guadalupe are carried through

the streets amid joyful singing, another practice that underscores her dynamic presence and intimate involvement in the lives of her devotees.

Our Lady of Guadalupe has been portrayed in her dual roles as liberator and protectress by writers such as Graham Greene, who observed in *The Lawless Roads* of 1950 that her persona "gave the Indian self-respect; it gave him a hold over his conqueror; it was a liberating, not an enslaving legend." That same year, poet Octavio Paz described her in *The Labyrinth of Solitude* as "the consolation of the poor, the shield of the weak, the help of the oppressed. In sum, she is the Mother of orphans." Marching under the banner of Our Lady of Guadalupe, the Mexican American activist César Chávez (1927–1993) sought social justice, humane living conditions, and fair labor practices for migrant workers in California, leading the United Farm Workers in nonviolent fasts, strikes, and boycotts, most notably the grape boycott of the 1970s, when, in solidarity, some 17 million Americans stopped buying grapes. Conservatives employ her image as well: Our Lady, who was pregnant when she appeared to Juan Diego, has emerged strongly within the Catholic pro-life movement as the patron of the unborn.

Her visibility increased when Pope John Paul II declared Our Lady of Guadalupe as the patroness of all the Americas in 1991 and was further encouraged by his 1999 apostolic exhortation, *Ecclesia in America*, which described her as the "Star of the first and new evangelization." Validated by widespread public devotion, the image of Our Lady of Guadalupe has entered the lexicon of global culture. Illustrative of its pervasive influence, the 2008 presidential candidate, John McCain, hoping to woo Latin American voters, orchestrated a photo opportunity at the Basilica of Guadalupe with the *tilma*; it was flashed around the globe. U.S. Secretary of State Hillary Clinton, visiting the basilica in 2009, made a highly publicized gaffe when she asked who painted the famous image. Felix Sanchez, the chairman of the National Hispanic Foundation for the Arts, lobbied for Sonia Sotomayor's 2009 Supreme Court confirmation, posting an online image of Our Lady of Guadalupe in which Sotomayor's face was superimposed over Our Lady's.

Although La Virgen's ubiquitous presence defies simple expla-

nation, her ability to mediate between often–contradictory forces—within history, religion, and ethnic groups, and within individuals who live in and outside the boundaries of traditional faith practices—makes her beloved. That her iconic image appears on bottle caps as well as in basilicas is proof of the wide faith in her perennial willingness to intercede between all people and God. Like water, she seeps in wherever there is an opening, imparting strength, dignity, and hope. As the tattooed men told Arturo Chavez, "She's the Mother of God, the Mother of Jesus, and she's my mother, too."

TWO STORIES

A.

Her mother asked to be buried beside her husband. Her mother asked to be buried with socks on, in case her feet got cold. Her mother asked to be buried in her girdle. An embalmer worked through the night. It seemed that certain parts swelled. The feet eased into the socks. But the waist and hips of the mother no longer fit the girdle. Since the girdle could not be placed *on* the mother, the daughter placed the girdle *beside* the mother, edged neatly between the mother's torso and the casket's quilted satin, so that when the mourners approached the casket to view the mother's body, they approached the mother and they approached the girdle.

B.

Her mother asked that her ashes be scattered in Central Park. The daughter carried the urn filled with the ashes to a secluded section by a stream. She had no thought of emptying it. Raising her arms high, she threw the urn into the stream. It floated slowly. . . . Soon some kids playing by the stream spotted the urn and fished it out. "They've got my mother!" The daughter ran full-speed. She grabbed the urn from the arms of one of the children, who fled toward the safety of the street. This time, when the daughter returned to her original spot, she carefully checked downstream before raising her arm to throw her mother in.

—ELISABETH FROST, 2008

Cathedral of Our Lady of the Angels, Los Angeles

SIX YEARS AFTER the Cathedral of Our Lady of the Angels opened, a memorial service was held there for the Mexican-born Angeleno sculptor Robert Graham (1938–2008), who created its great bronze portal, tympanum, and statue of Mary. Best known for his monumental works of public art, Graham was originally inspired by his childhood in Mexico, where artists such as Diego Rivera, José Clemente Orozco, and David Alfaro Siqueiros telegraphed messages of reform and revolution to the masses through their large-scale murals. Then, after he moved to Los Angeles in 1971, his work took on aspects of the city's light and, given his prolific sculptural output of lithe female nudes, the movie business as well. He was married to Anjelica Huston, actress and daughter of the filmmaker John Huston. In his eulogy, Cardinal Roger Mahony referred to their marriage as "an extraordinary confluence" of two types of artistry, visual and filmic.

A similar confluence marks the cathedral's design and outreach. The culture of Los Angeles, home of the movie industry as well as the nation's largest Hispanic population, depends on the creation of an idealized image of America that is exported globally. In this luxe narrative, however, there are no starring roles for the poor, the disenfranchised, or the newly arrived—the very people, many of them Latin American immigrants, whom the cathedral seeks to reach. The contrast between these disparate worlds is most evident in the cathedral's design, which marries the use of light, illusion, and the pageantry associated with entertainment culture to the rituals and familial bonds that characterize traditional Latino piety. But these contrasts are prominent, too, in its art program, which is largely devoted to Mary.

The cathedral's name recalls the 1781 founding of the city, originally called *El Pueblo de Nuestra Señora, Reina de los Angeles,* when forty-four settlers, or *pobladores,* of Spanish, Native American, and African

heritage came from Mexico and founded the pueblo that would become Los Angeles. Its campanile, plaza, and the use of a limited palette of materials and colors reference the city's Spanish colonial past and, through its highway location, its more recent but equally mythic car culture. The church overlooks the Hollywood Freeway, which runs alongside the fabled El Camino Real, the road the eighteenth-century Franciscan evangelizers once traveled.

The freeway location has been exploited in ways that conjure the collision of Hollywood not only with heaven but with most places in the developed world. From the highway, ostensibly a public, secular zone, millions annually see what can only be construed as ecclesiastical advertising. Driving west, one sees the fifty-foot-high lantern window atop the cathedral's façade, the mullions of which form the shape of a crucifix, which is even more prominent at night when it is lit from within. A massive rectangular window, also fronting the freeway, glows like a giant drive-in movie screen. The cathedral's 180-foot-high campanile is topped with a cross and is visible from either direction, as is a twelve-foot-high image of Our Lady of Guadalupe, which extends out from the highway barrier wall, announcing that not only is this a church but one with a particular devotion to the singular object of veneration for much of Latin America.

Much like a theater, the cathedral is most animated at night, when the entire structure becomes an illuminated beacon, visible for miles. While the evocative combination of light and shadows within a church's interior has historically provided a potent spiritual metaphor, the Los Angeles cathedral's nighttime lighting, in contrast, is outwardly directed—luminous advertising with the scale and marketing intent of its similar use in popular consumer culture.

Conceived as a radiant receptacle and dispenser of light, the cathedral was inspired by a verse in the Gospel of John: *I am the light of the world. Whoever follows me will never walk in darkness but will have the light of life* (8:12). This image of a spiritual path lit by divine light is physically expressed by the literal journey one makes around the massive 3.3 million-cubic-foot space and surrounding plaza and gardens. The concepts of pilgrimage and spiritual pro-

I had some stunning thoughts last night, the result of studying Tolstoi, Spengler, New Testament and also the result of praying to St. Mary to intercede for me to make me stop being a maniacal drunkard. . . . So far, every prayer addressed to the Holy Mother has been answered. . . . But I do want to point out, the reason I think she intercedes so well for us, is because she too is a human being.

—JACK KEROUAC, letter to Bob Giroux, February 1963

gression are most dramatically apparent in the side ambulatory, which slopes upward and narrows as one approaches the nave entrance. Here, the architect José Rafael Moneo, a Jesuit-trained Catholic and Pritzker laureate, provides a powerful kinesthetic experience that employs deferred gratification and an element of surprise: Instead of entering the narthex, then the nave, with the altar at the far end, as is traditional, visitors enter the cathedral at the eastern end next to the altar. One proceeds west along the ambulatory, catching tantalizing glimpses of the nave through gaps in the wall, which heightens a sense of anticipation. Confronting a large, ornate, seventeenth-century Spanish Baroque *retablo* (for a momentary return to the colonial past), one pivots right and enters the nave—a modernist, light-filled space. This entry sequence finds its artistic counterpart in artist John Nava's heroic tapestries on the

Our Lady of the Angels (detail), 2002
Robert Graham (1938–2009)
Bronze
8′ high (243.8 cm)
Cathedral of Our Lady of the Angels, Los Angeles

Robert Graham's sculptural portrayals of Mary dominate the plaza at the Cathedral of Our Lady of the Angels. The great doors, bronze and thirty feet tall, incorporate fifteen Marian portraits with traditional iconography, ranging from the Andean Virgin of Pomata to the Catalan Virgin of Montserrat. But above these doors, framed within a 23K-gold tympanum and floating above a luminous crescent moon, he sculpted Mary in a way that shattered previous Marian conventions.

Graham's interpretation eschews the usual trappings of majesty—crowns, jewels, and ornate robes—and avoids, too, the appearance of humble fragility that characterizes Western European Marian portraits. His Mary is young, athletic, and invincible. A mestizo beauty with ethnically ambiguous facial features that transcend geographic and political boundaries, she could be Hispanic, Asian, African American, or Caucasian. This Mary is authentically Angeleno. Her bare arms and bare feet, those of a capable working woman, acknowledge the warm weather and reveal her strength. Her regal self-possession, rivaling that of any screen goddess, derives from the absolute stillness of her pose and the triangular geometries in her dress, which speak of the Trinity and of Mary's threefold role as the mother, bride, and daughter of God. A sense of serenity is conveyed by her closed eyes and raised hands, which are upturned in a gesture of welcome and spiritual surrender. Sunlight and moonlight shine upon her, causing the gilded aperture encircling her head to glow like a halo.

sanctuary walls, which depict a procession of 135 saints and blesseds, sung and unsung. In a further blurring between celebrity and anonymity, in this case religious, Nava sought to portray the saints as real, approachable human beings and hired a Hollywood casting director to find models for the tapestries, many of them local residents of Ojai, where Nava lives.

This shall be a house of prayer for all peoples is carved into the cathedral's cornerstone. The critical word *house* conjures the idea, prominent in America by the mid–nineteenth century, of the nuclear family as the quintessential symbol of Christian piety, guided by caring parents and worshipping within the home. This notion blurs the boundaries between familial and institutional worship and merges flawlessly with the strength of the extended family unit in Latino culture and the presence, commonplace in their

dwellings, of home altars. At the dedication, Cardinal Mahony reiterated the message on the cornerstone, calling the cathedral "a vibrant symbol of God's habitat in our city." His repeated references to the idea of home and place reinforce the archdiocese's desire to provide a place for diverse audiences, particularly Hispanics, to gather.

With a structure and location that are in many ways aloof and removed from the very population it wishes to embrace, the cathedral's design is mitigated by many works of art and the provision of a public plaza that encourages community, as it was and continues to be expressed in the city's Old Plaza. The cathedral's Latino outreach is most evident in its art program. Cardinal Mahony overruled Moneo's desire to adorn the church with cerebral works of abstract minimalism by artists such as Agnes Martin and Martin Puryear, instead wanting art fashioned in a vernacular tradition. Reverend Richard S. Vosko, one of the nation's leading liturgical designers, was tapped to create the cathedral's arts program and oversaw nine major commissions, all by Southern California artists.

Culturally and visually, the most significant works of art portray the Virgin Mary. Mary's popularity can be gleaned from the distinctive religious practices of American Latinos, who account for about a third of all Catholics in the United States and whose numbers are projected to climb for decades. In Latino homes, religion is handed down by the mother, and women have long been recognized as leaders of prayer and song during Latino worship, which frequently is punctuated with liturgical dance and elaborate processions. Regardless of religious practice, more than half of all Hispanics pray to the Virgin Mary during difficult moments in their lives, a number that increases to seventy-nine percent within Catholic Latino groups.

This intensity of belief and how it is expressed, combined with a burgeoning Latino demographic, have fueled the increasing cultural presence of Our Lady of Guadalupe. In addition to her highway post, Our Lady of Guadalupe is honored on the cathedral's plaza in a shrine that includes a digitized reproduction of the canonical image of La Virgen de Guadalupe flanked by a collage of

children's faces with diverse ethnic features. Numerous flower and candle offerings are left there.

"La Virgen de Guadalupe: Dios Inantzin," a performance held annually at the cathedral, sums up its distinctive blend of cinematic theatricality and Latino piety and addresses the societal yearnings of recent arrivals to the city. Hugely popular with Los Angeles's Mexican community, the epic performance draws upward of 7,000 persons over two nights and is lush with feathered headdresses and ankle bells, mariachi music, drumming, and dramatic lighting. The cast involves some 120 performers, the great majority of whom are members of the local community. Most are amateurs, most are Latino, and many are immigrants. The performance is free.

The musical tells the story of Juan Diego of Cuautilan, to whom Our Lady of Guadalupe appeared in 1531 in Tepeyac, northwest of what is now Mexico City. The story is as much about Juan Diego as it is about La Virgen: Diego was rejected by both the indigenous community for being baptized and by Bishop Zumárraga, who scoffed at the idea that Mary would appear to an Indian peasant. According to the director, Jose Luis Valenzuela, a UCLA theater professor, the story has particular significance to recent immigrants to Los Angeles who, like Juan Diego, feel caught between two worlds. He says, "This is about Juan Diego's miracle. He has to persist and persist, and there is so much doubt and so much racism. . . . His own people reject him because he becomes Christian, and the Church doesn't like him because he's Indian." He says the story resonates with immigrants who feel ostracized—by their new American neighbors and by the relatives back home who feel betrayed by their moving to the United States. The performance is also a means of reassuring Latino youths that there is a place for them within the broader society: "If they know I'm a professor at UCLA and that some of the actors have gone to UCLA," according to Valenzuela, "they're going to grow up wanting to go to UCLA." He says that in addition to providing a spectacular setting, the cathedral affirms that "it's our house, we're inside, and we're in total command of the space and who we are."

A complex organism with the occasionally divergent agendas of integration and innovation, the cathedral is a political structure with myriad ties to Los Angeles's cultural, social, and economic life. It is also a vehicle for religious conversion, one that melds the forms of Latino devotion with the high–tech methods employed by the entertainment and advertising industries. While it is too soon to evaluate the success of the cathedral's Latino outreach, it can be said that the mechanics are in place to attract ever larger groups of those who do not feel represented by the exclusive imagery pur–veyed by Hollywood.

It is empty at the foot of the stairs. The noises that used to be here are gone.

The men came three weeks ago to take away the Climbomatic-*Whiztastic*-BOMBASTIC Stair-Chair 9000. The chair was installed in March; the stairs had been there for 12 years before that. But somehow it looks very empty now, without the chair. When it first arrived, Lilly kept calling it the "electric chair." I was the only one who seemed at all bothered by the misnomer.

"Lilly, for the fifth time, don't call it that."

"Why not?"

"Because an electric chair is—"

"You call it whatever you want, sweetie," Mom had said. "I'm going to give it a test run. Do you want to try it with me?"

Mom was skinny enough then that Lilly could fit in the chair with her. Up-down-up-down-up-down they went in the chair until Mom was too tired to ride anymore. And then Lilly had kept going, up-down-up-down. Up-down-up-down-up-down. Lilly cried when the men came to take the chair away.

When the chair wasn't moving, when it was just sitting at one end of the track waiting, it made a quiet grating humming sound, a kind of incessant aching buzz that was just loud enough to make you wonder whether you could really hear it at all. But the brass section drone of the chair was merely the underscore for the percussion section on the second floor.

"Schwooooooooooooooop!Psaaaaaaah . . . Schwooooooooooooop! Schwooooooooooooop! Psaaaaaaah . . . Schwooooooooooooop!"

The oxygen tank was loud. It was audible from the stairway and every corner of the second floor. After it had been there for a week or so I started to hear it from the first floor too—and then from the backyard and English class and field hockey practice. "Schwooooooooooooooop! Psaaaaaaah . . . Schwooooooooooooop!" It was constant, it was inescapable, it was there so Mom could breathe. That noise had been gone a lot longer than the chair.

—Carrie Neill, from "Fractured Geometry," 2009

Pentecost in the Book of Acts

WHEN THEY HAD entered the city, they went to the room up-stairs where they were staying, Peter, and John, and James, and Andrew, Philip and Thomas, Bartholomew and Matthew, James son of Alphaeus, and Simon the Zealot, and Judas son of James. All these were constantly devoting themselves to prayer, together with certain women, including Mary the mother of Jesus, as well as his brothers.

—ACTS 1:13–14

Her Assumption into Heaven

THE FIRST FOUR centuries of Christian history were profoundly silent on what happened after Mary died. Indeed, there still is no consensus on whether she died or merely fell asleep. Then, rather surprisingly, diverse Marian traditions, including more than sixty different narratives recounting the end of her life, emerged during the fifth and sixth centuries. Long-standing interest in Mary's theological significance and in these early narratives exploded in 1950, when Pope Pius XII proclaimed in the *Munificentissimus Deus* that Mary was assumed body and soul into heaven.

The origins of the belief that Mary was able to share in some extraordinary way in the full reality of eschatological resurrection are obscure, and efforts to pinpoint them have not met with much success. One early writer, Epiphanius of Salamis, writing in Palestine in the late 370s, wondered whether Mary died and was buried or if she "remained alive." After considering that the "woman clothed with the sun, with the moon under her feet, and on her head a crown of stars, who gave birth to a son" might indicate that Mary somehow remained immortal, Epiphanius refrained from any decisive interpretation—but nonetheless this idea, one that appears to have originated with him, has since become widespread.

In 2003, Stephen Shoemaker, whose research focuses on the historic veneration of the Virgin Mary, published what he believes is the earliest known narrative of Mary's Assumption: the Ethiopic *Liber Requiei* (*The Book of Mary's Repose*), which was composed in the fourth century and possibly as early as the third. The *Liber Requiei* is so lengthy (five books in 135 sections) and, in some instances, veers so far from the primary story line that it appears to be a compilation of still-earlier works. Its publication was part of the great tide of scholarship before and after the 1950 papal proclamation that was directed toward locating Assumption and Dormition traditions

as close as possible to the earliest days of Christianity, in order to lend (or erode) support of the Catholic dogma, an effort that marks the birth of modern Mariology.

The *Liber Requiei* account of Mary's Assumption resembles numerous ascents recounted in various ancient pseudepigraphic and Old Testament texts, including that of Elijah, who ascended to heaven in a chariot of fire (2 Kings 2:11); Enoch, who "walked with God" before he was carried by angels to the "highest heaven" (2 Enoch 67); and Baruch, who was "preserved unto the consummation of the times" (2 Baruch 76:2). Mary's Assumption is prefigured by Christ's Resurrection and Ascension. Like Christ during his dark night in the Garden of Gethsemane, Mary is afraid after an angel announces her impending death, and the women who surround her, like the apostles, wonder how they will manage if she herself is anxious. Three days elapse between Mary's "death" and her awakening in the Garden of Paradise. The account includes the tale of Jephonias, whose hands are cut off and restored once he embraces Mary, recalling both the high priest's slave whose ear was lopped off and reattached in Gethsemane and also the change of heart experienced by the Good Thief on the cross at Golgotha. Once she has been assumed, Jesus takes his mother on a heavenly tour and shows her the torments of hell; Mary, ever the intercessor, obtains for the damned three hours of respite every Sunday. A great gathering of angels brings a throne for Mary and, sitting upon it, she "went into Paradise."

On November 1, 1950, Pope Pius XII declared before tens of thousands gathered in St. Peter's Square:

> *By the authority of our Lord Jesus Christ, of the Blessed Apostles Peter and Paul, and by our own authority, we pronounce, declare, and define it to be a divinely revealed dogma: that the Immaculate Mother of God, the ever Virgin Mary, having completed the course of her earthly life, was assumed body and soul into heavenly glory.*

From that day forward, Catholics were obliged to believe in the Assumption—now defined and formalized as dogma in the *Munificentissimus Deus*—or risk excommunication for heresy.

Because the Bible makes few explicit references to Mary and says nothing about her being taken into heaven, the doctrine is supported implicitly by apostolic tradition—what was revealed to and taught by the apostles—and the sacred authority of the Church. In a satisfying twist, the *Munificentissimus Deus* also upholds Mary's heavenly assumption by naming those things on earth—the innumerable churches, cities, and artworks conceived and named in her honor—as one proof that she was exalted above all others.

Lacking an explicit Scriptural basis, much depends on the fact that Mary was a real person in history and, critically, the *kind* of person for whom an assumption into heaven was the only credible ending of her earthly existence. The *Munificentissimus Deus* observes

• • •

Death of the Virgin, ca. 1601–1605/1606
Caravaggio (1571–1610)
Oil on canvas
145×96″ (369×245 cm)
Musée du Louvre, Paris

Michelangelo Merisi da Caravaggio, commonly known by his last name, lived a robust, volatile life in Renaissance Italy. More so than any other painter before him, Caravaggio introduced dramatic lighting and unvarnished realism into religious painting. Moving away from the glorified, perfect bodies depicted by Michelangelo, Caravaggio used ordinary people as models—legend has it that he used a prostitute as his model for Mary—in paintings that emphasize their humility and humanity.

The *Death of the Virgin* was commissioned in 1601 by Laerzio Alberti, a Vatican official, for his family chapel in the church of Santa Maria della Scala in the Trastevere neighborhood of Rome. The painting was rejected, by either the church's clergy or the patron himself. Theories vary as to why, but most agree that a key factor was its depiction of the Blessed Mother in so frank and corporeal a manner. By 1607 it was for sale, and the painting traded hands throughout Europe before it was acquired by the French king Louis XIV in 1671.

The Virgin is depicted in unequivocal death: Her skin has an ashen pallor, her arms hang limply as her neck and head sag, her feet are bloated and, offensively to the sensibilities of that time, exposed. The red drapery overhead, with its deep shadows and heavy folds, creates a sense of oppressive weight. The dramatic poses of those surrounding her, thought to be various saints, describe their varying states of grief. The only sign of Mary's holiness is the slight line of a halo visible around the top of her head.

This is not an idealized portrayal of Mary being assumed into heaven with angels around her but a reaction to death and its aftermath. The body that bore Christ is presented as an empty shell. Caravaggio applies his penchant for realism to remind us that Mary was as human as we are.

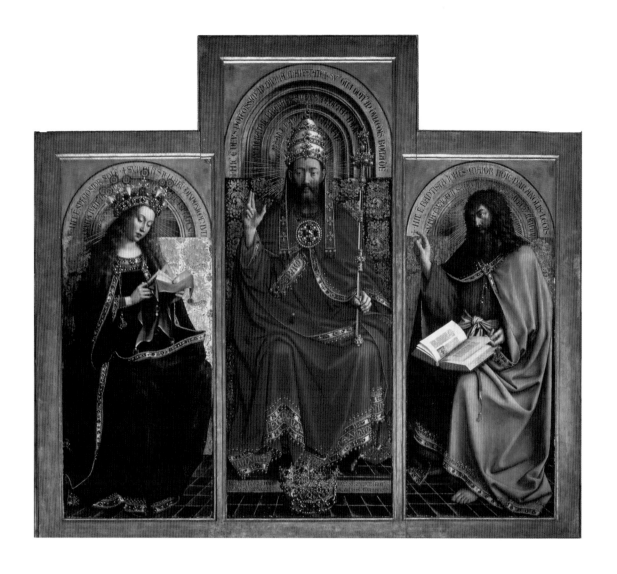

that it is "entirely imperative" that Mary "should be only where Christ is" and interprets numerous biblical verses as upholding the truth of her incorruptible body, unique identity, and bodily assumption. Her sinless body is praised as a resting place and sanctified ark in Psalm 132:8. Her singular favor with God and the enduring worth of her maternity is extolled in Luke's gospel by both the angel Gabriel and Elizabeth, who hails the pregnant Mary as *full of grace*. Her physical assumption is recalled by the Song of Songs, which describes a perfumed pillar of smoke that arises in

• • •

The Ghent Altarpiece (detail), 1432
Hubert (ca. 1366–1426) and Jan (ca. 1395–1441) van Eyck
Oil on panel
12×14′ (3.65×4.87 m) with wings open
Cathedral of St. Bavo, Ghent, Belgium

Brothers Jan and Hubert van Eyck were master artists in the Netherlands during the fifteenth century. Hubert began *The Adoration of the Mystic Lamb,* known as the Ghent Altarpiece, before dying in 1426 with much of the painting unfinished. Jan completed the painting over the six years that followed, exhibiting unprecedented mastery over the new medium of oil-based paint. The proliferation of oil paintings throughout Europe in the sixteenth century can be traced in part to this work and the "new realism" style it helped create.

The altarpiece was designed to hang in a side chapel in the Cathedral of St. Bavo in Ghent, in modern-day Belgium. It is a polyptych—a multipaneled work—with hinged doors that open and close. When the wings, or side doors, of the altarpiece were shut, the viewer would see the imagery on the wings' outer panels. When opened, generally on feast days and other holidays, the internal images would be revealed.

This detail—of Mary, Christ, and John the Baptist—is located in the upper tier of the altarpiece's center, inner panel. The vibrant colors and resplendent clothing leap out at the viewer, and we realize we are not looking at the earthly Mary. Rather, the rays of light coming from her head, her elaborate crown, and her bejeweled blue robes tell us that she is here glorified in heaven and seated at the right hand of her son.

Wearing the crimson robe of Revelation 19:13 and a three-tiered papal tiara, Christ raises his right hand in judgment. He is flanked by Mary and John, humanity's intercessors at the Last Judgment. John's intercession is active; he looks and gestures toward Jesus. Mary is more reserved and contemplative; she reads a devotional book with her mouth slightly open, concentrating. The green cloth with which she holds the book is the same color as John's cloak, while John's clothing bears no trace of the blue found in Mary's robes—a subtle reminder of Mary's unique role as the mother of Christ, where the acts she performed in bearing and raising Christ went beyond any other person's service to God.

the wilderness. St. Anthony of Padua quotes Isaiah (60:13)—*I will glorify where my feet rest*—to describe the place where Mary sits with God. The *Munificentissimus Deus* also sees Mary in Revelation's memorable portrait of a woman *with the moon under her feet.*

Mary's holiness is not separate from her body, which was sacred because it bore the Son of God: Her sanctity is proved by, and also predicated upon, the deliverance of Christ from her physical, virginal body. Similarly, Mary's Assumption cannot be considered apart from her Immaculate Conception: She was assumed bodily

into heaven because, immaculately conceived, she was without sin and not susceptible to bodily corruption. In support of this idea, the papal document quotes St. Bonaventure's sermon *De Assumptione B. Mariae Virginis:* ". . . her blessedness would not have been complete unless she were there as a person. The soul is not a person, but the soul, joined to the body, is a person. It is manifest that she is there in soul and in body." The deliberately ambiguous dogmatic statement that Mary had "completed the course of her earthly life" leaves open the possibility that she died or was assumed before her death.

• • •

Portal of the Virgin (north portal, west façade), ca. 1210–1220s
Cathedral of Notre-Dame de Paris (1163–1345; restored, 19th cent.)
Paris, France

Towering above the Seine, the Cathedral of Notre-Dame dominates the Paris landscape. Begun in 1163 under the direction of Bishop Eudes de Sully, work on the structure continued until 1345 and influenced the design of other cathedrals, notably those at Amiens, Chartres, and Reims. Notre-Dame was badly damaged during the French Revolution, but the 1831 publication of Victor Hugo's *The Hunchback of Notre Dame* revived interest in the cathedral. Much of the cathedral was restored under Eugène Viollet-le-Duc and Jean-Baptiste Lassus beginning in 1844.

The north portal of the cathedral's west façade, called the Portal of the Virgin, celebrates Mary and presents a number of scenes relating to her life. Starting at the trumeau (the column dividing the two doorways), we see the Virgin as a queen, crowned and holding a scepter of roses while cradling the infant Christ. Gazing up to the tympanum, the viewer encounters scenes that reiterate Mary's key role in humanity's salvation. At the lowest level, six Old Testament figures surround the Ark of the Covenant. Their scrolls bear the prophecies fulfilled by Christ, but the Virgin is also referenced here: the gabling above the ark echoes that above the trumeau, for, as the carrier of Christ, Mary is the ark of the new covenant. The central register presents the Entombment of the Virgin. According to the thirteenth-century *Golden Legend,* rather than dying, the Virgin fell asleep for three days before her Assumption, whereupon the apostles were miraculously transported to her deathbed from various parts of the world. Here they mourn as Christ prepares to take his mother to heaven. At the top of the tympanum, Mary is crowned Queen of Heaven as the heavenly throngs watch from the surrounding archivolts. Her role as queen, first apparent in the trumeau, has come full circle.

Since Queen Isabel of Spain began campaigning for the doctrine in 1863, the Vatican had received 2,600 petitions to recognize the Assumption from cardinals, archbishops, and bishops; 83,000 from members of the secular and religious clergy; and 8 million from the laity, according to a November 2, 1950, article reported on the front page of *The New York Times.* Eight million letters, written before email made such petitioning easy, make it clear how popular the doctrine was with Catholics. This is not surprising. Unshakable belief in Mary, born from highly personal experiences of her saving grace, has been described by many theologians and scholars as the greatest force in compelling the dogma into being. Through Mary, humanity's intercessor, the Church more fully recognized the worth and sanctity of the lay calling, and it is worth considering how doctrinal recognition of her cooperative role in

redemption shaped the outcome of the Second Vatican Council (1962–1965), which increased emphasis on the participation of the laity.

The doctrine widened the theological gap between Catholics and Protestants and scores of others who believed only what could be empirically proven. Once again, the issue of papal infallibility, the highly polarizing dogma issued in 1870 (interestingly, the dogma that preceded that of the Assumption), came under the spotlight and further fanned the incredulity that met the 1950 pronouncement. Many Protestants reacted with shock.

• • •

Assumption, Marian Altar, ca. 1505–1510 (restored, 1953)
Tilman Riemenschneider (ca. 1460–1531)
Lindenwood
Height 98″ (250 cm); overall height 354″ (900 cm)
Herrgottskirche, Creglingen, Germany

Like many of Tilman Riemenschneider's works, the *Marian Altar* is made from lindenwood. Its fine grain allowed for the intricate carving that defines much of this master's work. Although the Virgin was an old woman at the Assumption, here she has the smooth, beautiful face of a young woman. As she floats upward in a cloud of angels, each apostle bears witness in his own way, evident in their varying facial expressions and postures. Some apostles sing from hymnals, emphasizing the liturgical import of this event, while others look up from their books, drawn to the Virgin in wonder and amazement. The sharp, flowing folds of the figures' robes convey movement and encourage the eye to move around the composition.

The altarpiece's realism is also amplified by its lighting scheme: On August 25, the Feast of the Assumption (which today falls on August 15, due to calendar reform), the sun streamed into the Herrgottskirche, falling directly on the Virgin and her mandorla of angels, animating the nearly lifesize figures and adding to the scene's mystical quality.

Riemenschneider is acknowledged as the foremost wood sculptor of his age, yet the details of his training are unclear. Born in Thuringia, he was a registered journeyman (a trained worker paid per day) by 1483. He belonged to the Würzburg Guild of St. Luke, an artists' and artisans' guild so named because the evangelist Luke supposedly painted the Virgin's portrait. Riemenschneider prospered in Würzburg, holding a number of council offices. He became a master sculptor by 1485 and completed his first dated work, the Münnerstadt Altarpiece, in 1490. Riemenschneider's workshop was extremely productive, but the last decade of his life was ill-fated: In 1525 he was imprisoned and tortured for his refusal to support the bishop in the Peasants' Revolt, and it is possible that his hands were broken. After his release he was expelled from the Würzburg Council and fined, and he lived the rest of his life in relative obscurity until his death in 1531.

They were not alone—Catholics, too, left the Church, although most responses ranged from acceptance to jubilation that Mary had at last gained the recognition that had already been hers for centuries. Others regretted the timing, which came just as the historic divides between Catholics and Protestants were being bridged by organizations such as the World Council of Churches, formed in 1948.

Most Protestants have long had an uneasy relationship with the Mother of God, and the new dogma—positing as it does Mary's cooperation with humanity's salvation, the lack of Scriptural justification, and its late date—renewed old suspicions and fueled new fears. To elevate the admittedly long tradition and veneration of Mary to the status of an official doctrine, in effect laying claim to the same authority as the doctrine of the Trinity, seemed to be "completely presumptuous and without biblical warrant." Building so many ideas on the *fiat mihi* ("be it done unto me") and the motherhood of Mary was, according to the Protestant theologian Karl Barth, "flagrantly too much."

Protestants took particular issue with the idea of papal infallibility, maintaining that earthly authority must be qualified. The opinion that the Church's infallibility dangerously guarantees things that known acts and human logic cannot prove had the consequence, with respect to the Assumption, of attracting attention not to that dogma but to the "divinely-insured infallibility which, almost alone, supports it." Catholic theologian Karl Rahner speculated that perhaps the deepest reason behind Protestant rejection of the new dogma lay in their subscription to a "theology of the Cross" and not a "theology of glory," meaning that, for Protestants, the glory is a future promise and not a reality that exists even now. For all, the great difficulty, and mystical beauty, of the Assumption is that it is a truth revealed by God, one that cannot be proved by scientific inquiry or gleaned by sifting ever more carefully through history. It is a fact of faith.

Since ancient times, humanity has tried to imagine and describe a place that is not of this world but just beyond it, a celestial geography marked by those distant astronomical entities that can

Devotion to [Mary] does not require a choice between faith and critical inquiry. Instead, it asks for a difficult faithfulness to both, even when they appear to be contradictory and force us to live with ambivalence.

—SALLY CUNNEEN, *In Search of Mary,* 1996

be perceived from the earth, namely, the sun, stars, planets, and moon. By the time the Assumption was proclaimed, human beings were on the verge of actually traveling to the distant places of which the ancients could only dream. Ironically, now that we have been to the heavens, it is more difficult than ever to say just "where" heaven is.

Contemporary theologians describe the "place" of heaven as a "condition," a vagary that is justified because their conception of this spatiality is, instinctively yet without real reason, an extension of the known physical world. Rahner preferred to think of heaven as a place that came into being by the fact of Christ's Resurrection, through which the world acquired a new heaven and a new order. Mary's predestination, like ours, is linked to that of her son. According to Rahner, the new spatial condition that arose from Mary's transformation and Assumption is incommensurable with space as it was previously understood or represented. Heaven is not deprived of place merely because it cannot be accommodated by what science can prove: "Reality does not simply come to an end where our representation of it does." Rahner qualifies this: What is glorified still maintains a real connection to the world as we know it because it belongs to one, ultimately indivisible world, even if the transformative occurrence "marks precisely the point at which a portion of this world ceases to endure time itself."

The Assumption's miraculous message is this: We have the potential to become like, or even greater than, the angels—the possibility of transcendence exists. By cooperating in the salvation of the whole world, Mary shows us what is possible when human beings receive grace and act upon it.

. . .

The Nativity and **The Lamentation,** 1303–ca. 1305
Giotto di Bondone (ca. 1266–1337)
Fresco painting
Scrovegni Chapel, Padua, Italy

If Giotto were alive today, he probably would be one of the world's great film directors. His frescoes (wall paintings on plaster) at the Scrovegni Chapel in Padua, Italy, capture lifelike and believable human emotions and relationships. The chapel's interior is covered from floor to ceiling with paintings that, when they were created, ushered in a renaissance of the arts and new ways of expressing human potential. Three tiers of paintings depict some forty episodes in the lives of Mary, her parents, and her son. In *The Nativity, The Adoration, The Presentation in the Temple, The Wedding at Cana,* and *The Flight into Egypt,* her body is solid and straight-backed, her expression calm and dignified. But in *The Lamentation,* shown on the right, her body has crumpled next to Christ's, and her noble expression has dissolved into an eternal wail. Assuming a pose that echoes the one in the above Nativity, Mary gazes into Christ's lifeless face, her own face twisted in agony. You can feel his death reverberating through her body like the blast of a shotgun, physically overwhelming it with a pain that is far greater than the pangs that once accompanied his birth.

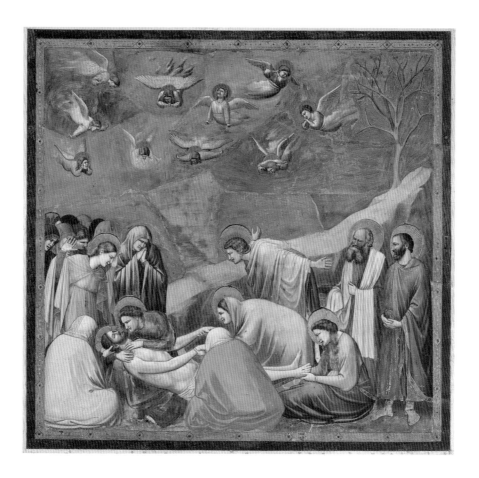

The Scrovegni Chapel was commissioned by the banker Enrico Scrovegni and was dedicated to the Virgin in 1303, probably on March 25, the feast day of the Annunciation. In *The Last Judgment* scene, which one sees before leaving the chapel, Enrico is depicted offering the Virgin a miniature of the chapel as an offering for his soul's salvation; scholars believe he commissioned the building as a way to repent for his work as a moneylender. Enrico's father, Reginaldo Scrovegni, is described in Dante's *Inferno* among those damned for avarice—yet banking was eventually a necessary cog in the new money-based economy.

Giotto was quite accomplished when he painted the chapel. The attribution of some of his works is questioned, although the Scrovegni Chapel and the campanile (bell tower) of Florence Cathedral have been confirmed as Giotto's. The most recent restoration of the chapel's frescoes, begun in 1977 and completed in 2002, involved treating seven hundred years' worth of condensation stains, repairing crumbling plaster, and removing elements from previous restorations. As a result, marvelous details such as a donkey's whiskers or an angel's tears are readily apparent, reanimating this fourteenth-century masterwork.

Mary's Many Faces

THE OPENING SEQUENCE of *Picturing Mary*, a documentary about Marian art over the centuries, consists of dozens of historical images of the Virgin's face—the face that most resembles Christ's—which morph from one portrayal to the next. A riveting piece of film, it captures the fluid, ever-changing nature of Mary's myriad identities—Ave Maria, Blessed Virgin, Second Eve, Mother of God, Mother of Sorrows, Black Madonna, Throne of Wisdom, and Queen of Heaven. As her facial characteristics change, they show a progression of aesthetic ideals that convey her enormous influence on art and visual theology and the evolving religious and historical context in which Mary was venerated. Beyond mirroring a particular time or circumstance, Mary is a cultural figure, because she enters and becomes part of culture's intricate web of meanings, making and sustaining culture at the same time that she herself is made and sustained in exchanges with those who venerate her.

The maternal image of Mary was a natural focus of piety for immigrants to America, for whom family, anchored by the mother, was all-important and who worked around the clock at menial jobs in order to help family members left behind in Europe to make the journey to America. Interestingly, the wave of European immigration to America crested during the century between the proclamation of two major Marian doctrines—that of the Immaculate Conception in 1854, which declared that Mary was born without original sin, and that of the Assumption in 1950, which said she did not die but was taken body and soul into heaven. Doctrinally, the declarations placed Mary apart from and beyond other human beings; she both was and was not "one of us." For those who wielded social power in America during that period—invariably white Protestants—these new Marian doctrines increased the sense that Catholics were somehow "other." The vast

majority of newcomers were Catholics of European extraction, beginning with the Irish and Germans, but soon encompassing the French, Italians, Poles, Hispanics, and others who brought with them devotional practices and rituals that both puzzled and alienated their new neighbors. In Robert Orsi's study of the religious devotions of southern Italian immigrants—walking barefoot behind the Madonna, kissing statues, participating in Marian festivals while eating and gambling under bright colored lights—he notes that such practices associated with the Madonna's cult (the technical term for Catholic devotions) have been deemed magical, superstitious, and theologically incoherent, creating religious hierarchies and ecumenical divisiveness. Simultaneously ostracized and comforted by their Marian faith, immigrants greatly enriched its expression in American culture. As the newcomers thrived, so did Mary. They fanned enthusiasm for Mary, now sanctioned by official Church doctrine, and membership in the many church groups that were organized in her name. Books, magazines, and pamphlets poured off newly founded Catholic presses, with some 10,000 new Marian titles published in the United States between 1948 and 1957—an exuberance that would fade among mainline American Catholics by the 1960s.

For all of her many associations with roses, Mary is a consistent thorn in the relationship between Catholics and many Protestant denominations. Historically, the issue of Mary has caused divisions among Christians, despite the distinctive Marian outlooks of the Reformers Luther, Zwingli, and Calvin. Taking into account the diversity of viewpoints in Protestantism, the primary reason for their silence on Mary can be summed up in two words: *sola Scriptura* (by Scripture alone), the Reformation maxim that places all understanding, authority, and salvation in the Word of God as it was divinely revealed in Scripture. (By contrast, Roman Catholics hold that doctrines—the Church's authoritative beliefs, guiding principles, and teachings—derive from Scripture but additionally are received as divine revelation and are revealed truths.) For Protestants, therefore, the scant mention of Mary in the New Testament, which amounts to largely unverifiable bits of historical data, meant her veneration fell outside such biblical authority. Secondly, Protestant

• • •

Our Lady of Czestochowa, ca. 14th cent.
Oil on wood panel
48×32.3" (122.2×82.2 cm)
Monastery of Jasna Góra, Poland

The deeply mysterious and scarred Black Virgin of Czestochowa is one of the most revered Black Madonnas—a group of portraits of Mary with dark skin, whether by artistic intention or by accumulation of candle soot. Credited with protecting the Polish nation from invaders on many occasions and with numerous miracles, Our Lady of Czestochowa was declared the Queen of Poland in 1656. Her miraculous icon is housed at the monastery of Jasna Góra in southern Poland, one of the largest pilgrimage sites in Christendom. The bejeweled covering, one of the icon's many "robes," cannot hide the Virgin's palpable sadness or the intensity of her gaze. She is portrayed as the Virgin Hodegetria, a Byzantine Marian type that typically holds Jesus on her left arm while she gestures toward him with the elongated fingers of her right hand, showing that he is the way to salvation. The Christ child raises his right hand in a gesture of blessing, joining his index and middle fingers in reference to his human and divine natures and locking his thumb over his other two fingers to signify the Trinity.

Tradition has it that the evangelist St. Luke painted the icon and the Empress Helena took it to Constantinople in the fourth century. It arrived in Poland in 1382, where it was struck by an enemy arrow and scarred during a Tartar siege. In 1430, the Jasna Góra monastery was vandalized and Mary's cheek sustained two more slashes; tradition has it that one of the vandals, attempting a third slash, was struck dead. In the last century, faith in the intercessory powers of the Virgin of Jasna Góra has deepened in the face of war. An estimated 1.5 million people gathered at the icon at the announcement of the Nazi defeat, and similar scenes accompanied the end of totalitarian Communist rule. Pope John Paul II regularly visited Jasna Góra, as has Benedict XVI. In 1966, President Lyndon B. Johnson, along with an estimated 100,000 people, attended the opening of the massive Shrine of Our Lady of Czestochowa in Doylestown, Pennsylvania, which was built to honor the Virgin and the millennium of Poland's founding as an independent state in 966.

• • •

**Blessed Kateri Tekakwitha and Nicolas Black Elk Holding Up
the Dead Christ under the Virgin of Consolation,** 1994
Father John Giuliani
Acrylic on board
20×12″ (51×30 cm)
Private collection

After reading Thomas Merton's *Seven Storey Mountain,* art student John Giuliani put down his paintbrush, entered the seminary, and served as a Catholic diocesan priest for two decades. Wanting to communicate the dignity of all persons, especially those whom society has marginalized, he began painting again in 1989. His paintings of Native Americans as Christian saints acknowledge their original spiritual presence in America and marry the beauty of beadwork, quill embroidery, weaving, and other native arts to the mysticism of orthodox icons. As he described it to me, "When the Lakota Sioux of the Dakotas first saw themselves depicted in my works as saints, they were ecstatic. Many of them contacted me, weeping even, and said, 'We have never before seen ourselves depicted as Mary, as Jesus, as saints.' So the flood began."

In this image, Mary's mantle embraces the Blessed Kateri Tekakwitha, a pious seventeenth-century Mohawk woman and the first Native American to be honored with beatification, and Nicolas Black Elk, the visionary Lakota medicine man who, understanding the revelation of the gospels as a fulfillment of his earlier visions, became a dynamic catechist on the Pine Ridge Reservation in South Dakota. The two support the body of Christ, who is not yet risen, and uphold the promise of the Resurrection. The sun, moon, haloes, and wreath of healing sage at Christ's feet speak of cosmological time, encompassing past, present, and future. Images of the Virgin holding out her mantle around the faithful are a type variously known as the Madonna of Mercy, the Madonna della Misericordia, or the *Schutzmantelmadonna.* Such portrayals are characterized by Mary's outstretched cloak, a potent symbol of protection against the troubles of this life and the next. The image type, which has deep roots in Roman, folk, and other ancient traditions, had become by the Middle Ages a favored way of portraying Mary.

insistence on the centrality of Christ necessarily means rejecting any focus on Mary apart from him—Mary is remembered and honored solely because of her son, and, in her *let it be with me*, as a model of faith. Moreover, God's selecting her as Christ's mother is entirely the result of divine grace, or justification by faith, and not due to any particular merit or capacity on Mary's part to cooperate with God.

The Dombes Group, founded in France by Catholics and Lutherans in 1937 to foster Christian unity, studies divisive theological issues, including, from 1991 to 1997, Mary's role in God's plan for salvation. *Mary: Grace and Hope in Christ* (2004), a document also known as the Seattle Statement, was developed by Anglicans and Roman Catholics in an attempt to bridge the denominational divide of nearly five centuries. Others engaged in ecumenical dialogue hope to address the gaps that still exist among Catholic, Protestant, and Orthodox understandings of Mary.

Promoting unity and understanding among Christian denominations was a major concern of the 1962–1965 Second Vatican Council, the central event of the past century for Catholics around the globe. Decisions reached there made dramatic, highly visible changes to Catholic liturgy and devotional practices that were intended to refocus the church on sacraments and Scripture. While these changes more fully recognized the role of lay persons and encouraged their active participation in the Church, they simultaneously diminished and, in some cases, literally swept away many of the practices—praying before statuary, lighting votive candles, saying Marian novenas—that were the lifeblood of popular Marian veneration. As one woman wistfully reflected, "They didn't want us to say the rosary in Mass anymore." Wanting to clarify Mary's role in the Church, many council members requested, but were denied, a separate conciliar statement on Mary. Instead, her role was addressed in a chapter in *Lumen Gentium* (1964), one of the documents emanating from the council. *Lumen Gentium* invoked Mary with neutral titles—advocate, auxiliatrix, and mediatrix—that underscored her subordinate role as maternal helper and did not detract from or add anything to Christ's role as the sole mediator. This was to appease theological conservatives and to avoid encouraging the many conciliar members who would maximize Marian language in

order to eventually gain a new dogmatic definition of Mary's role in divine mediation. The document painted Mary as "a model of the Church in the matter of faith, charity, and perfect union with Christ," a description, however true and beautiful, that reflects a patriarchal bias toward women: Mary is not the model of the *institutional* Church and its exercise of pastoral leadership.

Among those at Vatican II who asked for the separate, ultimately rejected Marian statement was the charismatic Karol Wojtyla, then Archbishop of Kraków, who would be elected Pope John Paul II fifteen years later. Papal Mariology took a new turn under John Paul II (r. 1978–2005), whose profound Marian devotion was readily apparent in his coat of arms—a capital "M" beneath a cross, representing Mary at the foot of Christ's crucifix, and the motto *Totus tuus* ("completely yours"). To celebrate the two thousandth anniversary of Mary's birth and in anticipation of the new millennium, he declared 1987–1988 a Marian Year, bookending the proclamation with two important papal documents—*Redemptoris Mater* ("Mother of the Redeemer") and *Mulieris Dignitatem* ("The Dignity of Women")—about women's vocation in light of Mary. Both stressed the singular nature of all maternity: Every time a woman gives birth, "it is always *related to the Covenant* which God established with the human race through the motherhood of the Mother of God." Recalling the *primacy of love* expressed in Corinthians 13, he wrote that *the dignity of women is measured by the order of love* that is the essence of God.

Taken literally, the language of the documents reinforces the historic split between male and female roles that has frustrated and anguished those who have pushed for equal discipleship. However, one cannot help but note that the word "pilgrimage" is used in *Redemptoris Mater* no less than thirty times, making literal allusion to Mary's earthly faith journey on one hand but also laying out a prophetic map of where the Church is slowly but inexorably heading. Mary is an actual, powerful female model of holiness, as evoked by her titles, shrines, private and public devotions, and theologies of maternal mediation, all of which keep womanly dignity and power alive in the Catholic Church—at a time when it still has no other official place to go.

One must sift through the nonsense and hostility that has characterized thought and writing about Mary, to find some images, shards, and fragments, glittering in the rubble. One must find isolated words, isolated images; one must travel the road of metaphor, of icon, to come back to that figure who, throughout a corrupt history, has moved the hearts of men and women, has triumphed over the hatred of woman and the fear of her, and abides shining, worthy of our love, compelling it.

—MARY GORDON, "Coming to Terms with Mary," *Commonweal,* 1982

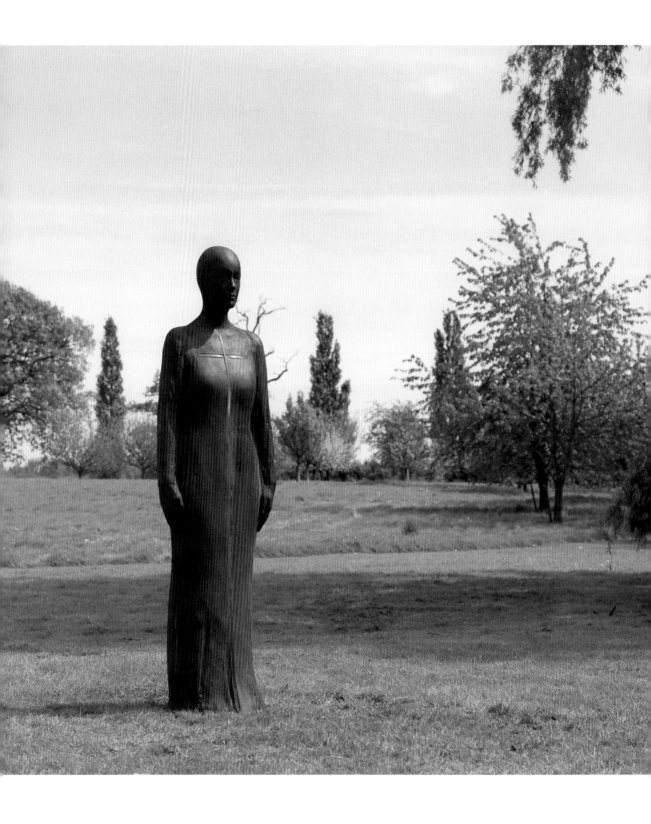

• • •

Illumination, 2003
Steinunn Thorarinsdottir
Cast iron and glass
69″ (176 cm)
Private collection

Steinunn Thorarinsdottir's iconic sculptures, like this one commissioned for a site in Surrey, England, capture the human condition in all its vulnerability, mystery, and essential dignity. The cast-iron life-size woman stands in lyric isolation amid the green countryside. Firmly rooted in the earth and the color of red soil, she appears to grow directly out of the grass, like a tree. Yet the vertical form with its muted mystical presence also suggests a bridge between heaven and earth. Her stillness intimates surrender or, perhaps, acceptance; yet, made of solid cast iron, she is exceptionally strong. A cruciform sliver of glass embedded in the sculpture pierces the woman's body and allows light to pass through it. The human spirit, literally visualized in glass and illuminating the figure from within, becomes a window to the soul, drawing us into the woman's heart. The cross inscribed into her body emphasizes the psychic and physical woundedness that often accompanies spiritual growth and transformation. Deliberately featureless, the woman is a symbol of Mary and of every woman who confronts loss and suffering with resilience and through faith. Like Mary, she bears the literal and metaphoric wounds of Christ, not passively but with a receptivity that unites her soul with the divine.

New and more expansive understandings of Mary came about in the wake of Vatican II and the Civil Rights Movement of the sixties. Groundbreaking work by feminist theologians has fixed a strong, clear light on the historical, theological, and ethical ramifications of Marian piety, pointing out the many ways it has both limited and liberated women and perpetuated stereotypical understandings of both sexes. The gift of freedom is more freedom: One of the ongoing legacies of feminist theology is liberation for all persons. For Latino Catholics—the largest, youngest, and fastest-growing sector of American Catholicism—much of the work of liberation has been carried out under the literal or metaphoric banner of Our Lady of Guadalupe.

Even as Christians on opposite ends of the political spectrum offer conflicting messages about her role and identity, these disputes only confirm Mary's lasting appeal to the sensibilities of twenty centuries. She has been, and continues to be, many things to many people. Mary is human, but as the vessel through which Jesus assumed his humanity, she is also the Mother of God. As a virgin, she is exemplar of both female purity and, paradoxically, oppression. Her person is used simultaneously to explain why women should and should not be allowed to enter the Catholic priesthood. Pro-life groups claim her as a champion of their cause, yet she is also the protectress of the social rights of women, especially those mothers who are poor and require better access to social services, education, and jobs. Her maternal role as nurturer makes her a beacon for environmentalists, but that same role is often seen as too narrow a definition, limiting women's full equality and human dignity. Even as she is considered holier than all women by Muslims, Mary's veneration nonetheless marks a continuing divide between Catholics and other Christian denominations. In her many fluid and paradoxical identities, and despite the modern era's drift away from religion, Mary herself remains a vital force. Like a deep well capable of containing every aspiration and desire, Mary invites us to drink from her depths and see in her changing, rippling reflection our own.

Where Are You?

ONE OF THE very first communications from God to human beings is a question. In the Book of Genesis, God asks Adam and Eve, *Where are you?* It's a strange question, because God, who created those first beings, and every other living thing, has no practical need to make such an inquiry. The couple, beguiled by the serpent, have eaten the apple and found fig leaves to cover their nakedness and hide from their Creator's question. When God asks—*Where are you?*—God expects a truthful answer. Life's pilgrimage is a daily answering of that question, for ourselves and for God. Discovering and naming where you are—the geographic, emotional, and spiritual place that you occupy, right here, right now, honestly and nakedly—stirs up life's force, tenderizes the heart, and clarifies and concentrates thoughts. Answered candidly, it can coax the spirit out of hiding. There is much that will never be known about Mary, yet we know the most important thing about her: When confronted by God, she answered in the affirmative, allowing herself to become impregnated with spirit. Although she didn't know where she was about to go, in that moment, full of grace, she said *yes* to the journey.

People want answers to that first question asked of humanity, and they search for it far and wide. The question as well as the answer says a lot about the nature of sacred places. The proliferation of spiritual retreats and pilgrimages—even the Vatican has a religious tourism agency—makes it clear that we are living in the age of the extreme seeker. Such travelers are eager to find places of meaning, where the broken fragments of self can be knitted back together by a journey to a site where belief, landscape, history, or some combination thereof, can make a whole. We long to find those places that make our internal harp vibrate and give life resonance. I, too, have traveled long distances to feel the powerful pull of locations of inspired natural beauty, like Sedona, or those with

Certainly time is the occasion for our strangely mixed nature, in every moment differently compounded, so that often we surprise ourselves, and always scarcely know ourselves, and exist in relation to experience, if we attend to it and if its plainness does not disguise it from us, as if we were visited by revelation.

—MARILYNNE ROBINSON, *The Death of Adam,* 1998

long oracular histories, like Delphi, or those with the undeniable psychological power of the pyramids at Giza or the cathedral at Chartres. But after many miles, I've begun to realize that the holiness of a place emanates from a deeper well than geography or architecture. *Where are you?* Answered from the place of heart and simplicity, wherever that may be on a given day, the reply illuminates the truth that any place in the world can be a City of God.

Many women, of all stripes, levels of education, and professional accomplishment, have told me they feel Mary's presence most strongly in the kitchen, during those quiet hours when they are cooking, cleaning up the Chinese takeout, or emptying the dishwasher. As Kathleen Norris beautifully expressed it in *The Quotidian Mysteries*, there is something about the sameness of those obligatory routines, unfolding in the most familiar room of the home, one's breath slowed to a meditative rhythm, that can unearth the transcendent. During a conversation with a wise Jewish man—who may or may not spend a lot of time in the kitchen—the idea of being "at home" with Mary came up. We were talking about Mary's ubiquitous presence and the extraordinary pull she has exerted on seemingly every chapter of history written over the past two thousand years. When he asked me where I felt her most, I replied immediately—the kitchen—but then amended it to include my dining room with its big table, thinking of the happy times when friends and family have gathered around it. And that room extended to the living room, where my son plays piano, his sweet notes wafting upstairs while I'm puttering around the bedroom and transforming even the making of a bed into a joyful task. But then again, I feel Mary in my garden, especially in October, when most of the flowers are gone except for one or two persistent roses that I count on seeing every autumn. I like the way they both defy and herald the coming winter. This book became a hymn in honor of her presence in the many literal and metaphoric rooms of my life, as well as a prayer that I would continue to feel at home in her company. I rely on her to help me answer and be at peace with my reply to God's question, *Where are you?*

• • •

Spring Blossoms, 2009
Susan Dupré
Digital print
Collection of the artist

Wild air, world-mothering air,
Nestling me everywhere,
That each eyelash or hair
Girdles; goes home betwixt
The fleeciest, frailest-flixed
Snowflake; that's fairly mixed
With, riddles, and is rife
In every least thing's life;
This needful, never spent,
And nursing element;
My more than meat and drink,
My meal at every wink;
This air, which, by life's law,
My lung must draw and draw
Now but to breathe its praise,
Minds me in many ways
Of her who not only
Gave God's infinity
Dwindled to infancy

Welcome in womb and breast,
Birth, milk, and all the rest
But mothers each new grace
That does now reach our race—
Mary Immaculate,
Merely a woman, yet
Whose presence, power is
Great as no goddess's
Was deemèd, dreamèd; who
This one work has to do—
Let all God's glory through,
God's glory, which would go
Through her and from her flow
Off, and no way but so.

—GERARD MANLEY HOPKINS,
from *The Blessed Virgin compared
to the Air we Breathe,* 1918

my research in Israel and the Balkans, and to Yale University for grants to work in Mexico and Turkey. I am indebted to the vision and assistance of Siobhán Garrigan, Patrick Evans, and Emily Scott, and to Yale Divinity School and the Institute of Sacred Music for their support of the Global Village Shelter installation on Sterling Quadrangle.

For generously reading and commenting on portions of the text, I thank Adela Yarbro Collins, John Demos, John Hare, Karsten Harries, Margaret A. Farley, Beth Griffin Matthews, Brother Kilian McDonnell, Robert S. Nelson, the Reverend Alan Strange, the Reverend Patrick C. Ward, and the Reverend Monika Wiesner. Many thanks to Kathy Daley, Sean McAvoy, Van Truong, and, especially, Sarah Celentano Parker, for their diligent research assistance.

I am grateful to the many artists, photographers, and writers whose vision has profoundly enlarged this book. My special thanks to Achim Bednorz for his keen powers of observation, friendship, and generosity. My enduring gratitude goes to the MacDowell Colony for a residency that allowed me to review these pages in a place of beauty and ferment, for introducing me to several poets whose lapidary lingua graces these pages, and, always, for championing art and artists.

My thanks to the team at Random House for loving books— a most exquisite and irreplaceable art form—as much as I do, and for bringing this one to life, including Gina Centrello, Tom Perry, Benjamin Dreyer, and Jennifer Hershey; Dana Isaacson, Vincent La Scala, Kathy Lord, and Jonathan Jao for their seasoned ears and sharp pencils; Carole Lowenstein for overseeing the design, Lynn Buckley and Thomas Beck Stvan for a beautiful jacket, and Simon M. Sullivan for his brilliant interior page design; and Lisa Feuer and Richard Elman for coalescing these collaborative efforts between two covers. Ted Goodman, indexer extraordinaire, thank you for your elegance and friendship. Heartfelt admiration and thanks to my editor, Millicent Bennett, who brought her creativity, passion for language, and scheduling acumen to this book, nurturing my vision while in the midst of becoming a mother herself. Many thanks to my steadfastly cheerful and expert agent, Alice Martell.

• • •

Spring Blossoms, 2009
Susan Dupré
Digital print
Collection of the artist

Wild air, world-mothering air,
Nestling me everywhere,
That each eyelash or hair
Girdles; goes home betwixt
The fleeciest, frailest-flixed
Snowflake; that's fairly mixed
With, riddles, and is rife
In every least thing's life;
This needful, never spent,
And nursing element;
My more than meat and drink,
My meal at every wink;
This air, which, by life's law,
My lung must draw and draw
Now but to breathe its praise,
Minds me in many ways
Of her who not only
Gave God's infinity
Dwindled to infancy

Welcome in womb and breast,
Birth, milk, and all the rest
But mothers each new grace
That does now reach our race—
Mary Immaculate,
Merely a woman, yet
Whose presence, power is
Great as no goddess's
Was deemèd, dreamèd; who
This one work has to do—
Let all God's glory through,
God's glory, which would go
Through her and from her flow
Off, and no way but so.

—GERARD MANLEY HOPKINS,
from *The Blessed Virgin compared
to the Air we Breathe,* 1918

Acknowledgments

MARY SENT MANY remarkable talents and good hearts to this book. Some of them were old friends, but others were strangers, or nearly so. I heard from many people, out of the blue, who "had an urge" to call, write, or mail me something. In a library of hundreds of books, titles I hadn't picked up in years would somehow migrate to the vicinity of my desk. Or a magazine at the dentist's office would be opened to a perfect picture. A chance comment would open up new insights into Mary and the ways she remains vibrantly present in our daily lives. These episodes made me realize that my primary job was to surrender—with all the courage and grace that that often misunderstood approach to life implies—and let Mary show me the book she wanted. *Out of the blue.* While that describes the many gifts Mary has given this book, my firsthand experience of her loving kindness changed my understanding of the phrase. For me, *out of the blue* now means from Mary, the Madonna of the protective blue mantle of the sky and sea. Some examples in these pages of her interventions are dramatic, yet pale in comparison to her abiding lessons and more enduring gifts—and those through whom she has expressed her generosity, whom I thank here.

Yale Divinity School and the Institute of Sacred Music, my home for the past five years, have provided the company and inspiration of rare scholars and friends with a deep thirst for God, knowledge, and social justice. In particular, I thank Dean Harold Attridge for his unstinting efforts to bring the study of theology and ethics to life in all the ways that this world allows. At the Institute of Sacred Music, I salute Director Martin Jean and Deputy Director Sally Promey for their wholehearted commitment to the arts and belief in its ability to transcend boundaries and build bridges. I acknowledge with gratitude traveling fellowships from Yale Divinity School and the Institute of Sacred Music that enabled

my research in Israel and the Balkans, and to Yale University for grants to work in Mexico and Turkey. I am indebted to the vision and assistance of Siobhán Garrigan, Patrick Evans, and Emily Scott, and to Yale Divinity School and the Institute of Sacred Music for their support of the Global Village Shelter installation on Sterling Quadrangle.

For generously reading and commenting on portions of the text, I thank Adela Yarbro Collins, John Demos, John Hare, Karsten Harries, Margaret A. Farley, Beth Griffin Matthews, Brother Kilian McDonnell, Robert S. Nelson, the Reverend Alan Strange, the Reverend Patrick C. Ward, and the Reverend Monika Wiesner. Many thanks to Kathy Daley, Sean McAvoy, Van Truong, and, especially, Sarah Celentano Parker, for their diligent research assistance.

I am grateful to the many artists, photographers, and writers whose vision has profoundly enlarged this book. My special thanks to Achim Bednorz for his keen powers of observation, friendship, and generosity. My enduring gratitude goes to the MacDowell Colony for a residency that allowed me to review these pages in a place of beauty and ferment, for introducing me to several poets whose lapidary lingua graces these pages, and, always, for championing art and artists.

My thanks to the team at Random House for loving books—a most exquisite and irreplaceable art form—as much as I do, and for bringing this one to life, including Gina Centrello, Tom Perry, Benjamin Dreyer, and Jennifer Hershey; Dana Isaacson, Vincent La Scala, Kathy Lord, and Jonathan Jao for their seasoned ears and sharp pencils; Carole Lowenstein for overseeing the design, Lynn Buckley and Thomas Beck Stvan for a beautiful jacket, and Simon M. Sullivan for his brilliant interior page design; and Lisa Feuer and Richard Elman for coalescing these collaborative efforts between two covers. Ted Goodman, indexer extraordinaire, thank you for your elegance and friendship. Heartfelt admiration and thanks to my editor, Millicent Bennett, who brought her creativity, passion for language, and scheduling acumen to this book, nurturing my vision while in the midst of becoming a mother herself. Many thanks to my steadfastly cheerful and expert agent, Alice Martell.

To my true blues, Dale, Danette, Kerry, Laurie, Leslie, Lily, Lizzy, Mary, and Regina for upholding me, heart, mind and soul, for lo these many years, thank you. I have traveled by your light. My wonderful family and their zest for sharing, embellishing, and recapping a good story have inspired all that I do. My father, Robert Dupré, has spent a lifetime noticing and sharing all the goodness and God-ness to be found in nature. How do I thank you for the ocean, Dad? There aren't words enough to thank my sisters, Cynthia and Susan, pearls of great price, for standing by me through every page of my life. For daily love and laughter, and for making my life a life, I thank my sons, Brendan and Emmet. This book is dedicated to my mother, Dolores Mary Dupré, in recognition of her love, example of faith, and extraordinary generosity.

Many friends and colleagues graciously offered their expertise, support, and hospitality, including: Anthony S. Aracich, S.J.; Kat Banakis; Mary Banks; Bonnie Apgar Bennett; John Everett Benson; the Bergmann Family; Ann Pinckney Bonner-Stewart; Lou Anne Bulik; David Cathey; Robert Clark Corrente; Joy Davis; Jane Driver; Margot Fassler and Peter Jeffery; Stephen Feiler, Knights of Columbus; Dan Ferrara; Mia Ferrara Pelosi; Linda Figg; Ray Ford; Janice Fournier; Jennifer Awes Freeman; Noriko Fujinami, Robert Graham Studio; Peter and Julie Gale; the Green family; Mark G. Griffin; Adrianne Hamilton; Cathy Hemming; Angelo Hornak; Robin M. Jensen; Marilyn Johnson; Karen Kinoshita; Jaime Lara; the Liuzzo family; Robert and Paula Loffredo; the Rev. Lindsay Lunnum; Ellen McCloskey; Helen McIldowie-Jenkins; Roberto Menchiari; David Michalek; Mary E. Miller; Nancy Miller; Dean Motter; John Nava; Grace Pauls; Patricia and Anthony Piselli; Anna Rabinowitz; the Rambusch family; Geraldine M. Rohling; Diane Samuels and Henry Reese; Eileen Smyth; Roy Spungin; Judy Sternlight; Father Thomas Stransky, C.S.P.; Barry Strauss; Brendan Tapley; Marco Vagnini; William Vareika; Lori Vine; Augusta and John Viola; Richard S. Vosko; the Walsh-Cady family; Audrey and Ray Waskiewicz; Timothy Weisman; and, always, all the Wahines.

Notes

9 SENSE OF THAT WORD: Hazleton, Lesley. *Mary: A Flesh-and-Blood Biography of the Virgin Mother.* New York: Bloomsbury, 2004, p. 6.

9 RARELY SPEAKS: A handful of passages in the Gospels of Luke and Matthew provide glimpses of Mary within the larger story of Christ's conception, birth, boyhood, and nascent ministry. In the Gospel of Mark, thought to be the earliest gospel, Mary merits a mention only twice, both times in the context of Christ's ministry. John's Gospel never identifies Mary by name but does report the presence of the "mother of Jesus," notably in Cana and at the foot of her son's cross.

11 FOR CENTURIES: Ehrman, Bart. *Lost Scriptures.* New York: Oxford University Press, 2003, p. 63.

11 "BLOOD AND GUTS": Johnson, Elizabeth A. *Truly Our Sister: A Theology of Mary in the Communion of Saints.* New York: Continuum, 2003, p. 91.

12 FULL HUMAN DIGNITY: Johnson. *Truly Our Sister,* p. 6.

12 DISCIPLE OF CHRIST: Blancy, Alain, Maurice Jourjon, and the Dombes Group. *Mary in the Plan of God and in the Communion of Saints.* Mahwah, NJ: Paulist Press, 1999, p. 58.

13 INTO THEIR DWELLINGS: Crossan, John Dominic, and Jonathan L. Reed. *Excavating Jesus Beneath the Stones, Behind the Texts.* San Francisco: Harper SanFrancisco, 2001, p. 35.

13 LIVED OUTDOORS: Johnson, Elizabeth A. "Galilee: A Critical Matrix for Marian Studies." *Theological Studies,* 70:2 (June 2009), p. 331.

16 ECONOMIC LADDER: Johnson. "Galilee," p. 331.

16 GATHERING OF THE FAITHFUL: Johnson. "Galilee," p. 338.

16 RULED BY PROXY: Johnson. "Galilee," p. 334.

16 "IN THIS WORLD": Gebara, Ivone, and María Clara Bingemer. *Mary: Mother of God, Mother of the Poor,* trans. Phillip Berryman. Maryknoll, NY: Orbis Books, 1989, p. 120.

17 THE HOLY LAND: I am grateful to Father Thomas Stransky for sharing his many insights on the Holy Land with me.

23 A GODDESS-CREATOR: Campbell, Joseph. *The Mythic Dimension: Selected Essays 1959–1987.* Novato CA: New World Library, 2007, p. 175.

26 CREATION MYTHS: Benko, Stephen. *The Virgin Goddess: Studies in the Pagan and Christian Roots of Mariology.* Leiden: Brill, 2004, p. 94.

26 THE VIRGIN MARY: Benko, p. 94.

26 CENTURY AND BEYOND: Cunneen, Sally. *In Search of Mary.* New York: Ballantine Books, 1996, p. 66.

26 POPULAR WORSHIP: Witt, Reginald Eldred. *Isis in the Ancient World.* Baltimore: Johns Hopkins University Press, 1997, p. 145.

26 SALVATION HAD FAILED: Witt, p. 144.

26 ANY GIVEN PERIOD: Rietveld, James. *Universal Goddess on the Via Sacra: Evolving Image of Artemis Ephesia.* Ph.D. diss., Claremont Graduate University, 2006, p. 20.

26 BEGAN TO SPREAD: Rubin, Miri. *Mother of God, A History of the Virgin Mary.* New Haven and London: Yale University Press, 2009, pp. 40–41.

26 CHRISTIAN ICONOGRAPHY: Mathews, Thomas F., and Norman Muller. "Isis and Mary in Early Icons," in *Images of the Mother of God,* ed. Maria Vassilaki. Burlington, VT: Ashgate, 2005, p. 9.

27 MEANT "THRONE": Mathews and Muller, p. 9.

27 MARIAN ASSOCIATIONS: Rubin, p. 41.

27 UNCONSCIOUS ASSOCIATIONS: Neumann, Erich. *The Great Mother,* trans. Ralph Manheim. Princeton, NJ: Princeton University Press, 1955, p. 15.

28 WITHOUT GENDER: Johnson. *Truly Our Sister,* p. 73.

29 RESIDES WITHIN GOD: Taylor, Sarah McFarland. *Green Sisters: A Spiritual Ecology.* Cambridge, MA: Harvard University Press, 2007, pp. 260–61.

29 WITH THE EARTH: Ruether, Rosemary Radford. *Goddesses and the Divine Feminine: A Western Religious History.* Berkeley, CA: University of California Press, 2005, p. 308.

31 SECOND CENTURY B.C.E.: West, Gerald. "Judith" in *Eerdmans Commentary on the Bible,* ed. James D. G. Dunn and John William Rogerson. Grand Rapids, MI: Eerdmans Publishing, 2003, p. 748.

33 RESTORE THE FAITHFUL: Warner, Marina. *Alone of All Her Sex: The Myth and the Cult of the Virgin Mary.* New York: Alfred A Knopf, 1976, p. 13.

33 FEMININE LIBERATION: Stocker, Margarita. *Judith: Sexual Warrior. Women and Power in Western Culture.* New Haven and London: Yale University Press, 1998, p. 2.

33 GENDER-DETERMINED THEOLOGY: Levine, Amy-Jill. "Sacrifice and Salvation: Otherness and Domestication in the Book of Judith," in *Women in the Hebrew Bible,* ed. Alice Bach. New York: Routledge, 1999, p. 374.

34 UNEXPECTED WAYS: Sawyer, Deborah F. "Dressing Up/Dressing Down: Power, Performance and Identity in the Book of Judith," *Theology & Sexuality,* 8:15 (2001), p. 25.

35 NO OTHER GODS: Harries, Karsten. "Untimely Meditations on the Need for Sacred Architecture." Paper given at the "Constructing the Ineffable: Contemporary Sacred Architecture" symposium, Yale School of Architecture, October 27, 2007.

35 WORSHIP AND DOGMA: Jensen, Robin M. *Understanding Early Christian Art.* New York: Routledge, 2000, p. 3.

35 INDEPENDENT AND WHOLE: Hamington, Maurice. *Hail Mary? The Struggle for Ultimate Womanhood in Catholicism.* New York: Routledge, 1995, p. 161.

38 DEVOTIONAL ACTIVITY: Orsi, Robert A. "The Many Names of the Mother of God," in *Divine Mirrors: The Virgin Mary in the Visual Arts.* New York: Oxford University Press, 2001, p. 5.

38 EARLY FOURTH CENTURIES: Jensen, Robin M. *Face to Face: Portraits of the Divine in Early Christianity.* Minneapolis: Augsburg Fortress, 2004, p. 191.

38 THE SEVENTH CENTURY: Belting, Hans. *Likeness and Presence: A History of the Image Before the Era of Art,* trans. Edmund Jephcott. Chicago: University of Chicago Press, 1994, p. 36.

38 DEMANDED IT: Cormack, Robin. *Byzantine Art.* Oxford: Oxford University Press, 2000, p. 87.

38 THAT WAS VENERATED: Pope John Paul II. *Letter to Artists,* April 4, 1999.

38 THE NEXT CENTURY: Rubin, p. xxv.

39 AND GENEVA: Eire, Carlos M. N. *War Against the Idols.* Cambridge, UK: Cambridge University Press, 1986, p. 107.

39 OVERTLY MASCULINE GOD: Eire. *War Against the Idols,* p. 315.

39 "IMAGES OF VIRGINS": Calvin, John. *Institutes of the Christian Religion* (1.11.7).

40 REFORMATION REDEFINED IT: Pelikan, Jaroslav. *Mary Through the Centuries: Her Place in the History of Culture.* New Haven and London: Yale University Press, 2009, p. 159.

44 WHOLE COMMUNITY: Harries, Karsten. *The Ethical Function of Architecture.* Cambridge, MA: MIT Press, 1997, p. 289.

44 NATURE OF A SACRAMENT: Weil, Simone. *Waiting for God,* trans. Emma Craufurd. New York: Harper & Row, 1951, p. 169.

53 GOD'S SAVING GRACE: Rahner, Karl. *Mary, Mother of the Lord,* trans. W. J. O'Hara. Wheathampstead UK: A. Clarke, 1974, p. 13.

61 SANTA MARIA MAGGIORE IN ROME: Jensen, Robin M. "Missing Joseph? The Father's Place at the Holy Family's Table." Talk, Society of Biblical Literature Annual Meeting, Boston, November 23, 2008.

61 AT THE AGE OF 111: *The History of Joseph the Carpenter,* trans. Alexander Walker. Electronic Bible Society. http://www.catholicculture.org/culture/library/fathers/view.cfm?recnum=1891.

62 HOLDING UP A LIGHT: Jensen. "Missing Joseph?"

62 GOD'S ONLY SON: Bernard of Clairvaux, Homily 2.16 on Mary, in *Homilies in Praise of the Blessed Virgin Mary,* trans. Marie-Bernard Saïd. Kalamazoo, MI: Cistercian Publications, 1993, p. 28.

63 LABOR ITSELF EXPANDED: White, Lynn, Jr. "The Iconography of *Temperantia* and the Virtuousness of Technology," in *Action and Conviction in Early Modern Europe: Essays in Memory of E. H. Harbison,* ed. T. K. Rabb and J. E. Seigel. Princeton,

NJ: Princeton University Press, 1969, pp. 199–201.

63 LATE MIDDLE AGES: Herlihy, David, and Anthony Molho. *Women, Family and Society in Medieval Europe: Historical Essays 1978–1991.* Providence, RI; Oxford: Berghahn Books, 1995, p. 153.

65 HE WAS PORTRAYED: Chorpenning, Joseph F., O.S.F.S., trans. and ed. *Just Man, Husband of Mary, Guardian of Christ: An Anthology of Readings from Jerónimo Gracián's Summary of the Excellencies of St. Joseph (1597).* Philadelphia: Saint Joseph's University Press, 1993, p. 3.

66 JOSEPH'S PATRONAGE: Chorpenning, p. 3.

68 OF HIS BIRTH: Rubin, p. 18.

68 AGAINST APOLLINARIANISM: Pelikan, Jaroslav. *The Emergence of the Catholic Tradition: (100–600).* Chicago: University of Chicago Press, 1971, p. 249.

68 NOT BORN OF HER: Graef, Hilda C. *Mary: A History of Doctrine and Devotion.* New York: Sheed & Ward, 1963, p. 104.

68 WORSHIPPED BY PAGANS: Warner, p. 65.

69 PERPETUAL VIRGINITY: Gambero, Luigi. *Mary and the Fathers of the Church: The Blessed Virgin Mary in Patristic Thought.* San Francisco: Ignatius Press, 1999, pp. 103, 104.

69 CHRISTIAN PANTHEON: Carroll, Michael P. *The Cult of the Virgin Mary.* Princeton, NJ: Princeton University Press, 1986, p. 85.

69 DESCRIPTION FOR JESUS CHRIST: Pelikan. *Mary Through the Centuries,* p. 57.

72 NOT IN OFFICIAL DOGMA: Ford, Kathleen Carey. "Portrait of Our Lady: Mary, Piero, and the Great Mother Archetype," *Journal of Religion and Health,* 43:2 (Summer 2004), pp. 93–113.

72 SCANT BIOGRAPHICAL DETAIL: Belting, p. 34.

73 "BEDECKED ITSELF WITH IT": "The Homilies of Photius, Patriarch of Constantinople," *Dumbarton Oaks Studies 9,* trans. Cyril Mango. Washington, DC: Dumbarton Oaks Research Library and collection, 1958, p. 102; quoted in Baldovin, "Worship in Urban Life," p. 66.

77 ("UNCONTAINABLE GOD"): Underwood, Paul. *The Kariye Djami,* Vol. 1. New York: Pantheon Books, 1966, p. 27.

77 BALANCE EACH OTHER: Underwood, p. 28.

78 ETERNAL DIVINE TIME: Ousterhout, Robert G. "Temporal Structuring in the Chora Parekklesion." *Gesta,* 34:1 (1995), p. 63.

78 ARCHER'S ARROW PASSES: White, Eric C. *Kaironomia: On the Will-to-Invent.* Ithaca NY: Cornell University Press, 1987, p. 13.

84 CREATED THE WORLD: Weil, p. 158.

84 MADE THE BEAST: Farley, Edward. *Faith and Beauty, A Theological Aesthetic.* Hampshire, UK: Ashgate, 2001, pp. 11, 12.

84 DISTANCE FROM IT: Harries, Karsten. "Untimely Meditations."

84 ALWAYS A PART OF IT: Farley, p. viii.

84 CHARACTERISTIC OF FAITH: Farley, pp. 27, 108.

84 GOODNESS AND TRUTH: Vanhoozer, Kevin J. "Praising in Song: Beauty and the Arts," in *The Blackwell Companion to Christian Ethics,* ed. Stanley Hauerwas and Samuel Wells. Oxford and Malden, MA: Blackwell, 2004, p. 117.

84 OR BEAUTY-GOODNESS: Pope John Paul II. *Letter to Artists,* April 4, 1999.

85 "ESSENCE OF BEAUTY IS": Plato. *Symposium: The Benjamin Jowett Translation.* New York: Modern Library, 1996, p. 42.

85 SENSES AND MIND: Maurer, Armand A. *About Beauty.* Houston TX: The Center for Thomistic Studies, 1983, p. 16.

85 PSYCHIC AWARENESS: Weil, p. 164.

86 "NEWBORNNESS" OF THE WORLD: Scarry, Elaine. *On Beauty and Being Just.* Princeton, NJ; Oxford: Princeton University Press, 1999, p. 22.

86 AND IS IMMORTAL: Scarry, p. 30.

86 "WORTH LIVING": Scarry, p. 25.

86 "DEEP DOWN THINGS": Hopkins, Gerard Manley. "God's Grandeur," 1877.

86 RELIGIOUS IMPULSE: James, William. *The Varieties of Religious Experience: A Study in Human Nature.* New York: Modern Library, 1994, p. 551.

87 OBLIGATION TO OTHERS: Scarry, p. 90.

87 WITH ETHICAL FAIRNESS: Scarry, p. 109.

87 RESPONSE OF LOVE: Steck, Christopher. *The Ethical Thought of Hans Urs von Balthasar.* New York: Crossroad Publishing, 2001, p. 9.

87 "AND TRUTH DONE": Steck, p. 10.

87 CHARACTERIZES FAITH: Farley, p. 106.

88 CHRISTIANITY AND ISLAM: Pelikan. *Mary Through the Centuries*, p. 67.

88 SPEAKER AND THE LISTENER: Stowasser, Barbara Freyer. *Women in the Qur'an, Traditions, and Interpretation.* New York and Oxford: Oxford University Press, 1996, p. 81.

89 ISLAM EMERGED: Mourad, Suleiman A. "Mary in the Qur'an," in *The Qur'an in its Historical Context*, ed. Gabriel Said Reynolds. New York: Routledge, 2007, p. 172.

89 THE PROPHET MUHAMMAD: Abu Sway, Mustafa. "Jesus Christ: A Prophet of Islam." Paper presented at the Palestinian Academic Society for the Study of International Affairs, Jerusalem, March 30, 2006, p. 1.

89 (SIMPLY MEANS "GOD"): Armstrong, Karen. *Islam: A Short History.* New York: Random House, 2002, p. 5.

89 WE ARE NOTHING: Armstrong. *Islam*, p. 6.

89 ARE "DISTORTED": Saeed, Abdullah. *Introduction to the Qur'an: History, Interpretation and Approaches.* New York: Routledge, 2008, p. 147.

90 WITH CALLIGRAPHY: Glassé, Cyril. *The New Encyclopedia of Islam.* Lanham MD: Rowman & Littlefield Publishers, 2008, p. 340.

90 FROM GOD'S SPIRIT: Stowasser, p. 78.

90 NO KNOWN CHRISTIAN ORIGIN: Mourad, p. 67.

90 THROUGH MARY, HIS MOTHER: Pelikan. *Mary Through the Centuries*, p. 75.

91 "TO THE MOSLEM PEOPLE": Sheen, Fulton J. "Mary and the Moslems," in *The World's First Love: Mary, Mother of God.* Fort Collins, CO: Ignatius Press, 1996, p. 203.

91 BETWEEN HEAVEN AND EARTH: Armstrong, Karen. *Jerusalem: One City, Three Faiths.* New York: Ballantine Books, 1997, p. 225.

91 AMPLITUDE THAN MARY: Pelikan. *Mary Through the Centuries*, p. 78.

92 "THE ROOT IS MARY": Tertullian. *De Carne Christi*, ed. and trans. Ernest Evans. London: S.P.C.K., 1956, p. 73.

92 "FLOWER OF HUMAN FLESH": Leo the Great. "Sermon XXIV," Dec. 25, 443 C.E.

92 JESSE TREE DESIGNERS: Fassler, Margot. "Mary's Nativity, Fulbert of Chartres, and the Stirps

Jesse: Liturgical Innovation circa 1000 and Its Afterlife," *Speculum*, 75 (2000), p. 396.

93 "WAS JESUS BEGOTTEN": Brown, Raymond E. *An Introduction to the New Testament.* New York: Doubleday, 1996, p. 175.

93 THE STATUS QUO: Gaventa, Beverly Roberts. " 'All Generations Will Call Me Blessed': Mary in Biblical and Ecumenical Perspective," in *A Feminist Companion to Mariology*, ed. Amy-Jill Levine, with Maria Mayo Robbins. London: T&T Clark International, 2005, p. 125.

93 WERE INSEPARABLE: Ritchey, Sara. "Spiritual Arborescence: Trees in the Medieval Christian Imagination," *Spiritus: A Journal of Christian Spirituality*, 8:1 (2008), p. 69.

93 SACRIFICE AND IMMORTALITY: Schama, Simon. *Landscape and Memory.* New York: Vintage Books, 1995, p. 218.

96 LAND OF MILK AND HONEY: Pintel-Ginsberg, Idit. "Narrating the Past—'New Year of the Trees' Celebrations in Modern Israel," *Israel Studies*, 11:1 (Spring 2006), p. 174.

100 CHRIST'S REDEMPTION: Cross, Richard. *Duns Scotus.* New York: Oxford University Press, 1999, p. 132.

100 *RETROACTIVE* REDEMPTION: Cross, p. 133.

101 "HAND OF AN ANGEL": Gaventa, Beverly Roberts. *Mary: Glimpses of the Mother of God.* Minneapolis: Fortress Press, 1999, p. 112.

101 WITH PAPAL APPROVAL: Rubin, p. 174.

101 DOGMA OF FAITH: McLoughlin, William, and Jill Pinnock, eds. *Mary for Time and Eternity: Essays on Mary and Ecumenism.* Leominster, UK: Gracewing Publishing, 2007, p. 342.

102 "STAIN OF ORIGINAL SIN": Pius IX. *Ineffabilis Deus*, December 8, 1854.

102 THROUGHOUT HER LIFE: Pius IX. *Ineffabilis Deus.*

102 "UNEXPECTED AND SURPRISING": Rahner, Karl. *Mary, Mother of All.* New York: Herder and Herder, 1963, p. 44.

103 SITES IN EUROPE: Warner, p. 294.

103 OF HUMAN HEALING: Warner, p. 293.

103 HEARTS OF THE PIOUS: Rubin, p. 138.

104 THROUGHOUT EUROPE: Rubin, p. 139.

106 EDIFICES IN FRANCE: Adams, Henry. *Mont-Saint-*

Michel and Chartres. Boston and New York: Houghton Mifflin, 1904, p. 91.

107 STAINED GLASS BEGAN: Von Simson, Otto. *The Gothic Cathedral.* New York: Pantheon Books, 1956, p. 100.

107 AS IT IS OF FAITH: Von Simson, pp. 54, 55.

108 POLYTHEISTIC CULTURES: Cunneen, p. 171.

109 EUROPEAN MONASTICS: Rubin, p. 125.

109 MONASTIC COMMUNITIES: Taft, Robert F. *The Liturgy of the Hours in East and West.* Collegeville, MN: Liturgical Press, 1986, p. 121.

111 GOD'S INDESCRIBABLE GLORY: Fulton, Rachel. "Mary," in *In Christianity in Western Europe c.1000–c.1500,* ed. Miri Rubin and Walter Simons. Cambridge, UK: Cambridge University Press, 2009, pp. 289, 290.

111 "SPIRITUAL SPRINGTIME": Pope Benedict XVI. "Address to the Participants in the International Congress Organized to Commemorate the 40th Anniversary of the Dogmatic Constitution on Divine Revelation 'Dei Verbum,' " September 16, 2005.

112 INTERPRETATIONS WERE MADE: Bynum, Caroline Walker. *The Resurrection of the Body in Western Christianity, 200–1336.* New York: Columbia University Press, 1995, p. 157.

114 THAN IN EVIL: Fassler, Margot. "Now Playing at the Center of the Cosmos: Hildegard of Bingen, 1098–1179." Lecture, Institute of Sacred Music, Yale University, September 16, 2009.

114 SPIRITUAL BIRTH TO CHRIST: Fassler. "Now Playing at the Center."

114 WHOLENESS AND PERFECTION: Bynum. *The Resurrection of the Body,* p. 163.

114 BODY AND SOUL: Bynum. *The Resurrection of the Body,* p. 161.

114 "THE WHOLE EARTH REJOICES": Beer, Frances. *Women and Mystical Experience in the Middle Ages.* Bury St. Edmunds, Suffolk, UK: St. Edmundsbury Press, 1992, p. 52.

114 ASPIRES TO GOD: Newman, Barbara. *Sister of Wisdom: St. Hildegard's Theology of the Feminine.* Berkeley: University of California Press, 1989, p. 45.

114 ATTITUDES OF THE TIME: Beer, pp. 21–25.

114 CONCRETE WORLD: Newman, Marsha. "Christian Cosmology in Hildegard of Bingen's Illuminations," *Logos: A Journal of Catholic Thought and Culture,* 5:1 (Winter 2002), p. 42.

115 THE VIRTUES: Newman. *Sister of Wisdom,* p. 16.

115 GOD AND HUMANITY: Newman. *Sister of Wisdom,* p. 17.

115 AS POWERFUL AS HER SON: Newman, Barbara. "Poet: Where the Living Majesty Utters Mysteries," in *Voice of the Living Light: Hildegard of Bingen and Her World.* Berkeley: University of California Press, 1998, pp. 176–177.

115 "GLORIOUS" IN HEAVEN: Julian of Norwich. *Revelations of Divine Love, Translated from British Library Additional MS 37790: The Motherhood of God: an excerpt, translated from British Library MS Sloane 2477,* ed. Frances Beer. Rochester, NY: D.S. Brewer, 1998.

115 PERFECTION THROUGH GRACE: Nuth, Joan. *Wisdom's Daughter: The Theology of Julian of Norwich.* New York: Crossroad, 1991, p. 159.

115 TO BE HUMAN: Palliser, Margaret Ann. *Christ, Our Mother of Mercy: Divine Mercy and Compassion in the Theology of the Shewings of Julian of Norwich.* New York: Walter deGruyter, 1992, p. 42.

118 "MEDIATED THROUGH LOVE": Fulton, Rachel. *From Judgment to Passion: Devotion to Christ and the Virgin Mary, 800–1200.* New York: Columbia University Press, 2003, p. 197.

118 TWELFTH-CENTURY FIGURE: Bynum, Caroline Walker. "Jesus as Mother and Abbot as Mother: Some Themes in Twelfth-Century Cistercian Writing," *The Harvard Theological Review,* 70:3/4 (Jul.–Oct. 1977), p. 261.

118 "OR OF INSTRUCTION": Bynum. "Jesus as Mother," p. 261.

118 ON A MOTHER'S MILK: Bynum. "Jesus as Mother," p. 283.

118 SENSIBILITY FROM ALL OTHERS: Greeley, Andrew. *The Catholic Imagination.* Berkeley: University of California Press, 2000, p. 91.

119 REVELATION OF GOD'S WILL: Newman. *Sister of Wisdom,* p. 158.

119 GOD ON EARTH: Cunneen, p. 164.

119 THE ENTIRE TRINITY: Bynum, Caroline Walker. *Jesus as Mother: Studies in the Spirituality of the High*

Middle Ages. Berkeley: University of California Press, 1982, p. 142.

119 BUT A MOTHER: Palliser, pp. 110, 111.

119 MOTHER–CHILD RELATIONSHIP: Palliser, p. 113.

119 WITHIN MOTHER MARY: Reinhard, Kathryn. "Joy to the Father, Bliss to the Son: Unity and the Motherhood Theology of Julian of Norwich," *Anglican Theological Review,* 89:4 (Fall 2007), p. 639.

120 SYMBOL OF THE DIVINE: Dupré, Louis K. *Symbols of the Sacred.* Grand Rapids, MI: W. B. Eerdmans, 2000, p. 80.

124 (MADE IN ABOUT 1530): Shapiro, Meyer. "Muscipula Diaboli, The Symbolism of the Merode Altarpiece," *The Art Bulletin,* 27:3 (Sept. 1945), p. 183.

124 VALUE OF INDUSTRIOUSNESS: Shapiro, p. 184.

125 TO A SACRED SHRINE: Botvinick, Matthew. "The Painting as Pilgrimage: Traces of Subtext in the Work of Campin and His Contemporaries," *Art History,* 15:1 (Mar. 1992), p. 7.

130 "WITH HER WOMAN KIN": Rilke, Rainer Maria. *The Life of the Virgin Mary,* trans. C. F. McIntyre. Berkeley and Los Angeles: University of California Press, 1947, p. 11.

134 SIGNIFICANCE OF HIS BIRTH: Fitzmyer, Joseph A., S.J. *The Gospel According to Luke I–IX* (Anchor Bible 28). Garden City, NY: Doubleday, 1981, p. 393.

148 MOST LIKELY MINOR: Drijvers, Jan Willem. *Helena Augusta: The Mother of Constantine the Great and the Legend of Her Finding of the True Cross.* Leiden and Boston: Brill Academic Publishers, 1997, p. 63.

148 HE HAD RISEN: Krautheimer, Richard. *Early Christian and Byzantine Architecture.* New Haven: Yale University Press, 1984, p. 60.

152 ON JANUARY 18: Finkel, Michael. "Bethlehem 2007 A.D.," *National Geographic,* 212:6 (Dec. 2007), p. 85.

160 EARLY CHRISTIAN ART: Grabar, André. *Christian Iconography: A Study of its Origins,* Bollingen Series 25, Vol. 10. Princeton, NJ: Princeton University Press, 1968, p. 12.

160 BIRTH OF A HERO: Warner, p. 6.

160 CHRISTIAN INTERPRETATION: Brown, Raymond E. *The Birth of the Messiah: A Commentary on the Infancy Narratives in Matthew and Luke.* Garden City, NY: 1977, pp. 188–90.

162 EARN GOD'S GRACE: Trexler, Richard C. *The Journey of the Magi.* Princeton, NJ: Princeton University Press, 1997, p. 24.

162 SEAT OF ROMAN POWER: Trexler, pp. 9, 23.

162 CHRIST'S AUTHORITY: Ross, Leslie. "Adoration of the Magi," in *Medieval Art: A Topical Dictionary.* Westport, CT: Greenwood Publishing Group, 1996, p. 5.

162 REACHED AN APEX: Brown. *The Birth of the Messiah,* p. 199.

162 SPECIFICALLY EARRINGS: Trexler, p. 80.

162 FROM THE COLLECTIVE: Trexler, p. 73.

163 " 'FRANK SENT THIS' ": Robinson, Sir Ken. "Do Schools Kill Creativity?" TED talk, February 2006. http://www.ted.com/talks/ken_robinson_says_schools_kill_creativity.html.

187 "BEING ELSEWHERE": Park, Clara Claiborne. *The Siege.* Boston: Back Bay Books, 1982, p. 12.

193 GENERATIONS OF DEVOTEES: Hamilton, Adrianne. "Translating the Sacred: Piety, Politics, and the Changing Image of the Holy House of Loreto." M.A. thesis, Eugene, University of Oregon, 2008, p. 38.

193 AND LEO X: Stinger, Charles L. *The Renaissance in Rome.* Bloomington, IN: Indiana University Press, 1998, p. 42.

196 VIOLENT WINDS IN 1619: Clarke, Desmond M. *Descartes: A Biography.* New York: Cambridge University Press, 2006, p. 64.

196 ON A SYMBOLIC LEVEL: Ousterhout, Robert. "Architecture as Relic and the Construction of Sanctity," *The Journal of the Society of Architectural Historians,* 62.1 (March 2003), p. 5.

198 IS A REMEMBERING: John Paul II. *Rosarium Virginis Mariae.* Apostolic letter, October 16, 2002, section 13.

202 AND ISLAM: Wills, Garry. *The Rosary.* New York: Penguin, 2005, p. xii.

205 CARDIAC PATIENTS' HEALTH: Krucoff, Mitchell W., M.D., and others. "Music, Imagery, Touch, and Prayer as Adjuncts to Interventional Cardiac Care: The Monitoring and Actualization of Noetic Trainings (MANTRA) II Randomized Study," *The Lancet,* 366:9481 (July 16, 2005), pp. 211–217.

205 "QUESTION OF UTILITY": Duke Medicine News and Communications. "Results of First Multi-center Trial of Intercessory Prayer, Healing Touch in Heart Patients," July 14, 2005. http://www.dukehealth.org/HealthLibrary/News/9136.

212 GLIMPSE OF HER HUMANITY: Pelikan. *Mary Through the Centuries*, p. 19.

214 TRAGEDY OF THE PASSION: Schuler, Carol M. "The Seven Sorrows of the Virgin: Popular Culture and Cultic Imagery in Pre-Reformation Europe," *Simiolus*, 21:1/2 (1992), p. 9.

214 ARGUABLY UNIQUE: Fulton. *From Judgment to Passion*, p. 199.

214 MORE ACCESSIBLE: Rubin, p. 244.

216 LOSS OF HER CHILD: Pelikan, Jaroslav. *The Christian Tradition: Reformation of Church and Dogma (1300–1700)*. Chicago: University of Chicago Press, 1985, p. 43.

219 BAVARIAN ROCOCO STYLE: This essay is indebted to Karsten Harries, specifically *The Bavarian Rococo Church: Between Faith and Aestheticism*. New Haven and London: Yale University Press, 1983.

219 ARE FAR OLDER: The Song's first line ascribes it to Israel's king Solomon, who reigned in the tenth century B.C.E.—"The Song of Songs, which is Solomon's"—though he is not the author.

219 FEMALE ENTERTAINERS: *The Bible, New Revised Standard Version*, ed. Zaine Ridling. Washington, DC: National Council of the Churches of Christ in the United States of America, 1989, p. 1308.

219 POTENTIAL MATES: Ridling, p. 1309.

220 MEDIEVAL AGE: Daley, Brian E. "The 'Closed Garden' and the 'Sealed Fountain'; Song of Songs 4:12 in the Late Medieval Iconography of Mary," in *Medieval Gardens*. Washington, DC: Dumbarton Oaks Research Library and Collection, 1986, p. 259.

221 ULTIMATELY FORMLESS: Tolle, Eckhart. *A New Earth*. New York: Penguin Books, 2005, p. 2.

221 "MARY'S FLAX": Fulton, Rachel. "The Virgin in the Garden, or Why Flowers Make Better Prayers," *Spiritus: A Journal of Christian Spirituality*, 4:1 (Spring 2004), p. 1.

221 ATTRACTIVENESS TO GOD: Fulton. "The Virgin in the Garden," p. 8.

221 OF THE VIRGIN MARY: Forster, Marc R. *Catholic Revival in the Age of the Baroque: Religious Identity in Southwest Germany, 1550–1750*. Cambridge, UK: Cambridge University Press, 2001, p. 61.

224 "CADENCE OF BLOOD": Angier, Natalie. *Woman: An Intimate Geography*. New York: Anchor Books, 1999, p. 97.

225 BEAUTY AND ACCURACY: Garrison, Fielding Hudson, M.D. *An Introduction to the History of Medicine*. Philadelphia and London: W. B. Saunders, 1921, p. 342.

225 SCIENTIFICALLY, GRASPABLE: In other anatomical models of the time, the interior of the body was imagined as a house having different rooms for different biological functions, similar to the room-as-womb metaphor proposed for Steinhausen.

225 AESTHETIC BEAUTY: Jan Wandelaar's illustrations can be seen online: "Dream Anatomy." 2006 U.S. National Library of Medicine, May 12, 2009. http://www.nlm.nih.gov/dreamanatomy/da_gallery.html.

227 RELAYED THEM TO HIM: Delany, John J., and James Edward Tobin. "Emmerich, Bl. Anne Catherine," in *Dictionary of Catholic Biography*. Garden City, NY: Doubleday, 1961, p. 374.

227 BUILT FOR HER: All selections are from Emmerich, Anne Catherine. *The Life of the Blessed Virgin Mary*, trans. Sir Michael Palairet, supplementary notes by Rev. Sebastian Bullough, O.P., ed. Donald Dickerson, Jr. Springfield IL: Templegate, 1954, p. 241.

230 BY THE VATICAN: Duicy, Michael P. *What's the Latest News on Mary's House in Ephesus?* International Marian Research Institute, May 1, 2009. http://campus.udayton.edu/mary/questions/yq2/yq381.html.

230 MARY'S LAST RESIDENCE: Duicy.

234 "SUPERNATURAL" DESIGNATION: For the status of approved and disapproved Marian apparitions since 1900, see J. C. Tierney, "Marian Apparitions of the Twentieth Century." International Marian Research Institute, Dayton, Ohio,

April 20, 2009. http://campus.udayton.edu/mary//resources/aprtable.html.

244 MESSAGE OF HOPE: Varghese, Roy Abraham. *God-Sent! A History of Accredited Apparitions of Mary.* New York: Crossroad Publishing, 2000, p. 7.

244 MEANINGFUL SUFFERING: Zimdars-Swartz, Sandra L. *Encountering Mary.* Princeton, NJ: Princeton University Press, 1991, p. 266.

245 SITE OF THE SPRING: Zimdars-Swartz, p. 58.

247 AS DOGMA IN 1854: Miravalle, Mark I. *Introduction to Mary: The Heart of Marian Doctrine and Devotion.* Self-published, 1993, p. 191.

247 WAS SO STRONG: Harris, Ruth. *Lourdes: Body and Spirit in the Secular Age.* New York: Viking, 1999, p. 82.

247 RESULT OF AUTOSUGGESTION: Harris, p. 336.

248 AND RESOURCEFUL: Harris, p. 307.

249 THE SECOND VERSION: Elizondo, Virgil. *Guadalupe: Mother of the New Creation.* Maryknoll NY: Orbis Books, 1997. Elizondo's text is based on the Spanish translation by Clodomiro L. Siller Acuña of the *Nican Mopohua*, a poem about Guadalupe's appearance, written in Nahautl for the Nahuatl people.

251 "HEAVEN AND EARTH": Elizondo, p. 8.

252 IMMACULATE CONCEPTION: Peterson, Jeanette Favrot. "Canonizing a Cult, A Wonder-Working Guadalupe in the Seventeenth Century," in *Religion in New Spain*, ed. Susan Schroeder and Stafford Poole. Albuquerque: University of New Mexico Press, 2007, p. 127.

252 PRE-HISPANIC TEMPLES: Harrington, Patricia. "Mother of Death, Mother of Rebirth: The Mexican Virgin of Guadalupe," *Journal of the American Academy of Religion*, 56:1 (Spring 1988), p. 29.

254 COLONIAL AUTHORITY: Taylor, William B. "The Virgin of Guadalupe in New Spain: An Inquiry into the Social History of Marian Devotion," *American Ethnologist*, 14:1 (Feb. 1987), p. 20.

254 PATRONESS IN 1737: Poole, Stafford, C.M. *The Guadalupan Controversies in Mexico.* Palo Alto, CA: Stanford University Press, 2006, p. 12.

256 NO SIGN OF ABATING: Poole, Stafford, C.M. *Our Lady of Guadalupe: The Origins and Sources of a Mexican National Symbol, 1531–1797.* Tucson: University of Arizona Press, 1995, p. 12.

256 STRENUOUS RESEARCH: Peterson, Jeanette Favrot. "Creating the Virgin of Guadalupe: The Cloth, The Artist, and Sources in Sixteenth-Century New Spain," *The Americas*, 61:4 (Apr. 2005), pp. 571–610.

258 "MIXED-RACE PEOPLE": Interview with the author, June 30, 2008.

259 CONFERENCE OF BISHOPS: Interview with the author, June 25, 2008.

261 MARY AND THE SAINTS: Interview with the author, July, 27, 2004.

262 STOPPED BUYING GRAPES: Gaustad, Edwin Scott, and Leigh Eric Schmidt. *The Religious History of America.* New York: HarperOne, 2004, p. 379.

267 WITHIN THE HOME: Kilde, Jeanne. *When Church Became Theater: The Transformation of Evangelical Architecture and Worship in Nineteenth-Century America.* New York: Oxford University Press, 2000, p. 47.

268 IDEA OF HOME AND PLACE: Cardinal Mahony's 2,935-word homily included the use of the words *home* (5 times), *house* (7 times), *plaza* (5 times), *square* (5 times), *place* (6 times), *dwelling* (3 times), *perch* (3 times), *cornerstone* (2 times), and *city* (16 times).

268 VERNACULAR TRADITION: Goldberger, Paul. "Sanctum on the Coast," *New Yorker* (Sept. 23, 2002), p. 96.

268 CLIMB FOR DECADES: Pew Hispanic Center report. "Religious Practices and Beliefs," in *Changing Faiths: Latinos and the Transformation of American Religion*, April 25, 2007. http://pewhispanic.org/reports/report.php?ReportID=75, June 24, 2008.

268 ELABORATE PROCESSIONS: Lara, Jaime. "Spiritual Sparks: The Hispanic Aesthetic in Religious Art and Architecture," *Faith & Form*, 41:3 (2008), p. 13.

268 CATHOLIC LATINO GROUPS: Pew Hispanic Center report, "Religious Practices and Beliefs," *Changing Faiths: Latinos and the Transformation of American Religion*, 2007.

269 THE UNITED STATES: All Valenzuela quotes from Letisia Marquez and Todd Schindler, "Theater Professor Stages Virgin of Guadalupe Story."

UCLA Newsroom, 2007. http://newsroom.ucla.edu/portal/ucla/electronicplay.aspx?fid=16742&id=E0C5478.

272 HAS SINCE BECOME WIDESPREAD: Daley, Brian E. " 'At the Hour of Our Death': Mary's Dormition and Christian Dying in Late Patristic and Early Byzantine Literature," *Dumbarton Oaks Papers*, 55 (2001), p. 80.

274 EARTHLY EXISTENCE: Pangborn, Cyrus R. "Christian Theology and the Dogma of the Assumption," *Journal of Bible and Religion* (April 1962), p. 95.

276 BODILY ASSUMPTION: Pius XII. *Munificentissimus Deus, Defining the Dogma of the Assumption.* Apostolic Constitution, November 1, 1950.

282 "BIBLICAL WARRANT": Pelikan. *Mary Through the Centuries*, p. 205.

282 "FLAGRANTLY TOO MUCH": Barth, Karl. *Kirchliche Dogmatik* (Zurich: EBZ, 1939),160, quoted in Alain Blancy and Maurice Jourjon and the Dombes Group, *Mary in the Plan of God and in the Communion of Saints.* Mahwah, NJ: Paulist Press, 1999, p. 87.

282 "SUPPORTS IT": Pangborn, p. 99.

282 EXISTS EVEN NOW: Rahner, Karl. "The Interpretation of the Dogma of the Assumption," *Theological Investigations*, Vol. 1, trans. Cornelius Ernst. Baltimore: Helicon Press, 1961, p. 226.

283 KNOWN PHYSICAL WORLD: Rahner. "Interpretation," p. 222.

283 "REPRESENTATION OF IT DOES": Rahner. "Interpretation," p. 222.

286 WHO VENERATE HER: Orsi, Robert A. "The Many Names of the Mother of God," p. 7.

287 ECUMENICAL DIVISIVENESS: Orsi. *The Madonna of 115th Street: Faith and Community in Italian Harlem, 1880–1950.* Second edition. New Haven: Yale University Press, 2002, p. xv.

287 BY THE 1960s: Ruether, Rosemary Radford. "Mary in U.S. Catholic Culture," *National Catholic Reporter*, 31:15 (Feb. 10, 1995), p. 15.

292 BECAUSE OF HER SON: Gaventa. *Glimpses*, pp. 16–17.

292 COOPERATE WITH GOD: Gaventa. *Glimpses*, p. 16.

292 PLAN FOR SALVATION: Blancy, Alain, Maurice Jourjon, and the Dombes Group. *Mary in the Plan of God and in the Communion of Saints.* Mahwah, NJ: Paulist Press, 1999, p. 3.

293 DIVINE MEDIATION: Tavard, George. *The Thousand Faces of the Virgin Mary.* Collegeville, MN: The Liturgical Press, 1996, p. 213.

293 PASTORAL LEADERSHIP: Johnson. *Truly Our Sister*, p. 67.

293 ("COMPLETELY YOURS"): Weigel, George. *Witness to Hope: The Biography of Pope John Paul II.* New York: Cliff Street Books, 1999, p. 265.

293 "MOTHER OF GOD": John Paul II. *Mulieris Dignitatem*, 19, August 15, 1988 (emphasis in original).

293 ESSENCE OF GOD: John Paul II. *Mulieris Dignitatem*, 24, August 15, 1988 (emphasis in original).

293 OFFICIAL PLACE TO GO: Johnson. *Truly Our Sister*, p. 91.

296 FEMINIST THEOLOGIANS: Among them Elisabeth Schüssler Fiorenza, Elizabeth A. Johnson, Margaret A. Farley, Letty M. Russell, Rosemary Radford Ruether, and Mary Daly.

Suggested Reading

Mary is a vast subject, one that has intrigued theologians, historians, and writers for some sixteen centuries. Over 100,000 books on the Virgin Mary, in addition to myriad clippings, pamphlets, and other ephemera, are held at the Marian Library at the University of Dayton, the largest collection of printed materials on Mary. Given the scale of the subject, I've suggested a handful of books for further reading. While this book rests on the scholarship of many, I owe a particular debt to the historical analyses and theological reflections of Rachel Fulton, Elizabeth Johnson, Robert Orsi, Jaroslav Pelikan, and Miri Rubin. My narrative approach was shaped by the work of Sally Cunneen and Kathleen Norris and lifted by the wisdom of Karl Rahner, Rainer Maria Rilke, and Simone Weil. The marginal commentaries throughout the book suggest the breadth of writing Mary has inspired.

Armstrong, Karen. *Jerusalem: One City, Three Faiths.* New York: Ballantine Books, 1997.

Belting, Hans. *Likeness and Presence: A History of the Image Before the Era of Art.* Trans. Edmund Jephcott. Chicago: University of Chicago Press, 1994.

Benko, Stephen. *The Virgin Goddess: Studies in the Pagan and Christian Roots of Mariology.* Leiden: Brill, 2004.

Burke, Mariann. *Re-Imagining Mary: A Journey Through Art to the Feminine Self.* Carmel CA: Fisher King Press, 2009.

Bynum, Caroline Walker. *Jesus as Mother: Studies in the Spirituality of the High Middle Ages.* Berkeley: University of California Press, 1982.

Castillo, Ana, ed. *La Diosa de las Americas/Goddess of the Americas.* New York: Riverhead Books, 1996.

Cunneen, Sally. *In Search of Mary: The Woman and the Symbol.* New York: Ballantine Books, 1996.

Elizondo, Virgil. *Guadalupe: Mother of the New Creation.* Maryknoll NY: Orbis Books, 1997.

Fulton, Rachel. *From Judgment to Passion: Devotion to Christ and the Virgin Mary, 800–1200.* New York: Columbia University Press, 2003.

Gaventa, Beverly Roberts. *Mary: Glimpses of the Mother of God.* Minneapolis: Fortress Press, 1999.

Graef, Hilda C. *Mary: A History of Doctrine and Devotion.* New York: Sheed and Ward, 1963.

Greeley, Andrew M. *The Mary Myth: On the Femininity of God.* New York: Seabury Press, 1977.

Harris, Ruth. *Lourdes: Body and Spirit in the Secular Age.* New York: Viking, 1999.

Hazleton, Lesley. *Mary: A Flesh-and-Blood Biography of the Virgin Mother.* New York: Bloomsbury, 2004.

Houselander, Caryll. *The Reed of God.* Notre Dame IN: Christian Classics, 2006.

Johnson, Elizabeth A. *Truly Our Sister: A Theology of Mary in the Communion of Saints.* New York: Continuum, 2003.

Katz, Melissa R., ed. *Divine Mirrors: The Virgin Mary in the Visual Arts.* Oxford UK: Oxford University Press, 2001.

Neumann, Erich. *The Great Mother: An Analysis of the Archetype.* Trans. Ralph Manheim. Princeton NJ: Princeton University Press, 1955.

Norris, Kathleen. *The Quotidian Mysteries: Laundry, Liturgy and "Women's Work."* Mahwah NJ: Paulist Press, 1998.

Orsi, Robert A. *The Madonna of 115th Street: Faith and Community in Italian Harlem, 1880–1950,* 2nd ed. New Haven: Yale University Press, 2002.

Pelikan, Jaroslav. *Mary Through the Centuries: Her Place in the History of Culture.* New Haven: Yale University Press, 1996.

Pentcheva, Bissera V. *Icons and Power: The Mother of God in Byzantium.* University Park: Pennsylvania State University Press, 2006.

Poole, Stafford. *Our Lady of Guadalupe: The Origins and Sources of a Mexican National Symbol, 1531–1797.* Tucson: University of Arizona Press, 1995.

Rabinowitz, Anna. *The Wanton Sublime.* Dorset VT: Tupelo Press, 2006.

Rilke, Rainer Maria. *Pictures of God.* Trans. Annemarie S. Kidder. Livonia MI: First Page Publications, 2005.

Rubin, Miri. *Mother of God: A History of the Virgin Mary.* New Haven and London: Yale University Press, 2009.

Ruether, Rosemary Radford. *Mary—The Feminine Face of the Church.* Philadelphia: Westminster Press, 1977.

Scarry, Elaine. *On Beauty and Being Just.* Princeton NJ: Princeton University Press, 1999.

Schoemperlen, Diane. *Our Lady of the Lost and Found.* New York: Penguin Books, 2001.

Spretnak, Charlene. *Missing Mary: The Queen of Heaven and Her Re-Emergence in the Modern Church.* New York: Palgrave MacMillan, 2004.

Tavard, George. *The Thousand Faces of the Virgin Mary.* Collegeville MN: The Liturgical Press, 1996.

Vassilaki, Maria, ed. *Images of the Mother of God: Perceptions of the Theotokos in Byzantium.* Burlington VT: Ashgate, 2005.

Warner, Marina. *Alone of All Her Sex. The Myth and the Cult of the Virgin Mary.* New York: Alfred A Knopf, 1976.

Weil, Simone. *Waiting for God.* Trans. Emma Craufurd. New York: Harper & Row, 1951.

Zimdars-Swartz, Sandra. *Encountering Mary: From La Salette to Medjugorje.* Princeton NJ: Princeton University Press, 1991.

Image Credits

iv, v x 5 7 10

14 16, 17 21 24, 25

28 36 43 46 51

iv, v Assumption, Bednorz-Images **x** Judith Dupré **5 Gates of Paradise,** Scala/Art Resource, NY **7 The Manger,** Library of Congress **10 Study for a Virgin,** John Nava **14 Nativity of the Virgin,** Scala/Art Resource, NY **16, 17 Rialto Bridge,** Marcoingegno Design Studio, Marco Vagnini, Roma **21 The Annunciation,** Smithsonian American Art Museum, Washington, DC/Art Resource, NY **24, 25 Peace,** Marcoingegno Design Studio, Marco Vagnini, Roma **28 Virgin and Child with Archangels and Two Saints,** Erich Lessing/Art Resource, NY **36 Madonna and Child,** Scala/Art Resource, NY **43 Madonna and Child,** Salve Regina University, courtesy William Vareika Fine Arts, Newport, RI **46 Korsunskaya Effeskaya (Mother of God of Korsun),** Helen McIldowie-Jenkins **51 Annunciation,** Bednorz-Images

52 **Annunciation,** Scala/Ministero per i Beni e le Attività culturali/Art Resource, NY 57 **Annunciation,** Tanja Butler, 2006 63 **The Glovemaker,** Karen Ostrom, 2004 66 **Saint Joseph the Carpenter,** Scala/Art Resource, NY 70, 71 **Triumphal Arch and Apse,** Bednorz-Images 74 **Presentation of the Virgin in the Temple,** Bednorz-Images 76 **Virgin Hodegetria,** Judith Dupré 79 **Koimesis (Dormition of the Virgin),** Judith Dupré 83 **Basket of yarn,** Judith Dupré 94 **Jakobs Traum (Jacob's Dream),** Courtesy Galerie Thaddaeus Ropac, Paris/Salzburg; photo: Charles Duprat 99 **Madonna and Child with the Birth of the Virgin,** Alinari/Art Resource, NY 105 **Chartres Cathedral,** Bednorz-Images 110 **The Vision of Saint Bernard,** Erich Lessing/Art Resource, NY 113 **The Coronation of the Virgin,** Réunion des Musées Nationaux/Art Resource, NY 117 **The Virgin and Child before a Firescreen,** National Gallery, London/Art Resource, NY 122, 123 **Annunciation Triptych,** The Metropolitan Museum of Art/Art Resource, NY 129 **The Nativity Story,** The Nativity Story © New Line Productions, Inc. Licensed by Warner Bros. Entertainment, Inc. All rights reserved. 132 **The Church of the Seat of Mary,** Judith Dupré

140 142, 143 147 149 150

161 164, 165 172 177

179 182 184 191 194, 195

201 207 208 210

140 **Global Village Shelter,** Mia Pelosi, Global Village Shelter 142, 143 **A Sudanese child sleeping on the ground in the morning after a night with heavy rains,** Christoph Bangert 147 **Adoration of the Shepherds,** Erich Lessing/Art Resource, NY 149 **Basilica of the Holy Nativity,** Judith Dupré 150 **Grotto of the Nativity,** Judith Dupré 161 **Still from** *Birdsong* **("El Cant dels Ocells"),** Roman Ynan, still photographer; Albert Serra, filmmaker; Capricci Films, distributor 164, 165 **Altarpiece of the Patron Saints,** Erich Lessing/Art Resource, NY 172 **Rest on the Flight into Egypt,** 2010, Museum of Fine Arts, Boston 177 **Slaughter of the Innocents,** Simon Trezise 179 **Baby's Clothes, Auschwitz,** Judith Dupré 182 **Mary and Her Son and Christ Teaching the Apostles,** Walters Art Museum, Baltimore, MD 184 **The Annunciation,** Scala/Art Resource, NY 191 **The Wedding Feast at Cana,** Erich Lessing/Art Resource, NY 194, 195 **Translation of the Holy House,** Bednorz-Images 201 **Passion Painting,** Patty Wickman 207 **Station Ten: Christ is stripped of his garments,** David Michalek 208 **Our Lady of Sorrows Procession,** Robert A. Lisak, 2008 210 **Pietà,** Scala/Art Resource, NY

213 **Deposition,** Erich Lessing/Art Resource, NY 215 **Tenebrae,** Melissa Weinman; photo: Richard Nicol 217 **Mourning Parents,** Bednorz-Images 223 **Ceiling fresco, St. Peter and Paul, Steinhausen,** Bednorz-Images 228 **The House of the Virgin Mary,** Judith Dupré 232 **Virgin and Child with Saint Anne and John the Baptist,** Art Resource, NY 235 **Basilica of Our Lady of Fatima,** André Dias Lopes, flickr.com/photos/andrediaslopes/ 236 **Our Lady of La Vang,** Courtesy Basilica of the National Shrine of the Immaculate Conception, Washington D.C., photograph: Geraldine M. Rohling 238 **Apparition Hill,** Judith Dupré 241 **Holy House,** Angelo Hornak Photo Library 246 **Grotto Shrine,** Lourdes, Bednorz-Images 250 **Santa Maria Guadalupe,** Courtesy Knights of Columbus 253 **Retablo de la Virgen Indigena,** 1995, J. Michael Walker 255 **Guadalupe Street, San Antonio, Texas,** Carol M. Highsmith Archive, Library of Congress 258 **Huexotzinco Codex,** Harkness Collection, Library of Congress 260 **La Guadalupana,** Delilah Montoya 266 **Our Lady of the Angels,** Courtesy Robert Graham Studio 275 **Death of the Virgin,** Erich Lessing/Art Resource, NY

276 278 281 284 285

389 290 294 299

Text Credits

"A Genealogy of Jesus Christ" was compiled by Ann Patrick Ware of the Women's Liturgy Group of New York, who has graciously released this text into the public domain.

Grateful acknowledgment is made to the following for permission to reprint previously published material:

The Scripture quotations in this publication are from the *New Revised Standard Version of the Bible,* copyright © 1989 by the Division of Christian Education of the National Council of the Churches of Christ in the United States of America and are used by permission.

America Press, Inc. "Sarah's List" by Kilian McDonnell, O.S.B. Originally published in *America,* June 22, 2009. Reprinted by permission of America Press, Inc., www.americamagazine.org.

Meredith Bergmann "The Crouching Venus" by Meredith Bergmann, copyright © 2004 by Meredith Bergmann. Reprinted by permission.

Andrea Cohen "Worldly Things for Danny B." from *Long Division* (Salmon Poetry, 2009) by Andrea Cohen, copyright © 2009 by Andrea Cohen; "22-Foot Mother" by Andrea Cohen, copyright © 2009 by Andrea Cohen. Reprinted by permission.

Laurie Foos Excerpt from *Bingo Under the Crucifix* by Laurie Foos, copyright © 2003 by Laurie Foos. Reprinted by permission.

Elisabeth Frost "Two Stories" by Elisabeth Frost, copyright © 2008 by Elisabeth Frost. Originally appeared in *Barrow Street.* Reprinted by permission.

Liturgical Press "In the Kitchen" by Kilian McDonnell, O.S.B. from *Swift, Lord, You Are Not,* copyright © 2003 by The Order of Saint Benedict, Inc. Published by St. John's University Press, Collegeville, Minnesota. Reprinted by permission.

Carrie Neill Excerpt from "Fractured Geometry" by Carrie Neill, copyright © 2009 by Carrie Neill. Reprinted by permission.

Lily Prigioniero "Restoration of an Icon" by Lily Prigioniero, copyright © 2009 by Lily Prigioniero. Reprinted by permission.

Anna Rabinowitz Excerpt from "The Woven Child" from *The Wanton Sublime* by Anna Rabinowitz (Dorset, VT: Tupelo Press, 2006). Reprinted by permission of the author.

Patrick C. Ward Excerpt from Annunciation Sermon given in 2008 at St. Anne's in-the-Fields, Lincoln, MA. Reprinted by permission.

Index

Caroto, Giovanni, 190
Catacomb of Priscilla, Rome, 37
Catholic Conference of Bishops, 202
Catholics. *See* Roman Catholic
 Church
Cavallini, Pietro, 15
Cennini, Cennino, 44
Ceres, 24
Chagall, Marc, 41
Chalcedon, Council of, 69, 133
Charlemagne, Emperor, 103
Charles the Bald, 103
Charles, King of Spain, 259
Chartres Cathedral, France, 103–108,
 279
 labyrinth, 106
 stained glass, 107
 North Porch Central Portal, *105*
Chavez, Arturo, 258, 263
Chávez, César, 262
Chavurah, 96
Chicago, Judy, 224
Christ. *See* Jesus Christ.
Christianity, ix, 18, 44, 53, 68, 71, 88,
 89, 90, 95, 173, 230
Christmas, 156–158
Christopher, Saint, medal, 124
Cihuacoatl, 254
Cipac, Marcos (de Aquino), 256
Cistercians, 111
Civil Rights Movement, 296
Clare, Saint, 50
Clinton, Hillary, 262
Coatlicue, 254
Cold War, 242
Cologne Cathedral, Germany *Altar-
 piece of the Patron Saints, 164, 165*
Colombe, Jean, 112
Communism, 238, 242, 288
Compline, 112
Confraternity of Archers, 212
Congregation for the Doctrine of
 the Faith, 234
Constantine, Emperor, 18, 75, 148, 149
Constantinople. *See* Istanbul, Turkey.
Contino, Antonio, 17
Contractus, Hermannus, 199
Coronation of Mary, *70, 105*
 scenes in Books of Hours, 110,
 112, *113*
Cortés, Hernán, 249, 252, 259

Counter-Reformation, 40, 65
Couturier, Marie-Alain, 41
Cranach, Lucas, 33
Crèches, 139–141, 145, 153–155, 216
Crusader structures, 13, 192
Cubism, 56
Cybele, 26
Cyril, Patriarch of Alexandria, 68, 69
Czestochowa, Poland, 237

Daniel, 58
Dante, 111, 211, 285
 Divine Comedy, 111
 Inferno, 285
 Paradiso, 211
Darfur, Sudan, 142
 refugee child, *143*
David, King, 92, 176
Deborah, 33
Delilah, 26, 32
Demeter, 26
DeMille, Cecil B., 17
Deposition of Jesus Christ, 212
 in art, 213, 285, 290
Deposition of the Virgin's Robe,
 Feast of the, 73
Descartes, René, 196
Diego, Juan, 249, 251, 252, 253, 259,
 261, 269
Divine feminine, 27, 28, 30
Divine Office prayers, 109
Dolci, Carlo, 200
Dolfi, Franco, 236
*Dolorous Passion of Our Lord Jesus Christ,
 The*, 227, 229
Dombes Group, 292
Dome of the Rock, Jerusalem, 133
Donatello, 33
Dormition of Mary (Death of), 274
 in art, 79, 275
Duke University Medical Center, 204

Eadmer of Canterbury, 101
Easter, 208
École des Beaux-Arts, Paris, 173
Egypt, 9
 flight into, 16, 61, 110, *172*, 173, 284
 according to Matthew, 172
Ein Karem, Israel, 128

El Camino Real, 265
Elijah, 58, 176, 273
Elizabeth, Saint, 54, 126, 127, 128,
 129, 130, 276
Emmerich, Anne Catherine, 227–228
Enoch, 273
Enrollment for Taxation, 78
Ephesus, 23
 Council of, 26, 38, 68–72, 133
 Mary's house, 227, 228, 229–230
 Temple of Artemis, 23, 72
Epiphanius of Salamis, 272
Esther, Book of, 31
Ethiopia, 182, 272
Eucharist, 75, 118, 199, 229, 239
Eustachius, 225
Eve, 26, 31
Eyck, Hubert van, 277
Eyck, Jan van, 213, 277

Fabisch, Joseph, 246
Falloppio, Gabriele, 225
Fatima, Basilica of Our Lady of,
 Portugal, 91, 196, 234, *235*,
 240–241
 Message of Fatima letters, 242
Faverches, Richeldis de, 240
Favrot Peterson, Jeanette, 256
Feminist theology, 27, 28, 33, 35, 114,
 118–119, 248, 296
Fiat mihi, 282
Field of Mars, Rome, 25
Fiume, Croatia, 192
Florence, Italy, 4, 53, 98, 185, 212
 Cathedral Campanile, 285
Flowers, 3, 85, 96, 154, 170, 209, 220,
 221, 224, 226, 252, 298
Francis of Assisi, Saint, 50, 101, 139–
 141, 145, 155, 161
 crèche, 139–140
Franciscans, 66, 71, 100, 101, 152,
 154, 155, 207, 265
François I, King of France, 233
Fuga, Ferdinando, 71
Fulbert of Chartres, 103

Gabriel, Angel, 10, 13, 20, 48, 50, 53,
 54, 56, 58, 101, 120–121, 276
 in art, 16, 21, 51, 52, 57, 122

ABOUT THE AUTHOR

JUDITH DUPRÉ is the author of several international bestselling books, including *Skyscrapers*, *Bridges*, *Churches*, and *Monuments*. Winner of a number of prestigious fellowships, she holds degrees from Brown University and studied at the Open Atelier of Design and Architecture in Manhattan. Currently, she is investigating the influence of time, memory, and beauty on sacred architecture at Yale Divinity School. She lives with her family outside New York City. For more information, visit www.judithdupre.com.

ABOUT THE TYPE

The text of this book was set in Nofret, a typeface designed in 1986 by Gudrun Zapf–von Hesse especially for the Berthold foundry.